TWENTIETH-CENTURY
MODERN MASTERS

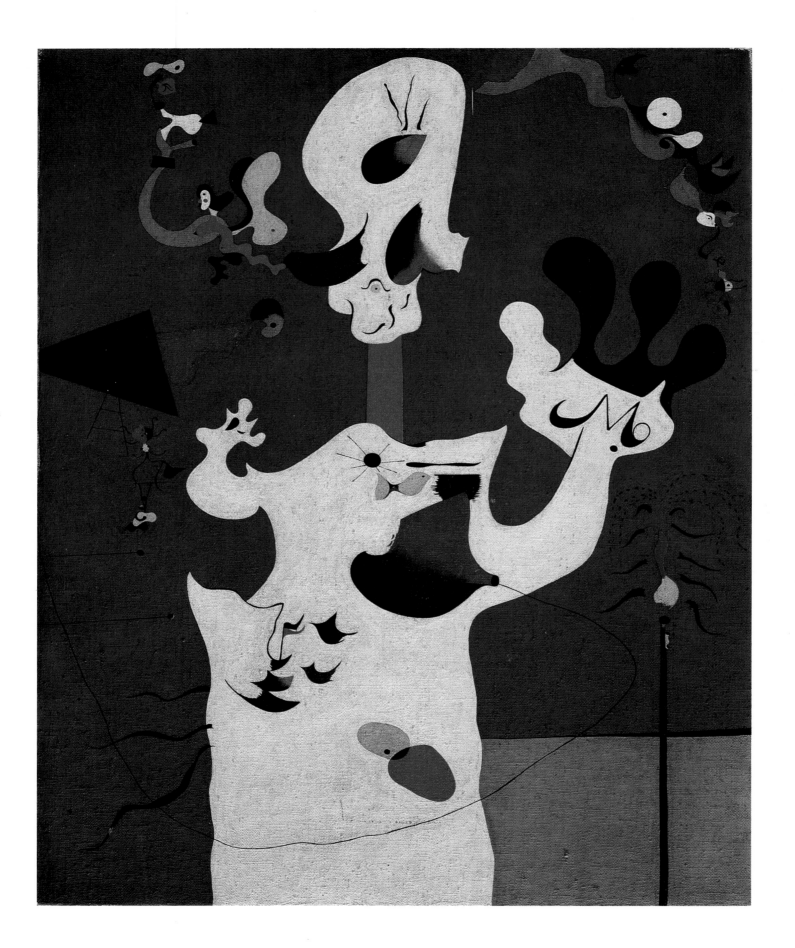

TWENTIETH-CENTURY MODERN MASTERS

THE JACQUES AND NATASHA GELMAN COLLECTION

Edited by William S. Lieberman

Catalogue by Sabine Rewald

Contributions by Dawn Ades, John Ashbery, Jacques Dupin,
John Golding, Lawrence Gowing, William S. Lieberman,
Philippe de Montebello, Pierre Schneider, and Gary Tinterow

THE METROPOLITAN MUSEUM OF ART

Distributed by Harry N. Abrams, Inc., New York

This catalogue has been published in conjunction with the exhibition "Twentieth-Century Modern Masters: The Jacques and Natasha Gelman Collection," held at The Metropolitan Museum of Art, New York, December 12, 1989–April 1, 1990

Published by The Metropolitan Museum of Art, New York

John P. O'Neill, *Editor in Chief*
Ellen Shultz, *Editor*
Gwen Roginsky, *Production Manager*
Joseph B. Del Valle, *Designer*

Copyright © 1989 by The Metropolitan Museum of Art
Library of Congress Cataloging-in-Publication Data
Rewald, Sabine.
 Twentieth century modern masters : the Jacques and Natasha Gelman
collection / edited by William S. Lieberman; catalogue by Sabine Rewald.
 p. cm.
 Catalogue of an exhibition to be held at the Metropolitan Museum,
December, 1989.
 Includes bibliographical references.
 ISBN 0-87099-568-5. — ISBN 0-87099-569-3 (pbk.). — ISBN
0-8109-1037-3 (Abrams)
 1. Art, Modern—20th century—Exhibitions. 2. Gelman, Jacques—
Art collections—Exhibitions. 3. Gelman, Natasha—Art collections—
Exhibitions. 4. Art—Private collections—United States—
Exhibitions. I. Lieberman, William Slattery, 1924—
II. Metropolitan Museum of Art (New York, N.Y.) III. Title.
N6487.N4M836 1989
709'.04'00747471—dc20 89-13054
 CIP

The color photographs were taken by Malcolm Varon, except for those on pages 111, 114, 146, and 250, which are by Lynton Gardiner. The black-and-white photographs are by the Photograph Studio, The Metropolitan Museum of Art

JACKET/COVER: Henri Matisse. *The Young Sailor II*. See page 88

FRONTISPIECE: Joan Miró. *The Potato*. See page 184

Printed and bound by Imprimeries Réunies Lausanne S.A., Lausanne, Switzerland

Contents

Foreword

WE ARE PLEASED at The Metropolitan Museum of Art when we can salute the "private eye," for it is private collections—those demonstrations of individual taste—that animate what otherwise might be, in large public institutions, somewhat static holdings. Therefore, it is both with great excitement and an extreme sense of privilege that we welcome this showing of the Jacques and Natasha Gelman collection at the Metropolitan Museum. Just how remarkable and how valuable this collection is was succinctly expressed in a statement in *The New York Times* in 1986: "It would be difficult to organize a major exhibition of 20th-century European modern painting without loans from the Gelman collection." Now, for the first time, the Metropolitan Museum offers the public the unique opportunity to see and enjoy together all eighty-one splendid works of art in the Gelman collection, each of which is discussed, documented, and reproduced in this catalogue.

The exhibition of the Gelmans' paintings, drawings, and sculpture is a significant event at the Metropolitan Museum, not only because the collection sustains a remarkable level of quality, and will delight both the eye and the mind of even the most exacting visitor, but even more so because most of the Gelman works fall within that province of twentieth-century art, the School of Paris, that has been for so long inadequately represented in our galleries. By what has proven to be a happy coincidence, the clusters of impressive works by such artists as Matisse, Picasso, and Miró that are present in the Gelman collection handsomely fill lacunae in the Lila Acheson Wallace Wing.

Equally significant is the distinctive character of this collection, put together with the invaluable currencies of love, passion, determination, and even pertinacity, and the result is a selection in which the viewer will sense clearly that academic training and scholarship did not blur the collector's eye.

The Gelman collection as seen at the Metropolitan Museum serves to remind us that encyclopedic collections such as ours are, in fact, an aggregate, formed over time, of the choices of numerous collectors and curators. It is in this way that museums become palimpsests of individual tastes and biases.

With her late husband, Jacques, Natasha Gelman has been an avid and discriminating collector. In the pursuit of the Gelmans' singular passion for works of art, they formed close

and enduring friendships. Both William S. Lieberman, chairman of the Department of 20th Century Art, and I—although Bill has known the Gelmans far longer—would like to think that this exhibition was born as much of valued friendship as of the manifest importance of bringing this superb collection before the public.

Bill Lieberman, especially, has followed closely the peripatetics of the Gelmans' style of collecting, and the introduction to this catalogue is due to him. It reflects not only his close personal ties with the Gelmans, but also his extensive knowledge of Picasso, which yields fascinating insights into several of the major examples by that master in the Gelman collection. Sabine Rewald, associate curator in the Department of 20th Century Art, is to be credited for her perceptive catalogue entries. It is thus with a sense of institutional pride as well as personal pleasure that we extend to Natasha Gelman our profound gratitude for allowing us to share her superb collection with our public. In celebrating this most happy event, the inauguration of the Jacques and Natasha Gelman collection at the Metropolitan Museum, we also wish to thank Eugene Victor Thaw, the late Pierre Matisse and Mrs. Matisse, Robert R. Littman, and Marylin G. Diamond. They have been exceptionally helpful in bringing to fruition this very special exhibition.

PHILIPPE DE MONTEBELLO
Director
The Metropolitan Museum of Art

Acknowledgments

I WISH to thank William S. Lieberman, chairman, Department of 20th Century Art, for asking me to catalogue this fine collection. He conceived this publication, chose its authors and their topics, was its exacting editor, and as always was most supportive.

The research for this catalogue was carried out with the help of a team of able assistants. I am deeply grateful to Kathy L. Hart and Nancy Spector for establishing the provenances, exhibition histories, and bibliographies for most of the works in this collection, and also for their invaluable additional assistance, which included tracking down rare photographs, out-of-the-way publications, and obscure references. Judith Meighan, Linda Norden, and Gail Stavitsky, Chester Dale and Andrew W. Mellon Fellows in the Department of 20th Century Art from 1988 to 1989, also assisted with research on individual works, as did many of the Museum's part-time and summer interns. I am particularly indebted to Andrea van Laer Feeser and Nora Heimann for checking the facts.

Eugene Victor Thaw, New York, provided information on works that he helped the Gelmans to acquire. Maria-Gaetana Matisse and the late Pierre Matisse, New York, answered with unending patience numerous queries concerning the histories of works that passed through their gallery. I am especially grateful to Pierre Matisse for describing the vacations he spent with his father in Collioure during 1905 and 1906.

I also owe much to Wanda de Guébriant, Matisse Archive, Paris, for generously providing bibliographical references to the nine works by Matisse in the Gelman collection, and for answering many questions regarding the dates of Matisse's early stays in Collioure. Likewise, Dominique Fourcade, Paris, opened his vast archive on Matisse to me. Special thanks are also due to Annette Giacometti, Paris. François Rouan, St. Maximin, and Sam Szafran, Paris, the two youngest artists represented in the Gelman collection, offered insights into their work.

Jean Pascot, the mayor of Collioure, Abbé E. Cortade of Pézilla la Rivière, the parish priest, and Jacqueline Maspharner-Veisse, Collioure, helped me in my search for any descendants of the sitter for Matisse's famous paintings *Young Sailor I* and *Young Sailor II* (both 1906). Thanks to them I found the sitter's son, the late Paul Montargès, and his wife in Collioure.

Many colleagues, scholars, art dealers, and others in the United States and abroad gave particularly valuable assistance: William R. Acquavella, New York; Thomas Ammann, Zurich; Roland Balay, New York; Vivian Endicott Barnett, The Solomon R. Guggenheim Museum,

New York; T. S. Bathurst, David Carritt Limited and Artemis Fine Arts Limited, London; Heinz Berggruen, Geneva; Ernst Beyeler, Basel; Brigitte Bourgeois, Musée du Louvre, Paris; Vava Chagall, Saint-Paul-de-Vence, France; Susan Compton, London; Elizabeth Easton, The Brooklyn Museum, New York; Andrea Farrington, Pierre Matisse Gallery, New York; Valerie Fletcher, The Hirshhorn Museum and Sculpture Garden, Washington, D.C.; Lydia Fons, Musée d'Art Moderne, Céret, France; Miriam da Costa, Galerie Claude Bernard, Paris; Stefan Frey, Paul Klee-Stiftung, Kunstmuseum, Bern; Guy Patrice Dauberville, Galerie Bernheim-Jeune, Paris; Richard L. Feigen, New York; Ena Giurescu, The Museum of Modern Art, New York; Stephen Hahn, New York; Maurice Jardot, Galerie Louise Leiris, Paris; Joop M. Joosten, Leiden, The Netherlands; Lewis Kachur, New York; Michel Kellermann, Paris; John Klein, Yale University Art Gallery, New Haven, Connecticut; Jane Lee, London; Robert Lubar, New York; Mary Lisa Palmer, Paris; Jacqueline Paulhan, Paris; Margaret Potter, New York; Theodore Reff, New York; John Rewald, New York; Margit Rowell, Paris; Alfred Richet, Paris; Antoine Salomon, Paris; Pierre Schneider, Paris; Sheldon H. Solow, New York; Louise A. Svendsen, Sotheby's, New York; Patty Tang, Eugene V. Thaw & Co., Inc., New York; Vivianne Tarenne, Musée National d'Art Moderne, Centre Georges Pompidou, Paris; Lillian A. Tone, The Museum of Modern Art, New York; and Simon Willmoth, Stoke-on-Trent, England.

Helpful in providing photographs or other assistance were: Gilberte Brassaï, Paris; Henri Dauman, New York; Letizia Enderli, Kunsthaus, Zurich; Xavier Girard, Musée Matisse, Nice; Margit Hahnloser-Ingold, Fribourg; Edwynn Houk Gallery, Inc., Chicago; Quentin Laurens, Galerie Louise Leiris, Paris; Antonia Mulas, Milan; Patricia L. Nicholls, The Phillips Collection, Washington, D.C.; Richard Tooke, The Museum of Modern Art, New York; Harry Torczyner, New York; and Annette Viallant, Paris.

I particularly thank Albert Kostenevich, The Hermitage, Leningrad, who went out of his way to be of assistance.

The staffs of various libraries in New York were very helpful. I want to thank especially Clive Phillpot, The Museum of Modern Art; Helen Sanger, The Frick Art Reference Library; Sonya Bay, The Solomon R. Guggenheim Museum; and William B. Walker and his staff at The Thomas J. Watson Library, The Metropolitan Museum of Art.

Many members of the Museum's staff offered their assistance: Ashton Hawkins, Office of the Vice President, Secretary and Counsel; Linda M. Sylling, Office of the Vice President for Operations; Lucy Belloli and Maryan W. Ainsworth, Paintings Conservation; Helen K. Otis, Margaret Holben Ellis, Betty Fiske, and Margaret Lawson, Paper Conservation; Colta Ives, David W. Kiehl, and Maria Morris Hambourg, Prints and Photographs; Gary Tinterow and Anne Norton, European Paintings; Ida Balboul, James Aquino, Sal Porcellati, Anthony Askin, Cynthia Iavarone, and John Koski, Department of 20th Century Art; Peter L. Donhauser, Special Programs; Patrick McGrady, Academic Programs; Jeffrey L. Daly, Stephen Hefferan, Johannes Knoopes, and Sue Koch, Design Department; Barbara Bridgers and Arvia J. Higgins, Photograph Studio; Willa Cox, Gerald P. Lunney, Martin Pecikonis, and Peter L. Bengston, Registrar.

Guy Bauman, European Paintings, gave lots of advice, editorial and otherwise. Kay Bearman, Department of 20th Century Art, was especially helpful.

John P. O'Neill, Editor in Chief, valiantly supervised the production of this book, which gained much from the diligent editing of Ellen Shultz and the elegant design of Joseph B. Del Valle. I also owe much to Teresa Egan, Gwen Roginsky, and Kathleen Howard, all of the Editorial Department, who helped with deeds, ideas, or advice. Rodolfo Aiello and Jean Wagner checked the bibliography, and Susan Bradford compiled the index.

Mrs. Gelman graciously allowed access to her collection, often on very short notice. She was always most generous and kind, which made the cataloguing of her collection all the more pleasurable.

SABINE REWALD
Associate Curator
Department of 20th Century Art

Introduction: A Chronicle

THE EXHIBITION, in 1989, of the Jacques and Natasha Gelman collection at The Metropolitan Museum of Art consists of eighty-one paintings, drawings, and bronzes by thirty twentieth-century European artists. Such a short, statistical summary is correct but it in no way describes what the Gelmans acquired, with love and sometimes after anguish, nor does it indicate Mrs. Gelman's continuing additions to the collection that she and her husband so splendidly formed.

The three of us were close friends for many years. We happily shared much time together, and they repeatedly allowed me to invite others to enjoy their warm hospitality. I am very pleased that several of these guests are, like myself, contributors to this publication.

Before I begin, I should point out that they also assembled two other collections, both of which are devoted to Mexican art: pre-Hispanic sculpture, of special interest to Mrs. Gelman, and modern Mexican painting beginning with works commissioned by Mr. Gelman from Rivera, Tamayo, and Frida Kahlo, among other artists. The present exhibition at the Metropolitan Museum shows only their European collection, which is borrowed from their home in New York.

Although acquired for personal enjoyment and never intended as a survey, the Gelmans' choice of European paintings and drawings is astonishingly coherent. Its quality is superbly sustained, and I find it difficult—perhaps impossible—to suggest any other private selection similarly defined in focus that is of comparable caliber. Representation of the School of Paris is particularly strong, and comprises a constellation of masterworks of our time. The two earliest pictures in the collection, an anecdotal street scene by Bonnard and an intimate conversation piece by Vuillard, were both painted in Paris slightly before 1900. The most recent works are by Francis Bacon and by later painters of the School of Paris, by Picasso and Giacometti in the 1960s, and by Rouan and Szafran, two younger French artists whose pictures date to the 1970s.

Bonnard, a master of luminescence in and out of doors, strengthened the Impressionist tradition by binding together light, color, and form. He is represented in the Gelman collection by four works postdating 1900: a tall painting of a nude leaving her bath (1910); a large domestic interior (1916); and two still lifes of the same year: one of fruit, the other of flowers (1926). All four paintings once hung in the Gelmans' dining room in New York. The

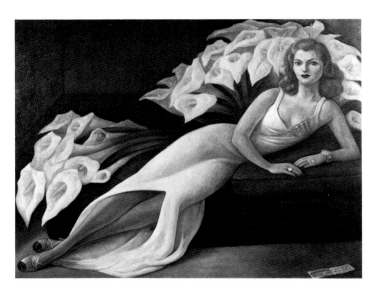

Figure 1. Diego Rivera. *Natasha Gelman*. 1943. Oil on canvas, 47¼ × 61¼ in. (120 × 155.5 cm.)

installation in their home, however, is never static. Placement changes, juxtapositions are revised, and Natasha always finds space for a new acquisition.

In the twentieth century, the first distinctive style of painting was developed by the Fauves in France. Its intensity lasted scarcely three years, and in the Gelman collection several works from 1906 by Vlaminck, Derain, and Matisse strikingly illustrate its short-lived vigor: a landscape of Chatou and a portrait of Derain painted by Vlaminck; a tumultuous street scene of London by Derain; and a still life, a portrait, and two drawings by Matisse. The most celebrated of the Gelmans' Fauve paintings is undoubtedly the portrait by Matisse called *The Young Sailor* of 1906 (page 88); after all these years, the sitter's identity has been sleuthed by Sabine Rewald, who contributed the individual entries to this catalogue. The Gelmans' drawings of the sailor, related to their painting of the same subject, was a surprise gift to them from Matisse's younger son, Pierre, who, with his wife, Maria-Gaetana, was their close friend. Pierre, of course, was for many years the doyen of art dealers in New York until his death in August 1989.

Matisse's career was long. It was also glorious, sustained by a sure sense of design and a mastery of color that remained vital and always innovative. Matisse is further represented in the Gelman collection by five works that followed his Fauve period; each is of major importance. Three are paintings: a view of Collioure (1907–8), majestic in its rhythmic discipline of nature, and two studies of different models (1916 and 1926–27), one seated and starkly silhouetted against a black background, the other reclining and integrated into a "harmony in red" (see pages 93, 142, 176). The model in the artist's studio is also the subject of a later drawing (1948), boldly brushed in in black on white (see page 247). The last Matisse in the Gelman collection is the tall *Snow Flowers* of 1951 (page 249), one of the largest of his *papiers peints et découpés*. Painted, cut, and pasted together when he was eighty-two years old, the collage is elegant in its heraldry and also marvelous in its asymmetrical balance of forms. Matisse's image, a magnificent decoration, makes no reference to the winter season.

Its arabesques represent leaves and flowers floating above the wave indicated at the lower right. Such foliate forms became part of Matisse's designs in the mid-1940s, in his first series of collages, at the same time that he was also recalling "souvenirs" of his voyage to Tahiti in 1930.

Although the *Young Sailor* is unquestionably the best known of the Gelmans' paintings by Matisse, my own particular favorite is his *View of Collioure* (page 93), also preferred by Marcel Duchamp. In 1943, Duchamp remembered: "Around 1907, he showed several large compositions which contained all the elements of his masterly conception. Perspective had been discarded and replaced by the relationship of strong hues which produced a third dimensional effect of its own. Figures and trees were indicated with heavy lines, building the arabesque adjusted to the flat areas of color. The ensemble created a new scenery in which the objective composition appeared only as a remote guide."[1] At the same time, Braque at L'Estaque and Picasso at La Rue-des-Bois were also creating "a new scenery"—landscapes that anticipated Cubism.

Besides such quintessential French painters as Matisse, Bonnard, and Braque, many foreign artists who lived and worked in France during the first half of the twentieth century are irrevocably associated with the School of Paris. Picasso, Gris, Miró, and Dali were Spanish; de Chirico and Modigliani were Italian; Chagall and Kandinsky were Russian; Ernst was German; Giacometti was Swiss; and Brauner was Romanian. Balthus and Szafran are also foreign born. Why did they gravitate to France? Gertrude Stein, herself a foreigner

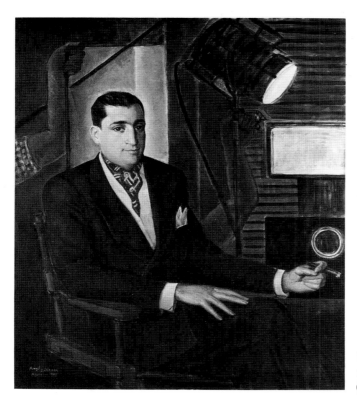

Figure 2. Angel Zárraga. *Jacques Gelman.* 1945. Oil on canvas, 51 × 43½ in. (129.5 × 110 cm.)

in that country, furnished four reasons that, for her and perhaps for us, are sufficient. Her reasons are not as idiosyncratic as they may sound:

> Foreigners belong in France because they have always been here and did what they had to do there and remained foreigners there. Foreigners should be foreigners and it is nice that foreigners are foreigners and that they inevitably are in Paris and in France. . . . Of course they all came to France a great many to paint pictures and naturally they could not do that at home. . . . So it begins to be reasonable that the twentieth century whose mechanics, whose crimes, whose standardization began in America, needed the background of Paris, the place where tradition was so firm that they could let anyone have the emotion of unreality. . . . Paris was where the twentieth century was.[2]

In the Gelman collection Picasso receives more attention than any other artist; his fourteen drawings and paintings span more than six decades. The earliest, painted in 1901 during Picasso's second stay in Paris, is of a girl he observed in a music hall in Montmartre, possibly the Moulin Rouge. The picture is small, its colors are vivid and intense, and Picasso's bold adaptation of a Divisionist technique anticipates Fauve brushwork by four years (see page 69). The same young girl also appears in profile in a previous drawing— almost a caricature—belonging to another private collection in New York. In that drawing (see Daix, *Blue and Rose*, p. 172, v. 36)[3] she wears an enormous hat and an extravagant boa as she promenades in a hobble skirt. She has dressed herself to resemble more worldly demimondaines but she lacks the sophistication of their practiced hauteur. The Gelman painting, smaller than the drawing, studies only the young girl's head. Hat and boa are recognizable, but Picasso reduces these elements of finery to a diffused pattern of colors—a pulsating background that serves as a contrast to her stark white face with its pert if somewhat common features. The painting's original owner was Ignacio Zuloaga, the fashionable Spanish artist and occasional dealer in the work of El Greco. Zuloaga lived in Paris, where, for a brief time, he was the young Picasso's mentor. I always assumed that this painting, a nighttime vis-à-vis to their earliest Bonnard, was the first Picasso that the Gelmans had acquired. I was incorrect. When talking with Natasha Gelman recently, she said that their first acquisition of a Picasso had, indeed, been a picture of a woman's head— as Jacques had told me—but that it was a very different, convulsive image painted twenty-five years later (see page 179), which they had purchased in Mexico in the 1940s.

The next Picasso in the Gelman collection was painted in the autumn of 1906, and it originally belonged to Gertrude Stein, who died in 1946. The small portrait, in relation to the Gelmans and myself, recalls several incidents: In 1968, after negotiating the sale of Gertrude Stein's collection, I was disappointed that Jacques Gelman was not invited to be among its five purchasers. The collection consisted of forty-seven drawings and paintings by Picasso and by Gris that had remained in the custody of Alice B. Toklas until they were seized by the legal heirs of Gertrude Stein. The drawings and the paintings by Picasso were stored in the vault of a British bank in London; those by Gris had remained in France, and were stored in a vault of an American bank in Paris. All forty-seven drawings and paintings

from the collection were subsequently exhibited in New York at The Museum of Modern Art, augmented by many works by Picasso and by other artists, which also had been collected by Miss Stein, as well as by her older brother, Leo, and her younger brother, Michael, and his wife. Among the additional works in the exhibition was Matisse's *View of Collioure*, which was recently acquired by the Gelmans and originally had been owned by Michael and Sarah Stein; the latter was once a student of Matisse and a collector of his art as well.

One cold winter evening in 1970, after I had completed the installation of the Stein collections at The Museum of Modern Art—the exhibition was called "Four Americans in Paris: The Collections of Gertrude Stein and Her Family"—I asked Jacques and Natasha Gelman to preview the exhibition before I joined them at supper. In the galleries of the Modern Museum they studied many famous works, including their own Matisse. What they admired most, however, were two paintings by Picasso: a small self-portrait painted in 1906, from Miss Stein's estate, and his very large and imposing figure composition *Three Women* of 1908 lent by the Hermitage in Leningrad (fig. 1, page 106).

At supper, Jacques good-humoredly growled that he had not been offered an opportunity to purchase anything from the Stein estate, but that he knew that it had been no fault of mine. Jacques had several questions. First—why, since Miss Stein had died in 1946, was the sale of her collection delayed for more than twenty years? I explained the reasons, and recounted my somewhat cloak-and-dagger pursuit of the Stein estate. I also described the conservation of the pictures, which, especially for those on or incorporating paper, had been extremely complicated; for a paper conservator, pulpboard and newsprint are tacky horrors. Jacques's questions continued. I replied, "Yes," that as far as I knew, "the small self-portrait previously had not been shown publicly." Then he asked why, in the installation, was the large *Three Women* so dimly lit? I explained that because of tensions with Israel and the recent threats that they had received, the Soviet authorities had insisted upon a huge, protective shield of Plexiglas; in Paris, the Soviet Tourist and Airline Office had been bombed, and no one wanted a similar occurrence in New York. The lighting, I added, was therefore deliberately dim, and, when the exhibition opened, a special guard would be assigned to the painting. I mentioned that David Rockefeller, the principal purchaser of the five who acquired the Stein estate, had negotiated the loan of the large painting, and that thanks to him it was the first time that the Soviets had agreed to lend a Picasso to the United States. The last of the questions was, "What's wrong with Braque?" (always one of Jacques's favorite painters). I was taken aback because I could not explain why Miss Stein had never acquired a single example of his work. At the end of supper—only I had dessert—Jacques sat back and said that what he and Natasha desired most were two fine Cubist still lifes, one by Picasso and one by Braque, even if the latter had not been sanctified by Miss Stein. Natasha reminded him that they might also like Picasso's small self-portrait—but that, unfortunately, was no longer available.

Several years later, on the first day of May, 1986, the Gelmans attended a gala at the Plaza Hotel in New York. In conversation, another guest happened to describe an early self-portrait by Picasso that she knew was for sale. As Jacques immediately realized, it was the

Stein picture—this time in the estate of one of the five purchasers of the Stein collection. The information was unexpected, and the Gelmans acted quickly. A few days later, on a Sunday, they telephoned me as I was preparing to leave for Australia, and asked me to stop by their apartment, which, of course, I did. That evening, together in a corner of their large salon, we raised a toast to the small portrait that, like us, comfortably sat on the cushion of an armchair. The picture was the last acquisition that Jacques and Natasha made together. Jacques died in July 1986, at the age of seventy-four.

Jacques and Natasha met in December 1939, a few weeks after he had seen her leaving the lobby of a building in downtown Mexico City. The handsome, dark-haired, and broad-shouldered Jacques was *bouleversé* by the blonde young lady who moved with the sure grace of a high-fashion model, and who, as she laughed, slightly turned her head. Natasha, however, did not notice Jacques. A day later, by coincidence, he saw her again. She was sitting in the garden of a hotel where she was waiting for a friend. Jacques noticed that she was reading a French newspaper published in Mexico. He quickly managed to discover her name, with more difficulty her address, and promptly began a courtship.

Both Jacques and Natasha had been born in Europe: Jacques in St. Petersburg, and Natasha in Bohemia (today, part of Czechoslovakia). Natasha, convent raised, attended schools in Vienna and in Switzerland. She was accustomed to traveling, and to the sophisticated and romantic life of European capitals and resorts. As a young man in Russia, Jacques had demonstrated a precocious interest in photography. He had received a stipend from the Soviet Union to study abroad, and when he departed his father gave him some Fabergé objects—literally, nest eggs—which fortunately Jacques was never forced to sell. In Germany, he became interested in moving pictures, and worked as a "camera pusher" for Pathé in Berlin before settling in Paris, where he began his career as a film maker.

In 1938 Jacques came to Mexico on a business trip. His permit was actually a tourist visa issued, Natasha was amused to discover, by Ethiopia. She was glad, however, that it was valid. With the advent of World War II, Jacques decided to remain in Mexico. After the war, he discovered that during the German occupation a small painting by Renoir and one by Vuillard that he had collected had disappeared from his Paris apartment on the Boulevard Suchet.

In Mexico, Jacques became the producer of films that starred his partner, Cantinflas—the most popular comedian in the Spanish-speaking world. Jacques knew not only how to make films, but also how to distribute them. Both he and Cantinflas prospered. They turned out one film a year, and they continued as partners until Jacques's death.

Jacques and Natasha were married in 1941. Soon after, they became Mexican citizens and celebrated their new status in Acapulco, then a fishing village. Russian, of course, was Jacques's native language; Natasha is fluent in several. Together, they always spoke French. They became equally at home in Mexico City and in New York, and after the war they frequently traveled abroad.

I return to the last acquisition that the Gelmans made together, the small likeness by Picasso originally collected by Gertrude Stein (see page 99). It is one of several that he painted of himself during the autumn of 1906 in Paris, and it commemorates his appearance

at exactly the age of twenty-five. Never again did he celebrate an anniversary in this way. In the larger self-portraits from the same time, he appears as a figure in three-quarter views, and once, unexpectedly, as a child. In the portrait in the Gelman collection, perhaps the last in the informal sequence, he concentrates upon the head. His hair lies flat, and he seems more youthful than his actual age. Features are generalized, and their contours strongly outline a compact design. The mask-like face and the sculptural treatment of form demonstrate the redirection of Picasso's style in 1906 after he had spent the summer in Gosol. This transition is most famously illustrated by the portrait of Gertrude Stein that he painted in Paris; it was begun before but finished after that summer. Today, both portraits can be seen in the Metropolitan Museum on the occasion of this exhibition.

The other painting by Picasso that Jacques had admired in 1970, at the exhibition "Four Americans in Paris: The Collections of Gertrude Stein and Her Family," was the large *Three Women* of 1908—a monumental configuration of three bathers, classical in subject, radical in style, and almost square in format. It is in no way an alluring picture, but it is masterful and overpowering, the sort of key work too often discussed as "transitional," described as "difficult," and dismissed as "unresolved." Jacques and Natasha, however, liked strong pictures, as so many works in their collection demonstrate.

Miss Stein, apparently, did not enjoy living with the large *Three Women*, and I suspect that her brother Leo heartily disliked them. In the *Autobiography of Alice B. Toklas* Gertrude Stein remembered that it "was an enormous picture, a strange picture . . . in a sort of red brown, of three women, square and posturing, all of it rather frightening." By 1913, a year before Gertrude and Leo parted and divided their collection, they had already sold the *Three Women* to Daniel-Henry Kahnweiler, Picasso's official dealer since 1912. He in turn sold it to Sergei I. Shchukin, a Moscow merchant who was an avid collector of French avant-garde art. By 1918, when Shchukin's collection was "nationalized" by the Soviets, he had assembled fifty-one paintings by Picasso and thirty-seven by Matisse!

The *Three Women*, on loan to the Modern Museum in 1970, had been in the collection of the Hermitage since 1948 and, of course, was not for sale. In any case, it certainly would have been much too large for the Gelmans' New York apartment. In 1978 and in 1980, however, Jacques and Natasha were able to acquire a watercolor and then a charcoal drawing that may be directly associated with the painting that they had so admired.

Picasso made many drawings and painted several paintings that relate to the large canvas *Three Women*. Among the first may be a watercolor I came upon while researching works by Picasso in private collections for Alfred H. Barr, Jr. (see Daix, *Cubism*, p. 214, no. 126). The watercolor, purchased by The Museum of Modern Art in 1957, is a horizontal composition, and its theme and figures—five nudes in a sylvan setting—derive from Cézanne. Although complete, Picasso never developed its composition into a larger painting in oil. Two of the five nudes in the watercolor—the couple embracing at the left—had already appeared in *Friendship* (Daix, *Cubism*, p. 210, no. 104), a slightly earlier painting begun in 1907 and also collected by Shchukin. Picasso decided to concentrate on the three remaining bathers—one kneeling, one standing, and one seated—all of whom would become "square and posturing" and, like Miss Stein herself, quite bulky.

Braque and Picasso, the Frenchman and the Spaniard, had met during the late autumn of 1907, and, almost immediately, began to work in close association. The *Three Women* may be one of the earliest instances of their interdependence. Picasso's compositions closely follows a similar figure group in a pen-and-ink drawing by Braque of 1907, which, today, unfortunately is lost.[4] Once the large painting was finished, Picasso continued to explore the theme of three nudes.

In the *Three Women*, references to an open landscape are severely reduced; indeed, the limited space around the three nudes actually confines them, and the group appears rigidly fixed in time. The disjunctive deposition of their limbs contradicts any sense of repose that might be suggested by their lidded eyes, curiously closed in reverie or repose. These women are no longer bathers; they are primordial giants.

Picasso also devoted a separate painting (Museum of Fine Arts, Boston; see fig. 1, page 103) to the central standing figure in the *Three Women*, for which the Gelmans' watercolor *Standing Nude* (page 102) was specifically made. The same raised arms, burst of muscle, and thrust of feet characterize another watercolor that immediately preceded the Gelmans' study (see Daix, *Cubism*, p. 212, no. 114).

Jacques and Natasha Gelman's second drawing relating to the large *Three Women* is the charcoal *Kneeling Nude* (page 105), which corresponds to the figure at the left in the Hermitage painting. When the Gelmans acquired the drawing in 1978, it was one that I knew well. More than twenty years before, Alfred Barr and I had seen a photograph of it, and when it arrived at Curt Valentin's gallery in New York, we immediately recommended its purchase to Nelson A. Rockefeller, who became its first American collector.

Picasso continued and variously developed the subject of three nudes in 1908. Smaller paintings and other drawings present the same three Graces in a decorative and more rhythmic fashion. The *Three Women* in the Hermitage, however, is a final statement, and its configuration and format remained in the mind's eye of the artist. Thirteen years later, during the summer of 1921 in Fontainebleau, Picasso painted the large *Women by a Spring*, showing one figure kneeling, one standing, and one seated, but all three now clothed. The painting, in the collection of The Museum of Modern Art in New York, is the same size as the *Three Women* in the Hermitage. Picasso had also considered a large composition of three nude men in 1908 that was never realized, but during that summer of 1921 in Fontainebleau he completed two other large paintings, each of three men, both of which are versions of the *Three Masked Musicians*. (There are two pictures entitled *Three Masked Musicians*, both painted in 1921; one is in The Museum of Modern Art, New York, and the other in the Philadelphia Museum of Art.)

In April 1966, Jacques suggested that I visit the Parke Bernet Galleries (now Sotheby's) where Helena Rubinstein's collection could be viewed before it came up for auction. We had studied the catalogue together, and Jacques encouraged me to acquire for myself a small gouache by Roger de La Fresnaye. Jacques himself could not attend the afternoon or evening sessions—he was on location in Mexico producing a film with his partner, Cantinflas. Through Eugene Victor Thaw, however, he bought a small Picasso watercolor at the sale: a study of a woman's head (see page 101). As in so many of Picasso's drawings and paintings of

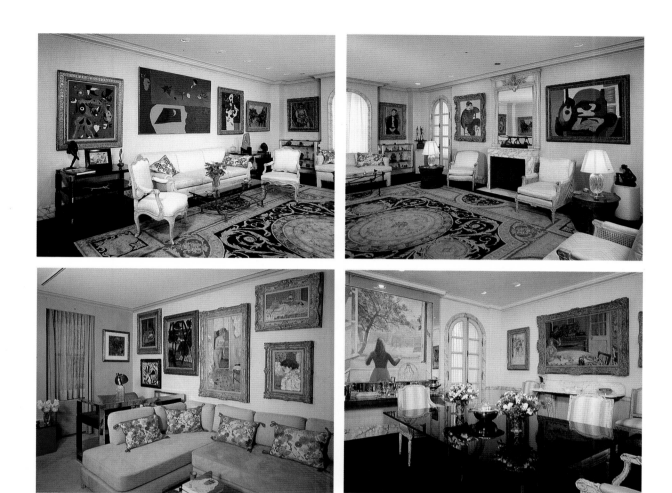

Figure 3. The Gelman apartment in New York, 1989

1908, the eyes appear to be shut, and the head relates to the painting known as *The Dryad*, another nude in a sylvan setting and again a painting collected by Shchukin (see Daix, *Cubism*, p. 215, no. 133). The Gelman study anticipates Picasso's chiaroscuro treatment of the full figure in which a nude, knees bent, seems to be seated without any actual support. The drawing, high on its sheet, shows only the "dryad"'s face. Matisse's *View of Collioure* and Miró's *Seated Nude* (pages 93, 154) were auctioned at the evening sale. Again through Eugene Thaw, Jacques and Natasha Gelman acquired both paintings.

In 1975, Jacques and Natasha moved from their duplex apartment overlooking New York's Central Park to a larger apartment on Park Avenue, which provided more space to accommodate their continually growing collection. A few architectural changes were necessary. When the superintendent of their new building checked the finished construction, Jacques and Natasha were astonished to hear him exclaim, "The pictures have come back!" He had recognized the Picasso watercolor, the Matisse *View of Collioure*, and Miró's *Seated Nude*, all three having, indeed, returned, if not to the same apartment then at least to the

same address. For many years Helena Rubinstein, as the Princess Gourielli, had occupied the penthouse floors of that building.

In 1971, to the Gelmans' satisfaction and delight, Jacques's quest for a Cubist still life by Braque and one by Picasso was happily concluded when, within a few months, they were able to acquire Braque's *Still Life with Banderillas* and Picasso's *Still Life with a Bottle of Rum* (pages 111, 114), both of which were painted sixty years before in Céret in the summer of 1911. Although never intended as a pair, the paintings make a perfect match, illustrating as they do the two painters' stylistic marriage. As Braque later remembered, "We were like two

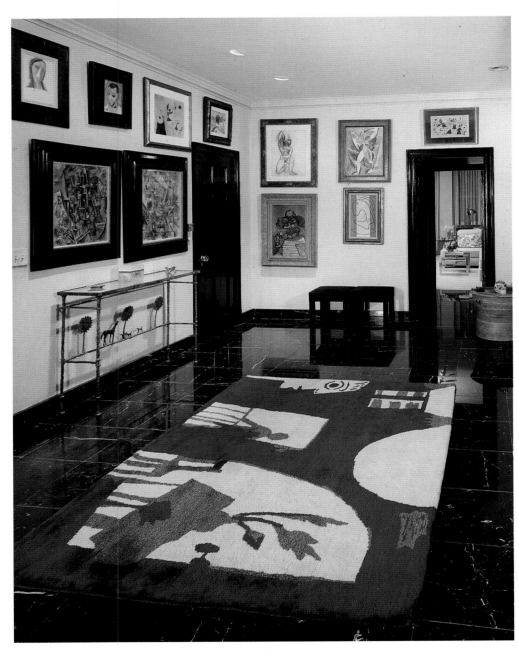

Figure 4. The Gelman apartment in New York, 1989

mountain climbers tied together." (For a discussion by Gary Tinterow of both paintings, see pages 33–34.) The still life by Picasso was once owned by the painter Ozenfant, and subsequently by the architect Le Corbusier.

Picasso had left the Montmartre quarter of Paris in October 1912 for Montparnasse, where he settled into a large apartment that Kahnweiler had found for him on the Boulevard Raspail. In November, following the initiative of Braque, Picasso began to compose his first *papiers collés*. These collages, charcoal drawings onto which pieces of paper are pasted, may have begun as an experiment, but they quickly developed into a series to which he devoted his principal energies throughout that winter. The most frequent theme of these works is the still life—specifically, the violin and guitar and the bottle and glass. A second subject, less varied in Picasso's treatment, is the head of a man represented not as a portrait but as an object of Cubist analysis. The *papier collé* collected by Jacques and Natasha Gelman is central to the series, as well as the tallest and most ambitious example (see page 116). It combines both subjects, the still life—the violin—and a man's head. A unity of concept, execution, and style sustains this first series of collages by Picasso. Although the inception and evolution of particular forms can be traced, it should be remembered that, as Picasso was drawing or pasting them down, he developed more than one image at a time. In retrospect, the series reveals a continuity of concentration that is remarkable, for, as a work in progress, its intensity ended only when Picasso left Paris in March.

What was Picasso's working process? I describe only the Gelman *Man with a Hat and a Violin* and its related *papiers collés*. On sheets of Ingres drawing paper, each measuring about 24 × 19 inches, he outlined in charcoal the flat contours of what he wished to represent. He then chose certain areas, whose shapes he had already outlined, for emphasis or for contrast. Over these areas he pinned smaller pieces of different papers that he had cut or transposed from various sources, most frequently newsprint. These smaller pieces of paper usually fit the sketched contours, and also filled in their shapes. Once satisfied with the placement of the papers, he pasted them down, over or within the charcoal outlines. The collage elements, torn from context and completely new in texture, lie flat on the larger sheet to which they are affixed. They add pictorial volume and create unexpected spatial relationships between what has been drawn and what is glued down. Picasso usually repeated on the collage element what he had drawn beneath it. Sometimes, however, he embellished it with further detail, and, occasionally, an area of the collage remains independent of any outline previously drawn.

In the Gelman collage, all of the pasted papers are clippings from newspapers. Were they chosen haphazardly? I think not. Very often such printed texts can be indirectly related to Picasso himself or events that concerned him. For instance, the excerpt in the Gelman collage reports a "tragique roman d'amour" (see page 118 for Sabine Rewald's summary of the printed text) that certainly must have reminded Picasso of the circumstances leading to the suicide of his friend Carlos Casegemas a dozen years before. I suggest that Picasso and perhaps his mistress cut out articles from newspapers, which they saved for the purpose of sharing later on.

Man with a Hat and a Violin was composed on two separate sheets of paper each 24 × 19 inches. These were joined at the horizontal line that divides the vertical composition in half. For other, smaller collages in the series, only one sheet of the same Ingres paper was used. Examine first the bust of the man, the upper sheet. Shoulders, neck, head, and top hat are swiftly and schematically outlined in charcoal. As traces of some lines indicate, Picasso considered two simultaneous views of the neck, head, and hat. On the collage element, the rectangle, Picasso reduces to geometric abbreviation the features of the face—brow, nose, and an eye. This upper half of the composition precedes one and follows another collage of the same subject, all three identical in size (one is in The Museum of Modern Art, New York; the other is in the Fogg Art Museum, Cambridge). The lower sheet, the second half of the composition, features a violin. The stringed instrument, however, does not fill the entire surface, nor is its placement centered. The violin at the bottom rests against the body of the man; the passage is unclear, and he is either seated or possibly standing. This lower sheet relates to yet another collage, again identical in size and type of paper, but probably executed slightly earlier (see Daix, *Cubism*, p. 290, no. 525). In contrast to the top sheet, the lower one contains several collage elements, only two of which actually define the violin. After connecting both sheets, Picasso extended downward the vertical line dividing the cylindrical form of the man's hat, which, in effect, sections the composition into quadrants. He further integrated both sheets by pasting newsprint over their connecting seam. This particular cutting had been rectangular, and its scalloped side—elsewhere, a guitar—once matched its other part at the lower left. The tall collage element at the lower right was probably added last. It contributes balance to the overall pattern of the composition but seems independent of the other forms. Exactly what is represented is not clear. Might Picasso have considered but abandoned a guitar, a bottle, or a glass?

A man wearing a top hat does not vanish from Picasso's art after 1912. In drawings and paintings he becomes a standing figure, and he makes a farewell appearance on stage in 1917. In May of that year, at the Théâtre du Châtelet in Paris, a man dressed in black and white and wearing a top hat stomped about in the role of the "Manager from New York" in Diaghilev's ballet "Parade," a collaboration of Jean Cocteau, Erik Satie, and Léonide Massine, for which Picasso designed the curtain, sets, and costumes.[5] Yet, more significant was Picasso's initiation of this century's most radical innovation in draftsmanship during the winter of 1912–13, with his *papiers collés*. Even Matisse, despite his own splendid and original achievements, would be in Picasso's debt (see page 249).

In the early autumn of 1988, Mrs. Gelman found an appropriate companion to Picasso's *Man with a Hat and a Violin*. She telephoned me in New York, from Switzerland, to describe a drawing by Gris that she had just seen. It was, I realized, the preliminary study for a painting that I knew well (see pages 119–21). That painting, *The Smoker*, had been collected by my friends Celeste and Armand Bartos and then by Baron Thyssen-Bornemisza, for whom I had recently catalogued a selection of the twentieth-century works in his collection. Both painting and drawing measure approximately the same size. I was more than interested because any studies for Gris's paintings are rare. Not only did he destroy most of them, but, in addition, his Cubist portraits can be counted on the fingers of one hand.

In 1906, soon after Gris arrived in Paris, he met his fellow countryman Picasso. Gris was quick to understand and absorb the new pictorial language of Cubism. Indeed, in retrospect, he is the most representational of the Cubist painters. Gris was also the most lucid, relying much less on instinct than did either Braque or Picasso. He excelled as a master of the still life, and when he died in 1927, at the age of forty, he had remained more faithful to Cubist theory than either Braque or his mentor and occasional rival, Picasso.

Although Gris's drawing is not as "pure" as Picasso's collage—Gris never composed collages on paper—the drawing is certainly related to it. The man's features are more dislocated, and they also conceal a profile. The subject matter of Braque's and Picasso's Cubist paintings is static, but Gris's top-hatted smoker ticks like a metronome in its anticipation of Futurist simultaneity of movement in time. It is more than likely that Gris had studied Marcel Duchamp's *Nude Descending a Staircase* (Philadelphia Museum of Art), which was shown at the Salon de la Section d'Or in Paris in 1912. This was the first significant public display of the new Cubist art, to which Gris also contributed, although Braque and Picasso did not. In the exhibition in Paris, Duchamp's multiple views of a figure in motion seem not to have caused a stir; in New York the next year they became a cause célèbre.

A few weeks after Natasha had decided to acquire the drawing by Gris I joined her in London, where we attended the opening of "Italian Art of the 20th Century" at the Royal Academy of Arts. She had been persuaded to lend to the exhibition the most hieratic single image of de Chirico's metaphysical period, *The Jewish Angel* (page 146), which had once belonged to my friend Roland Penrose (to whom Picasso's *Man with a Hat and a Violin* had also belonged). In another room of the Royal Academy exhibition was a group of portraits by Modigliani that included one of "Frank Burty" Haviland (see page 119), an American *amateur* in Paris, where he knew the two Mexican expatriate painters Rivera and de Zayas. I told Natasha that Haviland was also one of the early collectors of tribal art, but what fascinated both of us was that, coincidentally, he was also the subject of the portrait by Gris that Natasha had just purchased. The drawing handsomely takes its place between the other two paintings by Gris that she and Jacques had acquired: the proto-Cubist portrait of another smoker and the lyrical still life with a guitar of 1913 (pages 108, 123). In its subject and style, the last presents an interesting contrast with two still lifes, one by Picasso and the other by Braque, both painted in 1924 (see pages 168, 170).

Until John Richardson's multivolume biography of Picasso is published, the Spanish artist's best biographer remains himself: his own paintings, drawings, and prints. The first work by Picasso acquired by the Gelmans was the *Head of a Woman* painted late in the year 1927. This ferocious female image (see page 179) violently reflects the rupture of the artist's marriage. Away from both wife and mistress, he would metamorphose himself into a dying bull—a tragic victim—in a subsequent painting (see page 192). Both works are small and intense, and they similarly express rage: the first with hate, the second with self-pity. Even the portrait of Dora Maar (page 205), drawn and colored in 1938, contains autobiographical references. It is not difficult to sense Picasso's impatience with the nervous mannerisms of a woman whom he deeply loved and protected, one whom he could physically dominate but

never intellectually comprehend. One is reminded that in certain primitive societies the possession of a likeness of someone supposedly endows the maker or the owner with the power to control the person portrayed. Dora Maar, here, is captured by Picasso's spider web. Thirty years later—at the end of his life—Picasso cast himself in various roles, often as a mad painter and almost always in caricature. Among Mrs. Gelman's most recent acquisitions by Picasso is the *Cavalier and the Seated Nude* of 1967 (page 279), in which the man, surrogate for the artist, is costumed in a wig and a ruff. With one hand he pinches his pipe and with the other he awkwardly fondles the cross-eyed and cross-legged nude whose features closely resemble those of Picasso's penultimate companion. The two juxtaposed figures crowd the composition to the limits of the picture's frame.

Among the works by the Surrealists in the Gelman collection, the six paintings and two drawings by Miró offer the strongest representation of any individual artist. Their progression, splendidly sustained in quality, begins with a figure composition and a landscape—two very different examples from the artist's early years in Catalonia, and both painted after nature (see pages 154, 157). Following are two masterworks from his Surrealist period in Paris during the 1920s: the large *Animated Landscape* (page 181) and *The Potato* (page 184), the subject of the latter a proper female consort to Alfred Jarry's Père Ubu. The pair of contrasting watercolors by Miró in the collection are from his wartime "Constellations" series, the first swiftly drawn in Normandy in 1940, the other painstakingly worked a year later in Mallorca (see pages 219, 223). I have never asked Natasha who her favorite painter might be. I suspect, however, that it is Miró, for his elegant ebullience sometimes matches her own, and she always smiles particularly brightly when she looks at his two later paintings of women, birds, and stars (see pages 226, 229). Jacques Gelman's favorite painter, I know, was Braque. He told me so, and several times tried to persuade me to organize a retrospective of Braque's work. My answer to Jacques was that as a curator I could never match the great Braque exhibition Douglas Cooper had organized in 1956 for the Edinburgh Festival. When I repeated this answer once too often Jacques shrugged and said, "But that was a generation ago," and, indeed, it was. His growl turned into laughter, however, when I observed that, at the time of Douglas's show, Braque had been elected a member of the Royal Scottish Academy. Jacques stopped laughing, I remember, when I pointed to the portrait hanging on the wall behind us (see page 149) and said, "You know, Braque's wife sewed Modigliani's shroud."

The earliest of the four still lifes by Braque in the Gelman collection is the Cubist painting of 1911 (page 111), which contains his only visual reference to Picasso's nationality. The *Still Life with a Guitar* (page 170), of a decade later—which had once belonged to Douglas Cooper—offers a lyric return to the definition of contoured form. The tall *Billiard Table* (page 250), finished in 1952, provides a more expanded view of an interior, and is one of the most extraordinary of Braque's compositions. Over several years, he worked and reworked its surface, and, like his two horizontal variations on the same theme, executed at the same time, its format is large—the size of a door. A foreshortened foreground presents a challenge to any artist, and how marvelously Braque responds. He radically reverses familiar perspective. Proceeding from the firm support of the table's front legs, he shows the top flat

and receding, and then dramatically folds the table back toward the spectator. The same interior also contains a chair, and, as we know from photographs, a stove at the left replaced a goldfish bowl on a stand, perhaps because Braque did not wish to recall a favorite motif of Matisse. The two inverted tulip shapes above the table are not easily identified, but are, in fact, glass shades concealing the electric light bulbs in a chandelier. Was Braque also making reference to van Gogh? I think so, especially as the mauve *Garden Chair* (page 254), an out-of-doors still life, also suggests the work of the Dutch painter. *The Billiard Table* was the Gelmans' first painting by Braque; the Cubist *Still Life with Banderillas* was the last that they acquired.

For several years, Jacques and Natasha wanted to add to their collection "right" examples by Chagall and Dali. The Chagall that they did obtain in 1984 is actually one that they had previously owned (see page 135)—as is amusingly if indiscreetly recounted by Pierre Schneider (see pages 30–31). At the time, they had also considered acquiring a different painting by Chagall, which I, myself, much admired, but they decided against it, and the picture was bought, instead, by Baron Thyssen. The quest for an appropriate painting by Dali posed more of a problem. Natasha was not overly eager to have one, and Jacques firmly believed that Dali's best paintings were early and small in format. They had to wait quite some time, but found exactly what they wanted.

Julien Levy, an American dealer in avant-garde art, had been long retired when he died in 1981. In New York, he had been the first to show the work of Dali and, later, of Frida Kahlo, Matta, and Gorky. Julien kept for himself Dali's early canvas *The Accommodations of Desires* (page 286), a microcosm of colliding images painted in meticulous detail when the artist was only twenty-five. Julien's widow decided to sell the painting along with most of what remained from her husband's collection. Jacques and Natasha, unfortunately, were unable to attend the auction; Jacques was disappointed, but they had accepted a dinner invitation several months before for the same evening. (Jacques always disliked "advance bookings," as he described New York social life.) He requested Eugene Thaw to bid in his place. I was at the same dinner, which the butler interrupted to deliver a message from Mr. Thaw, who had just telephoned. The note that our astonished hostess read aloud was, "Tell Mr. Gelman, please, that now he has his desire." That evening Jacques joined me in dessert.

Three of the artists in the Gelman collection, Tanguy, Giacometti, and Dubuffet, were born at the beginning of the twentieth century. During World War II, Tanguy left France for the United States, where he married, and remained; it was in New York and in Connecticut that he painted the Gelmans' imaginary landscapes. Jacques particularly admired Tanguy, and he found quiet and repose, as well as a completely detached world, in the painter's haunting vistas, which lead to fixed horizons (see pages 230, 234, 237). All three Tanguy landscapes were acquired in 1958, and hung in Jacques's bedroom—as did Victor Brauner's *Prelude to a Civilization* (page 267), a vast anthology of magic symbols painted flat, in the "Egyptian style" (an expression that the Douanier Rousseau once used in conversation with Picasso). Brauner himself could see with only one eye.

Like Tanguy, Max Ernst and Fernand Léger also sought refuge in the United States during World War II. For Ernst, our country offered a new life and also a new wife: for

Léger, the period spent here was more one of exile, although he had visited three times before and liked New York. Ernst's *The Barbarians* (page 198), a small canvas painted before his departure for America, suggests in allegory the cataclysm that forced him to emigrate. Léger, who had been inspired by the new machines of the previous war, turned away from the events in Europe, and in the United States began his celebrations of human activity out of doors. His *Divers, Blue and Black* (page 217), painted in New York and developed from an earlier theme of dancers, easily could be scaled to a ceiling or a wall. Its overlays of color enforce an essentially graphic pattern.

Unlike Tanguy and Giacometti, Dubuffet developed the first of his characteristic styles late, and only during the last war. Previously, he had been a wine merchant. He received the first recognition as an artist when a series of portraits of his friends, none flattering and all astonishing, was shown in an incongruously elegant new gallery in the Place Vendôme in 1947. Dubuffet called the series "More Beautiful than They Think." During the war, Dubuffet had remained in Paris, where, one winter, he painted several city views. In the one in the Gelman collection (see page 241), the flat façade of the buildings rises like a backdrop, allowing only a glimpse of sky. Across the street, on the sidewalk, five figures who seem to jerk like marionettes are dwarfed by the houses that, in reality, are not actually very tall. It is February cold, even bright colors seem bleak, and the wooden platform shoes worn by the women incidentally recall one of the least serious deprivations imposed during the war. Dubuffet's *Jean Paulhan* (page 244), one of several of the artist's likenesses of the French author, belongs to the portrait series first shown in 1947, and is another of Natasha's most recent acquisitions.

The Gelmans did not choose to collect any Surrealist works by Giacometti. During World War II, which the artist spent in his native Switzerland, his style changed radically. After the war, Giacometti returned to Paris—his home, and a city that he dearly loved. The Gelmans collected four of his bronzes (two are uniquely painted) and a portrait of his wife (see pages 256, 258, 260, 263, 264, 275), and these are complemented, in their home, by furniture crafted by Giacometti's brother, Diego.

With its strong emphasis on painters of the School of Paris, the inclusion of single examples by certain other artists—for instance, by Mondrian, Klee, Bacon, and even an early Kandinsky—seems unexpected in the Gelman collection. However, the Mondrian was actually painted in Paris (see page 166), and easily relates to the Gelmans' paintings by Léger. The graphic intensity of Klee's *One Who Understands* (page 196) finds a precedent in Picasso's earlier *Head of a Woman* (page 179). Bacon's traumatic representation of himself in despair (see pages 289, 291) is more than matched by that same Picasso.

Bacon's small triptych projects tremendous force. When they saw the portrait in 1980, I think that it might have recalled to Natasha and Jacques certain paintings from Mexico's colonial past in which the face of Christ similarly appears thrice, not only as the Son but also as the Father and the Holy Spirit, a provincial representation of the Trinity forcibly condemned by Rome. The early watercolor by Kandinsky, however, does seem the "odd man out." It was painted many years before 1933, when Kandinsky moved to Paris to live

and work in an apartment found for him by Marcel Duchamp, and over the years its colors have faded (see page 133).

This informal chronicle of the Gelmans' collecting is incomplete, and one hopes that it will not come to an end for many years. How delighted Jacques would be with the additions that Natasha continues to make to their collection.

I have known many people, and I am fortunate to have many friends. Some, including Jacques, have died, and I am poorer as a result. With happiness rather than sadness, however, Natasha and I often talk of Jacques, and when I speak about him with others I find that they also agree that his presence remains exceptionally real. Sometimes I can hear him chuckling, and I remember not only what he said, but how he looked at paintings and how much he liked others to see those that he owned. He and Natasha shared a vision, which became a reality. Both Gelmans are your hosts at this exhibition at the Metropolitan Museum.

W.S.L.

1. William S. Lieberman, ed., *Modern Masters: Manet to Matisse* (exhib. cat.), New York, The Museum of Modern Art, 1975, p. 88.

2. William S. Lieberman, ed., *Seurat to Matisse: Drawing in France* (exhib. cat.), New York, The Museum of Modern Art, 1974, p. 7.

3. For this and subsequent references to works by Picasso published by Pierre Daix, see Pierre Daix and Georges Boudaille, *Picasso: The Blue and Rose Periods. A Catalogue Raisonné, 1900–1906*. Translated by Phoebe Pool. Greenwich, Connecticut, 1966; and Pierre Daix and Joan Rosselet, *Picasso: The Cubist Years, 1907–1916. A Catalogue Raisonné of the Paintings and Related Works*. Translated by Dorothy S. Blair. Boston, 1979.

4. Reproduced in Douglas Cooper, *The Cubist Epoch* (exhib. cat.), New York, 1971, ill. p. 28.

5. See William S. Lieberman, "Picasso and the Ballet," *Dance Index* V, nos. 11–12 (November– December 1946), p. 267.

Bonnard
and the School of Paris in the
Gelman Collection

I T IS NOT fanciful to think of those who habitually buy pictures as having something in common with those who paint them. They are in collaboration, sustained by the same confidence. They both believe that life is perfectible. In their different ways they teach the same faith and thanks to them we come to share it. Good painting is an earnest pledge that there will be great painting. A good collection, which is the meeting point between creativeness and the community, is in truth the point of art. For first visitors or those who look at art for the first time, it is a point of growth. For some, it is without doubt destined to become the point of life.

For example, take the Gelman collection. It would be good to know Jacques and Natasha Gelman, if only to ask them impertinently when they knew that their collection was becoming a creation in itself. Not all collectors share any of the taste and talent of the artists whom they capture. Creative temperaments are peculiar and people who provide themselves with the means to collect are in no way disqualified from the ways of the world. The early modern pictures that the Gelmans gathered were allied to the community with a closeness that was unparalleled in the advanced painting of the nineteenth century. The earliest pictures in the collection record a community of interest and the collectors give every sign of sharing in it. The ideal of art as life enhancing was a characteristic early-modern ethos. The spirit of early modern painting is actual and ideal by turns. Bonnard and Matisse, from opposite standpoints, reached in early maturity a quite similar Elysian if not Arcadian mood. In 1899 Vuillard painted Cipa Godebski at ease in a garden, where, relaxing in a wicker chair, his sister Misia seemed almost to vanish into her own yawn. The picture is both informal and beautiful; it anticipated the spirit of the *Revue Blanche* and the circle around Misia and Thadée Natanson (who might enter at any moment through the garden gate). Like Vuillard's *Conversation*, Bonnard's *Street Scene, Place Clichy*, by a year or two the only earlier picture in the collection, conducts us into the poetry of milieu and memory. These were quite consciously images of a culture in its moment of confidence and contentment. On the sidewalk of Place Clichy, poised to enslave it, was the dominating, intelligent woman of the age in the approximate likeness of Misia, but embodying a general ideal. The coat with ruffled cape is her badge in Bonnard's imagery. She reappeared with it in the poster that he drew for the Natansons' *Revue Blanche*. The juncture was saturated with

the reminiscent poetry of the epoch. I do not know if anyone younger than I can fully share it. Looking at *Street Scene, Place Clichy*, I am suddenly aware that I cherish a very specific recollection of the nickel frame that surrounded the back window of a cab in London as in Paris through the 1920s. That window, the frame of farewell glimpses, was the focus of a child's bewitchment and memories, from which the residue still makes *Place Clichy* a favorite picture. Nor does my private stake in the image of such streets end with the cab. Nothing ends with any abruptness in the art of Bonnard. The space of *Place Clichy*, doubled in breadth and transposed to a key of brown and yellow and to a rainy evening, returned with a woman in the same cape in a lithograph entitled *Rue, le soir, sous la pluie*, which was number ten of the suite "Quelques Aspects de la Vie de Paris," drawn by Bonnard in 1895 and published by Vollard four years later. It was no less magical. Long ago, when such things were the small change of the art market, I carried home an impression of the print in settlement of a price that was unpaid. I have lived with it for fifty years.

Memories under the aegis of which Bonnard presided are irresistible, however little relevance they may seem to have to the Gelman pictures. It is very much to the point to consider what the enchantments of the Gelman collection have to do with the indirect, nostalgic path toward modern art. The prophetic pattern-making style with which Bonnard's earliest paintings and the spirit of the Nabis reflected the example of Synthetism quickly gave way to a dappled, atmospheric vision. We are inclined to see Bonnard's art, liberated from its intellectual sources at the turn of the century, as more and more in the nature of a reversion to Impressionism, one that was welcome to the traditionalist taste of the time. This is an account of Bonnard from which the exhilaration and charm are missing; it cannot be the truth about him. Looking again at *Street Scene, Place Clichy*, and at the prints, we realize what is wrong with the description of him as *retardataire*. Bonnard was singular among the painters of the Belle Époque in that he was perfectly aware, while it was in progress, that the beauty of the epoch was unprecedented. He looked at the ordinary style of the streets, the shining puddles and the ruffled flounces of the women. In his paintings Bonnard was demonstrating as if to himself and to the milieu the respect in which Impressionism and any merely tonal notation, not least the latter-day theoretical variety, was now deficient because it was objective-seeming, impersonal, and styleless. Bonnard's attachment to the actual looked in quite a different direction and looked always with affection, often with amusement.

It is worth noticing what great collectors decide to resist. The Gelmans gave in general a wide berth to doctrine and principle or system. Impressionism, of course, lay outside their period but there is no sign of Neo-Impressionism either, which engaged the interest of some of their favorite painters. It interested Matisse and formed an indispensable step toward Fauvism. Without it the jumbled color of Matisse's juvenilia would hardly have attained the clarity that distinguished his art after 1905. In the Gelman collection Matisse is seen as the master of solid color. In the second version of *The Young Sailor* he eliminated what he referred to as the vibrato of separate brushstrokes and replaced it with a rolling rhythm in which he ventured on a more wholehearted response to color. If Matisse painted *Still Life with Vegetables* in 1905–6, it was one of the earliest Fauve—which is to say, deliberately

untamed—still lifes in solid color. The kind of sensitivity that Neo-Impressionism had stimulated in him is apparent at the point where the green background deepens into violet in answer to the brazen yellow of the coffeepot. Color is committed to a continuous adventure in the *Still Life with Vegetables*, culminating in the red pitcher, which presides over the scene, taking a blue-green halo from the ceramic plate leaning against the wall behind it.

In later pictures color as subtle as this was to be robustly embodied in specific forms, as is the exactly calculated balance of emerald with crimson-pink, which materialized ten years later as a portrait of Matisse's model Laurette. The beauty of the *Still Life with Vegetables* is that it anticipated just this robustness, yet it is little known, and hardly ever exhibited. The vigor that the Gelmans must have particularly valued in Matisse is seen again in another exceptional picture, the *View of Collioure*, which was simplified with a curvilinear boldness that gives it a significance among Matisse's landscapes analogous to the second *Young Sailor* among his figure paintings. Like the *Young Sailor* it was painted not from life but from a previous picture, the motif of which had been directly and delicately observed the year before. Fat black contours surround areas of transparent color like the leading of medieval glass. The Matisse family used to call the picture *Le Vitrail—The Stained-Glass Window*.

The Gelmans cherished a rather individual view of their chosen painters. In the pictures they selected there is usually a quiet excitement, a suggestion of subdued effervescence. The mood is set by the group that predominates: the half-dozen works by Bonnard. As the centerpiece of a great collection it is rather surprising. It is not at all showy; rather, it sets up a poetic awareness that runs through the whole collection. Even the paintings by Matisse, forming the strongest block of color, do not outweigh the group by Bonnard. The Gelmans' taste points to a quality in early modern art that is rarely specified or discussed. In Paris in the early years of the century a consensus was forming deeper than the stylistic controversies, regarding a common understanding of what a modern poetics would consist of, which was quite distinct from the forceful devices of style, and, indeed, resistant to their challenging impact, to the dramas of fragmentation, and to the shocks of contrived incongruity. Instead there is a quality of amusement.

After 1908 Matisse's leadership was challenged by the structured, schematic style that was evolving in the hands of Braque and Picasso—a style with a power quite beyond the reach of color, which was by nature evanescent and amorphous. It was Matisse himself on the jury of the Salon d'Automne who provoked the conflict that ended with Braque withdrawing all of his submissions, a conflict with fateful consequences for the consensus and thus for twentieth-century art. While Matisse sought to meet the challenge, treating Cubism as if it were another option, the Cubists moved on from "the little cubes" that had vexed Matisse in 1908 and an aesthetic as traditional as Cézanne's, to replace them with a fragmentation, which ruptured the formal unity that had been the agreed basis of imagery for six hundred years. The breach was irretrievable, and patrons were to face the same issue. Collectors like the Gelmans had little taste for the intellectual ardors of Cubism and there was nothing severe or strenuous in the pictures that they bought. Those by Léger are as lively as a dance; they might have been designed for the Ballets Suédois. The most significant link with Cubism is the evocative construction that de Chirico entitled *The Jewish*

Angel, which had a lasting influence on Metaphysical painting, while the most charming were without doubt the most predictable: Braque's delightful variations on familiar still-life themes.

The bitterness of the division in the exhibiting societies was lasting. It overshadowed Matisse's career until the 1930s, and for years Bonnard never submitted more than a single picture. Nevertheless, his momentum was uninterrupted and a continued support for it could be counted on. So the pictures by Bonnard are the heart of the Gelman collection, just because they avoided a *parti pris*. In New York, where the Intimists have been habitually underestimated, it may surprise some to find how satisfactory this is, even as an introduction to modern painting. We find Bonnard, without a single innovation of style, continually enriching the spirit and substance of painting.

Fauvism and Cubism, utterly at odds, had in fact a common source. Unlike Symbolism (a deliberately poetic descant on graphic invention, which never interested collectors like the Gelmans), they were both essentially Post-Impressionist styles, simultaneously stimulated and frustrated by the observation of nature. They were alternatives from the vast range of options that the nineteenth century spread before the twentieth. They ran parallel but in opposite directions; the formulations were incompatible and they were deadlocked. The life in Bonnard's pictures was quite distinct from the current ingenuities of style, a difference that is as unparalleled as it is compelling. In the Gelman collection there is one other picture that was similarly isolated and equally memorable—Rouault's sardonic satire on the demimonde, *The Manager and a Circus Girl*; he is said to have worked on it throughout the 1930s, until the defeat of the bourgeois order that supplied its theme.

Late in life Bonnard gave a straightforward account of what his art was about (transcribed in 1943 by Angèle Lamotte), which explained exactly how and why he freed himself from the naturalism of the Impressionist report on nature. What were his pictures about? They were about whatever first made him want to paint them—and now we learn the brilliant integrity of the man—to the absolute exclusion of everything else. How is such discrimination possible? What is it that he wants to paint? Here his account becomes quite precise. It is not just the interest or charm of a subject. On the contrary, Bonnard was positively afraid of the incidental details that a painter might notice. If he was not careful, he might find himself unable to resist them. He might let himself go, as he had in painting a bowl of roses on his table. He would lose himself and presently he would be unable to recover his first idea, the vision that seduced him, which had been his starting point.

Before he could paint, a subject had to possess a special seductiveness . . . (one can hear the diffidence in his voice) . . . what might be called beauty. He reminded himself that the starting point of a picture was an idea, without any necessary connection to the incidentals of an actual view. He was determined not to lose the idea on the way. The presence of actuality would be a positive nuisance; it would tempt him to rely on chance instead, by which he clearly meant the accidents of visual impression—exactly what an Impressionist would latch on to. His preference, Bonnard says, was to paint in the studio, well away from life. If the painter allows himself to refer to what he sees, his eye will be caught by details that he never noticed before. The painter is really lost, Bonnard has no doubt, if he is betrayed into *copying the shadows*.

It was an ideal, indeed, utopian program for painting from memory. First and foremost, it called on Bonnard's capacity graphically to fix not the binding contours of an image but its inward purport with rapidity and freedom, a freedom in particular from convention unparalleled in any style of his time, linked to a readiness to read his own shorthand and trust it. If the distinction from accepted canons is not evident, the drawing in the Gelman collection of a model in a slip perched confidingly on the edge of a bed is an accessible reminder. Has anyone, starting with paper the size of a pocket engagement book, set himself to keep pace with the shape of common experience, with such abundant rewards?

Looking at Bonnard's apparently circumstantial pictures some may question whether he really depended so much on memory. The drawings and his manner of using them supply the explanation. As a matter of fact, he confessed that he would steal a peep at the actual motif to check on it. One imagines him bobbing back and forth picking and choosing what he would decide to remember about his house and the view from it. He was the antithesis of an Impressionist because he cared nothing for optical data—indeed, dreaded them unless they accrued to his initial idea. For the first time in modern painting, instead of capitulating to his impressions, a painter re-created them in his head for incorporation in the conceptual unity, which was and is the indispensable unity of art.

Bonnard would have it that there was no other kind. Whatever the great nature painters thought they were doing, they were really imagining it as he did. Cézanne may have thought he was painting from nature with his powerful philosophic weaponry but Bonnard claimed that Cézanne was really basking in the sun like a lizard, waiting for the light to match his imagined effect. Renoir? He was just painting Renoirs. Monet? According to Bonnard he didn't stick at it for more than ten minutes.

Bonnard's reaction against the transience of Impressionism had a serious point. His images were durable because they were imaginatively wrought. Look at *After the Bath*. We are in the presence of a momentary passage through time and light but there is nothing transient about it; it is retained in the memory and reimagined. Nothing but the essentials of the seductive vision remain. The loved one, with the luster of the morning all about her, teeters forward across the bathroom, wobbling shyly until she is sure of the idyllic relationship, sure that she is loved in the bath. Straight from the tub, she is remembered as glistening wetly. For once in painting she is really wet, and this must have been what was so seductive. The liquid jewels of light model her shape with a completeness that could never have been posed. A bathrobe is brought, into which she will nestle; it is hardly a servant that holds it for her. The only subservience in Bonnard's world was his own.

The sensuous life-style fills the whole image; the memory of it is fresh. Behind the bather there is a tall mirror. It reflects a window vibrating with the sunlight in which she is seen; the reflected room is imagined as *contre-jour*, against the light, so inside the mirror frame we see a narrow zone of shadow, the bath and wall, a deep blue-gray, and a strip of the bather's shadowed back, remembered as a rich yellow-brown. In the rippling iridescence the color is surprisingly and splendidly alive. It is unforgettable because unforgotten. In the whole of Impressionism with its slices of life there is hardly anything so well considered and lasting.

The style in which Bonnard painted and his determination to guard the sensuous unities that were his subject have a wonderful modernity. In the twentieth century in a new respect the painter was living in the present. Imagery was reimagined in a new context, the context in which the woman with the flounces edged with braid, from the picture of Place Clichy (painted for Thadée Natanson), graced the pioneer poster that advertised the Natansons' *Revue Blanche*. It was the spirit of contemporaneity preserved for us by a whole range of artists from Satie to Proust, who were the Natansons' friends. The reminiscent poetry and the irony, the elaborate sophistication and a deceptive illusion of naïveté in the new spirit were often apparent in the art of Bonnard. We are seldom closer to that spirit than with the great pictures in the Gelman collection.

LAWRENCE GOWING

The Gelmans
and the Fauves

WORKS OF ART do not say everything that they have to say at all times. Different contexts bring different, sometimes contradictory, parts of their discourse to the fore. To confront a painting in the studio almost obliges us— provided we do not reject it outright—to espouse the artist's convictions, relate it to his aims, see it as a response to his life and to the concerns of his contemporaries. If, on the other hand, we meet the same picture in a museum, we shall find it hard not to view it as a moment in art history, a product and a producer of influences, a link in the concatenation of which the museum seeks, through the diversity and presentation of its collections, to serve as a convincing equivalent.

Between the studio and the museum, the work traverses a number of situations. Each tells us something different about the ways of, and the reasons for, looking at art. Among these stations along the road from creation to ultimate recognition or oblivion, the private collection is particularly important and revealing.

The difficulty, however, when one tries to do justice to that part of the artistic odyssey that one might call the phase of the collector, is to combine—or at least to encompass—two worlds that were not necessarily destined to meet, still less to cohabit. Yet, when the collection, as in the present case, is obviously coherent, not only in its insistences but also in its omissions, it provides a valuable commentary on the artists included in it. Therefore, a correlation between the collector and the collected, despite its difficulty—it is like doing two utterly different things at the same time—should at least be attempted.

"I have always wanted to do two things at the same time," Henri Matisse once remarked. This obsession is illustrated by one of the masterpieces of the twentieth century and of the Gelman collection, Matisse's *Young Sailor II* (1906). The subject is one we might expect a realist painter to come upon in the harbor of a fishing village such as Collioure: a young sailor sitting on a chair, in three-quarter view—as if he were ready to jump to his feet—a pose bespeaking the impatience of a fellow more at ease at the top of a mast than in front of an easel. What Matisse wished to do with this motif we know from the *Young Sailor I*, a genre portrait distinguished by the artist's heightening of local color. What he ended up by doing we can see in the *Young Sailor II*—a restatement undertaken soon after. The two

24

paintings are the earliest known instances of the "double takes" that were to occur frequently in Matisse's career. They are a response to the dual nature of his character and of his aesthetic: one-half conservative, the other half revolutionary. Often, when it proved impossible to accomplish these two contradictory things in the same place—on the same canvas—Matisse would fall back on doing them "at the same time."

The abyss that separates the *Young Sailor I* from the *Young Sailor II* explains why two versions of this subject were necessary. The figure confronting us in the later canvas is no longer a young Catalan fisherman, but, together with the reclining female in the *Blue Nude, Souvenir of Biskra*, painted in the same year (1906), the first of a strange new race of men and women, possessed by a Nietzschean energy—a barely repressed ferocity, more heroic than human—that will repeatedly appear in the pictures from the following years and will culminate in the terrifying performers of that hymn to a savage god, *Music* (1910).

Neither Matisse nor his sitter was prepared for the mutation. The savage god transfixes the young sailor, preventing him from getting up, and coerces him, despite his near-profile pose (which only the legs are able to sustain), into the frontality that is the prerogative of icons. Moderate, realistic portrait has given way to bold, abstract image. As Matisse himself noted, he had been—and was to be again and again—"possessed by a force stronger than himself" while engaged in a "normal" working procedure. The presence of the *Young Sailor* in the Gelman collection is due to a conversion of the same order. The collection was begun in 1941 in Mexico City after the marriage of its makers. The success of Jacques Gelman's first film provided the means. In 1945, Natasha Gelman traveled to New York in order to buy furnishings for their home. She had barely arrived when she received a telegram from her husband asking her to go to the Buchholz Gallery, look at the sculptures on view, and choose two. She purchased Degas's *Woman Putting on a Stocking* (1895–1910) and Renoir's *Washerwoman* (1916)—not exactly adventurous acquisitions, although the Mexican customs officer who saw the dancer's head and the washerwoman's shock of hair emerging from the cardboard boxes (wartime restrictions had made it impossible to find appropriate crates) in which the two bronzes had been precariously ensconced clearly thought they were. "Do you like these?" he asked Mrs. Gelman. "Of course not," she promptly replied. Whereupon he turned to a colleague and snapped: "Di, muchacho, cuanto es el kilo de fierro viejo?"

Over the next decade the Gelman acquisitions emphasized Impressionism and works by the Nabis. True, the Gelmans did purchase a Picasso, but it dates from 1901. The tone was set by Vuillard and Bonnard, and by Renoir, whose *La Loge* (1900) might be regarded as the epitome of the Gelman taste during those years. "It hung at the head of the stairs," Natasha Gelman recalls. "One day, I came home for lunch in ill humor. Seeing that man's moustache and ironical smile up there, I realized I couldn't face the Renoir any longer." When her husband came home she informed him of her distress. "So let's change it," was Jacques's instant reply.

They sold the picture (through Knoedler's) and bought their first Miró through Eugene Thaw. It was a nasty piece, bristling with nails and swarming with bits of string. Eventually, they grew afraid that the climate of Mexico City might make it fall apart and they sold it, but the decisive step toward contemporary art had been taken. As for Miró, the micro-

cosmic cruelty and cosmic breadth of the Catalan artist at his most daring were to become permanent features of the collection.

Today, only a very few works survive from that initial phase of their collecting. Picasso's *Girl in Profile* (1901) stands as a preamble to the radical paintings that now comprise one of the most impressive ensembles of Picasso's work in private hands. One Vuillard remains— but did not Matisse, Picasso's rival in the Gelman collection, once remark that during the decisive summer of 1905, which saw him evolve from the traditional to the avant-garde, he kept up his courage by recalling Vuillard's phrase, *la touche définitive*? All the Bonnards remain in the collection, but we have long since come to recognize the disquieting wolf hidden beneath the sheepish clothing of *intimisme*.

The intensity, the violence that characterizes Matisse's *Young Sailor II* is manifest in the tone of the entire collection as it exists now. A Rouault, which had pleased at first, was later found too pleasing. After a last-ditch stand in the drawing room,[1] it departed, leaving Matisse, Gustave Moreau's other illustrious student, to be represented by more forceful pictures.

Sergei Shchukin, perhaps the most impressive among twentieth-century collectors, never parted from an insipid late-nineteenth-century view of the Château de Versailles that had been his first acquisition: Boldness is a quality more often acquired than innate. Despite Bill Lieberman's insistent recommendation, the Gelmans hesitated to buy Balthus's *Thérèse Dreaming* (1938), previously owned by the Reverend James McLane: They found it "a bit daring" (prompting Lieberman to say, "Look, if it was okay for Father McLane to live with that picture it's okay for you"). And, of course, it has been.

"Painting is stronger than myself," Pablo Picasso once wrote. "It makes me do what it wants." The same is true for the kind of collectors to which the Gelmans belong. They are not reckless by nature and would readily give in to safer solicitations (Renoir's *La Loge* was purchased after Derain's explosive *Regent Street, London*, of 1906), yet that "force stronger than myself," of which Matisse—who, likewise, was a *révolutionnaire malgré lui*—spoke, would not let them. Viewed in this light, the inclusion of the *Young Sailor* in their collection seems logical, almost predestined.

True boldness is caution overcome.[2] By what? The answer to that question was the same for the artist as for his collectors. The first Matisse acquired by the Gelmans was by no means the most audacious: The *Odalisque, Harmony in Red* (1926–27) is a sophisticated translation of the subject matter and, indeed, of the style of François Boucher into the language of patterned surfaces that Matisse favored during his early years in Nice. To restate solely in terms of flat patches the glazes, the transparencies, and the flesh tones that such eighteenth-century masters and their modern disciple, Renoir, used was a tour de force all the more remarkable in that its objective was not to call attention to this modernization of Rococo frivolity but, on the contrary, to make it pass unnoticed.

There is no reason to suppose that the Gelmans were any less taken in by this subterfuge than were critics and historians, who only in recent years have come to discern the inventiveness with which Matisse carried out this subtle subversion of tradition. However, a

factor specific to Jacques Gelman accounts for his interest in this picture: his attraction to the color that gave the painting its title. "He liked red, he liked energy," Natasha Gelman recalls.

Vlaminck's portrait of André Derain (1906), ablaze with vermilion, hung in Sam Salz's bedroom. When the well-known art dealer remained adamantly opposed to his visitor's entreaties, Jacques resorted to the ultimate argument and lifted the picture off the wall.[3]

"People used to say: Fauvism is when there's red," Matisse reminisced. People were right: Red is the essence of color, the symbol and vehicle of its incendiary capacities. Incandescent reds, oranges, and yellows have not entirely taken possession of Vlaminck's *The Seine at Chatou* (1906), but they have forced the green, ocher, pinks, and blues to rise to the same shrill pitch of ferocity. In Derain's *Regent Street, London* (1906), splashes of vermilion are scattered throughout the painting, like the first sparks of a conflagration just beginning: Dark blues and grays still dominate the scene, but the ravenous restlessness of the flames has already contaminated them. Implicit in the agitation of *Regent Street*—and all the more effective for it—is the great chromatic fire lit by Derain a year later.

The pivotal role played by Fauvism in the Gelman collection is thus readily understood: The Fauves submitted to the violence of color. In Matisse's *Still Life with Vegetables* (1905–6) it torments, twists, consumes the motif, turning volumes into furnaces, outlines into rills of eye-searing, molten ore. Vlaminck could not bear the destructive power of color for more than a few seasons. Derain managed to do so slightly longer by strapping his subjects into fireproof compositions. Matisse alone was willing to undergo the test of fire to the end— that is to say, to reach beyond the threshold where destruction gives way to reconstruction by means of color, where realist representation is consumed and reborn as "abstract" or "decorative" (the artist used both words synonymously). For Matisse, the phase of destruction of the figurative motif occupied the summer of 1905; by the winter of that year and throughout 1907 the reconstructive process was under way and the transfigured images of which the *Young Sailor* is one of the most telling examples begin to emerge from the crucible of paroxysmic color.

Color had been the "force stronger than myself," the savage god that drove Matisse away from the conservative path he had decided to settle upon in 1903–4. What he had hoped to achieve when he set up his easel on the shores and in the woods around Collioure was a chromatic equivalent of the dramatic sunlight that met his eye. It was an aim not so different, after all, from the *peinture claire* that had been the Impressionists' goal—only still more *claire*. Yet, he had not reckoned with the chain reaction that would thereby be set off. When the process of heightening his palette transgressed certain boundaries, local color turned into total color. The painter was a master of modulated values: He now became a slave to pure tones. Matisse had been, for what proved to be everyone's benefit, a sorcerer's apprentice: Once unleashed, the violent spirit of his color transformed the prudent reformer into an ardent revolutionary.

That such is the natural effect of color is demonstrated also by the Gelmans themselves: Possessed by color, they moved, as we have seen, from safety to risk. For their collection, as for Matisse, however, "Fauvism isn't everything"—as the artist noted—"only the beginning of everything." What followed, as far as Matisse was concerned, is eloquently represented in

the Gelman collection. Pure color ushered in his new style, but the latter did not necessarily rely on the use of pure color alone. In his black-and-white drawing *Seated Nude Asleep* (1906), brush and ink assail the model's body with the virulence that characterizes Fauvism, and constitute the means by which the indirect discourse of painting since the Renaissance is translated—or, rather, transmuted—into the direct discourse of modern art. One of the most powerful drawings from that critical moment, the *Seated Nude* balances on the dividing edge between the destructive and the constructive phases of Fauvism: From the storm of piercing dots, jabbing thrusts, and battering waves the new image emerges, based on frankly stated outline rather than on modeling and shading. In fact, one can already see Matisse's line beginning to emancipate itself from the obligations of enwrapping bodies, reinventing them in accordance with the size and shape of the surface, as well as with the artist's feelings.

Throughout his career, Matisse would turn to drawing—or, rather, to painting in black and white—for confirmation of the fact that his work owed its success to its harmonic and melodic qualities instead of to its orchestration. Such graphic equivalents, usually executed with brush and ink, are particularly frequent in the period that one might call the second coming of Fauvism: They are a response to the blinding canvases of 1946–48, as well as to the final flowering of the *gouaches découpées*—a technique that gave Matisse the feeling that he was "carving color directly." The dialogue between black and white and color, which began with *Jazz* (1943–44) and culminated in the Chapelle du Rosaire (1944–52) in Vence, is also represented in the Gelman collection by the *Model Standing in the Artist's Studio* (1948) and the splendid *Snow Flowers* (1951).

Actually, that dialogue did not begin in *Jazz*; it was only made explicit by the confrontation of text and image. It is already subtly at work in the *View of Collioure* (1907–8). Until the Fauve crisis, Matisse had been primarily a disciple of Impressionism—that is to say, a painter of landscapes. It was as a landscapist that he approached the fateful summer of 1905, but it was as a figure painter that he emerged from his year-long trial by fire, for the figure lends itself more easily than landscape to the transformation—from realist representation to iconic image—brought about by Fauvism.

It is precisely the difficulty of restating old motifs in the new style that makes Matisse's post-Fauve landscapes so interesting. *View of Collioure* uses a device familiar to landscape painters ever since the Renaissance: The illusion of depth is created by staggering a succession of spatially and chromatically differentiated planes from foreground to horizon. However, Matisse interprets the device to suit his own needs. By painting the trunks and branches of the trees in the foreground black, he assigns them not to the plane occupied by the village, sea, and sky below and beyond, but actually to another world—that of script: Thus, the landscape in the distance is composed of pictorial forms, whereas the trees in the foreground are drawn signs, made to be read. We no longer look through the window, as painting from the Renaissance until Impressionism would have us do, but at a window. Indeed, *View of Collioure*, with its dark, arborescent shapes acting as a lead frame, reminds us of stained-glass windows. In 1908–9, Matisse may, in fact, have been toying with a project for just such a window for the German collector Karl Osthaus, whom he visited that winter.

(The project was never realized, but *View of Collioure* may have been affected by it—in which case the date of that picture, still problematic, might well be moved forward one year.) In any case, *View of Collioure* is the ancestor of the Tree of Life window at the Chapelle du Rosaire.

While Matisse sometimes employed black as an antidote to chromatic orchestration, at other times his use of it was definitely orchestral. "Black is a color," he affirmed, deliberately contradicting Claude Monet. The most impressive examples of this practice are to be found in the paintings of 1916–18 and, in particular, in the series inspired by his model Laurette, of which *Laurette in a Green Robe, Black Background* (1916) is one of the finest. Deep green, resonant violet, pallid ocher, and black are combined in perfect balance. *Laurette in a Green Robe* demonstrates Matisse's gift for using changing historical contexts to activate as yet underemphasized aspects of his art. The formal solution of *Laurette in a Green Robe*—the substitution of icon for portrait—which had emerged from the crucible of Fauvism, needed to be justified by solemnity. Hence, Matisse's insistence, in his *Notes of a Painter* (1908), on the need for expressing "the character of high gravity which resides in every human being." It was precisely this character that the world conflict fostered, as Matisse noted in 1916: "This war shall have its rewards—what gravity it will have given to the lives even of those who did not take part in it." Solemnity now radiated from all his models. *Laurette in a Green Robe* is the nocturnal counterpart, a decade later, of the solar icon known as *Young Sailor II*.

The history of the *Young Sailor II* after its completion is no less instructive. It was exhibited at the Armory Show in 1913, which underscored the importance accorded to it by the artist, who nevertheless parted with it some time later. In 1922, it was bought by Hans Seligmann, a citizen of Basel, then living, it seems, in the United States. The young man had fallen in love with the picture. Not having the money needed for its purchase, he was forced to turn to his family for help. He did not give them the real reason for his unexpected request, knowing it would have been regarded, at best, as preposterous. Instead, he wisely alleged that he needed funds to use as severance pay to put an end to some affair or other.

In 1952, Seligmann decided to sell the *Young Sailor*, and Pierre Matisse traveled from Paris to Switzerland to discuss the matter with him. The sum that Seligmann requested frightened the distinguished dealer, and he returned to Paris by the next night train, empty-handed, passing what proved to be a sleepless night: "I kept saying to myself, 'How would you feel if you saw that picture in a colleague's window?'" No sooner had Pierre Matisse arrived in Paris than he informed the owner of the painting that he accepted his terms. Back in New York, the financial implications of his *coup de foudre* began to worry him. Afraid that he would never be able to sell the *Young Sailor*, he did what art dealers in that predicament so often do: He had a spectacular frame built for the picture. Twenty-four hours later, one of America's most eminent collectors, Leigh B. Block, walked into Matisse's gallery and purchased the painting.

In 1969, Jacques and Natasha Gelman were dining with Frank Lloyd, the owner of the Marlborough Gallery. Lloyd mentioned in passing that he had a sculpture by Henry Moore that was too large to fit into his gallery, adding that it was meant for Leigh Block, whose

interest had lately shifted from painting to sculpture. "He owns the one picture I would really like to have," commented Jacques Gelman. This was not the sort of remark that escapes a dealer's attention; before long the Moore went to Leigh Block and the Matisse to the Gelmans.

The *Young Sailor II* is the type of painting that the art world usually describes as "difficult" or as a "museum piece," meaning, of course, that it lacks the superficial charm indispensable to appeal to all but the true collector. The trouble is that such pictures do not really appeal to museums either—at any rate, sometimes not for a very long time. For these works, the span between the alpha of the studio and the omega of the museum is enormous—a *traversée du désert*, as the French say, that could easily prove fatal were it not for the inspired collectors who shelter the pictures during that perilous period. Such prophetic works depend for their survival on a chain of solicitude until the moment when their merit is at last recognized and their place in history becomes definitively secured.[4]

Jacques Gelman, who was a collector of this kind, clearly acknowledged that such was his main function. "You must never forget," he told his wife, "that you are a real collector. You can buy the pictures, but after that you are responsible for them all your life. The works belong forever to the artists. Only the troubles belong to you."[5]

Collecting is a form of possession. The ordinary collector possesses the works; the true collector is possessed by them.

PIERRE SCHNEIDER

1. The manner in which pictures are hung provides as revealing an indication of taste whether in a collector's apartment or in the galleries of a museum. Pictures migrate, as did Rouault's *Twilight* (1937), from one room to another, sometimes ending up on the back of a closet door. Works by the youngest artists in the Gelman collection hang in the guest room.

2. The Gelmans' important acquisitions (*Laurette in a Green Robe*, for instance) were often preceded by anguished hesitation. On such occasions, one of the Gelmans would usually make the first, reckless move and, when overcome by perplexity, the other would bolster the spouse's faltering courage. From the beginning, for them collecting was a labor of love—and love takes two partners. No painting, drawing, or sculpture ever entered their collection before having been discussed and approved by both Jacques and Natasha. After Matisse's death, Picasso is reputed to have said, "I shall have to paint for both of us now." Since her husband's death in July 1986, Mrs. Gelman has continued to collect—for both of them.

3. Jacques Gelman obviously favored this method: Braque's *The Billiard Table* (1944–52) was removed from the wall above the chimney in Aimé Maeght's dining room the day the Gelmans came to lunch at the French art dealer's home. Yet, Jacques Gelman could also be implacably tenacious. For years, he had had his eye on Modigliani's *Boy in a Striped Sweater* (1917). The day that he learned that it would be up for sale in France, he caught a plane to Paris. Unfortunately, Sam Salz had taken an earlier flight. The angered Gelman told his wife, "If he doesn't let me have the Modigliani, I'll kill him." Instead, they had dinner at L'Escargot, and Jacques Gelman pleaded for the picture so ardently and so lengthily that he lost his voice. They stopped at Fouquet's to drink an *infusion*. At one o'clock in the morning Mr. Salz gave in. "If I hadn't," Salz later explained, "he would never have let me go back to sleep."

4. Miró was sitting next to Natasha Gelman at a dinner party. He asked her what painting of his the Gelmans owned. She told him about their *Seated Nude Holding a Flower* of 1917. "What! The girl with the bird on one knee, the flower on the other, and the bangs?" he inquired. Upon her affirmative reply, he added, "How wonderful! I thought it was lost forever!"

5. Even the most dedicated collectors occasionally succumb to lapses of faith, but they are willing to

make amends, whatever the cost. Jacques Gelman had always wanted a beautiful Chagall, and he found one, at last: it was *The Lovers* of about 1913–14. For some reason he parted with it, only to regret his decision at once. Several years later, his wife was browsing through the Galerie Beyeler in Basel. "I did something that simply isn't done," she recalls. She had opened a door marked "private," and peeked. "There was our Chagall." She immediately called her husband and informed him of her discovery. The Chagall entered the Gelmans' collection a second time, at a price ten times higher than what they had initially paid for the picture.

A Case for Cubism

THE IMPORTANCE accorded to Cubism in all writing on twentieth-century art has long relied upon its status as a revolutionary, avant-garde style and on its central position in the Modernist theory of the evolution of art. Cubism was certainly a product of the avant-garde (it succeeded in shocking Matisse, for example), and it was immediately designated a manifestation of Modernism by critics both hostile, like Louis Vauxcelles, and sympathetic, like Guillaume Apollinaire. According to later Modernist dogma, Cubism was the source from which all subsequent avant-garde art sprang, from the cool abstractions of Malevich and Mondrian and the boisterous examples of Futurism, to the insidious collages of the Dada artists and the abstract paintings of Pollock, de Kooning, Rothko, and Still. Yet, Cubism has little influence on artists today, and an avant-garde barely seems to exist: The enormous art-consuming public can no longer be shocked and tends to accept as valid virtually any work produced by anyone calling himself an artist. The great engine of Modernism, a force previously thought to have generated all the high art of the last two hundred years, is now considered dead by many critics and historians, while others speculate that its very existence was never more than a myth. With the dissipation of the Modernist climate—which nurtured an appreciation of Cubism for the last seventy-five years—it may now be possible to view Cubist art with an objectivity hardly known since it was first created.

The secure belief that modern art was inherently a continuum of successive styles was an important part of the critical climate in Paris before World War I. At the end of the nineteenth century, academic texts and artist's manifestos alike held that each maturing generation could rewrite history, claiming as modern those earlier artists whose work had anticipated that of the current avant-garde. History was to be written by the fittest to survive. Such a quasi-Darwinian theory of the evolution of modern art was still firmly entrenched in Europe and America through the mid-1960s. According to such critics as Clement Greenberg, Modernism was a movement that embraced artists who emphasized in their work characteristics deemed to be intrinsic to their specific medium—for example, flatness in painting—at the expense of other properties such as illusionism or anecdote. Post-World War II historians simultaneously claimed the Cubists and the Impressionists as the predecessors of the Abstract Expressionist artists whom they championed, just as Signac, in

1892, had identified Delacroix as the forerunner of Seurat. Yet, no historian today could diagram the art of this century with the confidence manifested in Alfred H. Barr's "A Chart of Modern Art" published in 1936. It is all but impossible to propose a linear evolution of modern art now that we know developments were often serendipitous and chaotic. Sophisticated theories collapse when one recognizes that art was created simultaneously in dozens of diverse provincial centers, where innumerable stylistic currents, from Realist to retrograde, multiplied outside the mainstream. If we disregard Modernist theory and isolate Cubism from the central historical position it has been accorded, it remains uncertain whether Cubist painting would retain its importance. Would it appear to be an artistic cul-de-sac or, worse, a bizarre aberration? If Cubism no longer exerts an influence on art today, can it still speak to us?

The fortunate presence in the Gelman collection of two superb Cubist still lifes by Braque and by Picasso, painted simultaneously in the summer of 1911, provides an excellent opportunity to examine Cubist art in the light of contemporary thought. These two paintings, created at the zenith of Braque's and Picasso's collaboration, provide interesting case studies because it is hard to imagine two works more difficult for an uninitiated viewer to appreciate than Braque's *Still Life with Banderillas* and Picasso's *Still Life with a Bottle of Rum* (see pages 111, 114). At first glance nothing seizes one's attention, and little delights the eye. Both paintings represent an art of negation: Color is limited to an austere palette of brown and gray, forms are fragmented, lines are interrupted, space is alternately suggested and denied. It is even difficult to recognize that the paintings were made by two different artists—no doubt a fact that would have amused Braque and Picasso. Working side by side in the French village of Céret, they deliberately suppressed their individuality, attempting to paint in a common, anonymous style. The letters of the alphabet that they included give the impression that these paintings have subjects, but the pictures could also be interpreted as abstract configurations—albeit with little of the sensory reward that most abstract painting provides, through beautiful color, for example, or the suggestion of infinite space.

The point of entry in such paintings is usually provided by the clues that lead to the subject: recognizable shapes of glasses and bottles, fragments of printed matter, the edge of a table. Referring to Cubist pictures, Picasso said, "In our subjects we keep the joy of discovery, the pleasure of the unexpected; our subjects must be a source of interest."[1] Caught by the joy of discovery, an engaged viewer will attempt to reconstruct a scene from the elements indicated—a still life of objects likely to be found on a café table: essentially neutral in emotion, but redolent nonetheless of the bohemian life of artists on the fringe of respectable society. Picasso's insistence on making the presence of the objects felt results in a sculptural-like grouping at the center of the composition, anchored by the vertical bottle of rum around which are arrayed (clockwise) the distinctively shaped bottle called a *porrón*; the Cubists' ubiquitous clay pipe (bottom right); a stemmed glass, rendered as an architect might show it, in section and in plan; and a folded newspaper. Picasso uses light and shade arbitrarily to bring the objects into sharp relief, and carefully builds up impasto to animate the center of the composition with small points of light, in contrast to the thinly painted margins. In the case of the Braque, only with the aid of the title can we recognize the

banderillas on the table—a reference, along with the periodical *Le Torero*, to Picasso's love of bullfighting. The remaining objects—a tall bottle at the right, a glass tumbler at the left, a footed compote near the bottom, and (perhaps) a siphon in the center—are rendered in a manner somewhat flatter and more pictorial than Picasso's relief-like style of painting.

Once the subject is discerned and the café scene materializes, it is nearly impossible to resist questioning the painter. Why this legible sign for a glass when the bottle is so obscure? "I paint forms as I think them, not as I see them," Picasso stated.[2] Why is the void surrounding them painted with the same substantiality as the material objects themselves? Braque often stated that the relationships between objects in space were pictorially more important than the objects themselves.[3] Why are the brushstrokes so self-consciously methodical? In attempting to reconstruct the myriad decisions made by the artist in executing the painting the viewer is engaged and challenged. Deciphering the painting becomes an intellectual game, and more often than not Braque and Picasso win. We ask the questions while they hold the answers.

These pictures remain compelling today precisely because they are so dense and obscure. We might soon tire of seductive, pleasurable, and more easily understood paintings. Picasso's magisterial *Still Life with a Cake* of 1924, for instance—a work of high Synthetic Cubism—impresses the viewer with its strong blues, reds, and greens; bold shapes; recognizable subject; and concurrent associations of texture and smell (see page 168), yet it does not draw one into the confines of creative thought as the *Still Life with a Bottle of Rum*, an Analytic Cubist painting made thirteen years earlier, manages to do. Although the *Still Life with a Cake* shows Picasso's mastery of his stylistic vocabulary—his pictorial eloquence—it is ultimately less engaging than Juan Gris's much earlier, and therefore more tentative, exploration of the same vocabulary, the *Still Life with a Guitar* (see page 123). Gris gave to this 1913 picture a sensual element—strong and surprising color (pale and deep blue, gold, purple, and red) in large expanses—that his colleagues Braque and Picasso had suppressed in their Analytic Cubist paintings. In doing so, Gris indicated the possibilities of Synthetic Cubism not yet realized by his friends. Although Gris's still life was completely plotted out in advance (the ultimate shortening of the newspaper was the most substantial change), while Picasso's *Still Life with a Cake* was in large part extemporized on the canvas, the searching quality of Gris's work, the absence of the facility of expression we find in Picasso's 1924 painting, permits easier access to the mind of the painter, and that quality, too, engages us.

Despite years of acclimation to Cubist imagery and to its assimilation into the modern visual landscape, what is striking is how strange and unfamiliar the 1911 still lifes by Braque and Picasso continue to appear. Analytic Cubism broke almost completely with the conventions of Western representation. Naum Gabo wrote, in retrospect, that "Cubism was a revolution directed against the fundamental basis of Art." Gabo recognized that this was no Philistine attack, but rather that it required "an especially sharpened and cultivated capacity for analytic thought to undertake the task of revaluation of old values in Art and to perform it with the violence that the Cubist school did."[4] Braque and Picasso were themselves conscious of how profoundly novel their art was, but few of their followers understood it, at

least in the first instance. Juan Gris's 1911 *Juan Legua* (see page 108) is a "cubified" portrait executed with all of the conventions of traditional illusionistic painting: single-point perspective, consistent lighting, well-developed chiaroscuro. Apart from the palette, the painting has little in common with the style of Braque's and Picasso's paintings of the same year. (Perhaps because of its traditional approach, the portrait is strongly imbued with the sitter's character.) By contrast, Gris's 1913 drawing *The Smoker* (see page 120) demonstrates that by then he had fully grasped the open-ended possibilities of Cubism. Here, no longer dependent on common notation or superficial appearances, he splayed the head out on the sheet just as Mercator did his maps. Gris freely invented signs for anatomical features like mouths, noses, and eyes. The personality of the sitter is nowhere evident, but Gris's excitement with his newly found abilities, an excitement that is still palpable today, is suggested in the exuberant arrangement of forms.

The invention of this new system of notation, a distinctive style of abbreviated representation, is unquestionably the most enduring achievement of the Cubist painters. Braque and Picasso abandoned the difficult and obscure style of their 1911 Analytic Cubist paintings, but they retained the shorthand manner of drawing in their Synthetic Cubist works. The precise and witty line in Picasso's 1912 collage *Man with a Hat and a Violin* served him equally well in the horrifying image of his *Head of a Woman* of 1927 (see pages 116, 179). In the later work he also used collage-like strips of exposed canvas similar to the strips of newspaper in the 1912 drawing. Léger, after abandoning in the 1930s the machine aesthetic he had developed after World War I, returned, as late as the 1940s, to the Cubist style of superimposing a cursive line over collage-like elements in his *Divers, Blue and Black* (see page 217). The origins of this rhythmic line can be traced, in the Gelman collection, from Picasso's 1906 *Self-Portrait* through the great nudes of 1908, the one standing, and the other kneeling (see pages 99, 102, 105). However, only after Braque's and Picasso's concerted efforts, from 1909 through 1911, to develop Analytic Cubism did they succeed in isolating the various components of picture-making—line, form, and color—and begin to bestow pictorial autonomy upon each of these components. This autonomy—what Amédée Ozenfant called "the clear conception of an art independent of a subject exterior to itself"[5]— is what so profoundly influenced many of the most important artists of this century. Yet, this historical significance can be put aside and Cubist paintings will nonetheless retain their visual and intellectual appeal. The greatest achievement of the Cubists was to open a new window, not onto nature, but into the mind and the actual process of artistic creation. That process is just as mysterious today as it was at the beginning of the century, and equally fascinating now as then.

GARY TINTEROW

1. Interview with Marius de Zayas, quoted in Alfred H. Barr, Jr., *Picasso*, New York, The Museum of Modern Art, 1946, p. 271.

2. Ramón Gómez de la Serna, *Completa e veridica istoria di Picasso e del cubismo*, Turin, 1944, quoted in George Heard Hamilton, *Painting and Sculpture in Europe: 1880–1940*, New York, 1972, p. 246.

3. Ibid.

4. Naum Gabo, "The Constructive Idea in Art," in *Modern Artists on Art*, edited by Robert L. Herbert, Englewood Cliffs, N.J., 1964, p. 106.

5. Amédée Ozenfant, *Foundations of Modern Art*, New York, 1952, p. 77.

The Gelman Braques

GEORGES BRAQUE first came to public attention as a Fauve painter; of Fauvism he later said, "That very physical painting delighted me."[1] Toward the end of his career he observed, "You see, I have made a great discovery. I no longer believe in anything. Objects don't exist for me except insofar as a rapport exists between them and myself. When one attains this harmony, one reaches a sort of intellectual nonexistence—what I can only describe as a state of peace—that makes everything seem possible and right. Life then becomes perpetual revelation. . . ."[2] Indeed, Braque's artistic evolution can be seen as the gradual transformation of the physical into the metaphysical, as a move from the world of clearly defined ideas and sensations into a realm of abstract speculation that at times borders on mysticism. The four Braques in the Gelman collection are a testimony to this remarkable artistic odyssey.

Still Life with Banderillas (1911) dates from the time of Braque's closest collaboration with Picasso in their creation of Cubism. The "banderillas," or decorated barbed darts—accoutrements of the bullfight—together with the last syllables of the word "torero," are a tribute to his Spanish colleague, and possibly a gently ironic comment on the respective positions each occupied in their forging of this deeply revolutionary movement. For if Picasso's stance was an overt challenge and reappraisal of perceived reality, Braque's role, though equally radical, was more painterly and poetic. He was the movement's technician, who, through patient research, was to solve so many of the pictorial problems that arose in the formation of this supremely complex and sophisticated style. Most immediately, he devised a new concept of space to complement Picasso's new treatment of form. Here, objects and pictorial space are dissolved into crystalline facets that advance and recede from the picture plane; space has become tactile, real.

Still Life with a Guitar (1924) fuses this new pictorial space back onto more naturalistic, at once recognizable, forms—the basic studio still life that, more than any other subject, lay at the core of Braque's art. The black background characteristic of his work of the period evokes deep, soft, but palpable space. The accuracy of the tonal values invites comparison with Chardin—a revered predecessor and mentor. The spectator is tempted to pick up the simple, white clay pipe and, hence, to enter into the painting's inner life. The harmonies are splendid in their sobriety—reminiscent of the still lifes of Holland's Golden Age.

In the latter stages of Braque's career, interiors assume the status of magnified or expanded still life. The "Billiard Table" paintings are a prelude to the last great "Studio" paintings—Braque's profoundest statements. Like the musical instruments of earlier periods, they immediately invoke tactile sensations; they ask us to walk around them in our visual imagination, to bend across them, to feel the trajectory of the billiard balls across their broad surfaces. In these paintings Braque's tendency to bend or crack objects and, thus, to fold and pleat the space that encloses them reaches its most explicit expression. The verticality of the Gelman *Billiard Table* (1944–52) makes it one of Braque's finest tours de force: We view the table from one of its narrower sides, just above eye level; the entire length of the table rises majestically upward but, by folding it toward us at the top, Braque allows us to insert ourselves metaphorically behind its far end. Braque, needless to say, was a billiards player just as, earlier on, he had been a dedicated amateur musician.

In the *Garden Chair* (1947–60), an ordinary, commercially manufactured piece of furniture becomes charged with hidden metamorphic powers. The chair and the still life upon it seem to melt and to dissolve, condensing into themselves the space of the terrace and arbor outside Braque's house in Varengeville. If the contemporary "Studio" pictures are metaphors for creativity, the "Chair" paintings symbolize rest and contemplation, pauses in the ongoing processes of an aging great painter's thought and work. In this picture, the chair invokes a human presence. The decorative scrolls of the metalwork have become signs of infinity.

JOHN GOLDING

1. Quoted in Dora Vallier, *Braque, La Peinture et Nous*, Paris, 1954.

2. Quoted in John Richardson, *Georges Braque*, London, 1959.

The Visual Imperatives
of Surrealism

Whether or not painting could, in André Breton's words, "comply with Surrealism's imperatives"[1] was, in the early years of the movement, a much-debated issue. Breton's first *Surrealist Manifesto* of 1924, broad as its revolutionary concerns were in terms of freeing language, poetry, and human experience from the "reign of logic" and the narrow stranglehold of reason, had relegated the contributions of painters to this project to a footnote. Yet, by the 1930s, Surrealism's visual manifestations were sufficiently notable internationally to prompt a major exhibition at The Museum of Modern Art in New York, "Fantastic Art, Dada, Surrealism," as the second of the museum's general retrospectives of modern art movements. The first had been "Cubism and Abstract Art" (1936), to which "Fantastic Art, Dada, Surrealism" was, its introduction announced, "diametrically opposed in both spirit and aesthetic principles."[2]

Surrealism was, however, still felt to be new, challenging, and controversial, too recent for a full critical judgment to be exercised:

We can describe the contemporary movement toward an art of the marvelous and irrational but we are still too close to it to evaluate it. Apparently the movement is growing: under the name of Surrealism it is now active in a dozen countries of Europe, in North and South America, in Japan; it is influencing artists outside the movement as well as designers of decorative and commercial art; it is serving as a link between psychology on the one hand and poetry on the other; it is frankly concerned with symbolic, "literary" or poetic subject matter and so finds itself in opposition to pure abstract art, realistic pictures of the social scene and ordinary studio paintings of nudes or still life; its esthetic of the fantastic, hypnagogic and anti-rational is affecting art criticism and leading to discoveries and revaluations in art history. When the movement is no longer a cause or a cockpit of controversy, it will doubtless be seen to have produced a mass of mediocre and capricious pictures and objects, a fair number of excellent and enduring works of art and even a few masterpieces.[3]

Such "final" judgment, of course, would not necessarily accord with Surrealist values, any more than popular success could gauge success in Surrealist terms and according to

Surrealist priorities. The very success of Surrealism and of Surrealist art was, in fact, a matter of alarm to Breton and the Surrealists, who watched the spread of notions of the fantastic in, for instance, fashion or advertising, under the name of Surrealism, but without any commitment to its fundamental ideas.[4]

Surrealism's embrace of the irrational and celebration of the marvelous was in no sense to be confused with the pursuit of fantasy for its own sake. Fantasy implies a denial of the real; Surrealism demanded a revolution of consciousness, drawing freely on the ideas of Freud. It was never the Surrealists' intention to seal off imagination from reality, desire from action, or dream from everyday life. "Everything tends to make us believe that there exists a certain point of the mind at which life and death, the real and the imagined, past and future, the communicable and the incommunicable, high and low, cease to be perceived as contradictions."[5] Surrealism was neither monolithic nor static, and its commitment both to Freud and to Marx provoked complex and difficult debates, defections, and excommunications. Around the central figure of Breton poets, writers, and artists moved, were drawn in and flung out. The painters, though, enjoyed a degree of autonomy unusual within the movement, partly because no *means* had been laid down a priori for Surrealist painting. The notion of automatism, for instance, central to the definition of Surrealism in the first *Manifesto*, through which the creative resources of the unconscious could be tapped, led, as was quickly demonstrated by Ernst, Masson, Man Ray, and Miró, in quite different directions, visually speaking.[6]

Breton, in his first major defense of painting's relevance to Surrealism's project, stressed the importance of what he described as an "internal model": "In order to respond to the necessity . . . for a total revision of real values, the plastic work of art will either refer to a *purely internal model* or will cease to exist."[7] Although a less than original notion, it was this belief in the primacy of the imagination—which could work with *any* materials—that opened the extraordinarily heterogeneous field of visual expression that constitutes Surrealist art. Breton dated the crucial break with the "external model" in painting to about 1910, with Picasso's so-called Cubism. The public's indignation when confronted by Cubism was still for Breton "a treasured memory. . . . The fact was that it had been thrown off balance by being deprived of that really pathetic satisfaction it was accustomed to derive from a placid contemplation of the 'faithful' reproductions of familiar scenes."[8] Picasso had "so heightened his awareness of the treacherous nature of tangible entities that he dared break openly with them." Conventional accounts of Cubism, while stressing its continued relationship to reality, usually acknowledge it as the seedbed of abstraction and non-objective art. Breton gave an altogether more poetic and lyrical explanation of the new independence of line and plane, freed from the burden of describing the already seen. Picasso's *"The Man with the Clarinet* remains," he wrote, "as a tangible proof of our unwavering proposition that the mind talks stubbornly to us of a future continent, and that everyone has the power to accompany an ever more beautiful Alice into Wonderland."[9] Cubism empowered the imagination to reconstruct the human body, to explore the expressive power of dislocation and disjunction, to play a line so that it is simultaneously contour of body and, say, musical

instrument. Cubism, in other words, opened the way to the kind of visual metaphor sought by Surrealist artists. In Picasso's *Head of a Woman* (page 179), full of sexual rage, the teeth *are* impaling spikes.

The unpredictable visual discoveries of Cubism—which, for the Surrealists, essentially meant those of Picasso—offer a clue, perhaps, to the Surrealists' interest in Giordano Bruno, who is quoted by Breton at the beginning of "Artistic Genesis and Perspective of Surrealism": "It is inconceivable that our imagination and our thought should outstrip Nature, and yet that there should be no reality corresponding to this continuous possibility of new visual experience."[10]

The dialectic between the real and the imaginary, central to Surrealist thought, was easily misunderstood. It was in this context that the Surrealists' attitude toward Picasso came under attack from the group of ex-Surrealist dissidents associated with the review edited by Georges Bataille, *Documents*. Picasso had always been given a prominent place in Surrealist reviews and exhibitions; Breton wooed him assiduously during the 1920s, although it was not until the 1930s that Picasso became actively involved in the movement.[11] In 1930, however, a whole issue of *Documents* was devoted to him. Michel Leiris published an article refuting Picasso's connection with the Surrealists in terms especially wounding to Breton, arguing that it was a mistake to confuse him with the Surrealists, who sought to present him as a man "in flight . . . before reality," whereas Picasso was really concerned not with remaking reality just for the sake of remaking it, but with "expressing all its possibilities, all the imaginable ramifications, so as to close with it even more tightly, truly to touch it. . . . In most of Picasso's pictures it is notable that the 'subject' . . . is almost always completely *down to earth*, in any case, never borrowed from the smoky world of the dream, not susceptible immediately of being turned into a symbol—that is to say, in no way surrealist."[12]

The restriction of Surrealism's perceived interests and interventions in the visual field to dream symbolism alone implied in Leiris's attack is surely unfair when we consider not just those artists directly involved in the movement but those adopted as pioneers or fellow travelers, such as de Chirico or Duchamp. De Chirico's metaphysical city squares and still lifes had long been an important source for the Surrealists. *The Jewish Angel* (see page 146) is among the most rigorously structured of his "still lifes," deliberately invoking Cubism, with the giant eye introducing not only a notion of the self-portrait but also of the seer or prophet.[13]

For Joan Miró, the Surrealist concept of automatism led to crucial plastic discoveries. The free washes of paint that often provide the background of Miró's paintings from the 1920s and the apparent spontaneity of the forms reveal his adoption of the principle of automatism, although his sketchbooks also offer evidence that he carefully planned the arrangement of the forms on the canvas.[14] He has said, "Forms take on a reality for me as I work. In other words, rather than setting out to paint something, I begin painting and as I paint the picture begins to assert itself, or suggest itself under my brush. The form becomes the sign for a woman or a bird as I work."[15] Miró was once told by Max Jacob that he possessed the temperament of a "learned primitive." Miró's primitivism, like that claimed

by the Dadaists, lay in his search for the roots of artistic creativity outside the given conventions of Western civilization. As a "learned primitive," he consciously sought his models in prehistoric art: in cave paintings and in the abstracted but basically figurative signs of ancient petroglyphs. It is often argued that these early sign-images are incipient writing, and Miró's calligraphic line frequently seems to seek to restore the ancient unity of the two processes, so long divided in Western civilization, of image-making and writing.[16]

Miró began to develop his sign language in 1923–24, but it became increasingly flexible and metaphoric rather than rigidly fixed. In *The Potato* (page 184), which is related to the "Dutch Interiors" of the same year, the woman is shown in three-quarter length; a thin line sweeps from her breast around to the left, fringing the edge of the picture and ending just before the little stepladder leading to the oddly Cubist potato-peeling knife. The figure as a whole becomes a landscape, fruitful as the earth itself. In *Animated Landscape* (page 181), the bird's tail is represented by the triangular sign used for woman in *Maternity*. In this painting, the ambiguity between inside and outside, ground and sky (the moon reflected in a pool or a window), suggests the imaginative transformation of the world.

The artists closely associated with the Surrealist movement during its first five years: André Masson, Joan Miró, Max Ernst, and Yves Tanguy, had responded in highly diverse and individual ways to Surrealism's imperatives, seeking equivalents to automatic writing (Ernst with the frottage technique, Miró with the washes of pure color applied at random to the canvas, and Masson with his sand paintings) or (like Tanguy) constructing visual metaphors for "mental landscapes." After the initial doubts within the movement as to the viability of a "surrealist art," following Pierre Naville's famous indictment of it: "Everyone now knows that there can be no such thing as surrealist painting,"[17] these artists, and others like Man Ray, had, with Breton's encouragement, established the visual dimension of Surrealism. Yet, however much they contributed to the intellectual as well as the artistic life of the movement, they had, on the whole, interpreted Surrealism's dictates in their own individual ways. Salvador Dali, who had joined the movement in 1929, pursued a somewhat different approach, intervening actively in Surrealist strategies, contributing to its theoretical debates, and devising new forms of Surrealist activity. As part of the campaign to revitalize Surrealism after the rifts and defections of 1929, Dali took up and promoted the idea of the Surrealist object and evolved his "paranoiac-critical method," which was embraced by the Surrealists as a tool of primary importance.[18] Dali's "exceptional interior 'boiling,'" as Breton described it, was an "invaluable ferment for Surrealism."[19] It wasn't long, however, before his exhibitionism and avidity, as well as his cynical exploitation of the visual games involved in the paranoiac-critical method, led to his rejection by the movement. Nevertheless, by the late 1930s he had become firmly identified with Surrealism in the public's view.

It is not difficult to understand the initial enthusiasm with which Dali was welcomed. He produced a small group of remarkable paintings in the summer and autumn of 1929 at Cadaqués, which are a quite original extension of Surrealism. Breton later recalled their impact: "The poetic and visionary content of these canvases is of an exceptional density and

explosive force. Nothing since the 1923–24 works by Max Ernst, like *Revolution by Night* or *Two Children Are Threatened by a Nightingale*, or works of 1924 by Miró like *The Tilled Field* and *Harlequin's Carnival* had possessed the same character of revelation. . . ."[20] These paintings, which include the *Accommodations of Desires*, offered a new means of representing an interior, mental world, and one that was particularly close to the Surrealists' current preoccupation with aspects of contemporary psychological and psychoanalytical theory, and with theories of perception. While linked, as Breton recognized, to such de Chirico-inspired dream canvases as Ernst's *Revolution by Night*, they were clearly not just a reprise of them. Like *Revolution by Night*, *The Accommodations of Desires* and other paintings in this group including the *Lugubrious Game*, the *Illumined Pleasures*, and *The Great Masturbator* hold in balance powerful personal anxieties and psychoanalytical theories from various sources.

This group of paintings employs a deep landscape vista, similar to Ernst's *Elephant of the Celebes* (1921), as the setting for scattered or clustered objects and figures. Devices to make landscape function as the sign of a world visible to an internal rather than an external "eye" were frequent within Surrealism, continuing Breton's metaphor from "Surrealism and Painting": "It is impossible for me to envisage a picture as being other than a window and . . . my first concern is then to know what it looks out on, in other words whether, from where I am standing, there is a 'beautiful view,' and nothing appeals to me so much as a vista stretching away before me and out of sight."[21] Tanguy, in paintings like *The Satin Tuning Fork* and *From Green to White* (pages 230, 237), blurs or repeats the horizon line so that divisions between sky, ground, and water are uncertain, denying the discrete identity of the familiar elements of this world and suggesting one hitherto unseen. Dali, by contrast, roots his landscape partly in the real world, in a curious mixture of the topographical and the imaginary. His featureless plain—perhaps, indeed, intended to represent the half-remembered landscape of a dream—was based, he has hinted, on the Plain of Ampurdán near Figueras. In *The Accommodations of Desires*, moreover, he makes clear reference to the jagged, lacerating, and unaccommodating rocks of the Catalan coast around Cadaqués, and to the sea in the distance.

Elegantly spread over the excremental-brown ground are six white pebbles, casting shadows. Applied to two of these are identical collages of lions' heads, almost indistinguishable from the enamel-smooth surface of the paint. From the second head, however, the face has been cut, leaving a blank white shape not unlike an inverted torso. Just the bared fangs of the lion's mouth are pasted onto a third stone, while the fourth has a flaming red afterimage emblazoned on it, the color of passion and blood. The human figures at the top of the painting are real, as opposed to hallucinatory, presences, unlike the images on the stones, but a closer look reveals differences within this reality, in that the violently entwined couple—bearded man and androgynous boy/girl—rise like statues from a pedestal extending from the head of a young man who is the protagonist of the drama, and who clutches his head in despair. It is the cluster of tiny painted images on the stone in the upper-right corner, casting its shadow on the bearded man, that provides a key to the repeated lions' heads and links them to the figures, revealing the sexual anxiety they symbolize. A steatopygous female torso, painted a lurid pink, has, in place of the genital area, the ghostly

shape of the same lion's head, and painted within this is the whole body of a lion. The threatening fangs of the roaring lion are thus identified with the female genitals, raising the classic specter of the "vagina dentata." The simultaneous fear and desire expressed in this image is closely linked, as Dali has said, to his own experience at the time. That the young man at the center of the drama is a self-portrait is confirmed from his autobiography, *The Secret Life of Salvador Dali*, in which he locates the painting *The Accommodations of Desires* at the moment that he and Gala, the wife of the poet Paul Éluard, were left alone at Cadaqués by the summer's visiting Surrealists. "Never in my life had I yet 'made love' and I represented this act to myself as terribly violent and disproportionate to my physical vigour." At this point he began the painting "in which desires were always represented by the terrorizing images of lions' heads."[22]

Dali elaborated, in Freudian terms, on his fear of the female body, hinting at the presence of childhood experiences as a source of his later neurosis, through, for instance, the presence of the minute nurse and child in the middle distance. The threat of castration—classically, in Freud's view, administered by the father (to whom another miniature figure in the middle distance probably refers, as the figure is, recognizably, Dali's own father, hand raised in threat)—could be supplemented by the boy's observation at some point in childhood of the female lack of a penis, and his conclusion that the female genitals were, in fact, a wound. The clustering of sexual themes and the use of symbols indicate Dali's familiarity with Freudian theory and with Freud's case histories, as well as with the Oedipus complex and its extensions and variations. For instance, the ambivalent figure embracing the bearded man, who has the body of a woman but the head of a boy, may be a reference to the repressed homosexual desire of the son for the father described by Freud in his "Schreber case"; doubts might well arise as to the extent to which the "autobiographical" continues in *The Accommodations of Desires* and in related paintings.

One conclusion to be drawn from this—still sketchy—account of the painting is that it is not constructed simply to represent a dream image. Although dream elements may come into it—in the way that dreams often supplied the key to Freudian analysis, once the uncovering of the latent meaning behind the manifest surface of the dream had been achieved—its central concern is not with finding a visual metaphor for dream experiences, nor with recording a specific dream image, but rather, with expressing through visual images a disturbed (neurotic) frame of mind. Dali provided both the neurosis and its interpretation. No wonder that Freud once, apparently, remarked to him, "Your mystery is manifested outright. . . ." What Dali did, effectively, was to construct for himself a case history along the lines of Freud's "Little Hans," "The Wolf Man" (whose dreams of wolves staring at him through a window triggered an infant neurosis), or the "Schreber case," using both his own sets of terrorizing elements—the ants, for example, crawling out of the "wounded" stone—and classic symbols of psychoanalysis (woman as jug/container).[23]

This project was fully in line with the contemporary Surrealist interest in insanity and mental disorders. In November 1930, André Breton and Paul Éluard published a series of texts simulating states of mental disorder, such as dementia praecox and "delirium of interpretation," under the title *L'Immaculée Conception*. When extracts from it were published

in the Surrealist review *Le Surréalisme au Service de la Révolution* [SASDLR], they were accompanied by Dali's drawings.[24] In Dali's own important text *La Femme Visible* he expressed his parallel pursuit in his own terms: "The pleasure principle acting against the reality principle, the paranoiac delirium of interpretation, the disturbances of affective knowledge, overestimation, the transparent confusion of simulacra, everything, in sum, that constitutes the violent categories of thought, culminates in love through its lasting and mortal power."[25] Although the debt to Freud in the reference, for instance, to the pleasure principle and the reality principle is clear, equally important are Dali's allusions to the notion of paranoia, which was a subject of particular interest to psychology at the time. Jacques Lacan's article "Structure des Psychoses Paranoïaques," of 1931, describes the cardinal signs of three different types of paranoid psychosis.[26] Of these, the most relevant here is Lacan's second type (which he was not the first to discuss), "delirium of interpretation." This had, Lacan says, earlier been "magisterially described" by Sérieux and Capgras, who had defined those of "paranoiac constitution" as "reasoning madmen." "The delirium of interpretation" involved the active construction of everyday events and objects according to an overriding obsessional idea, but it had nothing to do with passive hallucinations, nor primarily with dreams. "The delirium of interpretation," as Lacan put it, "is a delirium of the home, the street, the forum. These interpretations are multiple, extensive, repeated. . . ." This recalls Freud's comments on the Schreber case ("Psychoanalytic notes on an autobiographical account of a case of paranoia"): "Paranoia decomposes just as hysteria condenses. Or rather, paranoia resolves once more into their elements the products of the condensations and identifications which are effected in the unconscious."[27] The multiplications and decompositions in *The Accommodations of Desires* could be seen to bear witness to the deliberate simulation of paranoia.

Out of the visual simulation of paranoia Dali was to develop what he called his "paranoiac-critical method": "It is," he wrote, "by a clearly paranoiac process that it has been possible to obtain a double image: that is to say, the representation of an object which, without the slightest anatomical or figurative modification may at the same time be the representation of another totally different object."[28] To underline the originality of his method for Surrealism, Dali stressed the active character of paranoiac thought as opposed to what he described as the passive character of other mechanisms used by the Surrealists to explore hidden or unconscious mental processes, such as automatism. "I believe that the moment is near," he wrote, "when, by an active and paranoiac process of thought, it will be possible (simultaneously with automatism and other passive states) to systematize confusion and to contribute to the total discrediting of the world of reality."[29] Although his method was later to degenerate into little more than a game of perceptual fantasy, in the paintings of 1929 and the early 1930s he introduced a new and ironic element into visual Surrealism. "My whole ambition in the pictorial domain is to materialise the images of concrete irrationality . . . in order that the world of imagination and of concrete irrationality may be as objectively evident, of the same consistency, of the same durability, of the same persuasive, cognoscitive and communicable thickness as that of the exterior world of phenomenal reality."[30] His mode of painting, a licked academic realism in miniature, subverted the "things of reality"

by parodying the "means of expression . . . of the great realist painters" so as to realize visually an internal, mental world.

Surrealism became not only the major intellectual force during the 1920s and 1930s, but also, as Gombrich put it in *The Story of Art*, "the best known of the inter-war movements of art." By this time (1950) Dali had become the inevitable focus of historical and critical accounts of the movement. Gombrich, not surprisingly given his interest in problems of perception, discusses in the context of Freudian dream imagery Dali's "paranoiac-critical method," and makes an interesting comparison between Dali and an example of ancient ritual art: a statue of the Aztec rain god Tlaloc, in which his features are constructed severally of rattlesnakes. "How great," Gombrich notes, "is the difference in spirit for all possible similarity of method! Both images may have emerged from a dream, but Tlaloc, we feel, was the dream of a whole people, the nightmare figure of the divine power that held sway over their fate; Dali's dog and fruit bowl [*Apparition of Face and Fruit Dish on a Beach*] reflect the elusive dream of a private person to which we hold no key."[31] Surrealism exemplified for Gombrich the breakdown of a tradition, but his lament for a lost community of purpose obscures the extent to which a modern mythology was in the process of construction.

DAWN ADES

1. André Breton, "Artistic Genesis and Perspective of Surrealism" (1941), in André Breton, *Surrealism and Painting*, New York, 1972, p. 64.

2. Alfred H. Barr, Jr., Introduction to *Fantastic Art, Dada, Surrealism* (exhib. cat.), New York, The Museum of Modern Art, 2nd ed., 1937, p. 9.

3. Ibid., p. 13.

4. André Breton's *Second Manifesto of Surrealism* (1929) already warned against the adulteration and simplification of the movement's objectives.

5. André Breton, "Second Manifesto of Surrealism," in *Manifestos of Surrealism*, Ann Arbor, 1969, p. 123.

6. The definition ran as follows: "Pure psychic automatism by which it is intended to express, either verbally, or in writing, or in any other way, the true functioning of thought. The dictation of thought, in the absence of any control exerted by reason, and outside any moral or aesthetic considerations."

7. Breton, "Surrealism and Painting," in *Surrealism and Painting*, op. cit., p. 4.

8. Breton, "Artistic Genesis and Perspective of Surrealism," op. cit., p. 52.

9. Breton, "Surrealism and Painting," op. cit., p. 6.

10. Breton, "Artistic Genesis and Perspective of Surrealism," op. cit., p. 51. Bruno, a philosopher and scientist who argued that the world consisted of an infinite series of solar systems, was burned at the stake for heresy and blasphemy in 1600.

11. See Elizabeth Cowling, "'Proudly we claim him as one of us': Breton, Picasso and the surrealist movement," *Art History* 8, no. 1 (March 1985).

12. Michel Leiris, "Toiles récentes de Picasso," *Documents* 2, no. 2 (March 1930), quoted in Cowling, op. cit., p. 100 (translated by the author).

13. I am indebted to Matthew Gale, now completing his doctoral dissertation on de Chirico, for this interpretation.

14. See Gaëtan Picon, *Joan Miró, Carnets catalans...*, Geneva, 1976, and Christopher Green, *Cubism and Its Enemies*, New Haven, 1987, pp. 269–71, for further discussion of the relationship between Miró's sketches and the automatic paintings of the 1920s.

15. James Johnson Sweeney, "Joan Miró: Comment and Interview," *Partisan Review* XV (February 2, 1948), p. 212.

16. See Sidra Stitch, *Joan Miró: The Development of a Sign Language*, St. Louis, Washington University Gallery of Art, 1980.

17. *La Révolution Surréaliste* no. 3 (April 15, 1925), p. 27.

18. Dali gave an account of his paranoiac-critical method in "The Conquest of the Irrational," in *The Secret Life of Salvador Dali*, London, 1968.

19. André Breton, "What Is Surrealism?", in S. Rosemont, ed., *What Is Surrealism*, London, 1978.

20. André Breton, *Entretiens*, Paris, 1952, p. 155.

21. See Breton, "Surrealism and Painting," op. cit., pp. 2–3. See also Jennifer Mundy, "Surrealism and Painting: Describing the Imaginary," *Art History* 10, no. 4 (December 1987), for an interesting discussion of Breton's debt to such psychologists of perception as Dr. P. Quercy.

22. *The Secret Life of Salvador Dali*, op. cit., p. 241.

23. See Sigmund Freud, "Psychoanalytic notes on an autobiographical account of paranoia" of 1911 [the "Schreber case"] and "From the History of an Infantile Neurosis" of 1918 ["The Wolf Man"], published in *Case Histories 11*, 1979; and also Freud, *The Interpretation of Dreams*, 1900.

24. André Breton and Paul Éluard, "L'Homme," in *Le Surréalisme au Service de la Révolution* [SASDLR] no. 2 (October 1930).

25. Salvador Dali, *La Femme Visible*, Paris, 1930 (translated from an extract in *Salvador Dali Rétrospective 1920–1980* [exhib. cat.], Paris, Musée National d'Art Moderne, Centre Georges Pompidou, 1979, p. 170).

26. Jacques Lacan, "Structure des psychoses paranoïaques," in *La Semaine des Hôpitaux de Paris* (July 1931). I am grateful to David Lomas for drawing this to my attention and for signaling the importance of Sérieux and Capgras [see his unpublished master's thesis, London, Courtauld Institute of Art, 1987].

27. Freud, *Case Histories 11*, op. cit., p. 185.

28. Salvador Dali, "L'Âne Pourri," in SASDLR no. 1 (July 1930), p. 10 [this was an extract from *La Femme Visible*].

29. Dali, "L'Âne Pourri," op. cit., p. 9.

30. Dali, "The Conquest of the Irrational," op. cit., p. 417.

31. E. H. Gombrich, *The Story of Art*, London and New York, 1950, p. 451.

Miró and the
Gelman Collection

THE EYE of the collector, if he is a true lover of painting, seems to me as mysterious as the eye of the creator. The light that a collector's choice sheds on a painter's work is an inseparable part of that work and, in a certain way, the culmination of the artist's creation. In this respect the selections by Jacques and Natasha Gelman from among Miró's paintings are revealing.

Throughout his life, Joan Miró was tempted by two approaches to art, alternating between one and the other: "I throw myself into the dark and question the unknown," was counterbalanced by "I know what I know, and I clarify with certainty the vision that asserts itself." The Gelmans chose pictures that exemplified the latter spirit, the light half of the Janus-faced Miró, and the consistency of their choices led to impressive results. Out of nine acquisitions, they brought together seven that are unquestionable masterpieces by the Catalan painter. The Gelmans favored the solar side of Miró's artistic duality, his pure color and precise line, neglecting the exploratory paintings and the violent gestural works—the artist's struggles in the shadows. Their preference is nowhere betrayed, and that is what is so special about what they collected.

The two early paintings from Miró's figurative period already reveal the power and precision of his energetic style—a style organically related to the Mediterranean landscape in which he worked, and whose rhythms, contrasts, and light became the basis of his future creations. *Vines and Olive Trees, Tarragona* (see page 157) anticipates his mature period, and is elucidated by it in turn, its formal strength and lively rhythms reinforced by the absence of the anecdotal and effective imagery that blunts the impact of other paintings by Miró from the same years. A clear and consistent sequence of horizontal accents progresses, in decrescendo, from the strongly accentuated vines in the foreground to the line of mountains in the distance via the profusion of olive trees and the contrasting cadences of the soil. The fugal movement of this landscape and its simple theme can be compared with the *Women and Bird in the Night* of 1944 (see page 226). Painted twenty-five years apart, across the leaps, pirouettes, and metamorphoses of the artist's career, these two pictures have more in common than not. They reveal the same approach to pictorial surface, the same emphasis on individual symbols, the same rhythm and chromatic play, and, especially, the same autonomy of the picture space.

The female figure became a major element in Miró's art, at once imperious and omnipresent. Frequently associated with the bird, as well as with the sun, moon, and stars, it embodies the artist's treatment of the theme of love and the stylistic changes in his work. In a few of the pictures in his early style the female form remained free from the network of imagery that later on would render it enigmatic. The female figure in the *Seated Nude Holding a Flower* of 1917 possesses an almost aggressive femininity (see page 154), the bulging forms of the arms, belly, and breasts, and the harsh Fauve-like colors, contributing to the figure's sculptural mass. The body contrasts with the child-woman's face, whose closed, elongated eyes convey an impression of absence or distance, of silence.

The 1920s were the most turbulent years for Miró, both for the rapidity of the change in his style and the pursuit of his goals. His artistic breakthrough followed the discovery of the Dada movement and his own encounter with the Surrealists. More than any other artist, Miró displayed an amazing freedom and a logic in his investigation of the unknown that led André Breton to refer to him as the "most Surrealist of us all."

The dream-like paintings and experimental works from this period were shunned by the Gelmans, who preferred the sunnier aspects of his expression. One such work is the *Animated Landscape* of 1927 (see page 181), among the most mysterious of the imaginary landscapes that Miró painted in Montroig, in the summer light of Catalonia. This and other, related pictures provided him with an escape, and served as an antidote to the explorations of the unconscious that preoccupied him during the winters spent in Paris. Detached from the spell of an anguished fanaticism, the landscapes return to pure color, a distilled and luminous space, and a clarification of figurative form.

The Potato of 1928, in the same chromatic register, is like a grandiose effigy of the Earth Mother. A blind giantess with a white body is set against a cerulean blue sky. Her raised arms and immobile pose accentuate, by contrast, the movement, activity, and metamorphosis of the tiny figures whirling around her. An air of jubilation hovers about the goddess, who appears to draw nourishment, brilliance, and energy from the earth.

1940. World War II has begun. In a small village on the Normandy coast Miró paints the first of his "Constellations," a series that he would continue in Palma de Mallorca and in Catalonia throughout the tribulations of the war and his exile from France. This series enables him to distill fifteen years of artistic innovation, and to extract the essence of his personal language of signs and pure colors.

Women on the Beach of February 1940 (see page 219) is among the early "Constellations," open yet taut, and astonishingly precise. From painted sheet to painted sheet the interweaving of forms and symbols gradually tightened, spreading web-like structures of increasing density across each subsequent composition. *Toward the Rainbow* (see page 223), painted in Palma in 1941, is characteristic of this tight rendering of space where hen-like creatures, birds, and stars interlace until the individual motifs can no longer be distinguished from the collective spirit and song.

JACQUES DUPIN

Yves Tanguy

HOW SURREAL is Surrealist painting? The question has been argued at least since 1925 when Pierre Naville wrote in the review *La Révolution Surréaliste*: "Everyone knows now that there is no *Surrealist painting*. Neither pencil marks recording chance gestures, nor images representing dream figures, nor imaginary fantasies can be so qualified." He went on to clarify this point somewhat: "How is it that what we call literature is nurtured almost exclusively by love, and that words turn love so easily to account, while the plastic arts are cut off from it, or that we only glimpse it there, veiled and ambiguous? There is really no literary equivalent of the *nude*."[1]

Perhaps even literature had to cheat a little in order to be able to call itself surrealist. Automatic writing was the ideal, and it was occasionally practiced by Breton and others during the early days of the movement, but the results are usually so unsatisfactory as literature that something obviously had to be done. Even the writing labeled "automatic" has obviously been shaped and smoothed after the fact of its execution, while the finest poetry of Breton, Éluard, and Aragon shares the ideals of order and clarity that have characterized French literature since Racine and Boileau: Only the subject matter is different. How much more difficult then for a painter to transcribe the spontaneous madness of the Surrealist vision with the laborious means at his disposal. Thus, from the beginning most Surrealist painters settled for illustrating Naville's "images representing dream figures" with techniques not very different from those of a van Eyck or a Vermeer. Not until the later works of Jackson Pollock and Action Painting would the act of painting itself become surrealist, and by that time painting was abstract, having abandoned dream figures.

Although the Surrealist painters sometimes used random procedures such as Ernst's *frottage*, Masson's sand painting, and Wolfgang Paalen's *fumage*—in which smoke from a lit candle held close to the canvas was used to suggest forms—the results have the finished look of these artists' traditionally made pictures and those by Dali, Magritte, and Delvaux. Hence, a staleness or weariness in so much of this work: The energy of the image has been siphoned off into the task of representing it.

One could argue that a handful of artists, in their different ways, successfully met the challenge of Surrealism's call for "*liberté totale*": Arp, despite his abstract language; Klee and de Chirico, although they remained on the fringes of the movement; Miró, whose

customary badinage can seem alien to its spirit; and especially Tanguy. As his style evolved from its rather crude and naïve beginnings in the 1920s through the amazing illusionism of his later years, it came to seem a mechanism as skilled and impersonal as a camera lens, ideal for documenting the imaginary animal, vegetal, and mineral phenomena that inhabit his paintings: beings of a type never encountered before yet palpably real, living if not breathing.

Once articulated, his mature style changed very little; instead, development takes the form of a steadily increasing tension. Forms can pullulate endlessly, amoeba-like, in late paintings such as the 1954 *From Green to White*, although they can just as easily turn monolithic, as in *My Life, White and Black*, of a decade before. At most, there are shifts of perspective in some of the pictures of his last phase: One's viewpoint may be situated slightly below the activity on the canvas, instead of above it; objects can crowd the foreground instead of receding endlessly toward the horizon. Color takes on a greater feeling of saturation or sharpness. Tanguy noted in the 1940s: "Here in the United States the only change I can distinguish in my work is possibly in my palette. . . . Perhaps it is due to the light. I also have a feeling of greater space here, more 'room'. But that was why I came here."[2]

Although Dali and Magritte were equally skilled technicians, and Dali perhaps even more so, what they chose to record was the real world seen through Surrealism's distorting lens. The concrete abstractions that are constantly erupting onto Tanguy's canvases are closer to the Surrealist ideal of "all that has never been, which alone interests us," in Éluard's phrase:[3] paradoxically spontaneous despite the hours of painstaking labor that went into their execution. Thus, at a time when people no longer have problems construing as art Naville's "pencil marks recording chance gestures," when the results seem to warrant it, Tanguy's painting speaks directly to us. The trappings of retro-chic that dilute the message of his gifted contemporaries are simply absent; there is no residue of either craft or literary content. His work is Surrealism in its purest visual form, and therefore ranks with the most powerful artifacts our century has produced.

JOHN ASHBERY

1. Pierre Naville, "Beaux-Arts," *La Révolution Surréaliste*, no. 3 (April 15, 1925), p. 77.

2. Yves Tanguy, *Arts Digest* 28, no. 14 (January 15, 1954), p. 33.

3. Paul Éluard, "Raymond Roussel: L'Étoile au front," *La Révolution Surréaliste* no. 4 (July 15, 1925), p. 32.

Note

Only the English titles of the works are given in the entries. The artist's title in its original language or, if not known, the title under which the work was first published or exhibited, is listed in the Provenances, Exhibitions, and Bibliographic References section (see page 293). Dimensions are given in inches, followed by centimeters. Height precedes width (followed by depth when relevant). Inscriptions are given when the work is signed, dated, or inscribed by the artist. Unless otherwise stated, translations from the French are by the author. When published translations have been emended they are indicated as such.

EXHIBITIONS AND BIBLIOGRAPHY
Exhibitions and bibliographical references are selective. If the exhibition was accompanied by a catalogue, it is included in the List of Exhibitions, and is not repeated in the Bibliography. Full citations for the short references used here are found, under the individual artist's name, in the List of Exhibitions and the Selected Bibliography (see pages 317, 332).

ABBREVIATIONS
Daix
Daix, Pierre, and Georges Boudaille. *Picasso: The Blue and Rose Periods. A Catalogue Raisonné, 1900–1906.* Translated by Phoebe Pool. Greenwich, Connecticut, 1966.

Daix, Pierre, and Joan Rosselet. *Picasso: The Cubist Years, 1907–1916. A Catalogue Raisonné of the Paintings and Related Works.* Translated by Dorothy S. Blair. Boston, 1979.

Dauberville
Dauberville, Jean, and Henry Dauberville. *Bonnard: Catalogue raisonné de l'oeuvre peint, 1888–1947.* 4 vols. Paris, 1966–74.

Dorival and Rouault
Dorival, Bernard, and Isabelle Rouault. *Rouault: L'oeuvre peint.* 2 vols. Monte Carlo, 1988.

Dupin
Dupin, Jacques. *Joan Miró: Life and Work.* Translated by Norbert Guterman. New York, 1962.

Fabre
Josep Palau i Fabre. *Picasso: The Early Years 1881–1907.* Translated by Kenneth Lyons. New York, 1981.

Haesaerts
Haesaerts, Paul. *Renoir: Sculptor.* New York, 1947.

Rewald
Rewald, John. *Degas Sculpture.* New York, 1956.

Zervos
Zervos, Christian. *Pablo Picasso: Oeuvres.* 33 vols. Paris, 1932–78.

The
Jacques and Natasha Gelman
Collection

The Century's Turn
1895–1901

Edgar Degas

French, 1834–1917

WOMAN PUTTING ON A STOCKING

1895–1910
Bronze
16¾ × 11¼ × 5¾ in. (42.5 × 28.5 × 14.5 cm.)
set F, no. 70
Stamped (on the base): Cire / Perdue / A. A. Hébrard; *incised: 70/*F

EDGAR DEGAS never intended that his wax sculptures be cast in bronze, and during his lifetime only one sculpture, the *Little Fourteen-Year-Old Dancer* (1879–81; Rewald XX), was exhibited publicly, at the Paris Salon of 1881.

Between the 1860s, when Degas began modeling wax, and 1917, when he died, it is believed that he produced several hundred sculptures. According to the inventory made by his dealer, Joseph Durand-Ruel, after Degas's death, however, only about one hundred and fifty of the works in wax—most of them broken or disintegrated—were found in his studio. Of these, only seventy-four were in good enough condition to be cast in bronze, and, even among those, half needed repairs. That so few survived was a result of the artist's ingenious, if unorthodox, working methods. He modeled the statuettes from a mixture of plasteline and wax, to which cork was added as a filler. The figures were then mounted on improvised armatures that sometimes collapsed, often causing considerable damage to a sculpture, such as the loss of a limb. Other works were probably left behind when, in 1912, Degas was forced to vacate his three-story lodgings in the rue Victor Massé, where he had lived for over twenty years, and moved to a smaller apartment on the boulevard de Clichy.[1]

From the mid-1890s on, when Degas's failing eyesight made painting and drawing especially difficult, he increasingly turned to sculpture, modeling statuettes in wax, from life. An account published by one of his sitters makes clear that posing for Degas was a trying experience. The aged artist was often in an irascible mood, insisting on difficult poses that involved "gymnastics on one leg," after which the exhausted model had to take a rest.[2] Degas would pace back and forth between the subject and his sculpture, and, to compensate for his impaired vision, would trace her outlines with his thumb and measure her proportions with calipers, sometimes bruising the young woman in the process.[3]

Since Degas's surviving sculptures represent only a portion of his entire production, and since none is dated, it is difficult to establish a chronology. As John Rewald has noted, "perhaps not always the most significant works have survived."[4] Those that still exist depict Degas's favorite subjects. With the exception of a few sculpted heads, these include horses, dancers, and women—bathing or dressing—all caught in a fleeting moment. It has been suggested that, while Degas appears to have engaged adolescent models to pose for his earlier works, the later sculptures depict more mature and less slender sitters, stockier in

build than actual professional dancers. Since the subject of this statuette—of which two additional versions exist (Rewald LVI, LVII)—seems to fit the latter category, it is more convincing to imagine her as a model rather than as a dancer, even though few ordinary women would be as adept at pointing their toes. In accordance with the artist's expressive and summary late painting style, the surface here is as rough and coarse as the scaly bark of trees—in Gary Tinterow's apt comparison.[5] The face is indicated by a few flat planes, and the missing left foot either broke off from the wax model or perhaps never existed at all.

Despite the obvious similarities between Degas's two-dimensional and three-dimensional dancers and bathers, differences exist. Of his thirty-eight statuettes of dancers, about half assume actual ballet positions—far superseding in number such postures among the figures in the approximately fifteen hundred paintings, pastels, prints, and drawings with the same subject. In these, Degas delights in showing the dancers and bathers off guard, stretching, yawning, or even scratching themselves. The gestures are often awkward, and the realism of several nudes as humorously cruel as some of the verbal quips for which Degas was known. The two-dimensional dancers and bathers never seem to be as precariously balanced on one leg as the model in this sculpture. Whether adjusting a shoe, pulling up a stocking, or drying a foot, the women in Degas's pictures are either seated or else grasp onto a piano or the back of a chair for support.

1. The casting in bronze of Degas's sculpture did not begin until 1919, two years after his death, at the Hébrard foundry in Paris.

Much of the information in this entry has been taken from John Rewald, *Degas, Works in Sculpture: A Complete Catalogue*, New York and London, 1944.

Twenty-two casts of each of seventy-two works were made and those intended for sale were marked with letters from *A* to *T*; the three additional sets included the master set and one each for Degas's heirs and for the foundry. It appears that bronze casts of the *Little Fourteen-Year-Old Dancer* were made in the 1920s in an unnumbered edition of at least twenty-five examples, and the seventy-fourth work, *The*

Schoolgirl, was not cast until the 1950s. See Gary Tinterow, "A Note on Degas's Bronzes," in *Degas* (exhib. cat.), New York, The Metropolitan Museum of Art, 1988, pp. 609–10, for the most succinct explanation.

2. Alice Michel, "Degas et son modèle," *Mercure de France* (February 16, 1919), p. 469.

3. Ibid., p. 460.

4. John Rewald, op. cit., p. 14.

5. Gary Tinterow, "Fourth Position Front, on the Left Leg," in *Degas*, op. cit., nos. 290, 291, pp. 473–74.

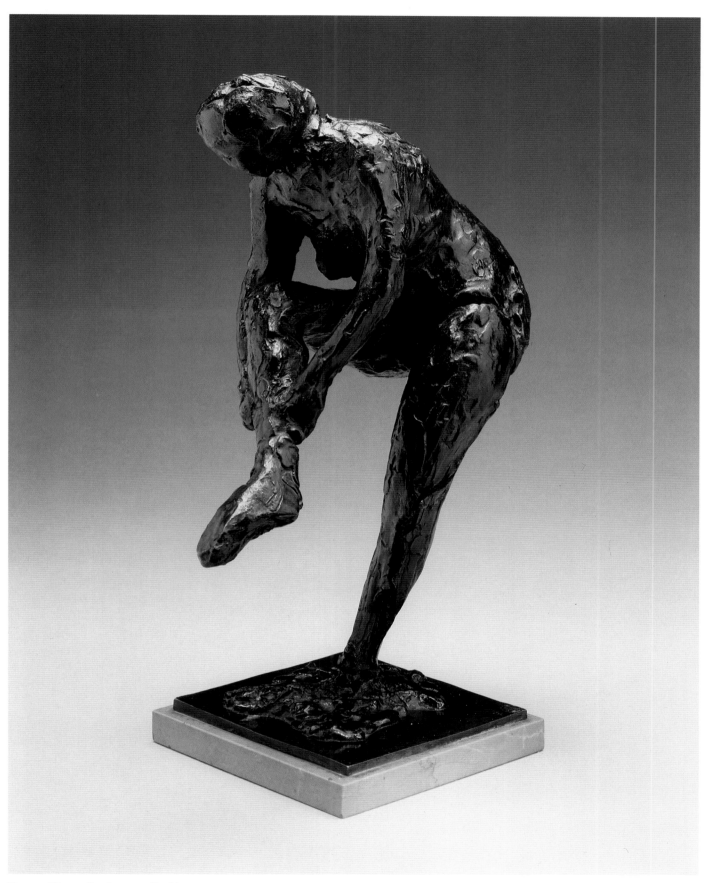

Degas. *Woman Putting on a Stocking*

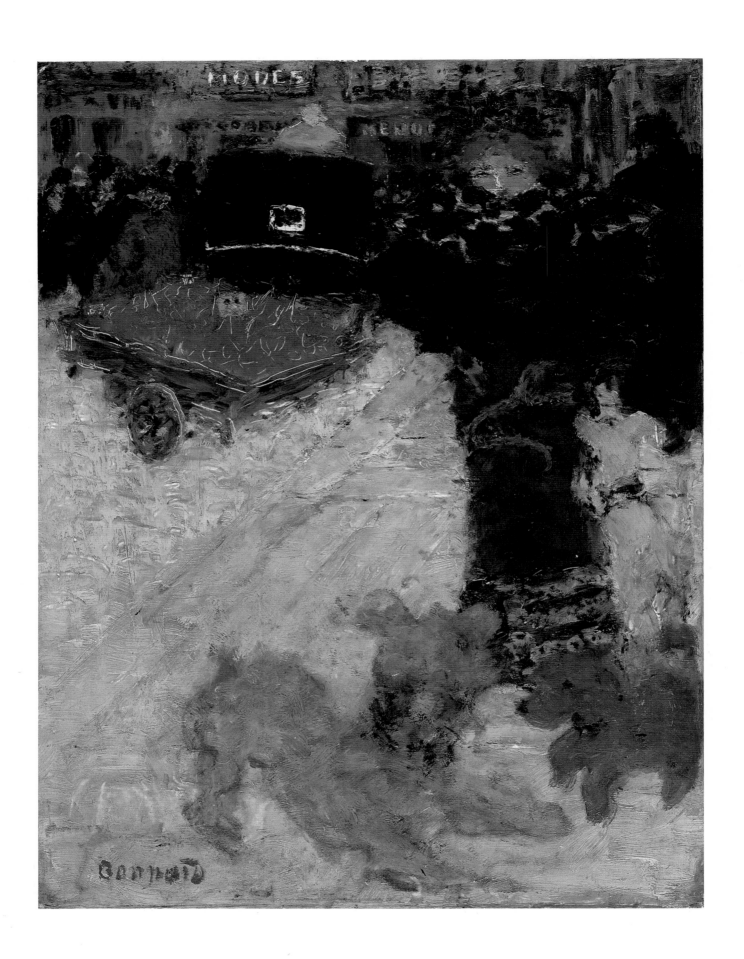

Pierre Bonnard

French, 1867–1947

STREET SCENE, PLACE CLICHY

about 1895
Oil on cardboard
13⅞ × 10⅝ in. (35.3 × 27 cm.)
Signed (bottom left): Bonnard

I N 1889, after he sold a design for a poster to the company France-Champagne for one hundred *francs*, Pierre Bonnard decided to become an artist. The sinuous lines of the poster drawing reflect the influence of Japanese wood-block prints, which Bonnard admired. The poster, a lithograph, subsequently intrigued Henri de Toulouse-Lautrec (1864–1901), who sought out Bonnard, and eventually became his friend.

The previous year, 1888, Bonnard had enrolled at the Académie Julian, a private art school where he learned to perfect his drawing and painting. It was at the academy that he

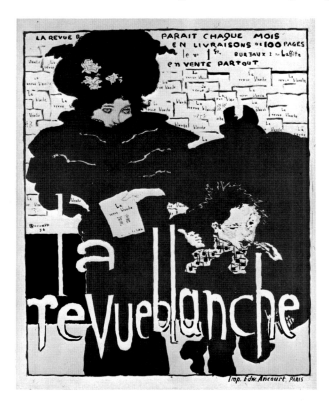

FIGURE 1. Pierre Bonnard. Poster for *La Revue Blanche*. 1894. Lithograph printed in 4 colors, 31½ × 24⅜ in. (80 × 62 cm.). The Metropolitan Museum of Art, New York, Purchase, Gift of Joy E. Feinberg of Berkeley, California, 1986, 1986.1081

met and became a close friend of Édouard Vuillard (1868–1940), Maurice Denis (1870–1943), Félix Vallotton (1865–1925), Paul Ranson (1864–1909), and Paul Sérusier (1863–1927)—all of whom banded together in 1888 to form a group that they called the "Nabis" (Hebrew for "Prophets"). Their anti-Impressionist, anti-Naturalist, and mystical leanings were inspired by Gauguin's belief that the artist should not copy nature but, instead—through simplification, vivid color, and arabesque lines— produce personal, poetic, and emotional interpretations of reality. Although the flat, decorative patterns in the works of Vuillard and Bonnard display a kinship with those of their Nabi colleagues—busily engaged designing posters, stage sets, theater programs, furniture, mosaics, and stained-glass windows—the two art-

ists remained aloof from the group's endless theoretical discussions. While the aim of the Nabis' art was to transcend daily life, Vuillard and Bonnard continued to be deeply rooted in it.

Bonnard, especially, saw poetry and humor in the ordinary incidents of Parisian street life. Between 1895 and 1900, he recorded his delight in this subject matter in an extensive series of small paintings and lithographs. He was attracted by the most inconspicuous things: a fleeting face in a crowd, shoulders hunched in cold weather, the silhouette of a waif-like woman crossing the street, or small children pattering off to school or weighed down by heavy baskets of laundry.

For the present painting, an elegant woman in black walking her fashionable dogs had caught the artist's fancy. At the time that Bonnard painted this picture, he was living and working at 65, rue de Douai, a stone's throw from the boulevard de Clichy, the large thoroughfare that joins the Place Clichy and the Place Pigalle in the 9th *arrondissement* of Paris.[1] Today, the neighborhood is still lively—full of shops, restaurants, cabarets, and dance halls, and known for its bustling night life.

As in the other works in this series, all small in scale, the forms are broad and general, and the artist's palette is reduced primarily to soft grays, beiges, and ochers, with highlights of black. The curvy, asymmetrical composition, and the unexpected foreshortenings derive from the examples of Gauguin as well as of Japanese prints. Bonnard gathers the figures and the action of the street—the shoppers, the storefronts, a carriage, and a pushcart vendor—at the top of the picture, leaving the foreground to the woman and her dogs: a gray whippet, a brown terrier, and a light-colored poodle. Her face nestled in the wide, white-trimmed collar of her black cape, the woman might have stepped out of Bonnard's 1894 poster for the magazine *La Revue Blanche* (see fig. 1). The artist composed a similar setting for *The Costermonger*, one of twelve color lithographs from his portfolio "Quelques Aspects de la Vie de Paris" (see fig. 2), published in 1899 by the art dealer Ambroise Vollard (1867–1939).

1. Most of the over fifty Parisian street scenes that Bonnard painted throughout his life depict the neighborhood around the boulevard de Clichy. Even after he moved to the south of France in 1925, Bonnard continued to keep a studio in this district.

FIGURE 2. Pierre Bonnard. *The Costermonger*, from the portfolio "Quelques Aspects de la Vie de Paris." 1899. Lithograph printed in 5 colors, 11⅜ × 13⅜ in. (29 × 34 cm.). The Metropolitan Museum of Art, New York, Harris Brisbane Dick Fund, 1928, 28.50.4 (6)

Édouard Vuillard

French, 1868–1940

CONVERSATION

about 1897–98
Oil on board
15⅝ × 19⅝ in. (39.6 × 50 cm.)
Stamped (bottom right): E. Vuillard

O F ALL HIS WORKS, Édouard Vuillard's small, poetic, dimly lit "intimiste" interior scenes dating from the 1890s are most coveted by collectors. The settings of many of these pictures are the various modest Parisian apartments that Vuillard shared with his sisters and his mother—a widowed dressmaker and his lifelong muse. He often depicted Mme Vuillard at work, in the company of her assistants, unrolling bolts of material, cutting, and sewing, amidst a profusion of subtly hued, patterned wallpapers, screens, curtains, tablecloths, and clothing. The artist's closest Nabi confrères, Pierre Bonnard (1867–1947) and Ker-Xavier Roussel (1867–1944), and his friend the theater enthusiast Aurélien Lugné-Poë (1869–1940), frequently stopped by the Vuillards' for a visit, and he painted them in the same interiors as they lingered after a meal.

Vuillard's second muse during the 1890s—he never married—was Misia Natanson (née Godebska; 1872–1950), the Polish wife of Thadée Natanson (1876–1951). Thadée, together with his two brothers, Alexandre and Alfred, had founded the art journal *La Revue Blanche* (1891–1903), which was devoted to the best in contemporary music, literature, and art. Misia, the daughter of a lesser-known sculptor and the granddaughter of a renowned cellist, was high-spirited, intelligent, witty, independent, and beautiful. Her talents as a pianist had impressed the aged Franz Liszt, as well as her teacher, Gabriel Fauré. In her apartment in the rue St-Florentin in Paris (which also was known as the "annexe" of the offices of *La Revue Blanche*), she entertained and charmed writers, poets, and painters. Henri de Toulouse-Lautrec, Pierre Bonnard, Pierre-Auguste Renoir, and Félix Vallotton all made paintings of Misia,[1] usually representing her listening to music or at the piano, in luxurious interiors to which her presence adds a languid sensuality. However, no artist painted Misia as often as Vuillard, either in her Parisian apartment, or—as here—at her country house. (After he designed a frontispiece for *La Revue Blanche* in 1894, Vuillard became an intimate of the Natansons.) By choosing a shaded grove surrounded by dark tree trunks as the setting, Vuillard gave this outdoor scene the look of an interior. Misia, at the right, wears a black dress with floppy sleeves and leans back dozing in her chair. The mysterious figure of a woman, hovering in the distance at the left and also in black, is a motif often found in the artist's interior views, seen either entering a room or peering through an open door.

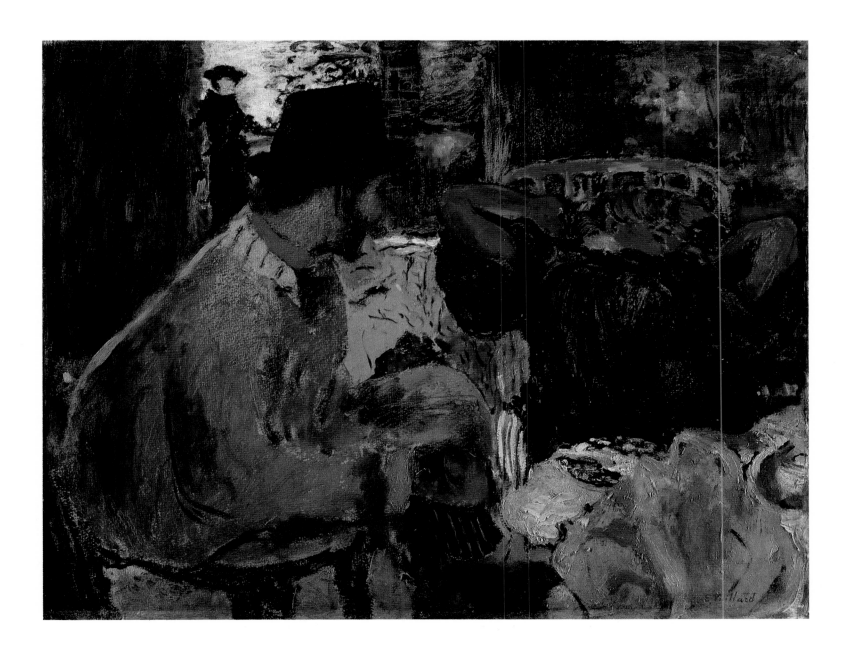

FIGURE I. Photograph taken at "Le Relais," in Villeneuve-sur-Yonne, France, after the funeral of Stéphane Mallarmé.
From left to right: Pierre Bonnard; Cipa Godebski and his wife, Ida; Thadée and Misia Natanson; and Pierre-Auguste Renoir
(Photograph: Alfred Natanson; Courtesy Annette Vaillant Archives, Paris)

Opinions differ as to the identities of the surroundings and of the man Misia is with. According to Claude Roger-Marx, who published the first monograph on Vuillard in 1946, the scene is set in Valvins, a small village near Fontainebleau where the Natansons had a country house, "La Grangette," until early in 1897. Roger-Marx suggested that the man was Misia's half-brother Cipa Godebski (1875–1937),[2] a musician, as his rotund body, full beard, and narrow-brimmed hat are familiar from several other paintings of him by Vuillard, some of which are portraits and others interior scenes in which he appears along with Misia. Cipa's red-and-black striped socks, and the blue-and-white plate on the table provide the only accents of color in a composition made up mostly of browns, beiges, grays, and greens. The conch-like shape in the right foreground is undoubtedly the hat worn by another woman seated across from Misia.

If, on the other hand, one is to believe Antoine Salomon, Vuillard's grandnephew and the compiler of his catalogue raisonné, this "conversation" takes place at "Le Relais," the large manor house in Villeneuve-sur-Yonne that the Natansons rented in the spring of 1897, and where Vuillard spent the summers of 1897–99 as their guest. According to Salomon, the man in the painting is Bonnard[3]—but, in fact, Bonnard was much slimmer and lankier than the person shown here seems to be.

Both Cipa Godebski and Bonnard were in Villeneuve in the autumn of 1898, as we know from a photograph of them with Cipa's wife, Ida, Thadée and Misia Natanson, and Renoir (see fig. 1), taken the day after Stéphane Mallarmé's (1842–1898) funeral in Valvins, where the poet had a country home. Mallarmé's sudden death had caught his friends by surprise, and many of them rushed to his funeral still wearing their everyday clothing. After the burial, Thadée Natanson invited everyone to Villeneuve. In the photograph, Misia's pose is the same as in Vuillard's picture, but she is wide-awake.

Vuillard might have painted this mournful little scene during the days following Mallarmé's death. The artist had greatly admired the poet. Numerous elements in his paintings—either suggested or veiled, rather than clearly defined—have been compared to Mallarmé's hermetic, Symbolist poetry. This might explain why Vuillard made three versions of this rather dark and somewhat gloomy composition—all of which still remained in his studio at the time of his death.

1. The information about Misia and her circle is taken from Arthur Gold and Robert Fizdale, *Misia: The Life of Misia Sert*, New York, 1980.

2. Claude Roger-Marx, *Vuillard: His Life and Work*, translated by Edmund B. d'Auvergne, London, 1946, p. 61.

3. Letters to the author of February 9 and March 2, 1989.

Pablo Picasso

Spanish, 1881–1973

GIRL IN PROFILE

1901
Oil on cardboard, mounted on Masonite
20⅝ × 13½ in. (52.5 × 34.3 cm.)
*Signed (lower left): –*Picasso

P ABLO PICASSO's second stay in Paris lasted from May 1901 until January 1902.[1] He shared a two-room attic apartment at 130, boulevard de Clichy, with Pedro Mañach, a slightly older Catalan factory owner and art dealer who had taken a fancy to Picasso's work and who, in exchange for paintings, had helped to support him since the artist's first visit to Paris the previous year. Picasso occupied the larger of the two rooms—the former studio of his friend Carlos Casagemas, who had shot himself in February over an unhappy love affair.

In June 1901, at the instigation of Mañach, Ambroise Vollard mounted the first exhibition of Picasso's work at his Paris gallery. The show comprised more than sixty pictures that had been painted both in Spain and in France, and reflected the influence of the painters that Picasso had studied in Paris—among them Degas, Vuillard, van Gogh, Toulouse-Lautrec, and Eugène Carrière. The works were executed with a rich palette in a style that ranged from the impressionistic to one employing flat, decorative patterns. We cannot know if the present small picture was among those on exhibition—the catalogue's checklist is too general—but stylistically and in terms of its content it belongs to the group of works shown by Vollard.

A woman's face—she might have come from a Toulouse-Lautrec poster—is set against "clouds" composed of brilliantly colored yellow and white brushstrokes, offset by an area, at the upper left, of patches of green and black. The mottled brushwork gives the effect of sparkling electric light, a novelty at that time. As the related watercolor entitled *Au Moulin Rouge* of 1901 (Zervos VI, 351; Daix, V. 36) indicates, these "feathery" passages form part of the girl's attire: a fur, or feather, collar, and one of those awe-inspiring hats, then in fashion, topped with a huge red pompon. One wonders who she might have been, seen thus, in a quick glimpse, in the glittering night. Her heavy makeup, red, pouty lips, and coarse profile all suggest that she was a nighttime habituée of Montmartre.

Picasso traded this painting for a work by Ignacio Zuloaga (1870–1945), whose paintings of Spanish dancers and bullfighters were enormously popular. Zuloaga's son, Antonio, kept the work until it was acquired for the Gelman collection in 1952.

1. Biographical information in this and in all subsequent entries about Picasso has been taken from the exemplary chronology of the artist's life estab- lished by Jane Fluegel in *Pablo Picasso: A Retrospective* (exhib. cat.), edited by William Rubin, New York, The Museum of Modern Art, 1980.

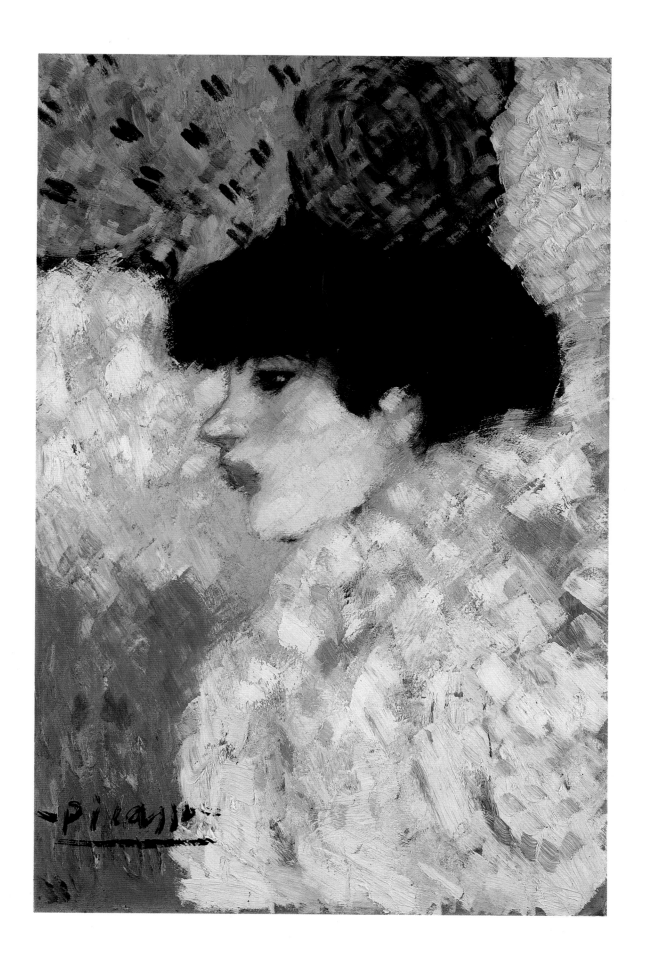

The Fauve Painters
1905–1908

Henri Matisse

French, 1869–1954

STILL LIFE WITH VEGETABLES

1905–6
Oil on canvas
15⅛ × 18⅛ in. (38.5 × 46 cm.)
Signed (bottom left): Henri-Matisse

MATISSE and Derain first introduced unnaturalistic color and bold brushstrokes into their paintings in the summer of 1905, as they worked together in the small fishing port of Collioure on the Mediterranean coast. When these pictures were exhibited later that year at the Salon d'Automne in Paris, they inspired the witty critic Louis Vauxcelles to call them "fauves" ("wild beasts"), in his review for the magazine *Gil Blas*. This term was later applied to the artists themselves.

Until the summer of 1905, Matisse had worked in a variety of styles. However, these must be regarded merely as "preparatory" to the radical new way of painting he and Derain had initiated. For Matisse, who was very methodical, this "preparatory" period had been lengthy. Gradually, his early dark interiors and still lifes evolved into more light-filled paintings in pure color—especially when he worked out of doors, first in Brittany (1896 and 1897) and later in Corsica (1898). While in Brittany, he learned of the art of the Impressionists and of van Gogh from the English painter John Russell (1858–1931), and back in Paris he received sound advice from the aged Camille Pissarro. Yet, it was the paintings of Cézanne, with their simplified structure, in which spatial relationships were expressed through color alone, that proved most decisive for Matisse. The influence of Cézanne's works is most apparent in Matisse's starkly rendered studies after the nude, painted in 1900; characterized by combinations of greens, pinks, blues, and purples, they presage what came to be known as "Fauve" color. Equally important to Matisse's development was the summer of 1904, which he spent in the company of the Neo-Impressionist painters Henri-Édmond Cross and Paul Signac at the latter's villa in Saint-Tropez. Upon Matisse's return to Paris that fall—as a consequence of discussions with the two painters and probably with their encouragement—Matisse adopted their method of composing a picture with pure, high-keyed dots of color. Although he soon tired of the fussiness of the Pointillist technique, it taught him how to structure a composition and indicate space by means of contrasting planes of color.

While working in Collioure during the summer of 1905, Matisse met the painter Georges-Daniel de Monfreid, who had been a friend of Gauguin and served as executor of the latter's estate. At Monfreid's nearby country home in Corneilla-de-Conflent, Matisse saw Gauguin's late paintings firsthand, and he was especially responsive to their brilliant

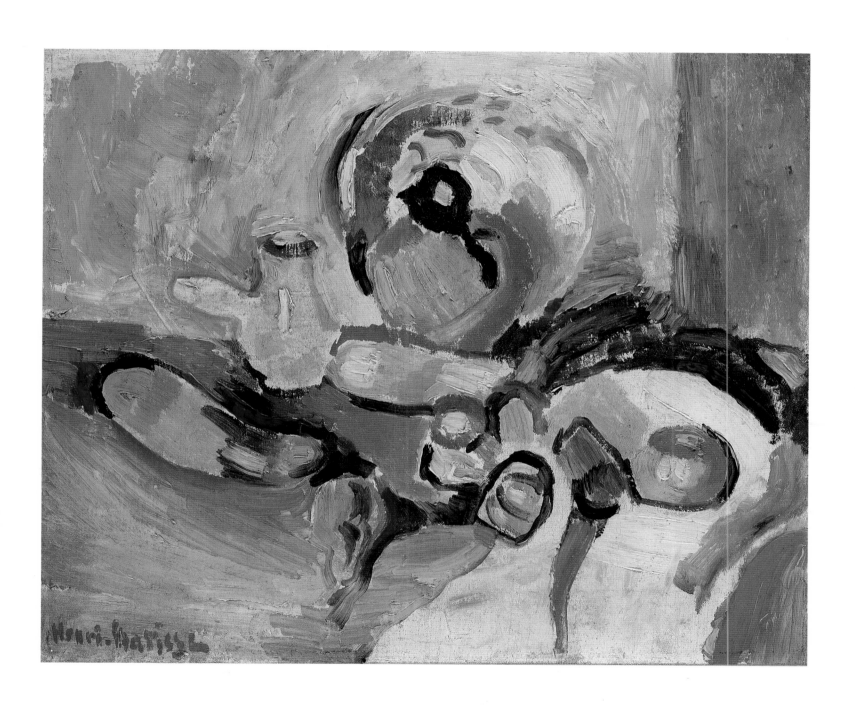

hues and flat decorative patterns. At the outset of his stay in Collioure, Matisse was still combining in a single painting Neo-Impressionist blocks of color and daubs and squiggles of pigment applied with variously sized brushstrokes, but at the close of 1905 and early in the following year he began to construct his pictures with flatter areas of color. It would appear that Matisse painted this still life during that period, sometime between late 1905 and the beginning of 1906.

Dominated by complementary reddish and greenish hues, this composition nevertheless still evokes the art of Cézanne. With rhythmic brushstrokes, Matisse rendered space and objects alike in flat color planes, depicting what he saw around him. The green, white, and blue plate, the round red pitcher, and the yellow coffeepot are typical of the pottery produced in the south of France. Similarly, the vegetables look as if they had just tumbled out of Matisse's shopping basket after a trip to the local market. There are zucchini, red and green peppers, tomatoes, an onion, and a carrot. Or is it a chili?

Maurice de Vlaminck

French, 1876–1958

THE SEINE AT CHATOU

1906

Oil on canvas

32½ × 40⅛ in. (82.5 × 102 cm.)

Signed (lower left): <u>Vlaminck</u>

C HATOU, now a suburb of Paris, in Maurice de Vlaminck's time was a small village situated to the west, along the Seine. Opposite it lies the Île de Chatou, a long, narrow stretch of land in the center of the river. The scene shown here appears to have been observed from a point on the island facing the village of Chatou, with its red-roofed houses, on the mainland, across one arm of the Seine. Turn-of-the-century photographs give the approximate view depicted by Vlaminck (fig. 1), as well as the location on the island from where he composed the painting (fig. 2).[1]

Vlaminck was born in Paris to a Flemish father and a French mother, both of them musicians who were virtually impoverished. At the age of sixteen, he left home and moved to Chatou. A boisterous and physically large man, Vlaminck supported his wife and two children by working as a professional cyclist and as an itinerant violinist in the bars and restaurants of Montmartre. Vlaminck met Derain in June 1900, and they immediately became friends. The following year they shared a studio on the Île de Chatou, in what had been the Restaurant Levaneur, next door to the celebrated Café Fournaise, known to Flaubert and de Maupassant, and immortalized in Renoir's famous painting *The Luncheon of the Boating Party* (1881).[2] Later in 1901, Vlaminck moved to Rueil, across the Seine, but he continued to paint in Chatou—alone, or in the company of his friend Derain when the latter was on leave from the army (he served from 1901 to 1904). Together, the two artists formed what has been called the "School of Chatou," and their painting style—characterized by bright colors and bold brushstrokes—became a harbinger of Fauvism.

The self-taught Vlaminck embraced painting with the same unbridled passion as he did life itself, spontaneously choosing the most straightforward forms and basic hues to express his feelings: "I try to paint with my heart and my guts without worrying about style."[3] The work of van Gogh exerted the greatest influence upon him. As he often remembered, the van Gogh retrospective at the Galerie Bernheim-Jeune in Paris in 1901 had overwhelmed him. However, as John Elderfield has pointed out, it was actually only after the second large retrospective exhibition of van Gogh's work at the Salon des Indépendants in the spring of 1905, and after Vlaminck had seen the Fauve paintings Matisse and Derain produced during the summer of 1905 in Collioure, that he followed the example of the three artists, and took the final step toward embracing the Fauve style.[4]

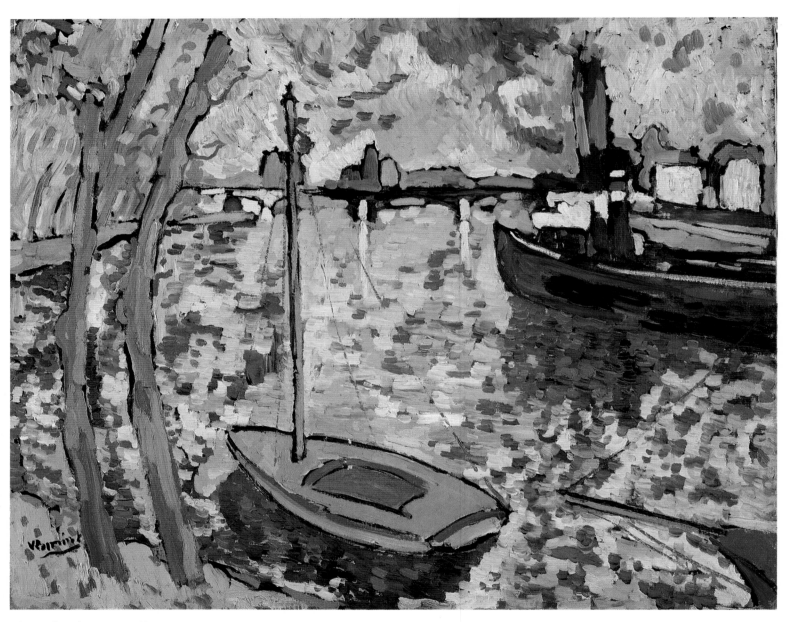

Vlaminck. *The Seine at Chatou*

After Ambroise Vollard purchased Vlaminck's existing stock of paintings and his future output early in 1906, the artist was able to devote himself fully to painting, and his work became more lighthearted and exuberant. He spent the summer of 1906 in and around Chatou, painting pictures such as this one, in which he emulated the undisguised brushwork and intuitive application of paint of van Gogh's late, expressive style, which he so admired. Combining the primary colors of blue and red with white, Vlaminck applied them directly from the tube in daubs and swirls of pigment, employing these conventional hues, here, for the white houses, green leaves, reddish-orange tree trunks, and the blue, red, and white trawler in the background.

1. John Klein of the Yale University Art Gallery, New Haven, has shared with me his knowledge of the specific sites in Chatou favored by Vlaminck.

2. John Golding, "Fauvism and the School of Chatou: Post-Impressionism in Crisis," *Proceedings of The British Academy* LXVI (1980), p. 86.

3. Marcel Giry, *Fauvism: Origins and Development*, translated by Helga Harrison, New York, 1981, p. 132.

4. John Elderfield, *The "Wild Beasts": Fauvism and Its Affinities*, New York, 1976, p. 30.

FIGURE 1. View from the Île de Chatou, down the Seine, with the village of Chatou at the right. About 1900 (Courtesy John Klein, Yale University Art Gallery, New Haven)

FIGURE 2. The location on the Île de Chatou from which Vlaminck painted *The Seine at Chatou*. The Café Fournaise is at the far right. About 1900 (Courtesy Roger-Viollet, Paris)

Maurice de Vlaminck

French, 1876–1958

ANDRÉ DERAIN

1906
Oil on cardboard
10⅝ × 8¾ in. (27 × 22.2 cm.)
Signed (bottom left): <u>Vlaminck</u>

VLAMINCK was a "natural" Fauve, whose use of highly intense color corresponded to his own exuberant nature. His restless assertiveness expressed itself in a rough contempt for education, academies, and museums, an attitude that contrasted sharply with the sophistication of his friend André Derain, who was well schooled and widely read. In 1898, Derain attended studio classes supervised by the painter Eugène Carrière, where he met Matisse, and also studied the Old Masters in the Louvre. In 1904, after completing his military service, Derain continued his studies at the Académie Julian in Paris. The many letters written to Vlaminck, during Derain's military service (1901–4) and after, reveal a careful thinker—again, in marked contrast to Vlaminck, whose claims, in his various autobiographies, must always be taken with a grain of salt. (For example, Vlaminck always boasted of having been the leader of the Fauves.) It is difficult to follow the exact development of Vlaminck's Fauve style. He did not date most of his canvases, but when he did assign one to a picture, he often made it appear to predate the work's actual execution. No critical study or catalogue raisonné exists on either the man or his work.

This portrait of Derain has usually been assigned to 1905, no doubt because of the presumably reciprocal portrait that Derain painted of Vlaminck that same year. With vibrating and boldly "smeared-on" brushstrokes of relatively subdued color—except for the strident pink face and orange hair and moustache—Derain had depicted his friend wearing a bowler hat. It seems doubtful, however, that in 1905 Vlaminck would have responded with a portrait that was more daring in color than Derain's, especially as the paintings he exhibited at the Salon des Indépendants early in 1906 are characterized by heightened local color, instead of by the daringly juxtaposed hues of this work. This would suggest a date later in 1906 for the present painting. In addition, not until 1906 did the artist sign his works simply "Vlaminck"—underlining his name, as he did here.[1]

The head of Derain, shown life size and in extreme close-up, is more vivid than any photograph could be. There is no indication of surrounding space. Vlaminck boldly

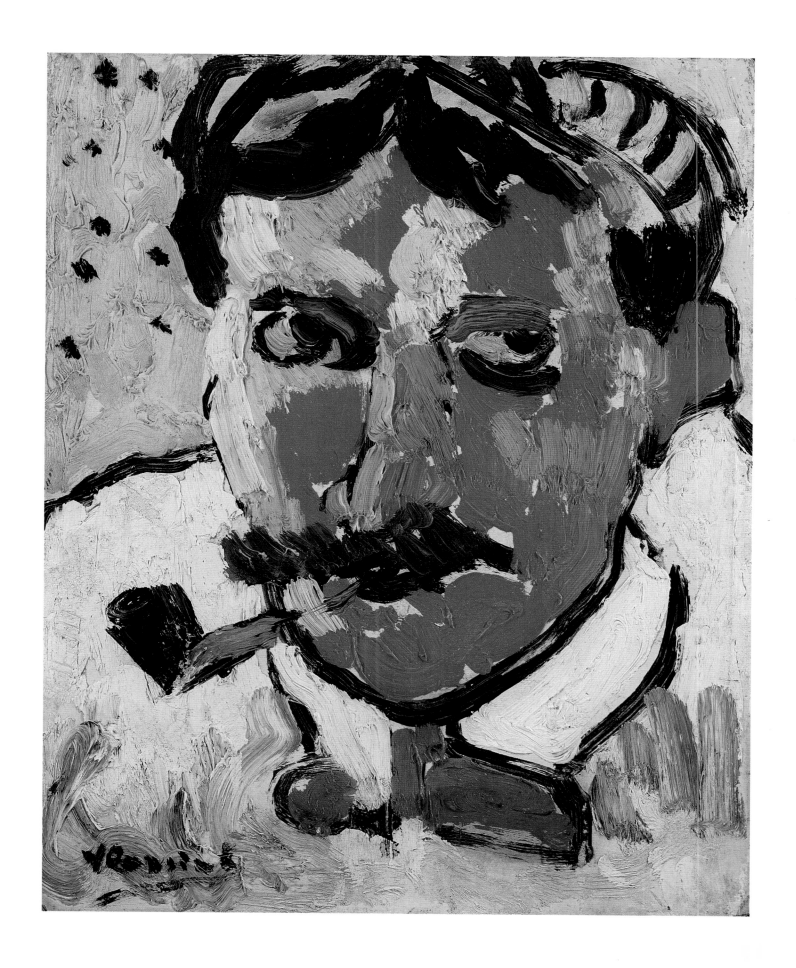

outlined in black the contours of the head, hair, shoulders, and collar. Then he painted the face red, highlighting rather than modeling the facial features with strokes of vivid chrome yellow and by a daring patch of green on the nose. Both eyes have blue lids, and the blue moustache spirals out to the left. The picture brings to mind van Gogh's self-portrait *The Painter with a Pipe* (1889), which Vlaminck saw on view at the Salon des Indépendants in 1905 in the second large retrospective devoted to that master's work.

Derain kept this portrait until his death in 1954.

1. Marcel Giry, *Fauvism: Origins and Development*, translated by Helga Harrison, New York, 1981, p. 80.

André Derain

French, 1880–1954

REGENT STREET, LONDON

1906
Oil on canvas
26 × 39 in. (66 × 99.2 cm.)
Signed and dated (bottom right): De<u>rain</u>/*1906*

ANDRÉ DERAIN would have taken his life in his hands if he had ever set up his easel in the midst of the double-decker omnibuses, the carriages and hansom cabs—all harnessed to galloping horses—and the bicyclists, sandwich men, and shoppers on Regent Street, one of London's finest and busiest commercial thoroughfares.

The art dealer Ambroise Vollard had been the impetus behind Derain's trip to London in March 1906. The commission came in response to the exhibition of Monet's views of London, painted between 1899 and 1901, which took place at the Galerie Durand-Ruel in Paris in 1904. These late works by Monet reveal his fascination with the London fog, and represent three basic views of the Thames, seen under constantly changing light and weather. Vollard had decided that he wanted London depicted by a "contemporary painter"—a Fauve. Thus, Derain's visit to London the previous autumn (1905), at which time he painted several views of the city, was most probably a "scouting trip" for his future assignment.

The Fauve painters, whose spontaneous responses to nature were often subjective, synthesized elements of Impressionism and Neo-Impressionism with the decorative patterns of Gauguin and the expressionist style of van Gogh. As an artist, Derain occupied a place midway between the impetuous Vlaminck and the more controlled Matisse. He worked with Vlaminck in Chatou, near Paris, intermittently from 1900 on, and he spent the summer of 1905 with Matisse in the Mediterranean port of Collioure, where their previous experiments with color culminated in the pictures that, when they were later exhibited, would come to be called "Fauve."

Among Derain's fifteen or so scenes of London, the most striking are those of the Thames, in which he gave free rein to color, inventing red boats and painting the water green and yellow and the sky orange.[1] In this view of Regent Street near Oxford Circle, his palette is more restrained, consisting primarily of subdued blues and strategically placed scarlets. The contemporary photograph of Regent Street seen in figure 1 shows that Derain did not exaggerate. The street and the sidewalks were jammed, the population of the city

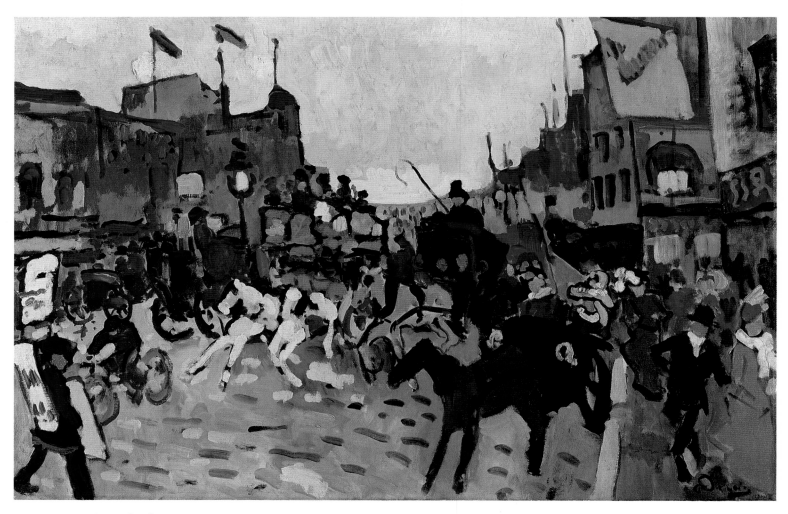

Derain. *Regent Street, London*

having reached nearly four-hundred thousand at that time. In one respect, however, Derain romanticized London. He deliberately avoided showing any of the motorcars that, in use from 1886, had begun to dominate the city's streets and boulevards.

1. In a letter of November 24, 1988, Michel Kellermann, in Paris, who is preparing the catalogue raisonné of Derain's work, supplied information on the number of views of London painted by the artist.

FIGURE 1. Regent Street, London. About 1910 (Courtesy Roger-Viollet, Paris)

Henri Matisse

French, 1869–1954

SEATED NUDE ASLEEP

1906
Brush and black ink, over pencil, on paper
18¼ × 14⅞ in. (46.5 × 37.7 cm.)
Signed (at bottom): hm

IN 1907, a friend of Henri Matisse criticized what he saw as ". . . willful deformations, a bit too premeditated," in the woodcut for which this drawing served as the model. This critic went on to complain that it required "great effort to look at it seriously, attentively, respectfully."[1] Today, the image seems to have lost little of its original impact.

This fine example of a Fauve ink drawing is the largest of a group of three made in preparation for the artist's three known woodcuts.[2] Each drawing depicts a nude model in a different position on a chair. The three woodcuts were shown in Paris at the large retrospective exhibition of Matisse's work at the Galerie Druet in March 1906 and at the Salon des Indépendants in 1907. A fourth, much larger drawing of a standing nude probably formed part of this group, but was never adapted to a woodcut.[3]

In this work, Matisse aimed at simplification while also creating a decorative pattern composed of variously sized brushstrokes, dots, daubs, and wavy and straight parallel lines. In contrast, the woman's somewhat distorted body, rendered with the brush in a thick, nearly continuous line, remains starkly white and unadorned. Her crouching posture displays a certain symmetry: the incongruous bulge of her stomach is echoed by her breast, the points of her two elbows are paralleled by those of her knees, and the curve of her shoulder blade corresponds to that of her right buttock. The strong decorative elements found in these ink drawings are characteristic of the woodcuts by Paul Gauguin and Félix Vallotton, as well as of van Gogh's drawings. As Jack Flam has noted, about 1900 Matisse purchased an ink drawing of a peasant by van Gogh known as the *Portrait of Patience Escalier* (1888), which contains similar bold linear accents in the background.[4]

Although the woodcut based on this drawing was described in the catalogue of the 1907 Salon des Indépendants as a "gravure sur bois," for many years it was erroneously referred to as a linocut in much of the Matisse literature. Only when the original wood block was rediscovered in the 1960s was the error corrected. Recent examination of the block (Victoria and Albert Museum, London) has established that the drawing and its replication on wood match to a hairline.[5] This suggests that the method of transfer from paper to wood was possibly a photographic process, which was devised by Auguste Clot, the printer who executed many of the fine albums of lithographs by the Nabis. Such a transfer technique would also explain the absence of any kind of abrasures or tiny holes—such as pinpricks—in

the drawing, the usual damage that results from a manual transfer process. The pencil marks visible, here, under the ink lines do not relate to the transfer, but are rather the remains of the artist's preliminary sketch.

After the printing of the woodcut in an edition of fifty early in 1906 this drawing disappeared. It was believed lost, until the heirs of Auguste Clot sold it in 1979.[6]

1. Cited in Alfred H. Barr, Jr., *Matisse: His Art and His Public*, New York, 1951, p. 99.

2. Actually, a fourth, little-known woodcut—in two artist's proofs—exists and is entitled *Le Luxe*, 1907. See Marguérite Duthuit-Matisse and Claude Duthuit, *Henri Matisse: Catalogue raisonné de l'oeuvre gravé établi avec la collaboration de Françoise Garnaud*, vol. 1, Paris, 1983, no. 320, ill. p. 251.

3. This drawing is now in a private collection. See John Elderfield, *The Drawings of Henri Matisse*, introduction by John Golding, catalogue by Magdalena Dabrowski, New York, The Museum of Modern Art, 1984, cat. no. 17, ill.

4. Jack Flam, *Matisse: The Man and His Art (1869–1918)*, Ithaca, N.Y., and London, 1986, p. 151, ill. p. 154.

5. Betty Fiske, assistant conservator at The Metropolitan Museum of Art, examined Matisse's wood block in the Victoria and Albert Museum, London, and suggested that a photographic transfer process probably was employed.

6. Conversation with Wanda de Guébriant in Paris, June 3, 1988.

Henri Matisse

French, 1869–1954

STUDY FOR THE YOUNG SAILOR I

Collioure, 1906
Pencil on paper
8¾ × 7¼ in. (22.3 × 18.3 cm.)
Stamped (bottom left): HM.

THIS DRAWING is one of two extant small pencil studies (see fig. 1, page 90) of a young fisherman that Henri Matisse made in preparation for the paintings of 1906 entitled *The Young Sailor I* (see fig. 1) and *The Young Sailor II* (see page 88).

In this spontaneous, quick sketch, Matisse seems to have worked out the overall composition of the figure. If he has placed the sailor too far to the left— the right arm is partly cut off—he later adjusted the position of the figure in the two finished paintings of the same subject.

The present drawing undoubtedly served as the basis for the more realistically rendered *Young Sailor I* rather than for the stylized, second painted version derived from it.

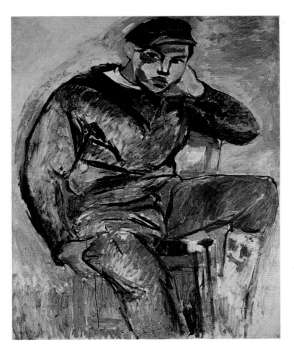

FIGURE 1. Henri Matisse. *The Young Sailor I*. Oil on canvas, 39 × 29¾ in. (99 × 75.7 cm.). Private collection

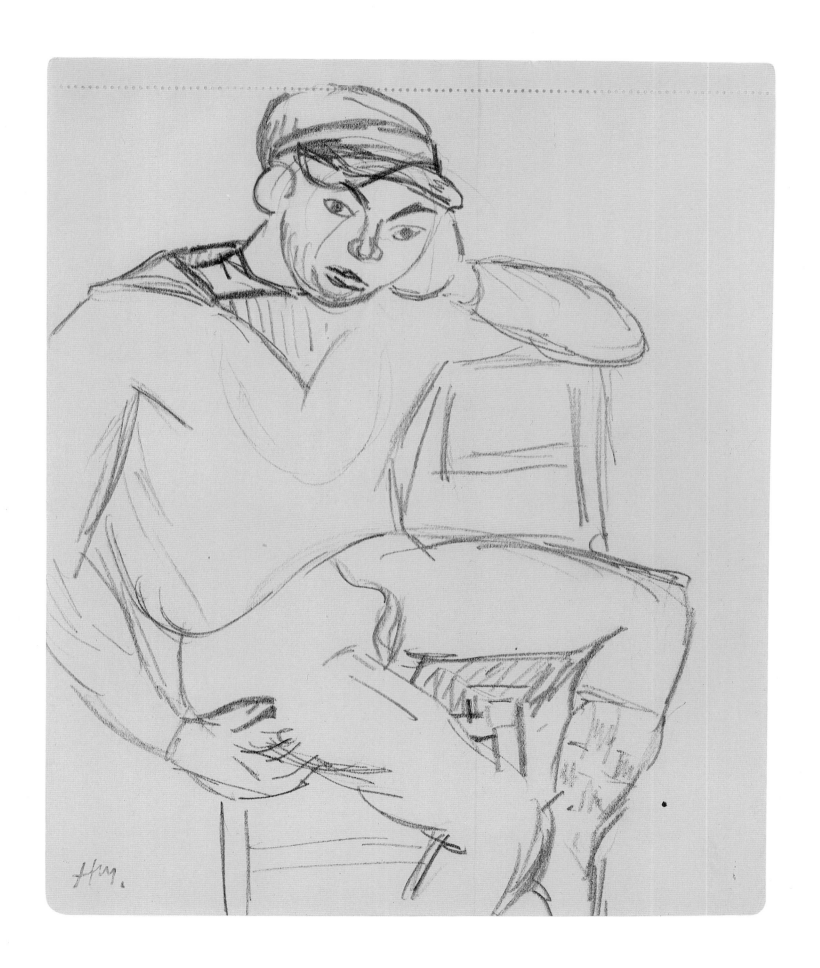

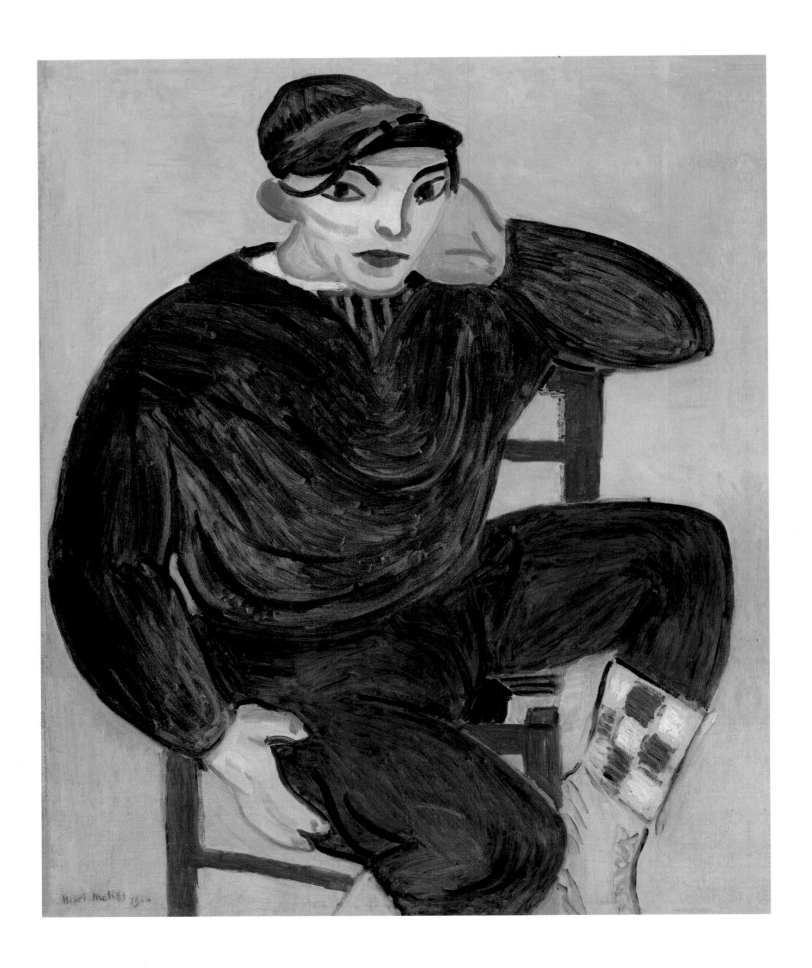

Henri Matisse

French, 1869–1954

THE YOUNG SAILOR II

1906
Oil on canvas
40 × 32¾ in. (101.5 × 83 cm.)
Signed and dated (bottom left): Henri-Matisse/*1906*

FOR THE LAST eighty-three years, the identity of the figure depicted in the two versions of *The Young Sailor* was unknown. Recent research has established that the sitter was an eighteen-year-old fisherman named Germain Augustin Barthélémy Montargès (1888–1938).[1]

Germain was one of about nine hundred fishermen who lived in the small Mediterranean fishing village of Collioure, near the Spanish border, at the turn of the century. These men took their boats out at night and, with the aid of lanterns, fished for anchovies and sardines. Today, only four fishermen are left in Collioure. Large boats with modern equipment now operate from other ports.

Since Germain was six-feet tall and of athletic build—which is unusual for Catalans—it is not surprising that he might have caught Matisse's eye during one of the painter's early-morning strolls along the pier in Collioure's harbor. (From 1905 on, Matisse liked to spend the summer months—and sometimes even the winter—in Collioure, which he continued to do, intermittently, until about 1914.) Another characteristic that made Germain stand out in a crowd was his Slavic features. These are shared by the Montargès family, as is apparent in a 1988 photograph of Germain's son Paul (1928–1989; see fig. 2, page 91), and are still referred to, by the people in Collioure, as "cet air primitif" ("that primitive look").[2] Paul, who had followed in his father's footsteps and become an anchovy fisherman, but later worked in a wholesale fish factory, had recently retired. When in June 1988 he was shown a photograph of Matisse's 1906 drawing of his father (see fig. 1, page 90), who died when Paul was only ten years old, he thought he recognized his dead brother, also named Germain (1911–1976). Incidentally, Paul had never heard of Matisse.

Here, Germain wears typical fisherman's garb: a navy blue cap and pullover, over a white undershirt and a blue-and-pink striped jersey, baggy green pants, green-and-white checked socks, and sturdy, laced-up shoes with rubber soles. In the first version of *The Young Sailor* (see fig. 1, page 86)—quite plausibly painted by Matisse in a single sitting—figure and ground are rendered with freely applied brushstrokes in all the colors of the rainbow.

However, in the second version, the contours have been sharpened, forms are more defined, and the colors have been reduced to large, mostly flat areas of bright green, blue, and pink—a decorative style and a palette adopted by Matisse from this point on. In this later version, Matisse changed the expression and the mood of the sailor drastically. His stylizing brush wiped off the earlier round-cheeked youthfulness of Germain's face, replacing it with a mask-like expression of savvy cunning from which a touch of licentiousness seems not absent. Germain's rather theatrical looks and his colorful costume, set against the pink, candy-colored ground, combine to make this work one of Matisse's most decorative portraits in the Fauve manner.

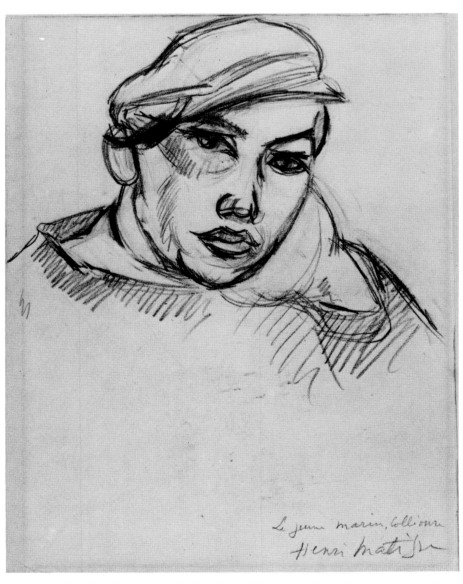

FIGURE I. Henri Matisse. Study for *The Young Sailor I*. 1906. Pencil on paper, 10 × 7¼ in. (25.4 × 18.4 cm.). Art Gallery of Ontario, Toronto, Gift of Sam and Ayala Zacks, 1970

Germain married in 1910, and became the father of six girls and two boys. A sometime stoker on a large ship, he would go on long trips to faraway places.

1. It has sometimes been suggested that the model for the sailor was Matisse's son, Pierre. However, the latter was only six years old at the time that the *Young Sailor* was painted. Pierre Matisse, in conversation on May 25, 1988, in New York, said that the model was an unknown sardine fisherman from Collioure who had posed for his father for about one day. His information prompted my "on-the-spot" research. Also helpful were Jean Pascot, the mayor of Collioure; Abbé E. Cortade of Pézilla la Rivière; and Jacqueline Maspharner-Veisse of Collioure.

2. Jean Pascot, Collioure, June 13, 1988.

FIGURE 2. Paul Montargès, the son of the sitter for Matisse's paintings *Young Sailor I* and *Young Sailor II* (both 1906). Collioure, France. June 1988 (Photograph: Sabine Rewald)

Henri Matisse

French, 1869–1954

VIEW OF COLLIOURE

1907–8
Oil on canvas
36¼ × 25⅞ in. (92 × 65.5 cm.)
Signed (bottom right): Henri Matisse

BETWEEN 1905 and 1914, Matisse spent various summers and one winter in the small fishing village of Collioure on the Mediterranean coast. It is not far from the Spanish border, and only a short automobile ride away from the town of Céret, further inland in the mountains, which was the favorite summer retreat of the Cubists from about 1911 on. During Matisse's first summer in Collioure, his family initially lived in a small pension, "La Mère Rosette," on the Avenue de la Gare (today, Avenue Maillol).[1] Derain also stayed at the pension when he came to join Matisse, and painted a large shop sign of a harlequin at the owner's request.[2] Later in the summer, Matisse moved into an apartment facing the harbor, from which he painted various window views, among them the famous *Open Window, Collioure* (1905). Then, from about 1906 until 1914, the artist rented the upper floor of a small house complete with a studio and skylight next door to "La Mère Rosette." From there it was only a seven-minute walk to the picturesque site above the rock

FIGURE 1. The approximate site from which Henri Matisse painted the *View of Collioure*. June 1988 (Photograph: Sabine Rewald)

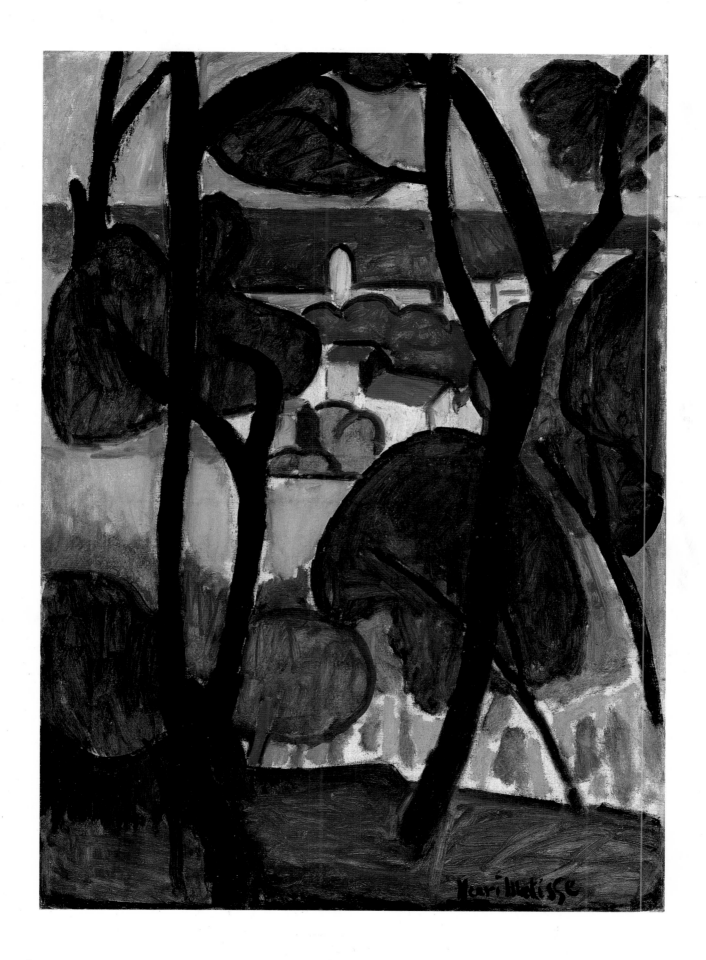

called the "Roca-Alta d'en Beille" (Catalan for "High Rock"), where Matisse often went to paint views of Collioure, such as this one.[3] The rock is located among the few remaining cork oaks and umbrella pines of what was then known as the "Bois d'Ambeille," which covered a low hill just outside Collioure. Today, this hill is dotted with single-family houses. (Standing above the "Roca-Alta" now is the villa of the local pharmacist from whose terrace, in June 1988, the photograph of Collioure shown in figure 1 was taken.)

By 1907–8, the suggested date for this painting, Matisse had developed the flat and decorative style that he had employed for the first time in 1906 in the second version of *The*

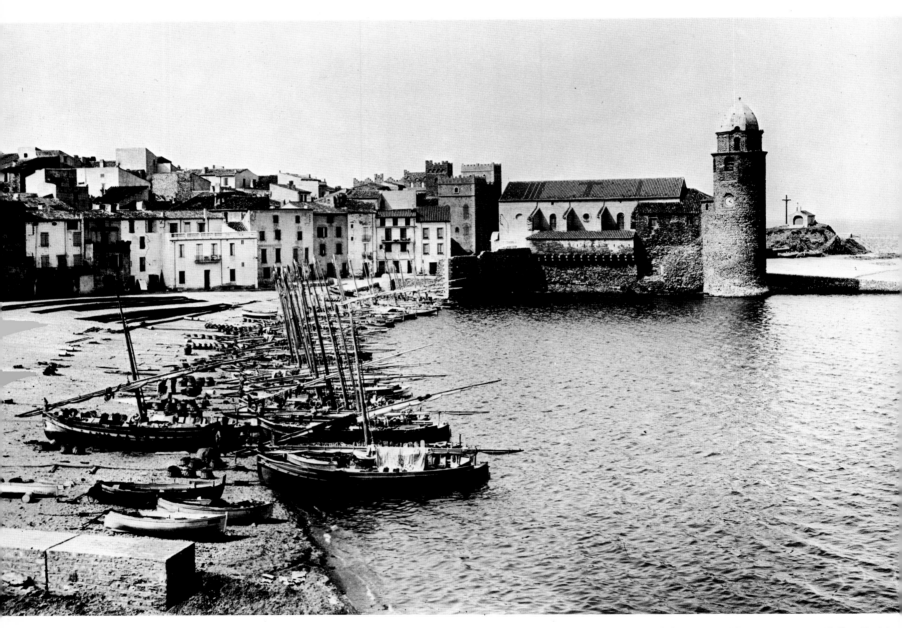

FIGURE 2. The harbor of Collioure, France, with the church of Notre-Dame-des-Anges, at the turn of the century (Courtesy Roger-Viollet, Paris)

Young Sailor (see page 89). The sinuous black lines of the trunks and branches of the stylized umbrella pines encircle flat areas of greens, blues, mauves, and earth tones, evoking an Art Nouveau stained-glass window. (Not surprisingly, the Matisse family referred to this painting as *Le Vitrail*, and it is often listed as such in early exhibition catalogues.)[4] Through the foliage is a distant view of several red-roofed houses, the tower of Collioure's church, and a horizontal band marking the division between the pink sky and deep-blue sea. (The thirteenth-century tower was built on a promontory that juts into the sea. It originally served as one of two lighthouses that protected the harbor until, at the end of the seventeenth century, it was joined to the church of Notre-Dame-des-Anges, which was erected next to it [see fig. 2].)

The exact date of this painting has long puzzled critics. The Matisse archive in Paris, currently preparing the catalogue raisonné of the painter's work, assigns the *View of Collioure* to 1907.[5] Other scholars on stylistic grounds have proposed the year 1908, but they were ignorant of the precise dates of Matisse's sojourns in Collioure, which have only recently become known. As Matisse was not in Collioure in 1908—he worked there only during the years 1905 to 1907, 1911, and 1914—it has also been suggested that the picture was painted in 1908 from memory.[6] It is also possible that it dates from the winter of 1907–8, when Matisse's impressions of the summer spent in Collioure were still fresh.

1. Conversations with Pierre Matisse, New York, May 25, 1988, and April 25, 1989.

2. Conversations with Jean Pascot, Collioure, June 1988. This painting was later detached from its wooden panel, and sold to the art dealer Jos Hessel in Paris. Its present whereabouts are unknown.

3. I am grateful to Jacqueline Maspharner-Veisse of Collioure—the niece of Marie Astiée, from whom Matisse rented the house on the Avenue de la Gare—who, in June 1988, took me to the place from which Matisse painted this view of Collioure.

4. Jack Flam, *Matisse: The Man and His Art 1869–1918*, Ithaca, N.Y., and London, 1986, p. 234.

5. Conversation with Wanda de Guébriant, Paris, June 3, 1988.

6. Flam, ibid., n. 45, pp. 493–94.

The Cubist Painters
1906–1913

Pablo Picasso

Spanish, 1881–1973

SELF-PORTRAIT

Paris, Autumn 1906
Oil on canvas board
10½ × 7¾ in. (26.6 × 19.7 cm.)

PABLO PICASSO and his companion at the time, Fernande Olivier (1881–1966), spent the summer of 1906 in Gosol, a mountain village high in the Spanish Pyrenees close to the Andorran border. Gosol was so remote then that it could be reached only by mule, and even today there is no bus linking it with the outside world.

As Fernande wrote, in her 1933 book, Picasso always felt rejuvenated by visits to his native Spain. He would become "serene," "healthier," and "happier."[1] The artist painted this small sketch after he returned to Paris from Gosol in the autumn of 1906, along with several other self-portraits to which it is closely related. The most famous of these is the *Self-Portrait with Palette* of 1906 in the Philadelphia Museum of Art.

Here, the twenty-five-year-old Picasso depicted himself as younger than in any of his earlier self-portraits, in which poverty and hunger often seem to have aged him. If, in this picture, he looks like a painted terra-cotta sculpture without any furrows or wrinkles, it is because he gave himself the stylized features of the archaic Iberian stone reliefs and bronze figures (600–200 B.C.) that he saw, in the spring of 1906, on exhibition at the Musée du Louvre. Picasso had been very impressed by this important group of Iberian reliefs, recently excavated at Osuna in southern Spain.

An Iberian influence first appears in the work dating from the end of Picasso's stay in Gosol, and figures prominently in the paintings that he completed upon his return to Paris in the autumn of 1906. It was at this time that he also finally finished the painting of his friend the American writer and collector Gertrude Stein (1874–1946). After about one hundred sittings, in the winter and spring of 1905–6, Picasso had remained dissatisfied with the portrait, and had rubbed out the face. Then, in the absence of the model, he painted her features with a mask-like immobility.

1. Fernande Olivier, *Picasso et ses amis*, Paris, 1933, pp. 114–17.

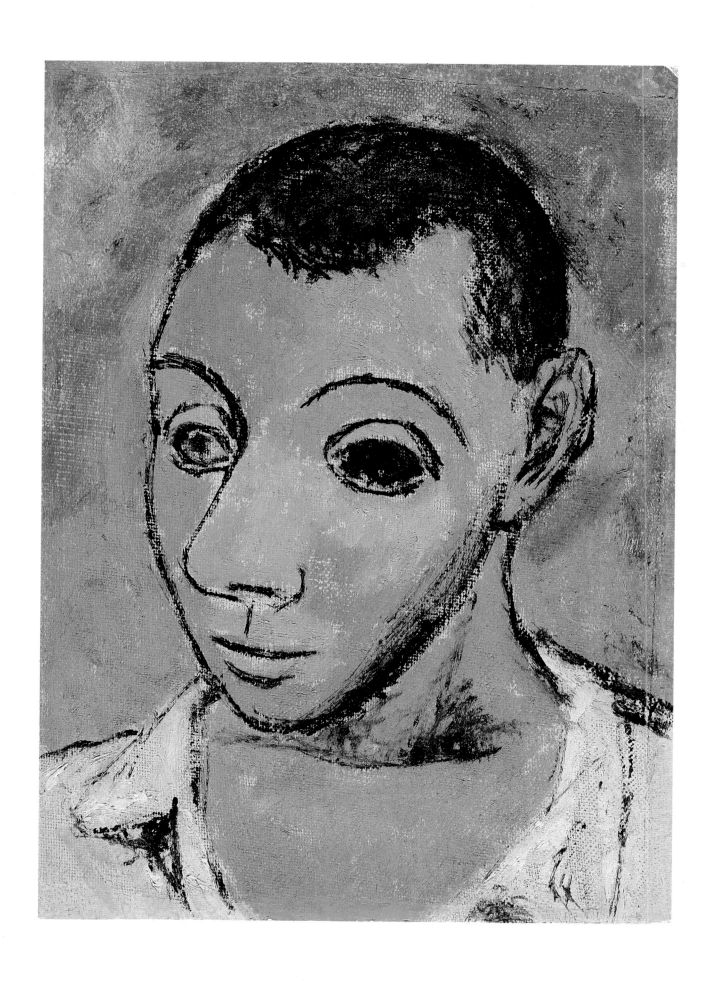

Pablo Picasso

Spanish, 1881–1973

HEAD OF A WOMAN

Early 1908
Watercolor on paper
12½ × 9⅜ in. (31.7 × 24 cm.)
Signed (on the reverse): Picasso

IF PABLO PICASSO made innumerable preparatory studies for his large painting *Les Demoiselles d'Avignon* of 1907, he made just as many related sketches, paintings, and drawings *after* he was done with it. Although the precise date of Picasso's introduction to African art has become a hotly debated issue for art historians, most scholars now agree with Picasso, who traced his interest to late May or June 1907. That was when he visited the ethnographical museum in the Palais du Trocadéro in Paris—an experience that led him, that summer, to change the faces of the two figures at the right in the *Demoiselles*. He gave them strange, monstrous heads, freely adapting the style of the African and Oceanic art that he had recently seen. These influences are apparent in numerous subsequent head and figure studies by Picasso, including the present one.

This small study belongs to a group of eight that all relate to the *Bust of a Female Nude* (fig. 1), painted early in 1908 (Daix, 135–142). Each of these sketches of elongated, oval faces is characterized by slits for eyes and by a long, wedge-like nose with a wide lower rim. The gently inclined head in this watercolor, the most graceful of these studies, seems more Gothic than African.

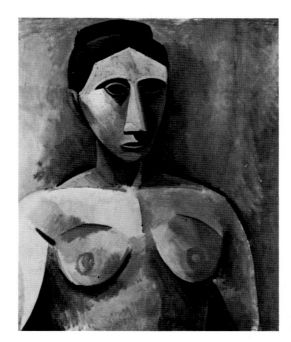

FIGURE 1. Pablo Picasso. *Bust of a Female Nude.* Early 1908. Oil on canvas, 28¾ × 23⅝ in. (73 × 60 cm.). Národní Galerie, Prague

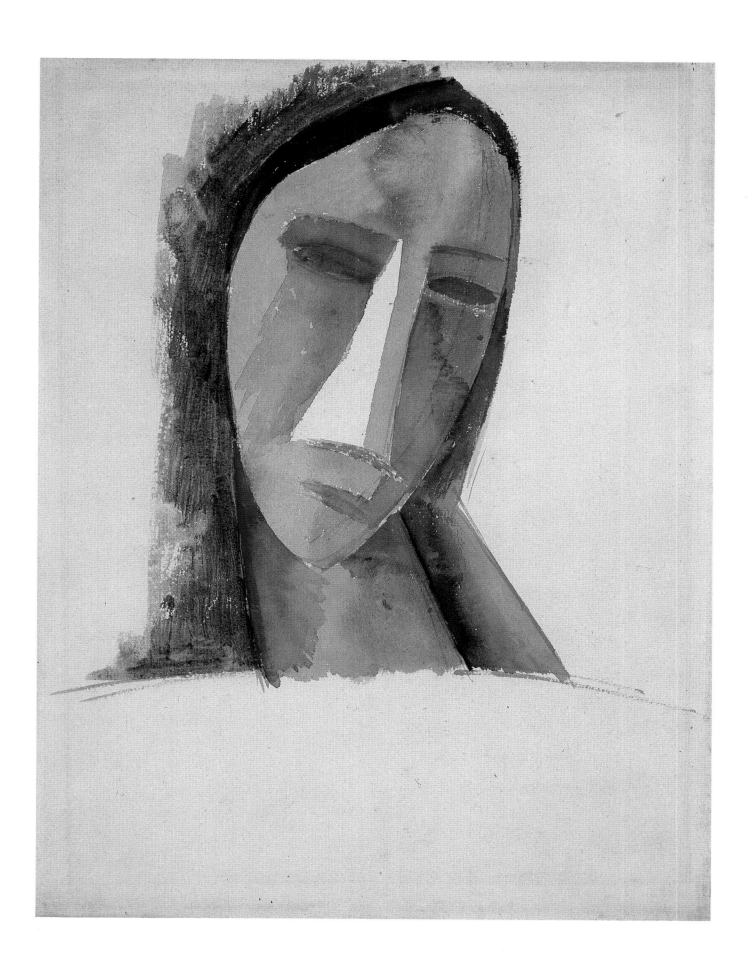

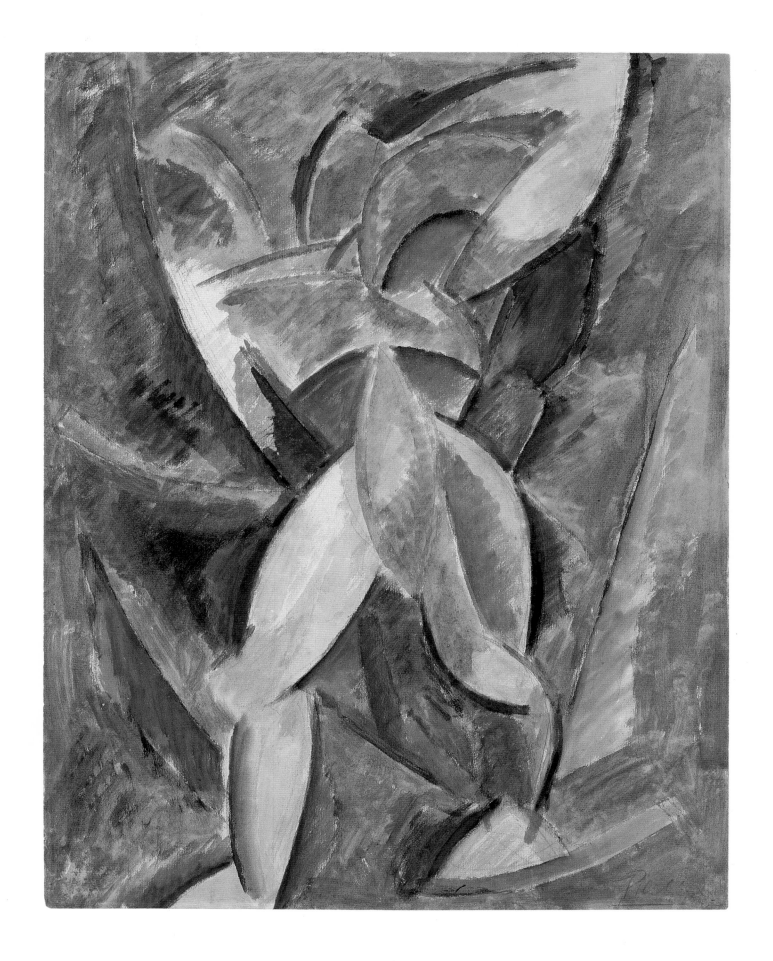

Pablo Picasso

Spanish, 1881–1973

STANDING NUDE

Paris, early 1908
Watercolor, gouache, and pencil on cardboard
24¼ × 18⅝ in. (61.5 × 47.3 cm.)
Signed (bottom right): Picasso

PABLO PICASSO never painted to sell or to please. When he showed his large canvas entitled *Les Demoiselles d'Avignon*—with its drastically compressed space and distorted figures—to his poet and painter friends in the summer of 1907, he was met with their shock and apprehension. Even the art dealer Ambroise Vollard, who only the year before had given Picasso two thousand *francs* in return for paintings, stopped buying from him—at least for a while. As for Picasso's friends, they first had to come to terms with the radical break from nineteenth-century illusionism that the *Demoiselles* so aggressively embodied.

This study for the painting *Standing Nude* of early 1908 (see fig. 1), one of seven sketches (Daix, 110–116), is the version that most closely resembles the finished work. With striding gait and oddly peaked left arm, the pose of the nude figure is reminiscent of those of Cézanne's "Bathers," as well as of the two central figures in the *Demoiselles d'Avignon*.

A similar nude reappears, further simplified, in the center of *Three Women (Rhythmic Version)*, Spring 1908 (Daix, 123). Together, all of these paintings and sketches form part of a large group of monumental "Bathers"—either single figures as here or clusters of three or five (see fig. 2, page 107)—that Picasso executed for his large painting *Three Women* (Summer 1908; reworked Winter 1908–9), the first version of which was done in the "African" style (see page 105, and fig. 1, page 106). The present figure is composed of elliptical shapes that overlap the crescent-shaped planes of the surrounding space. Figure and ground merge completely—a phenomenon already initiated in the *Demoiselles*. In contrasts of blue and burnt sienna the image heralds the rhythmic patterns of the Art Deco style.

FIGURE 1. Pablo Picasso. *Standing Nude.* 1908. Oil on canvas, 59⅛ × 39½ in. (150.3 × 100.3 cm.). Museum of Fine Arts, Boston, Juliana Cheney Edwards Collection

Pablo Picasso

Spanish, 1881–1973

KNEELING NUDE

Paris, Autumn 1908
Charcoal on paper
25 × 18⅞ in. (63.4 × 48 cm.)
Signed (bottom right): <u>Picasso</u>

IN THE winter of 1908–9, Pablo Picasso changed the style of the large painting *Three Women*—completed in the summer of 1908—from its earlier "African" mode into a Cubist one (see fig. 1, page 106). This drawing of an imposingly muscular woman is a study for the left-hand figure in the second, "Cubist" version of the picture that was painted over the "African" one. We know about the latter solely from a faded photograph showing the poet André Salmon (1881–1969) posed in front of the painting.[1] The drawing demonstrates, like a textbook, the geometrization of forms that led to early Cubism. The lower part of the figure's body, with its antediluvian limbs, is only roughly sketched in. More fully developed is the upper part, where Picasso has "broken up" the torso, the raised arm, and the head into various sections. The arm, especially, looks as if it had been carved out of wood, its slightly shaded planes evoking volume.

The "Cubist" version of the painting *Three Women* resembles a bas-relief carved out of rock or wood, its subtly shaded planes of ocher, green, and gray imperceptibly linked with one another through what, in Cubist painting, is called "*passage*." Gone are the stronger color contrasts and the striations of the first "African" version—which an experienced eye can discern in the faded photograph.

Since Picasso had not previously worked in a Cubist mode, there has been much speculation about what generated his change of style. In his seminal discussion of the beginnings of Cubism, William S. Rubin suggests that Picasso's new approach resulted from seeing the landscapes that Georges Braque had painted at L'Estaque (in the south of France) in the summer of 1908.[2] These landscapes, highly abstracted in emulation of Cézanne, had been reduced to geometric forms linked by "*passage*." When they were shown that November at Daniel-Henry Kahnweiler's gallery in Paris, the critic Louis Vauxcelles, in his review for *Gil Blas*, used the term "cubes" to describe them. Some months later, he employed the word "Cubist."[3]

After his exposure to the work of Braque, Picasso's art evolved along a similar course. The landscapes that he painted in La Rue-des-Bois—a lush, green spot north of Paris—recall those by Cézanne and by the Douanier Rousseau in their structural, often naïve simplifications of form.[4] Thus, Picasso was more than receptive to the still greater simplifications evident in Braque's early Cubist landscapes, and it was that style that he

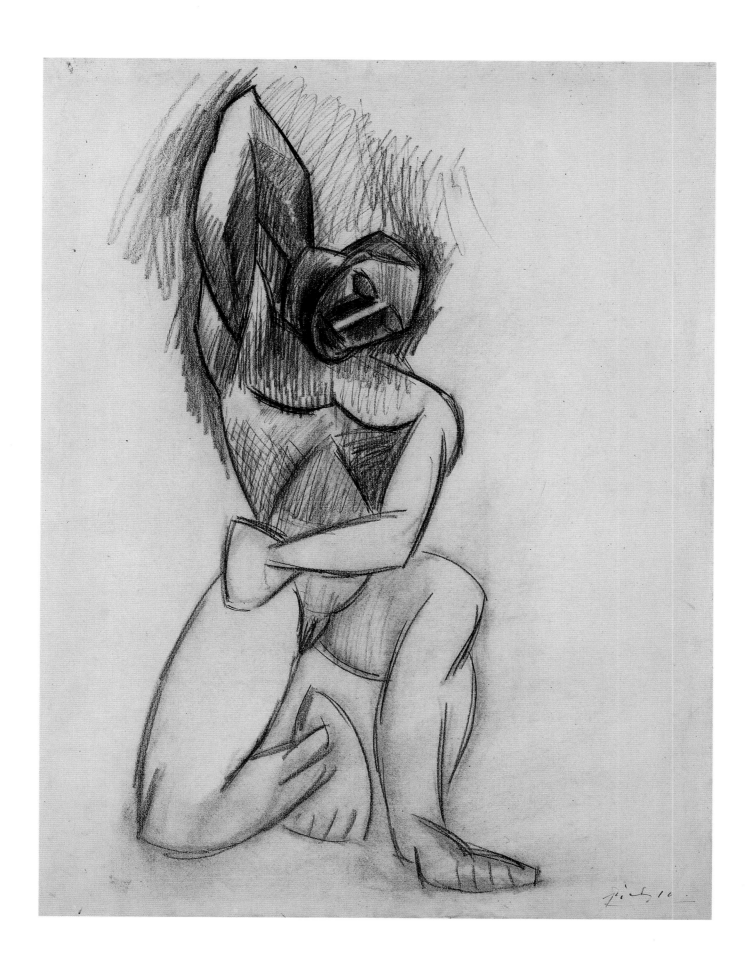

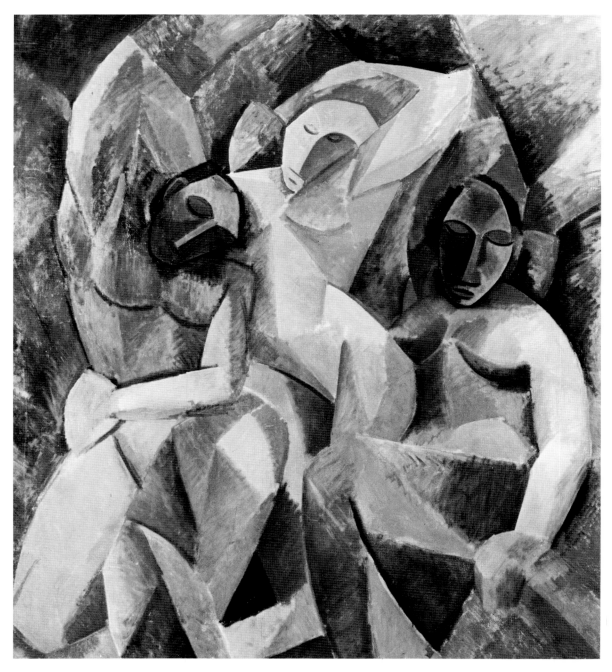

FIGURE 1. Pablo Picasso. *Three Women*. Begun, Summer 1908; reworked November 1908–January 1909. Oil on canvas, 78¾ × 70⅛ in. (200 × 178 cm.). The Hermitage, Leningrad

readily adopted in his own paintings, including the *Three Women*. During the winter of 1908–9, Picasso and Braque also became close friends and together set out to develop the new style into a fine art.

1. See the illustration in *Pablo Picasso: A Retrospective* (exhib. cat.), edited by William Rubin, New York, The Museum of Modern Art, 1980, p. 89.

2. William S. Rubin, "Cézannisme and the Beginnings of Cubism," in *Cézanne: The Late Work* (exhib. cat.), edited by William S. Rubin, New York, The Museum of Modern Art, 1977, pp. 151–202.

3. The term "Cubism" was coined to designate a style that, in actuality, has little to do with cubes, but is, instead, a geometric reduction of forms within a relief-like space.

4. William S. Rubin, "Cézannisme," op. cit., p. 182.

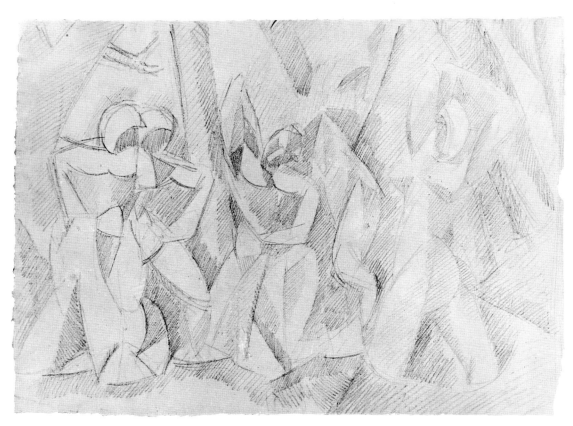

FIGURE 2. Pablo Picasso. Study for *Bathers in the Forest*. Spring 1908. Pencil on paper, 12⅝ × 17⅛ in. (32 × 43.5 cm.). Musée Picasso, Paris (Courtesy Réunion des Musées Nationaux, Paris; © Photo RMN–SPADEM)

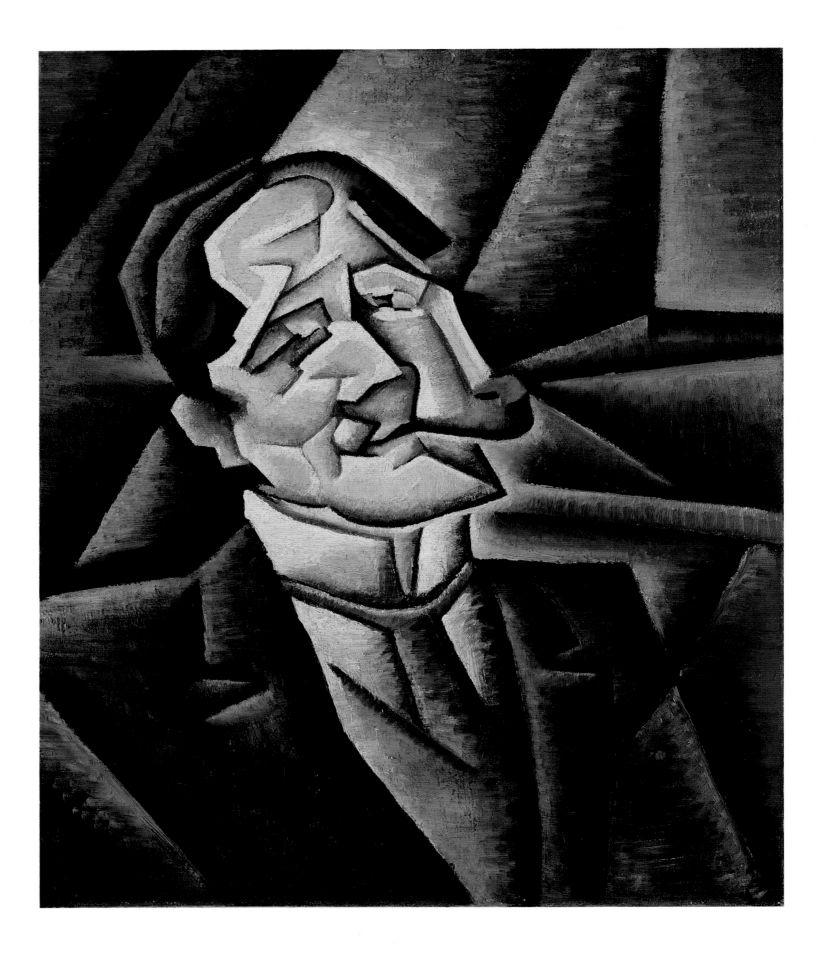

Juan Gris
(José Victoriano González)

Spanish, 1887–1927

JUAN LEGUA
1911
Oil on canvas
21⅝ × 18⅛ in. (55 × 46 cm.)
Inscribed (bottom left):
A mi Amigo Legua/afectuosamente/Juan Gris

THE SPANISH journalist Juan Legua is depicted in this somber portrait as a bearded, middle-aged gentleman smoking a pipe; his stiff collar underscores his formal dress.[1] Like all of the sitters in the few portraits Gris painted, Legua is easily identifiable, and undoubtedly looked just as the artist presents him. Until 1910, Gris had worked as an illustrator—first in his native Madrid, and from 1906 on in Paris, where he supplied French magazines with humorous and satirical drawings. (The artist took the name "Juan Gris" shortly before his move to the French capital.)

This portrait is an early, tentative effort at Cubism—a style that Gris embraced at the start of his career as a painter. In 1911, the date of this work, Picasso and Braque were involved in the most hermetic phase of their experimentation with Analytic Cubism. However, the methodical Gris, instead of adopting the style of the two painter/colleagues that he admired most, returned to the source of Cubism—Paul Cézanne—whose work he meticulously studied. Thus, unlike Picasso and Braque, who dissected forms into a multitude of small facets that they reassembled to create shallow, three-dimensional compositions evocative of bas-reliefs, Gris left his forms virtually intact. Here, for instance, the bust of Legua is perfectly recognizable, although it appears to be composed of corrugated-cardboard planes on which the background light falls in geometric shafts. Everything glistens with a gray, metallic sheen. Legua's face, alone, has been subjected to faceting, giving him a slightly wrinkled, yet humorously twinkly air—an effect that may betray Gris's former activity as a satirical illustrator.

Seven years after Gris's death, Legua remembered his friend in a short article, which describes the artist's early days in Paris when he was impoverished and lived in a dismal hotel room in the rue Caulaincourt in Montmartre.[2] Legua tells how Picasso, Gris's compatriot and six years his senior, found him a studio adjoining his own in a dilapidated,

two-story building at 13, Place Ravignan, which was jokingly referred to as the "Bateau-Lavoir." He continues to relate how Gris's studio soon became a meeting place for poets and painters. Legua concludes his reminiscence on a hopeful note—that the name Juan Gris would one day appear in the *Dictionnaire Larousse*. Nineteen years later, in 1953, it did.

1. In 1956, Douglas Cooper identified Juan Legua as a Spanish journalist who had worked in Paris. More recently, Elisabeth Cuspinera of the Spanish Consulate in New York and Edward C. McBride of the United States Information Service have tried to trace Legua to Spain but to no avail. Professor José Altabella of Madrid suggests that Legua was not Spanish, but a Latin American journalist active in Paris (letter of May 25, 1989). However, Legua's name does not appear in the yearbooks that list the journalists, both French and foreign, who worked in Paris during those years. Thus, the name "Legua" might have been the sitter's rarely used nom de plume, or perhaps he was not a journalist after all.

2. Published in *L'Intransigeant*, December 25, 1934, p. 6.

Georges Braque
French, 1882–1963

STILL LIFE WITH BANDERILLAS
Céret, Summer 1911
Oil on canvas
25¾ × 21⅝ in. (65.5 × 55 cm.)

THE CLOSE collaboration between Pablo Picasso and Georges Braque (1909–14) and their joint invention of Cubism have become the stuff of legend. As Braque later remembered: "We lived in Montmartre, and we saw each other every day and talked a lot . . . things were said between us that will never be repeated . . . that no one would understand now . . . we were like two mountain climbers roped together."[1]

Following in the footsteps of his father and grandfather, who had been house painters, Braque left Le Havre for Paris in 1900, to be apprenticed to a painter/decorator. The technical knowledge he was to acquire would serve him throughout his life. As for his painting style, he abandoned a conventional, realist mode to briefly embrace Fauvism. Then he discovered Paul Cézanne, the painter whom he would come to admire most, whose works he studied thoroughly. In the autumn of 1907, Braque met Picasso, and, in the latter's studio, was astounded when he saw the large canvas of *Les Demoiselles d'Avignon*. By

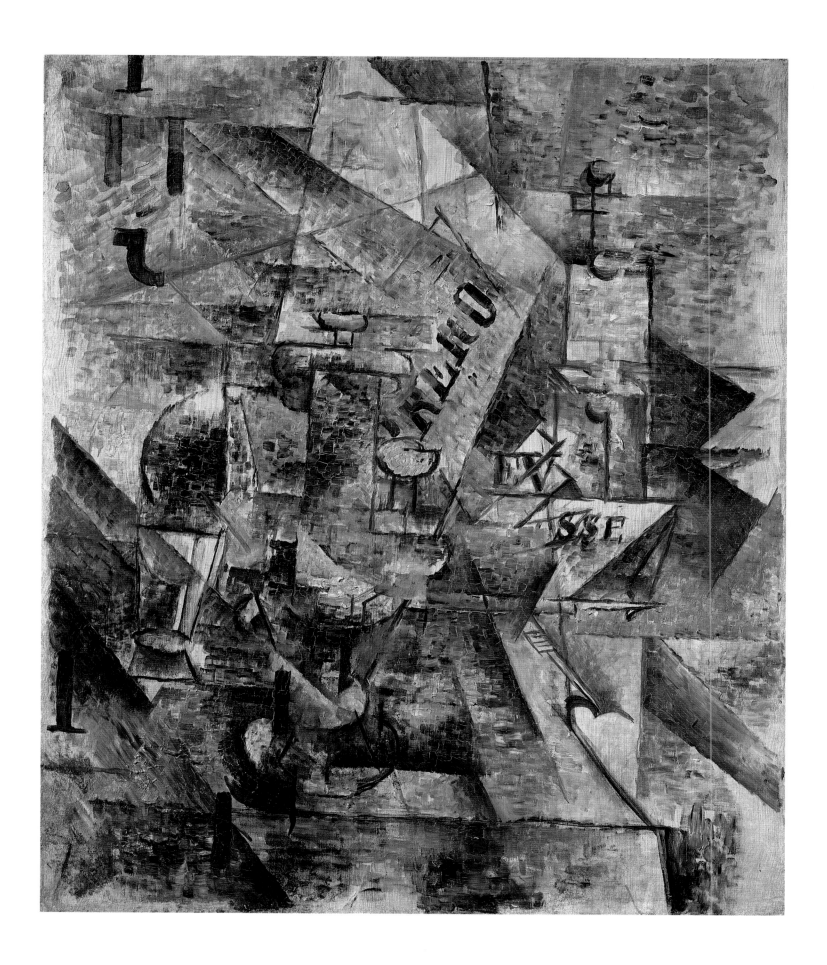

the end of the summer of 1908, which he spent at L'Estaque, Braque was painting starkly abstracted landscapes that reveal the influence of Cézanne. These works, simplified into geometric forms whose planes are linked to one another, might be called the very first Cubist paintings. They, in turn, influenced Picasso. By the winter of 1908–9 Braque and Picasso were inseparable. Picasso, the Spaniard, was short, passionate, restless, and unpredictable, while Braque, the Frenchman, was tall, deliberate, methodical, and reserved. Yet, for all their pronounced differences—indeed, perhaps, because of them—during the years of their collaboration the two painters seem to have complemented each other.

Braque painted this still life in Céret, the small town in the French Pyrenees that was so popular with poets, musicians, and artists—especially, with the Cubists—before World War I that it has been called the "spiritual home of Cubism." Picasso's *Still Life with a Bottle of Rum* (see page 114), in the Gelman collection as well, was painted at the same time, also in Céret, where he had been joined by Braque during the last two weeks of August and the first week of September. By that time (1911), Picasso's and Braque's works had become difficult to tell apart—a phenomenon that the artists actually strove for, by not signing their paintings. Indeed, they even claimed that sometimes they had difficulties themselves recognizing their own pictures.

During the last phase of the style known as Analytic Cubism—also referred to as "hermetic"—Picasso and Braque broke down their forms even more. Thus, their compositions consisted mainly of large, abstract planes and faceted ones, along with various arcs, narrow and wide angles, and series of straight and diagonal lines. The sober palette of grays, browns, and blacks—some opaque, some not—often applied, as here, in short brushstrokes to create a dappled effect, enabled the planes to overlap and merge with one another in a shallow, relief-like space. Some tenuous links with reality survive when images of naturalistic objects, or parts of them, are incorporated in the composition.

The banderillas of the title, which cross each other diagonally and horizontally, are the most recognizable objects in the picture. During the bullfight, these dart-like, steel-barbed, wooden sticks decorated with paper are inserted into a specific muscle in the bull's neck by the matador's assistants, the banderilleros, to injure and weaken the animal. Except, of course, for the large, black letters, the other objects in the painting are too fragmented to be clearly identified. However, among them might be a tall, thin bottle, a stemmed glass, and the spout of a *porrón*, or Spanish wine bottle. The letters "ORERO" stand for the bullfighting magazine *Le Torero*, references to which also appear in contemporary works by Picasso—among them, the above-mentioned *Still Life with a Bottle of Rum* (see page 114), the *Still Life "Le Torero"* of 1911 (Zervos II¹, 266; Daix, 413), and the later *Aficionado* of 1912 (Zervos II², 362; Daix, 500). Because Braque, unlike Picasso, was not a bullfight enthusiast, it is likely that he included these tauromachian allusions—the only ones in his oeuvre—as a tribute to his friend.[2]

1. Dora Vallier, "Braque: La Peinture et nous. Propos de l'artiste recueillis," *Cahiers d'art* 34, no. 1 (October 1954), p. 14.

2. The letters "SSE" could refer to the daily newspaper *La Presse*, and the combination of "EV" and "SSE" to a play on the sound of "éviscérer" (the French word for "to disembowel")—unless, perhaps, they are cryptic references to something known only to the two painters.

Pablo Picasso

Spanish, 1881–1973

STILL LIFE WITH A BOTTLE OF RUM

Céret, Summer 1911
Oil on canvas
24⅛ × 19⅞ in. (61.3 × 50.5 cm.)
Inscribed (on the reverse): Picasso/Céret

ONE IS hard-pressed to see the bottle of rum indicated in the title of this work, which was painted during the most abstract phase of Cubism, known as "high" Analytic Cubism (1910–12). Until that time, the subject of a Cubist picture by Pablo Picasso or Georges Braque could usually be recognized. Although figures and objects were dissected or "analyzed" into a multitude of small facets, these were then reassembled, after a fashion, to evoke those same figures or objects. In 1910, a major change in style occurred. Picasso and Braque so abstracted their works that they were reduced to just a series of planes and facets. Furthermore, because the artists' palettes were limited to browns, grays, and blacks, these planes and facets overlap or imperceptibly merge with one another in the ambiguous, shallow space typical of Cubist compositions. Indeed, paintings such as this resemble intricately constructed, abstract, two-dimensional reliefs. While these works are always rooted in nature—be they still lifes, figure studies, or, to a lesser extent, landscapes—links to that natural world appear severed, save for the barest clues. Here, for example, in the upper center of the picture are what seem to be the neck and opening of a bottle. Some spidery black lines to the left of the bottle might denote sheet music, and the round shape lower down, the base of a glass. In the center, at the far right, is the pointed spout of a *porrón* (Spanish wine bottle).[1]

The degree of abstractness of these paintings made Daniel-Henry Kahnweiler, the artists' dealer and friend, appeal to Picasso and Braque to give their pictures realistic titles—but even titles were not foolproof. One collector, apparently, lived happily with his "landscape," when, in fact, he owned a figure of a musician.[2]

Picasso and Braque must have realized at one point that their Cubist approach had become too cerebral. Therefore, in the spring of 1911, Braque introduced letters, words, and numbers into his work—thus adding a realistic touch, while, at the same time, providing a welcome source for further ambiguity and puns. A letter's inherent two-dimensionality emphasizes the flatness of the picture surface on which it floats, while making the shallow, Cubist space beneath it seem more three-dimensional. In addition, these letters often refer obliquely to the subject of the picture.

Picasso painted the *Still Life with a Bottle of Rum* during the summer of 1911 in Céret, where he was joined by Braque, who executed the *Still Life with Bandilleras* (see page 111)

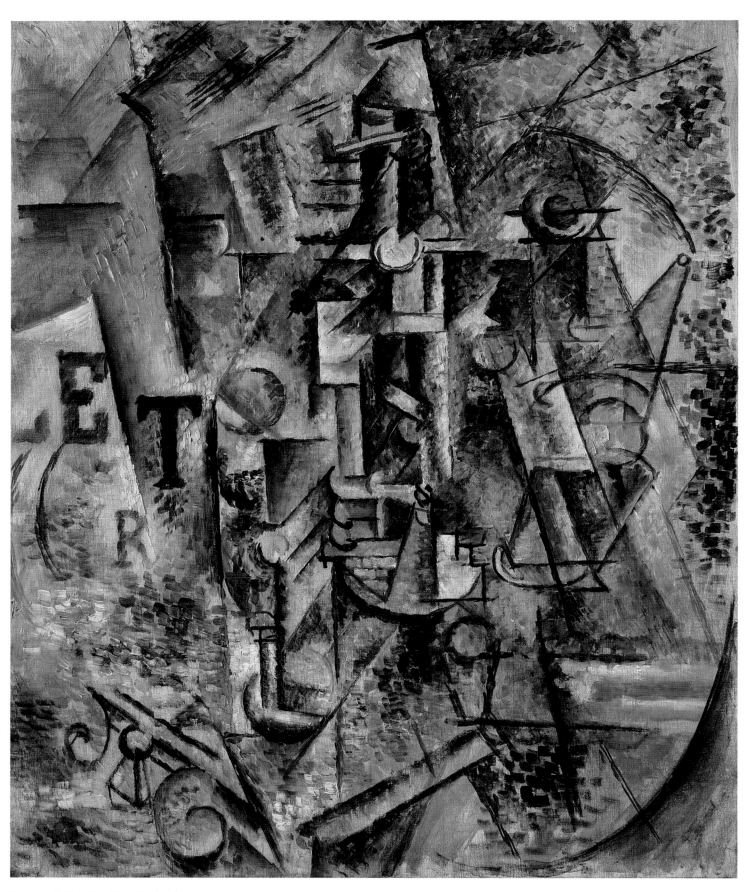

Picasso. *Still Life with a Bottle of Rum*

as its companion piece. (By a fortunate coincidence, both pictures are in the Gelman collection.) In addition, Braque, Juan Gris, Auguste Herbin, Henri Matisse, and Manolo (Manuel Martínez Hugué) also lived for a while in Céret. In fact, Hugué was the one who first told Picasso about this small town in the Pyrenees where Picasso spent the summer of 1911 and parts of 1912 and 1913.

The *Still Life with a Bottle of Rum* is one of the first works—preceded only by *Still Life "Le Torero,"* also of 1911 (Zervos II², 266; Daix, 413)—in which Picasso included letter forms, thereby copying, within one month, what had been Braque's invention. It has been suggested that the letters "LETR" refer to *Le Torero*, the magazine for bullfighting fans—Picasso being one of them—but they might simply be a pun on the French word *"lettre."*[3]

1. Lewis C. Kachur detected the *porrón*. See his unpublished dissertation, "Themes in Picasso's Cubism, 1907–18," New York, Columbia University, 1988, p. 131.

2. Roland Penrose, *Picasso: His Life and Work*, New York, 1958, p. 178.

3. Douglas Cooper and Gary Tinterow, *The Essential Cubism: Braque, Picasso & Their Friends, 1907–1920* (exhib. cat.), London, Tate Gallery, 1983, p. 260.

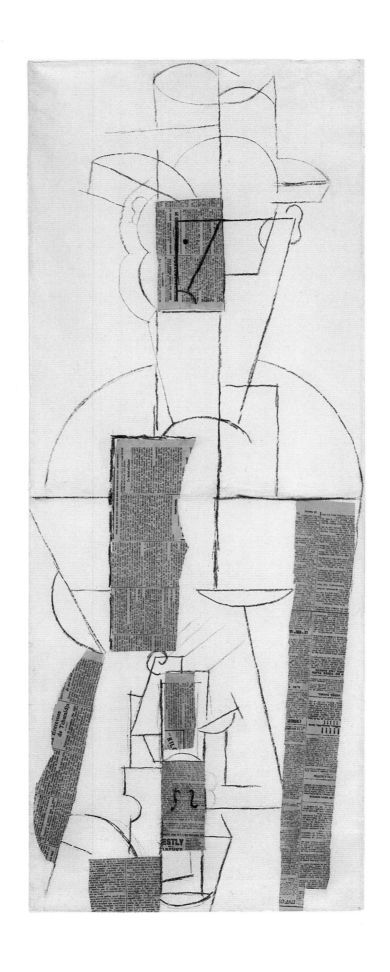

Pablo Picasso

Spanish, 1881–1973

MAN WITH A HAT AND A VIOLIN

Paris, December 1912
Cut-and-pasted newspaper, with charcoal, on two sheets of cut-and-pasted paper
48⅛ × 18⅝ in. (123.3 × 47.3 cm.)
Signed (on the reverse, at the upper left): Picasso

IN THE AUTUMN of 1912, Picasso and his newest love, Eva Gouel (Marcelle Humbert; 1885–1915), moved into a studio in Paris at 242, boulevard Raspail, just one block away from the intersection with the boulevard Montparnasse where such cafés as Le Dôme, La Rotonde, and La Coupole, made famous by artists, are clustered.

During the winter of 1912–13 Picasso executed a great number of *papiers collés*. With this new technique of pasting colored or printed pieces of paper onto their compositions, Picasso and Braque swept away the last vestiges of the three-dimensional space (illusionism) that still remained in their "high" Analytic works. Whereas, in Analytic Cubism, the small facets of a dissected or "analyzed" object are reassembled to evoke that same object, in a shallow space, in Synthetic Cubism—initiated by the *papiers collés*—large, neutral or colored pieces of paper themselves allude to a particular object, either because they are often cut out in the desired shape or else sometimes bear a graphic element that clarifies the association.

The present work belongs to a group of about seventeen other *papiers collés* by Picasso composed solely from newspaper articles (see Daix, 524, 535–539, 542–547, 549–550, 552–554). Here, he arranged cuttings from *Le Journal* of December 3 and 9,

FIGURE 1. Pablo Picasso. Study for *Man with a Hat and a Violin*. 1912. Watercolor, 12¼ × 9⅞ in. (31 × 25 cm.). Whereabouts unknown (Zervos XXVIII, 242)

1912, on a sort of scaffolding of straight and slightly curved charcoal lines,[1] a number of which might have been "helped along" by a ruler or a compass. The various texts refer to the Balkan Wars, to the unrest in the mines in the "Nord" and "Pas-de-Calais" *départements*, to critical issues debated in Parliament and in the Chambers, and to local announcements and advertisements.[2]

The man's head—one eye is visible—is seen from both the front and back, below his top hat. The left side of his face, as well as his ears, echoed by the shaped piece of newspaper at the lower left, resembles the contours of a stringed instrument. The man is huge in comparison to the tiny violin in his lap. Picasso, although not a violin player, was especially fond of violins from the autumn of 1912 to early 1913 (see fig. 1). The instrument appears in at least fourteen of some forty *papiers collés* that he produced at the time, while the guitar figures in only six works. Stringed instruments such as violins, guitars, or mandolins became favorite objects in Synthetic Cubist still lifes because they could be "alluded" to merely by the use of details like the scroll, pegs, and sound holes, or by a curved silhouette.

Were the clippings Picasso incorporated into his collages at that time chosen at random? Opinions differ. It has been suggested that Picasso purposely selected texts that refer to the Balkan Wars,[3] but it would have been difficult for him not to have included any such references, since those events dominated the pages of most newspapers at that time. The newspaper cutout that makes up the body of the violin seems, however, not to have been picked by chance. It is from an article that appeared on page 6 of *Le Journal* of December 9, and its heading, "Tragique roman d'amour," had probably aroused Picasso's curiosity. It relates how Henri Aubert, a twenty-six-year-old young man from Plaisance, a small town in the Pyrenees, met Léonie Vignon, a twenty-three-year-old singer in a cabaret in Paris, became her lover, and, after his jealousy and violence had driven her away, shot himself in a café. The melodramatic events thus matter-of-factly described, in the context of Picasso's collage, come across like a popular ballad—one that could be part of this musician's repertoire. The circumstances of this suicide no doubt reminded Picasso of his friend Carlos Casagemas, who, in 1901—disappointed in love—had also shot himself to death in a Parisian café.

1. Lewis Kachur of New York kindly suggested that I check *Le Journal* of December 1912 for the specific dates of these seven newspaper clippings.

2. See Patricia Leighten, "Picasso's Collages and the Threat of War, 1912–13," *The Art Bulletin* 67, no. 4 (1985), p. 665.

3. Leighten, ibid., pp. 663 ff.

Juan Gris
(José Victoriano González)

Spanish, 1887–1927

THE SMOKER
1913
Charcoal, crayon, and wash on paper
28¼ × 23¼ in. (71.8 × 59 cm.)
Inscribed (lower left):
À mon cher ami Frank Haviland/bien affectueusement/<u>Juan Gris</u>

FRANK HAVILAND (1886–1971), the subject of this Cubist drawing, was a descendant of David Haviland, an American who founded a porcelain factory in the mid-nineteenth century in Limoges, France, that still bears his name. Born and educated in France, Frank was artistically inclined, and in 1910 he set aside his interest in music for painting, after coming in contact with Picasso's work. He called himself "Frank Burty," adopting the surname of his maternal grandfather, Philippe Burty, a writer and critic. "Frank Burty" Haviland's first exhibition was held at Alfred Stieglitz's gallery "291" in New York in 1914. Judging from contemporary reviews, he painted in a realist mode that he naïvely "cubified" because of his admiration for Picasso.[1]

In her book about Picasso and his friends, written in 1933, Fernande Olivier described Frank Haviland as "tall, blond, too distinguished, too young . . . an intimate friend who was attentive and discreet. The Rich One."[2] Haviland is known to have befriended and helped many artists, among them Modigliani, who painted his portrait in 1915, and the Spanish sculptor Manolo (Manuel Martínez Hugué), a close friend of Picasso. After Manolo settled in Céret in 1910, he persuaded such artist friends as Picasso, Braque, and Gris, as well as Frank Haviland, to join him there. By 1913, Haviland had come to Céret, having bought an old monastery that he restored. That September, in Céret, Gris painted the portrait of Frank Haviland entitled *The Smoker* (Thyssen-Bornemisza Collection, Lugano).

This preparatory drawing is exceptional mostly because it exists at all. Gris usually destroyed all his preliminary studies, and requested that his wife, Josette, and his friend Daniel-Henry Kahnweiler do likewise with any that remained after his death. Thus, only drawings that Gris inscribed as gifts to his friends—such as this one—survive. Also of note are the large dimensions of this work, and its highly finished state. (While the drawing is somewhat wider than the painting, the forms in each are identical in size.)

The bust-length portrait of Frank Haviland shows him formally dressed and wearing a top hat. The large, fan-like planes are delineated with heavy charcoal lines, some of which were possibly strengthened with a ruler, and accentuated by means of subtle shading. Set among the angular planes are several tubular shapes that suggest the curves of the hat and brim. Humorous details include the hair and a sideburn, the squiggly ear, chin, collar, and

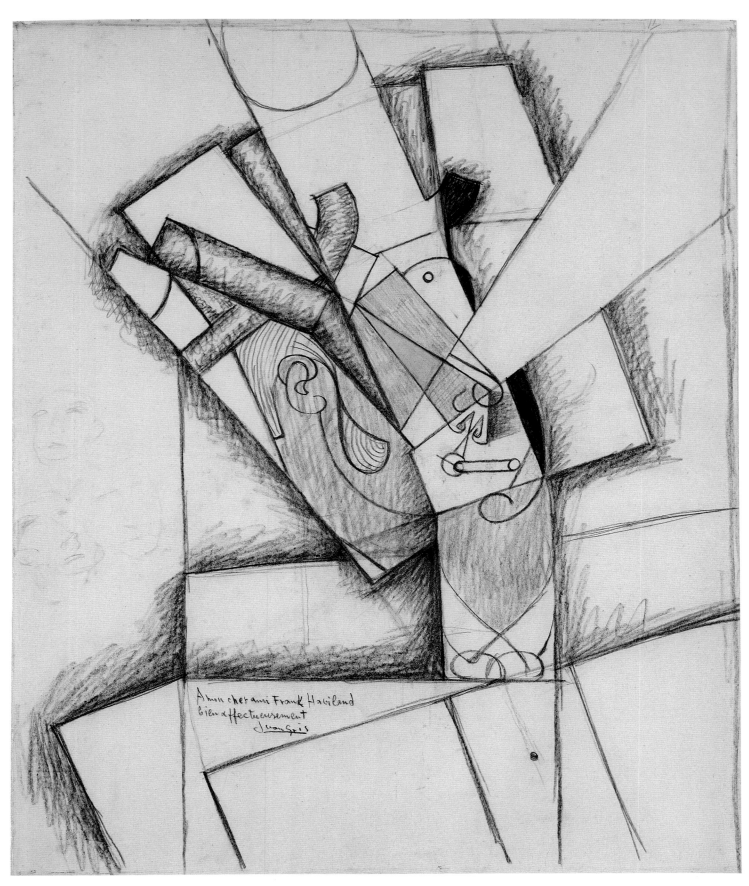

Gris. *The Smoker*

bow tie, the geometric nostrils, one beady eye, and the round mouth holding a long, unlit cigarette. The relatively austere color scheme centers on dark gray for the hat and pale browns and ocher for the areas of the face and neck.

This study for *The Smoker* usually has been dated 1912. However, when it was first exhibited at the Buchholz Gallery in 1950—after Curt Valentin purchased it directly from Haviland—the drawing was listed in the catalogue as from 1913, which, in fact, is correct. Both the drawing and painting (the latter is dated September 1913) are executed in an identical style.

1. See Jean Loize, "Frank Burty," *Reflets du Roussillon* 13 (Spring 1966), pp. 27–32.
2. Fernande Olivier, *Picasso et ses amis*, Paris, 1933, p. 138.

Juan Gris
(José Victoriano González)

Spanish, 1887–1927

STILL LIFE WITH A GUITAR

Céret, September 1913
Oil on canvas
26 × 39½ in. (66 × 100.5 cm.)
Inscribed (on the reverse): Juan Gris/Céret 9–13

FROM 1911, the beginning of his career as a painter, Juan Gris was never reluctant to include his work in the various *Salons*. Unlike Picasso and Braque, who stopped exhibiting their Cubist pictures publicly during the period of their collaboration (from about 1909 to the outbreak of World War I), Gris, in 1912, showed his paintings at the Salon des Indépendants and at the Salon de la Section d'Or in Paris. In the autumn of 1912, he also signed a contract with the art dealer Daniel-Henry Kahnweiler, who championed many of the Cubists—Picasso and Braque among them. Kahnweiler would become Gris's lifelong friend, faithful correspondent, and, after the artist's death in 1927 at the age of forty, his first biographer.

Of the more than six hundred recorded paintings in the artist's catalogue raisonné, seventy-five percent of them are still lifes. Gris painted the present canvas in the small hill town of Céret in the French Pyrenees, where he worked from August until October of 1913. Gris's stay in Céret marked his first holiday since his arrival in Paris from Spain in 1906. (Before World War I, Céret attracted many artists—most notably Picasso, who spent the summer of 1911 and parts of 1912 and 1913 there.) This was a happy and productive period for Gris. Of the thirty-six paintings from 1913 that survive, more than one-third were done during his three months in Céret. By then, the artist had developed a colorful Cubist style of broad, angular, overlapping planes, a style that, within a year, would evolve into a fully formed Synthetic Cubist idiom no doubt influenced by the *papiers collés* Picasso and Braque had first devised in September 1912.

Such words as "bold," "pure," "clear," "assertive," and "legible" are often used to describe Gris's works. Indeed, the seemingly poetic clutter of this still life has been carefully conceived. We have no difficulty deciphering the objects that Gris depicted, here, among the planes that are either brilliantly colored, in such strident combinations as orange, purple, blue, green, and red, or else painted to simulate wood graining. Everything gravitates around the large guitar resting on the flat yellow portfolio, the newspaper, and the sheet music. These, in turn, are surrounded, in a half-circle, by the three-dimensionally represented dice cups and stemmed glasses, and the pipe, bunches of grapes, and drapery. Some objects are echoed by their "negative" black shadows, while other objects—such as the pipe—are themselves painted merely as shadows. Despite all of this apparent flatness, Gris was able to suggest depth as well as to present the objects from varying viewpoints. While we see the guitar in relief, the two dice cups at the left are rendered in isometric projection, as if seen from high above. Their exaggerated height makes them look somewhat like smokestacks.

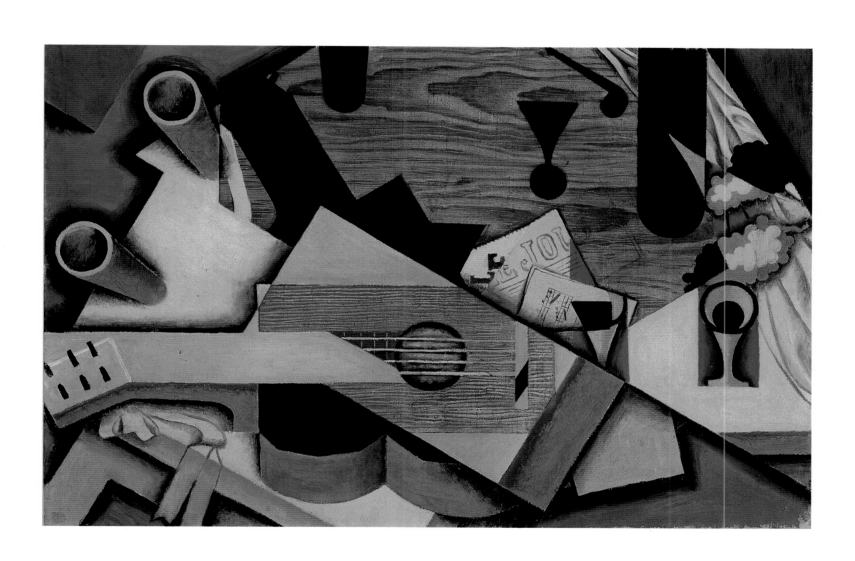

Tradition and Change
1909–1919

Auguste Rodin

French, 1840–1917

GUSTAV MAHLER

1909
Bronze
14 × 9 × 10 in. (35.5 × 22.8 × 25.4 cm.)
Signed (on the right side of the neck): A. Rodin
Inscribed (on the back of the neck, at the left): A. Rudier

O N APRIL 22, 1909, Paul Clemenceau wrote to Rodin: "If you are free to do so, please come tomorrow, Friday, at 12:30 to have lunch with us at the Café de Paris. Mahler will be there. We could arrange everything while dining. Remember that Mahler is convinced that it is your own wish to do his bust, or he would have refused to pose."[1] The meeting thus arranged took place, and the French sculptor and the Austrian composer, each at the zenith of his career, were favorably impressed by one another.

In his biography of Rodin, Frédéric Grunfeld notes that by 1909 the sculptor's studios in Meudon and in Paris had become "a million-franc crafts enterprise employing a staff of full-time workers and a great many part-time assistants and subcontractors who were kept busy filling orders from all over the world."[2] American industrialists and individuals prominent in society, the arts, and the political and financial worlds flocked to the atelier of Rodin, who was then the most highly remunerated portrait sculptor in Europe. Money, however, was not always enough to ensure that one was worthy of the honor of posing for Rodin.

The Austrian painter Carl Moll (1861–1945)—the stepfather of Gustav Mahler's wife, Alma (1879–1964)—had initiated the portrait commission on behalf of Mahler's admirers in Vienna. Rodin liked the music of Mozart, Beethoven, and Gluck. While he was not familiar with that of Mahler (1860–1911),[3] when he learned that Mahler was as great a musician as he himself was a sculptor, Rodin agreed to a special discount price for the clay portrait bust, even though he charged the usual fee for the bronze casts. The bust of Mahler was to be Rodin's only portrait of a musician.

By the spring of 1909, when Mahler was forty-nine years old, he had completed his 8th symphony, the Symphony of a Thousand. He and Alma arrived in Paris from New York, after he conducted his last season at the Metropolitan Opera and signed a three-year contract with the New York Philharmonic Orchestra. Since Mahler was obliged to return to Vienna eight days after his historic lunch with Rodin, the sculptor worked quickly, scheduling sittings about one-hour-and-a-half long, which were difficult to endure for the nervous Mahler, who "couldn't keep still even for a minute."[4] Apparently, misunderstandings occurred between both men, as neither spoke the other's language. When Rodin asked Mahler to kneel in order to better measure the volume and contour of his head, the

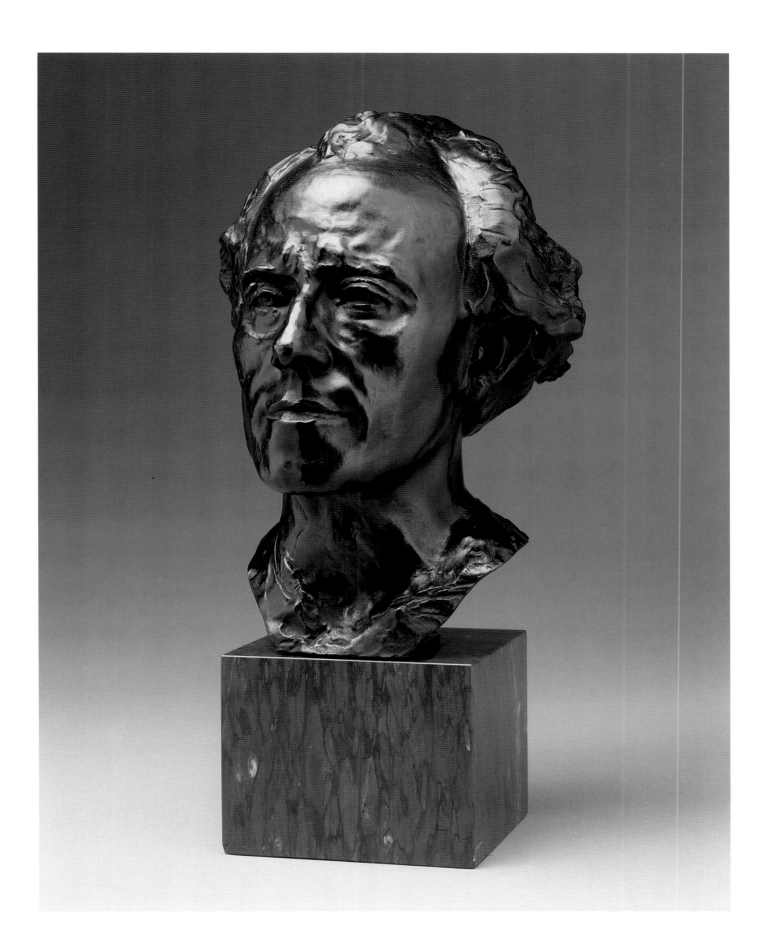

FIGURE I. The young Gustav Mahler (Courtesy Roger-Viollet, Paris)

temperamental composer resented having to assume this humiliating posture, and promptly left the studio.

Alma Mahler, who had associated with painters and sculptors in Vienna, was fascinated by Rodin's techniques: "He first made flat surfaces in the rough lump [of clay], and then added little pellets of clay which he rolled between his fingers while he talked. He worked by adding to the lump instead of subtracting from it. As soon as we left he smoothed it all down and the next day added more. I scarcely ever saw him with a tool in his hand."[5]

Rodin usually made several studies of a sitter, which represented different stages in the modeling process. Plaster casts of each of these successive studies were produced, all with different facial expressions. At the time that Rodin was at work on this portrait, Mahler was ill with the rheumatic heart disease that had been diagnosed two years earlier and would be the cause of his death in 1911. His ascetic, rather sharp features appear drawn, and he seems to have prematurely aged, yet he still retained the appearance of a man who—as Alma remembers in her autobiography—never knew how to rest, and who was haunted by the phobia of "time wasted away from his work."[6]

Rodin completed two busts of Mahler in bronze: this version, with its relatively smooth surface, and a rougher, more experimental variant. In addition, Rodin's assistant, Aristide Rousaud, made a carving in marble of this version in which the head seems to emerge from the block of stone. When the latter was first exhibited, Rodin gave it the title *Buste XVIII*^e *Siècle*, and later simply called it *Mozart*. It has been on exhibition at the Musée Rodin in Paris with that name ever since, much to Alma Mahler's surprise when she visited that museum.

Mahler never saw the actual bronze bust, but only the photograph of it that was included in a book commemorating his fiftieth birthday that was given to him by his admirers in 1910.[7]

1. Cited in Frederic V. Grunfeld, *Rodin: A Biography*, New York, 1987, p. 535. Grunfeld wrote extensively about this portrait commission (pp. 534–37)—the source of most of the information in this entry.

2. Ibid., p. 556.

3. See John L. Tancock, *The Sculpture of Auguste Rodin: The Collection of the Rodin Museum, Philadelphia*, Philadelphia, 1976, p. 552.

4. Grunfeld, op. cit., p. 535.

5. Ibid., pp. 535–36.

6. Alma Mahler-Werfel, *Mein Leben*, Frankfurt-am-Main, 1960, p. 44.

7. Grunfeld, op. cit., p. 537.

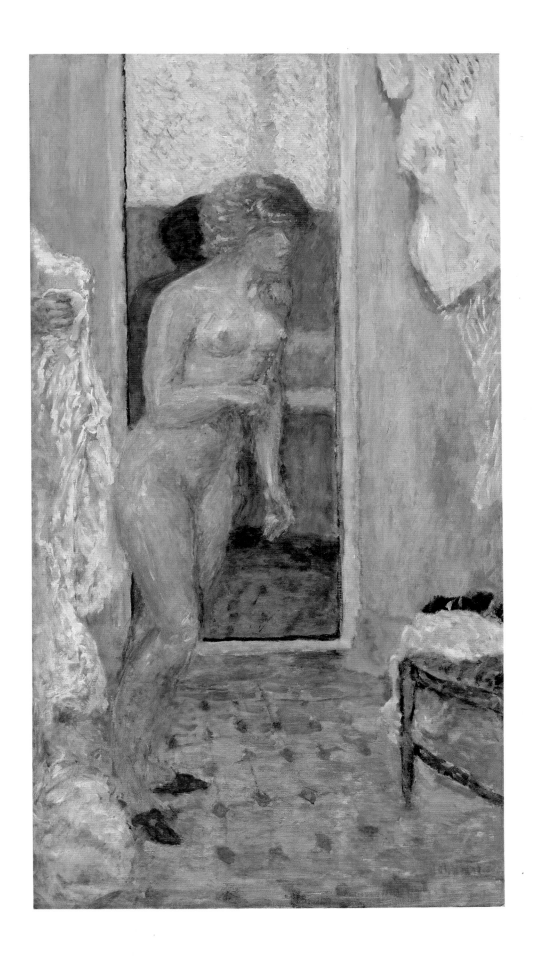

Pierre Bonnard

French, 1867–1947

AFTER THE BATH

1910
Oil on canvas
48¼ × 25½ in. (122.5 × 65 cm.)
Signed (bottom right): Bonnard

I T IS APPARENT from the paintings of Parisian scenes by Pierre Bonnard dating from the mid-1890s that he was fond of recording the simple incidents of daily life (see page 60). Some ten years later, the painter would find inspiration for his indoor scenes in the intimate, everyday events that take place mainly in dining rooms and in the bath.

Bonnard presents a standing, naked woman who, having just taken a bath, is about to be rubbed down with a huge white towel that is being offered to her by her maid, whose hand, alone, is visible at the far left of the composition. Light streams into the picture from the foreground, suffusing the nude and her surroundings—the long, vertical mirror; the patterned, tile floor; the chair; and various white garments—with a warm, golden glow. The source of this light is the window high above the tub that is reflected in the mirror behind the figure.

The woman is probably Marthe (Maria Boursin; 1869–1942), whom Bonnard had met in 1893, and who became the painter's companion and, in 1925, his wife. Marthe apparently was extremely shy and withdrawn, and also obsessed with her body, whose care consumed many hours each day. The daily rituals of bathing and anointing herself, always in a completely self-absorbed fashion, became the source for the painter's series of female bathers.

In his pictures of Bathers, Bonnard habitually gave an exotic look to the functional, rendering in brilliant colors the floor- and wall-tiles, mirrors, garments, fabrics, and often the bather herself. Marthe's lithe, graceful body, with its high-set breasts, remains forever young throughout the forty-seven years that she appears as the painter's model. Her posture here—she is caught in arrested motion, unaware of the invisible viewer—offers a fine example of Bonnard's intention "to show what one sees when one enters a room all of a sudden." Indeed, he never painted from nature or from the model, but, instead, recorded from memory his impressions of a scene witnessed earlier—often, as here, hundreds of times.

After the Bath is one of three paintings—all of approximately the same height, but of different widths—that depict the corner of a bathroom with a tall mirror (see Dauberville II, 494–495). Perhaps it is the bathroom in Bonnard's studio on the Quai Voltaire, in which he worked in 1910, or one in a house that he visited, either in Saint-Tropez or in Antwerp, in September and November of the same year.

Wassily Kandinsky

Russian, 1866–1944

RAIN LANDSCAPE

1911
Watercolor on paper
10 × 12½ in. (25.4 × 31.7 cm.)
Signed (bottom right): ⚠

I N MUNICH, Wassily Kandinsky and Paul Klee (1879–1940) had been neighbors for some three years before they finally met in October 1911. Shortly afterward, Klee wrote in his diary:

> Luli [Louis-René Moilliet (1880–1962), a Swiss painter and friend of Klee] often
> goes to visit him [Kandinsky], sometimes takes along works of mine and brings
> back pictures without any subjects by this Russian. Very curious paintings.
> Kandinsky wants to organize a new society of artists. Personal acquaintance has
> given me a deeper confidence in him. He is somebody, and has an exceptionally
> fine head and mind . . . during the course of the winter, I joined his "Blaue
> Reiter."[1]

The Blaue Reiter (Blue Rider) was an informal group of lyrical Expressionist painters founded by Kandinsky and Franz Marc (1880–1916) on the occasion of the group's first exhibition at Thannhauser's Moderne Galerie in Munich in December 1911. The name came about because of Kandinsky's fascination with the motif of a horse and rider, which figured prominently in his works from 1902 until 1914. Marc also admired horses, and both artists were fond of the color blue. In 1912, the group published the *Blaue Reiter Almanach*, a book that recorded the members' interest in music; in folk art and the art of children and of primitive peoples; and in the European avant-garde. Kandinsky suggested the scope of the almanac and, together with Marc, was its editor.

The present sketch, which dates from the most highly regarded period in Kandinsky's career (1910–14), relates in theme, style, and size to ten other extant watercolors that Kandinsky originally executed for the almanac's cover, but which were discarded in favor of a color woodcut of a horse and rider. In vibrant hues and in various degrees of abstraction, all ten watercolors depict a rider on a horse, in an imaginary hilly landscape under a sky dotted with clouds.[2] Here, black wavy lines indicate the grassy slopes of two hills. At the upper left, a white horse charges uphill, carrying a rider whose yellow cape billows in the wind. The immense brown rain cloud in the center was originally far less prominent, but the areas of red, turquoise, and yellow around it have faded. Traces of the original, deep

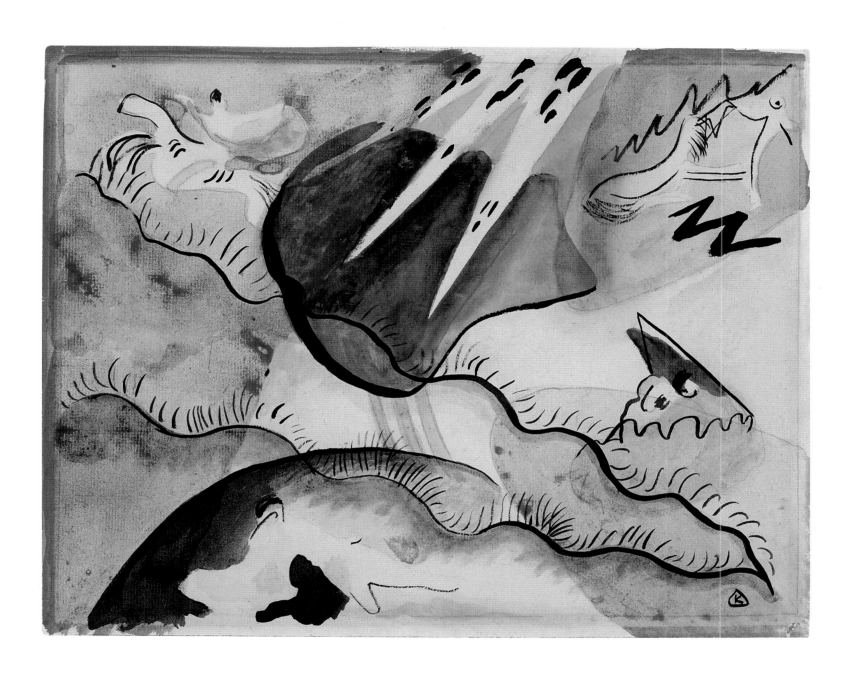

colors still remain at the outer edges of the sheet. The title *Rain Landscape*, not Kandinsky's own, dates to 1920, when the watercolor was first reproduced in the German art magazine *Der Ararat*.[3]

In his long treatise "On the Spiritual in Art" (1911), Kandinsky singled out music as the "most non-material of the arts," finding in its "pure sound . . . the expression of the artist's soul." In emulation of music, Kandinsky wanted to move away from representation in his paintings in order to arrive at "pure" abstract forms and color. To these he attributed "spiritual values," and he believed that the artist created them out of "inner necessity" and "spiritual impulses." For Kandinsky, the act of painting was a religious experience.

1. Felix Klee, ed., *The Diaries of Paul Klee: 1898–1918*, translated by Pierre Schneider, R. Y. Zachary, and Max Knight, Berkeley and Los Angeles, 1964, p. 265. Translation emended.

2. All ten watercolors are illustrated in *Der Blaue Reiter* (exhib. cat.), compiled by Hans Christoph von Tavel, Bern, Kunstmuseum, 1986, pp. 96–98.

3. Vivian Endicott Barnett, The Solomon R. Guggenheim Museum, New York, has kindly supplied this information.

Marc Chagall

French, born in Russia, 1887–1985

THE LOVERS

1913–14
Oil on canvas
43 × 53 in. (109.2 × 134.7 cm.)
Signed and dated (bottom right):
Chagall/Marc *1911* [sic]/Paris; *signed twice (on the reverse):* Chagall

MARC CHAGALL'S childhood was a happy one. He was born in a suburb of Vitebsk, a small, provincial Russian town near the Polish border, where, as a young man, he studied briefly with Jehuda Penn, a local painter. In 1907, in Saint Petersburg, Chagall attended the Imperial School of Fine Arts, and, intermittently between 1908 and 1909, he took classes with Leon Bakst. However, it was his memories of the peasants and the animals in Vitebsk's Jewish ghetto that would serve him all his life with themes for his paintings. Jewish folklore and Old Testament tales, and the circus would become his preferred subjects.

Mainly self taught, Chagall developed a unique style that blends sentiment and fantasy, and combines events separated by time and space in a single composition. People, animals, and objects are shown upside down or floating through the air—an effect that the poet Guillaume Apollinaire, in 1911, would call "supernatural." From 1910 to 1914, he lived in

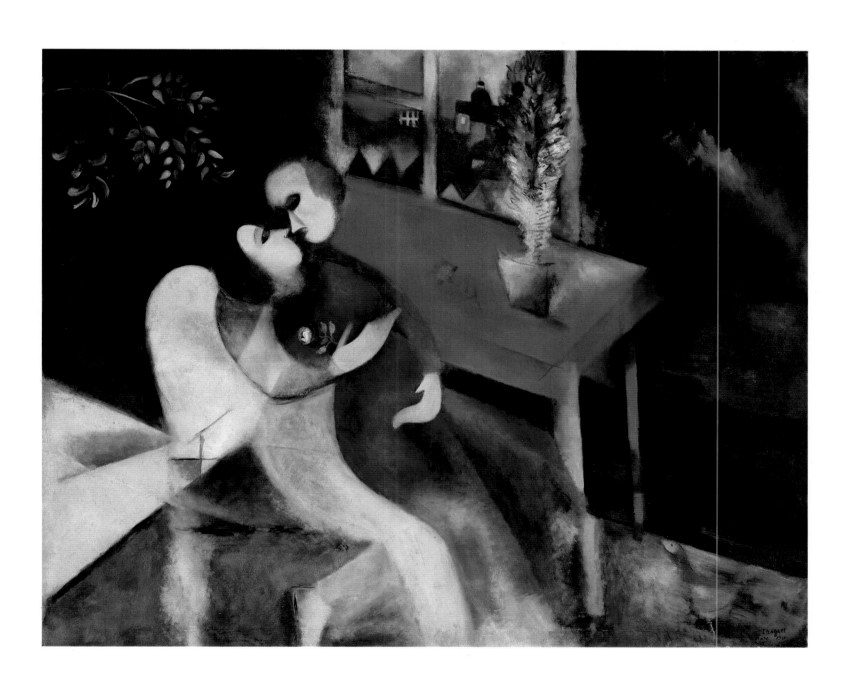

Paris, where he was supported by a monthly stipend from Max Vinaver, a wealthy patron of the arts. In the winter of 1911–12, Chagall moved into a studio at "La Ruche" ("the Beehive"), a building-complex housing about one hundred and forty artists, located at 2, Passage Dantzig. Overwhelmed by the quality of the light in Paris and by its art-filled museums and galleries, Chagall roamed the Louvre and visited exhibitions. At night, he would paint. He experimented with Fauvism, and also became acquainted with Cubism. He rejected the latter style for his own mode of painting, but he often would adopt certain Cubist features, such as the reduction of his compositions to flat, sometimes translucent or overlapping planes of color, thus eliminating any impression of depth.

The present nocturnal picture, painted in Paris, is part recollection and part anticipation. According to Chagall's biographer, Franz Meyer, it represents the artist with his fiancée, Bella Rosenfeld, in his room in Vitebsk.[1] (Bella, the daughter of a well-to-do Vitebsk family, was well educated, and well traveled. She and Chagall were married in Vitebsk in 1915, after he returned to Russia via Berlin following his long absence in France.) Through a window, we glimpse the pitched roofs of the buildings in the village and a round cupola perhaps belonging to the seventeenth-century Ilinski church that Chagall mentions in his autobiography, *My Life* (1922), as visible from his apartment.[2] The light of dawn—or of dusk—singles out a few objects: the red table, with its tall potted plant; the silvery-white branch at the upper left; Bella's flower; the man's large and strategically placed hands; the mask-like white faces; and a strange, curved white form also at the left. As is the case with so many of Chagall's depictions of lovers floating through the air, this couple seems completely weightless. Likewise fantastical is the way in which the man's head seems attached to the tip of his left shoulder, and the fact that Bella seems to lack arms, hands, and feet. Bearing in mind that Chagall liked to place his scenes in a biblical or religious context, it is possible that the ambiguous white form might be the man's wing—which would turn the picture into an Annunciation scene. However, instead of a dove, a hen struts at the lower right—as Chagall might have observed in his backyard in Vitebsk.

On stylistic grounds, Franz Meyer dates this work to 1913–14, even though Chagall dated it 1911. The artist had left most of his Parisian paintings undated until 1914, when he was about to leave France. Then, in preparation for a one-man show that Herwarth Walden was organizing at his Galerie der Sturm in Berlin—to take place in June 1914—Chagall was forced to date the pictures after the fact, which perhaps accounts for the error.[3] It was Walden's Berlin exhibition that established Chagall's fame in Germany, and exerted a great influence on German artists, such as Max Ernst (1891–1976), Georg Muche (1895–1987), Kurt Schwitters (1887–1948), and Heinrich Campendonk (1889–1957). *The Lovers*, one of the largest and last works that Chagall painted in Paris—but one of the earliest to treat a theme that would preoccupy him all his life—was probably included in the landmark Galerie der Sturm exhibition.

1. Franz Meyer, *Chagall*, New York, 1967, p. 204.
2. Marc Chagall, *My Life*, translated by Elisabeth Abbott, New York, 1960, p. 76.
3. Meyer, op. cit., p. 143.

Pierre-Auguste Renoir

French, 1841–1919

WASHERWOMAN

1916
Bronze
13¼ × 11½ × 6 in. (33.7 × 29.2 × 15.2 cm.)
Inscribed (at the left): Renoir

PIERRE-AUGUSTE RENOIR wrote to a friend in 1913, "When Vollard first spoke to me about sculpture, I told him to go to hell, but after thinking it over, I let myself be persuaded."[1] That, indeed, was when Renoir's dealer, Ambroise Vollard, hired the young Catalan sculptor Richard Guino (1890–1973) to assist the aging artist in projecting his painterly ideas into three dimensions.

Guino had been a student of Aristide Maillol. According to Paul Haesaerts, who later catalogued Renoir's sculpture, Guino's style, "before and after his meeting with Renoir, was not very fixed; it might be said that he did not have a style of his own."[2] The collaboration between the seventy-two-year-old Renoir and the twenty-three-year-old Guino began in 1913 and lasted until 1917, and its fruition produced some nineteen sculptures, all of which Vollard intended to have cast in bronze.[3]

Renoir suffered from severe rheumatoid arthritis, which had completely paralyzed his legs, causing him to be confined to a wheelchair. His hands had lost their flexibility, his fingers becoming stiff and bent. To paint, he fixed a paintbrush to his right hand, relying upon the motion of his arm to propel the brush. War brought additional hardships—two of his sons, Pierre and Jean, were wounded in 1914, and his wife, Aline, died in June 1915—but Renoir, nevertheless, continued to create serenely happy images of women in both painting and sculpture.

This bronze statuette represents a washerwoman soaking her linen. It is endowed with the same earthiness, ample proportions, and vague expression that characterize all of Renoir's female figures, especially those depicting bathers, which appear in his oeuvre after 1885. Together with another small study of a blacksmith forging iron (Haesaerts, 19), the initial plastic conception of the *Washerwoman* was begun by Renoir during the summer of 1916 at "Les Collettes," his house in Cagnes-sur-Mer in the south of France. Both works, of which several different versions exist, were conceived as allegories portraying *Water* and *Fire*, and were envisioned as companion studies for larger sculptures to be placed outdoors. The first version of the *Washerwoman* was fired in terra-cotta, cast in plaster, and then reworked, the changes consisting primarily of subtle variations in the hands and the forearms.

The collaboration with Guino has been described by Renoir's son Pierre: "A sketch on paper or canvas by Renoir would furnish the general set-up of the mass of clay. With a light

wand the old man would indicate how the work was to continue, at one place making a mark on the maquette where the ready modeling tool of the young sculptor was to cut away excess volume, at another place showing by a pass through the air how the contour was to swell out by the addition of more material. . . . They communicated by grunts when the thing got so close to the definite result that it got exciting . . . the sculptor would be making his little jabs with the tool, so much like my father's brushstrokes that you'd think the work came from his hand, as indeed it almost did."[4]

In 1917, Guino began work on the enlarged version of the *Washerwoman*, also known as *Water* (Haesaerts, 21). He was guided by the model, and by certain of Renoir's drawings that had become the property of Vollard—who enjoyed the exclusive right to all of the artist's bronzes. According to Haesaerts, Renoir hardly ever interfered with the making of the large version, which differs from the small one in that both hands grasp the cloth in order to pull it from the water. While the intended large versions of the washerwoman and the blacksmith figures were still in the formative stage, Renoir, no longer pleased with Guino, halted their collaboration. Only the *Washerwoman* was cast in bronze—and it lacks the lively surface treatment that characterized Renoir's style as it appears in this original and smaller version.

In 1973, Guino brought a lawsuit against Renoir's heirs and the French court decided that "the sculptures which he executed to Renoir's designs should be attributed to the joint authorship of the two men."[5]

1. Letter to Alfred André, cited in Barbara Ehrlich White, *Renoir: His Life, Art, and Letters*, New York, 1984, p. 261.

2. Paul Haesaerts, *Renoir: Sculptor*, New York, 1947, p. 17.

3. Renoir had first tried sculpture in 1907, modeling a portrait medallion of his young son Claude, followed the next year by a portrait bust.

4. Cited in Walter Pach, "Pierre-Auguste Renoir," *Scribner's Magazine* (May 1912), reprinted in *Queer Thing, Painting*, New York, 1938, p. 106.

5. John House, "Venus Victorious," *Renoir* (exhib. cat.), London, The Hayward Gallery, and Boston, Museum of Fine Arts, 1985–86, cat. no. 127, p. 290.

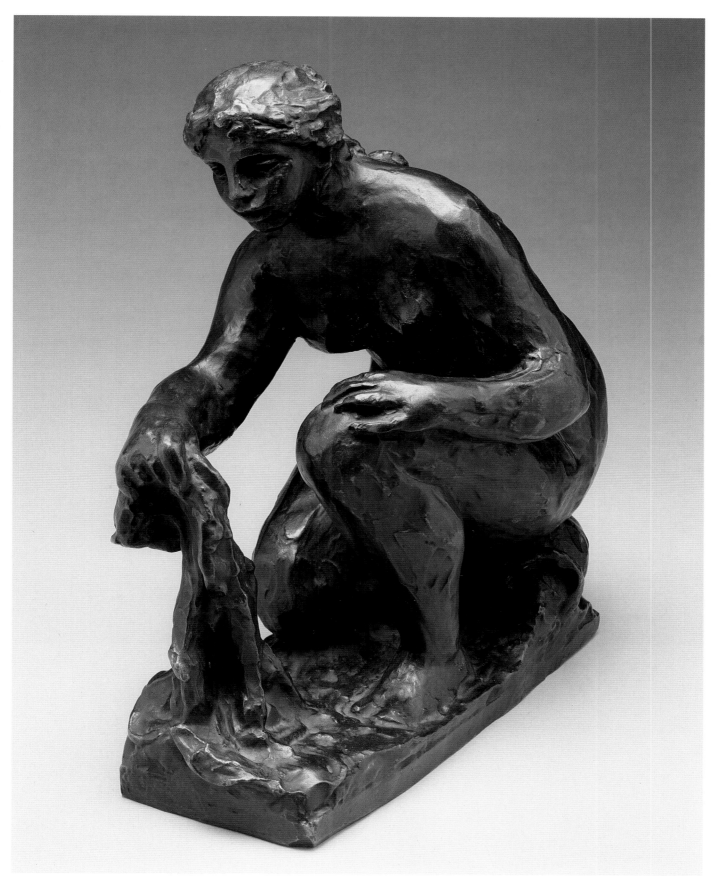

Renoir. *Washerwoman*

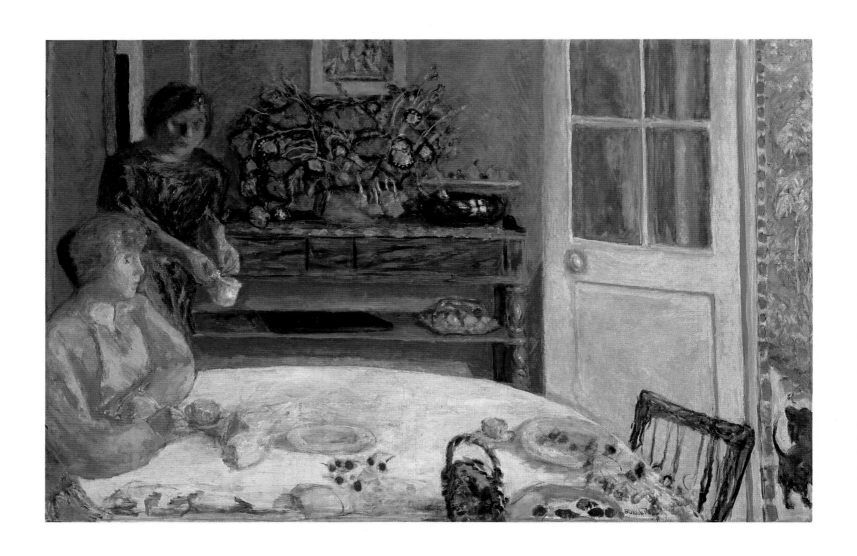

Pierre Bonnard

French, 1867–1947

THE DINING ROOM, VERNONNET

about 1916
Oil on canvas
37¾ × 57¼ in. (95.7 × 145.4 cm.)
Signed (bottom right): Bonnard

IN 1912, Pierre Bonnard purchased "Ma Roulotte" ("My Gypsy Caravan"), a house in the village of Vernonnet, in the valley of the Seine. Due to his companion, Marthe's, poor health, she and Bonnard spent increasingly more time in the country, away from Paris. Their house was a modern, two-story dwelling surrounded by a garden that reached to the banks of the river. Judging from photographs, "Ma Roulotte" had little charm, but Bonnard is known to have been oblivious to his surroundings.

According to those who knew Bonnard, the colorful interiors that he depicted in his paintings contrasted sharply with the plain surroundings in which he actually lived and worked. Here, Bonnard transforms the undoubtedly very simple dining room in "Ma Roulotte" into a sumptuous decor aglow with rich reds, purples, oranges, and whites. A warm light emanates from the doorway, illuminating the wall, the lush bouquet of wild flowers on the console, the large tabletop, and the marigold-yellow blouse of the seated, red-haired visitor. This scene probably never took place because Marthe, shown standing, was so shy that she did not like to receive guests.

This painting continues a succession of scenes of dining-room interiors that Bonnard created, with infinite variations, throughout his career. Previously, in 1909, in similar compositions, he had moved the out-of-doors inside by including open doors and views from windows, and in a work dating from 1913 he brought the landscape even further into the room (see Dauberville II, 763). In this painting, however, he emphasizes the interior itself, and the landscape appears only as a narrow vertical strip at the extreme right, just wide enough for a glimpse of Marthe's dachshund, "Ubu."

The Dining Room, Vernonnet (about 1925; see Dauberville III, 1316), painted some ten years later, is closely related to this picture, but there is no trace of the little basket of fruit on the table; it only appears in works from 1916 through 1918.

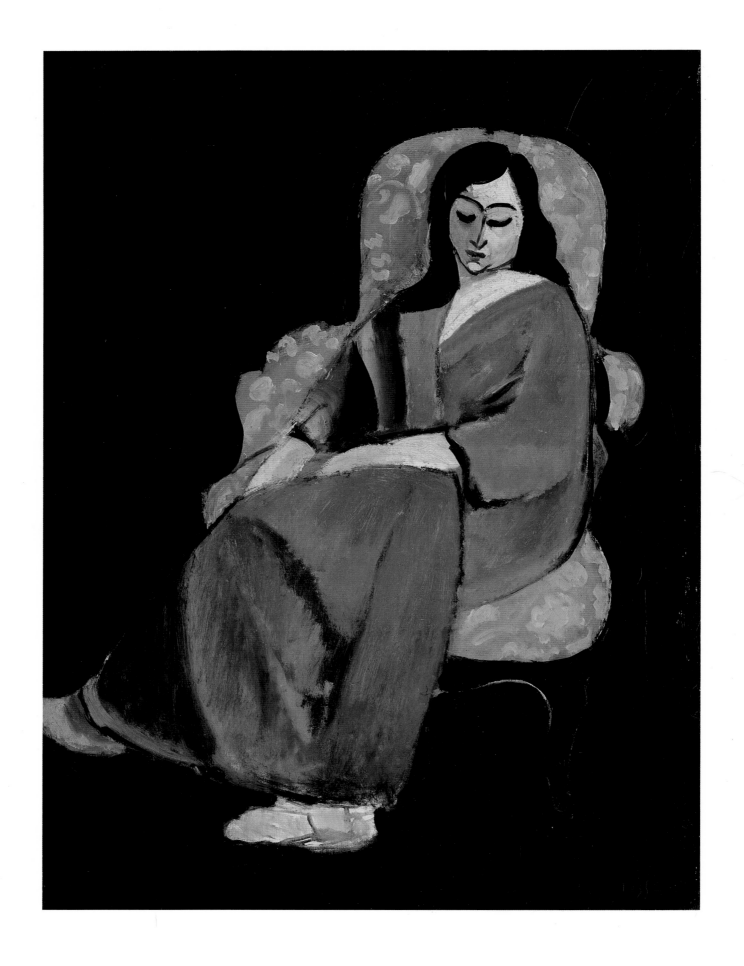

Henri Matisse

French, 1869–1954

LAURETTE IN A GREEN ROBE, BLACK BACKGROUND

1916
Oil on canvas
28¾ × 21⅜ in. (73 × 54.3 cm.)
Signed and dated (bottom right): H-MATISSE 16

BETWEEN DECEMBER 1916 and the close of 1917, Henri Matisse painted at least twenty-five pictures of an Italian model named Laurette. She also posed with her sister and with a woman named Aïcha for some fifteen additional works by the artist. Laurette was recommended to Matisse by Georgette Sembat (née Agutte; 1867–1922), a painter and Matisse's friend. Mme Sembat, the wife of the Socialist deputy Marcel Sembat (1862–1922)—author of the first monograph on Matisse—had been aware that the model was Matisse's "type."[1]

FIGURE 1. Henri Matisse. *The Painter in His Studio.* 1917. Oil on canvas, 57⅝ × 38⅛ in. (146.5 × 97 cm.). Musée National d'Art Moderne, Centre Georges Pompidou, Paris

Sometimes Matisse depicted Laurette wide-awake, as in a series of close-up portraits, and at other times she is shown lounging languorously on a sofa. Sometimes she wears the exotic costume or headdress of an odalisque. This painting, however, is different. Here, Laurette, in floppy slippers, without her usual decorative accessories, and undoubtedly nude under the voluminous green robe, appears to rest between sittings. Since there are no indications of the room or of the surrounding space, the curvilinear shape of the plush Second Empire armchair envelops Laurette like a fluffy pink cloud on which she seems to float, like an earthy Madonna, through a pitch-black void.

Between 1914 and 1921, Matisse occasionally painted the backgrounds of his portraits or still lifes black. However, he would use black with such exclusiveness only one more time—namely, in the tiny version of this canvas that appears as a picture-within-a-

picture on an easel in *The Painter in His Studio* of 1917 (fig. 1). Laurette's posture in the latter painting varies only slightly from the one she assumes in the present work.

Matisse painted these pictures of Laurette in his studio at 19, Quai Saint-Michel, in Paris. The studio was on the fourth floor, facing the Préfecture de Police on the Île de la Cité, just across the Seine. We glimpse a section of this building through the open window in *The Painter in His Studio*. As remembered by the artist's son, Pierre, Laurette was somewhat unconventional. When she stopped posing, and took a break, she would go to the open window for some air, oblivious to the fact that she was stark naked. According to Pierre Matisse, "On these occasions the windows of the Préfecture would be quickly filled with staring men."[2]

1. Conversation with Wanda de Guébriant in Paris, June 3, 1988.

2. Conversation with Pierre Matisse in New York, May 25, 1988.

Giorgio de Chirico

Italian, born in Greece, 1888–1978

THE JEWISH ANGEL

1916
Oil on canvas
26⅝ × 17¼ in. (67.5 × 44 cm.)
Signed and dated (lower left): G. de Chirico/1916

GIORGIO DE CHIRICO is most acclaimed for the melancholic Italian cityscapes that he painted between 1911 and 1917. In these pictures, public squares are deserted, except for a lone statue, and arcaded buildings are seen in exaggerated perspective. Clear autumn light casts long evening shadows, although, curiously enough, the time of day, often shown on round clocks high up on train stations, is always between 1:00 and 3:00 P.M.—in Italy the hours of siesta.

Such settings often function as a stage on which simple, everyday objects—such as bananas, a plaster cast, artichokes, a ball, or a glove—are casually thrown. Seen thus, out of context and magnified, they assume strange, unreal identities, and seem in keeping with the example the Surrealists would later give to describe the meaning of the "surreal." Indeed, the "early" de Chirico, the painter of simple and magical dream pictures, became one of the acknowledged predecessors of the Surrealists.

Like Marc Chagall, who conjured up his native Russia in the works he painted from 1910 to 1914 while he was living in Paris (see page 135), de Chirico created his most elegiac Italian cityscapes while he, too, lived in the French capital, from 1911 to 1915. In 1915, he was drafted into the Italian army, in Ferrara, and although he was subsequently released due to a mental disorder, he remained in Ferrara until 1918, which is where he painted the present picture. It was also in Ferrara that, together with Carlo Carrà (1881–1966), he founded the short-lived movement known as the "scuola metafisica." It appears that the objects depicted in the paintings by the artists in this group were supposed to convey a meaning that went beyond their physical appearance.

Upon de Chirico's return to Italy from Paris in 1915, he had begun to make paintings of interiors filled with strange objects. This canvas, with its monochromatic gray background and, as the sole indication of space, the shadows cast by light from the right, is exceptional among these "interiors." Similarly, although the "carpentry" depicted in *The Jewish Angel* appears in many other contemporary works by de Chirico, it never is so self-contained as to form the main subject or focus of a picture. Here, the exquisitely crafted and painted "carpentry," stacked pell-mell above what might be two mileage stones of the kind usually found near railroad tracks, anticipates the recent "Exotic Bird" reliefs by the American artist Frank Stella. What is interesting is that, not long ago, when William S. Rubin wrote about

de Chirico. *The Jewish Angel*

de Chirico, it was Stella who helped him to identify the pink polka-dotted fancy swirl in this painting as the template of an "Irregular Curve," or Railroad Curve.[1] (The latter was a wooden object used in mechanical drawing, from the mid-nineteenth century on, by railroad engineers such as de Chirico's father.) In fact, everything assembled in this elaborate composition relates in one way or another to the professions of both the elder and the younger de Chirico. The thin stretchers were employed by Giorgio de Chirico, while, in addition to the aforementioned "Irregular Curve," the blue-and-white measuring device and the bent, curved, or odd-shaped pieces of wood might be further references to his father's railroad career. Among these objects is a large piece of cardboard, its upper-left corner folded forward like a visitor's calling card. The huge eye crudely drawn on it—the iris and pupil comprising one large, black form—seems odd in contrast to the precisely and realistically rendered "carpentry." Perhaps this scaffold-like structure and its eye are supposed to constitute an abstract portrait and, as such, are de Chirico's tongue-in-cheek comment on Synthetic Cubist collages with similar subjects.[2]

The same, unblinking eye stares out from the artist's *Greetings of a Distant Friend* of 1916, a still life of two cookies, where—combined with the title and the turned-up corner of the paper—it also assumes the character of a calling card. In his autobiography de Chirico mentions that the shop signs and window displays in Ferrara had fascinated him,[3] and he might very well have seen an enormous eye—like the one in the painting—on a sign for an optician's shop. How appropriate of de Chirico to include the motif of the eye in this painting, along with other objects that refer to professions in which measuring and seeing play important roles.

De Chirico could not have been unaware that a large, all-seeing eye is the traditional way of representing God the Father, and this might have inspired his choice of title, since Old Testament angels are usually the messengers of the Almighty.

1. William S. Rubin, "De Chirico and Modernism," in *De Chirico* (exhib. cat.), edited by William S. Rubin, New York, The Museum of Modern Art, 1982, pp. 67, 79, n. 32.

2. However, William S. Rubin suggests that *The Jewish Angel* might be an " 'abstract' Cubist-inspired counterpart" to the artist's earlier "realist" portrait of his father in *The Child's Brain* of 1914. The latter is a gruesomely morbid representation of the elder de Chirico with eyes closed and his flabby torso naked.

This striking image has been widely quoted by artists, among them Max Ernst and Salvador Dali. Rubin suggests that Picasso likewise cited this image, however abstractly, in his *Man with a Pipe* of 1915 (Zervos II2, 564), to which de Chirico, coming full circle, is supposed to have responded with *The Jewish Angel*. See William S. Rubin, op. cit., p. 69.

3. *The Memoirs of Giorgio de Chirico*, edited and translated by Margaret Crosland, Coral Gables, Florida, 1971, p. 80.

Amedeo Modigliani

Italian, 1884–1920

BOY IN A STRIPED SWEATER

1918
Oil on canvas
36 × 21½ in. (91.5 × 54.5 cm.)
Signed (top right): modigliani

S HORTLY AFTER his death from tuberculosis in 1920, at the age of thirty-five, the circumstances of Amedeo Modigliani's brief and tumultuous life became embroidered by myth and legend. He grew up in Livorno, Italy, one of four children of a cultivated, once prosperous Jewish merchant family. In order to ease financial matters, his enterprising mother and her sister, a literary critic, opened an experimental school for precocious children, teaching them philosophy and literature.[1] The intellectual and literary fervor at home influenced the young Modigliani, a beautiful and sensitive child, who, it is said, read Lautréamont, Nietzsche, Wilde, Verlaine, and Henri-Louis Bergson, and, when he was older, could recite whole pages from Dante's *Divine Comedy*.

Modigliani's life was overshadowed by illness. At the age of fourteen he suffered from a bout of pleurisy that ended his formal schooling. In 1901, he contracted a typhoid infection, followed by tuberculosis—from which he would never recover. Between 1902 and 1906, Modigliani visited Capri, Naples, Florence, Venice, and Rome. The actual beginnings of his career as an artist coincided with his arrival in Paris in the winter of 1906, with a small allowance from his family, which he continued to receive until the outbreak of World War I. In the remaining fourteen years of his life, he would produce an oeuvre comprising some 420 paintings—of which only about fourteen are dated—and innumerable drawings.

Except for four landscapes painted in 1919 in the south of France, his main subject matter consisted of portraits. Between 1917 and 1919, Modigliani also produced about twenty-five *Nudes*—paintings whose eroticism, although stylized, is frankly sensuous. His early portraits (1906–9) reflect the influence of Edvard Munch, Toulouse-Lautrec, and the Picasso of the Blue period, after which Modigliani fell under the spell of Cézanne. By 1916, he had found his own style, which James Thrall Soby so aptly called one of elegant "mannerist elongation."[2] This particular mode of reducing the features of his sitters to their essentials was largely provoked by Modigliani's previous activity as a sculptor, from 1906 to 1915—a period when he hardly painted at all. Dr. Paul Alexandre, his first patron and collector, had introduced the artist to the Romanian sculptor Constantin Brancusi in 1909. During the following years—with the latter acting as his teacher and mentor when they were neighbors in the Cité Falguière—Modigliani produced twenty-nine monumental sculpted heads (twenty-eight in stone and one in wood) and two full figures. Carved directly into the stone,

the archaistic, stylized features of these heads derived from non-European art and, of course, from that of Brancusi. The onset of World War I, however, resulted in the closing of most of the building sites in Paris where the artist found his materials. The difficulty in obtaining stone, along with respiratory problems brought on by dust, made Modigliani give up sculpture. Many consider his carved totemic, strangely androgynous smiling heads as his most original contribution to the art of this century. However, while these were imaginary, his painted portraits were always from the model, and usually finished in a single sitting. Modigliani was also a consummate draftsman, and, throughout his stay in Paris, attended sketching classes.

It is a tribute to the artist's insight into human nature that, with just a few telling details, often of an ironic or satirical nature, he was able to achieve a striking likeness. This quality, as noted by John Russell, is most pronounced in Modigliani's portraits of men,[3] among them, of the artists and writers Jean Cocteau, Max Jacob, Juan Gris, Chaim Soutine, and Jacques Lipchitz, and also of the dealers Paul Guillaume and Leopold Zborowski.

By 1918, Modigliani's style had become more fluid and graceful, and his palette had lightened—as can be seen in this painting of a seemingly shoulderless young boy somewhere between thirteen and fifteen years of age. As in most of Modigliani's close-up or half-length portraits, there is little indication of the surroundings. Usually a blank wall or, as here, a paneled door were the artist's favorite backgrounds. Modigliani represents the boy's body at a slight angle, to which he aligns the direction of the nose and upper lip. It gives the sitter a somewhat sardonic and even tough look, rather surprising in someone that young. The boy's ill-fitting dark-blue suit, blue-and-white striped sweater worn over a dark shirt, and his wide cummerbund resemble the uniform of a restaurant or hotel busboy or porter. From March 1918 until May 1919, Modigliani and Jeanne Hébuterne (1898–1920), his mistress and the mother of his child, lived in the south of France—mainly in Nice—because of the artist's seriously deteriorating health.[4] Lacking his usual coterie of friends, Modigliani employed local young servants, shopgirls, and children as his models.

1. Carol Mann, *Modigliani*, New York and Toronto, 1980, p. 9. Much of the biographical information on Modigliani is taken from this volume.

2. James Thrall Soby, *Modigliani: Paintings, Drawings, Sculpture*, New York, The Museum of Modern Art, 2nd rev. ed., 1954, p. 9.

3. John Russell, *Modigliani* (exhib. cat.), London, The Arts Council of Great Britain, 1963, p. 7.

4. Carol Mann, op. cit., p. 161.

Fernand Léger

French, 1881–1955

THE BARGEMAN

1918
Oil on canvas
19⅛ × 21⅜ in. (48.5 × 54.2 cm.)
Signed (bottom right): F LEGER

IN ADDITION to Picasso, Braque, and Gris, Fernand Léger ranks among the foremost Cubist painters. By 1912, he had developed his own, personal adaptation of Cubism. Utilizing pure color, he simplified the forms in his pictures into geometric components of the cone, cube, and sphere, leaving their contours unbroken. Léger was also fascinated by machines and by modern technology—which, he was firmly convinced, were capable of changing not only our lives but also our ways of seeing. He expressed these views in his paintings as well as in his many published essays.

Léger's concept of the relationship between modern life and art was significantly reinforced by his experiences during World War I, when, in his capacity as a sapper and stretcher-bearer, he was brought face-to-face with the grim advances in technology on the one hand, and with the courage of ordinary men on the other—both of which would become the subjects of his paintings.

The Bargeman, which shows a boat set against a background dominated by the façades of houses, provided the artist with the opportunity to combine several of his favorite themes: motion, the city, and men at work. With colorful and overlapping disks, cylinders, cones, and diagonals, Léger presents a syncopated, abstract equivalent of the visual impressions of a man traveling along the Seine through Paris. All that can be seen of the bargeman, however, are his tube-like arms, in the upper part of the composition, which end in metallic-looking claws. These appear to clutch at the violet-accented, fan-like form resting on the large yellow, red, violet, and white disk, which looks somewhat like a steering wheel. (Also in 1918, Léger painted another version of this subject—now in the collection of The Museum of Modern Art, New York—that includes the head of the bargeman, as well as two larger paintings, both known as *The Tugboat*, the final one of which is dated June 1918.)

Léger's boatmen resemble the robot-like figures in a large canvas entitled *The Cardplayers* (1917) in the Rijksmuseum Kröller-Müller, Otterlo. The artist worked on the painting at the

Léger. *The Bargeman*

152

hospital in Villepinte where he was recovering from war injuries, and the picture, indeed, most dramatically recapitulates his work of that period. It was also in Villepinte in 1917 that Léger made the initial sketches for the "Tugboat" and "Bargeman" series (see figs. 1, 2),[1] which would occupy him intermittently until 1923.

1. See Christopher Green, *Léger and the Avant-Garde*, New Haven and London, 1976, p. 167.

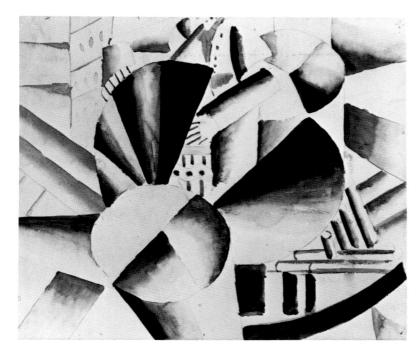

FIGURE 1. Fernand Léger. *The Bargeman.* About 1917. Watercolor on paper, 9¾ × 11⅜ in. (24.7 × 28.8 cm.). Kunstmuseum, Bern, Hermann and Margrit Rupf-Stiftung

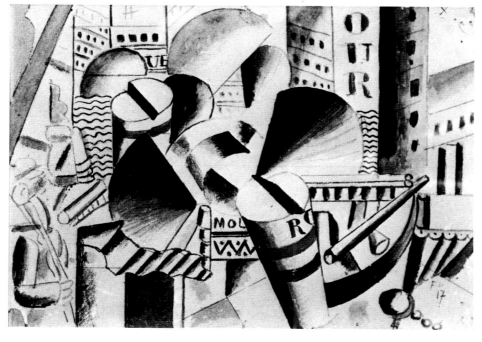

FIGURE 2. Fernand Léger. *The Bargeman.* 1917. Gouache on paper. Private collection

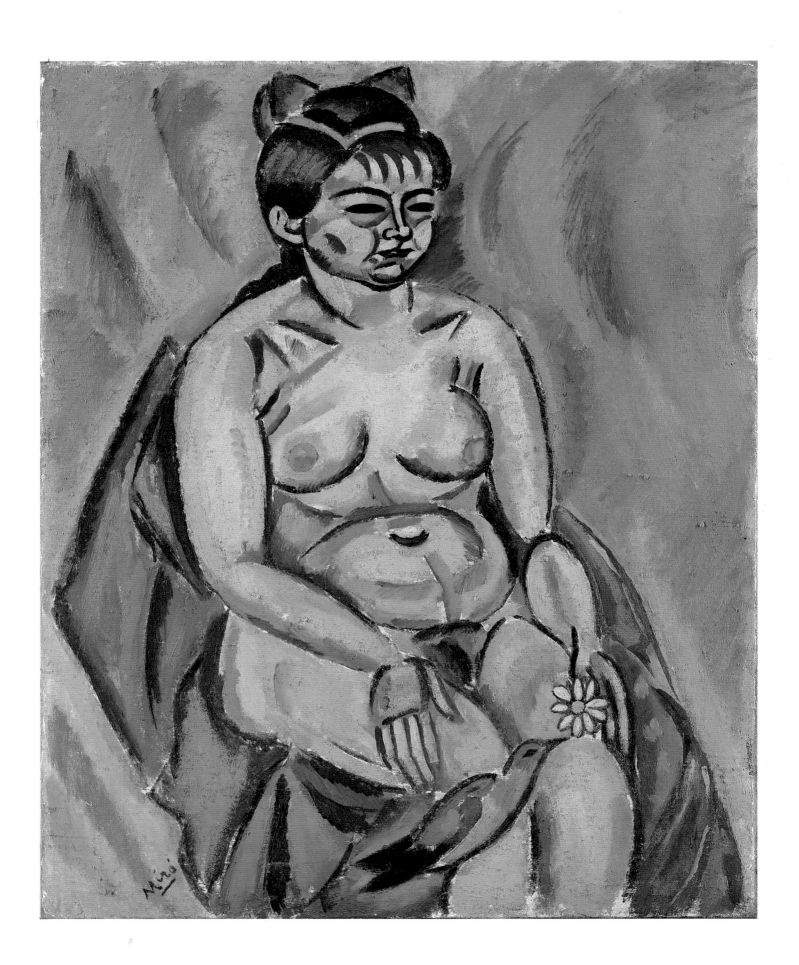

Joan Miró

Spanish, 1893–1983

SEATED NUDE HOLDING A FLOWER

1917
Oil on canvas
32 × 25¾ in. (81.3 × 65.5 cm.)
Signed (bottom left): <u>Miró</u>

W ITH ONE or two exceptions, Joan Miró's early paintings, dating from 1914 through 1916, were still lifes and landscapes. During those years, he intermittently attended evening classes at the Cercle Artístic de San Lluc in Barcelona, studying and making drawings of male and female nudes. Several of these small pencil sketches still exist (see fig. 1), and a few, dated 1917, are of the same model that appears in the present painting.

FIGURE 1. Joan Miró. *Nude* (from Notebook F.J.M. 366–418). About 1917. Pencil on paper, 12⅜ × 8½ in. (31.3 × 21.5 cm.). Fundació Joan Miró, Barcelona

This *Seated Nude*—Miró's first painting of the subject—was probably completed early in 1917, when the artist was only twenty-four years old. It relates in style to two other works—one, a self-portrait (1917; Dupin 49) and the other, a portrait of Miró's friend the artist Josep F. Rafols (1917; Dupin 51).

The dark outlines and the somewhat strident combinations of blue, mauve, and green owe much to Fauve examples. The rendering of the background drapery and of the model's body are crude, but the total image, far from being an awkward rendition of form, is strong and vibrant.

This picture was included in Miró's first one-man show in February 1918 at the Galería Dalmau in Barcelona. The only purchaser was Josep Dalmau himself. In private hands ever since and never shown publicly, *Seated Nude Holding a Flower*—in the Gelman collection since 1967—was presumed lost for many years.

Joan Miró

Spanish, 1893–1983

VINES AND OLIVE TREES, TARRAGONA

1919
Oil on canvas
28½ × 35⅝ in. (72.5 × 90.5 cm.)
Signed and dated (bottom left): Miró./1919

MIRÓ SPENT the summer of 1919 at his family's farm near Montroig (Catalan for "Red Mountain"), a large village in the province of Tarragona, about one hundred and twenty kilometers from Barcelona and only six kilometers from the Mediterranean coast (see fig. 2, page 158). Highly disciplined in his working habits, the artist divided his days among several pictures. For example, during the mornings he continued a painting begun the previous year, depicting the village of Montroig, entitled *Montroig, The Church and the Village* (1919; Dupin 63), and in the afternoons he worked on this picture, which he described to his painter-friend E. C. Ricart, in a letter of July 9, 1919, as: ". . . a large canvas with a landscape of olive trees, carobs, vines, mountains (a torrent of

FIGURE 1. View across the plain of Montroig, Spain, with the village of Montroig in the distance, at the far right. June 1988 (Photograph: Sabine Rewald)

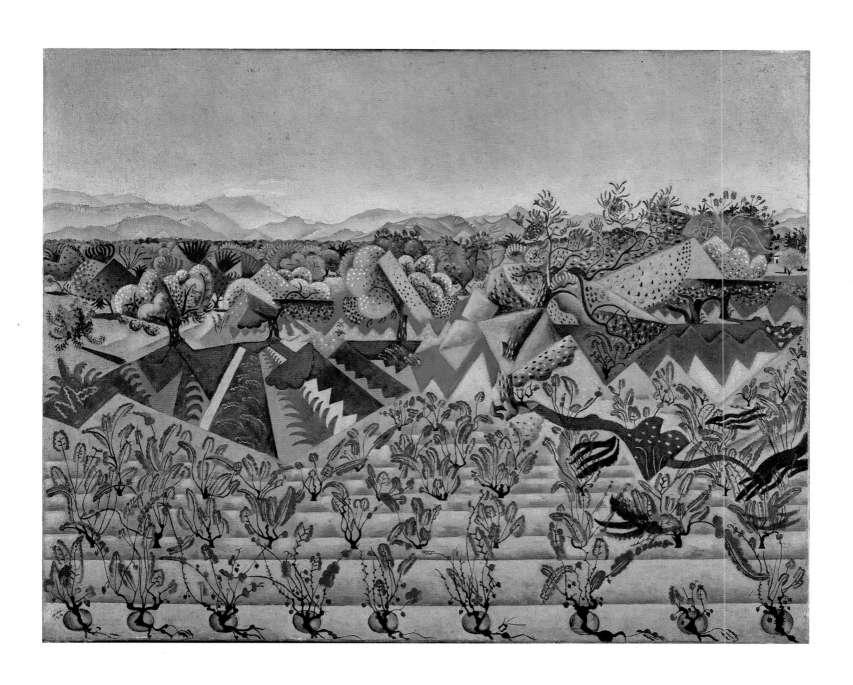

light). I can work comfortably on this canvas from my room (terrific convenience). . . . I want to study it carefully, spending all summer on it and alternating my work with some light sketching so as not to tire myself out too much, spending so much time on one canvas."[1] Then, six weeks later, he informed another friend that he had changed both paintings "a thousand times," and that in the present work, his "afternoon painting" as he called it, "the horizontally sliding sun had caused [him] to use a kind of *pointillisme*."[2]

In his published letters and interviews Miró often states how deeply attached he was to the landscape of Montroig. He identified with Montroig as fiercely as a proud Catalan peasant with his soil. From the time that Miró settled in Paris in 1921 until his move to Palma de Mallorca in 1956, he spent several months each year in Montroig, relaxing and working. He recorded his love for the village and its surroundings in the nearly forty landscapes that he painted there between 1914 and 1922—the most famous of which is *The Farm* of 1921–22 (Dupin 76), which belonged to Ernest Hemingway.

FIGURE 2. The nineteenth-century "Mas Miró," Montroig, Spain. The artist's studio is in the foreground. June 1988 (Photograph: Sabine Rewald)

The view from the farm, here, shows the mountains about three kilometers to the north; behind us, another three kilometers away, is the sea. As in the earlier *Seated Nude Holding a Flower* of 1917 (see page 154), Miró mainly used various shades of green and mauve—the latter, to represent the red earth of the region as it appears bleached by strong sunlight. In a style described by Jacques Dupin as "poetic realism"—which Miró had adopted the previous summer in a series of four landscapes—the artist minutely detailed every tiny leaf, twig, and root of the row of plants in the foreground. They hardly look like vines—although that is how Miró referred to them in his letter to Ricart. Gaily interrupting this detailed realism are the colorful, cubistic planes of the middle ground. Further in the distance, the band of highly stylized and much-simplified trees and bushes dotted with tiny "pointillist" flecks evokes the shimmering atmosphere of the "horizontally sliding sun" that Miró also mentioned in his letter. The afternoon sun wraps the distant mountain chain in a transparent gold-and-mauve light. These mountains extend from the "Pla de la Sereno" peak on the left, through the high, saddle-topped "Mola de Llaveria" (912 meters), to the "Escornalbou" visible on the right—beyond which a row of trees partly hides the continuing chain of mountains.[3] A comparison of the view as shown in the painting with a photograph of it taken from Miró's farm in 1988 (see fig. 1, page 156) indicates how the artist compressed the distances between the individual mountaintops. The actual village is situated about three kilometers from the farm, its houses clustered around a large church at the foot of a mountain. Although in the photograph in figure 1 the village is visible far off, to the right, in the painting it is hidden behind high trees and bushes. However, Miró did choose to include one of his favorite places, the hermitage known as the "Mare de Deu de la Roca." According to Dupin, it was where the artist liked to take visitors. Perched high on a rock, the hermitage appears in both painting and photograph as two tiny white spots in the distance.

1. *Joan Miró: Selected Writings and Interviews*, edited by Margit Rowell. Translations from the French by Paul Auster; from the Spanish and Catalan by Patricia Mathews, Boston, 1986, pp. 60–61.

2. Ibid., p. 63.

3. José-Maria Aragones y Roca, the mayor of Montroig, supplied the names of these mountains in June 1988.

The 1920s

Fernand Léger

French, 1881–1955

MECHANICAL ELEMENTS

1920
Oil on canvas
36⅛ × 23½ in. (91.8 × 59.7 cm.)
Signed and dated (lower right): F LEGER/20
Inscribed by the artist (on the reverse):
ÉLÉMENT MÉCANIQUE/F LEGER (DEFINI . . . [?])/20

The public was disgusted by my paintings. For two years, Léonce Rosenberg, my dealer at the time, could not sell any of the works from my "mechanical period," while the mandolins of the Cubists moved briskly. "The last thing I want to see is a Léger," said a famous collector to poor Léonce, who by that time had begun to feel pretty desperate. Then, one day Léonce came to see me, and, as I could not stand the situation much longer either, I asked him point-blank: "Would you like me to tear up our contract?" To which he answered, "Give me twenty-four hours to think it over." The next day his mind was made up: "I will hold out," he said. And he did. Seven years later, the entire "mechanical period" was sold.[1]

THIS WAS how Léger, in 1954, described the public response to the works from his "mechanical period," which lasted from about 1918 to 1923. The designation no doubt derived from the title *Éléments mécaniques*, which he gave to many of his paintings, and which reflects his infatuation with the machine and with modern technology.

Works from the "mechanical period" are characterized by recurring interchangeable geometric elements—among them, the cone, the cylinder, and the disk—that seem suspended in a completely flat or shallow, relief-like space. Actually, none of these works depicts specific mechanical parts, but, instead, each is meant to evoke the impersonality of a new machine age.

In this picture, we are confronted with a rather cheerful and decorative mechanized world—one that might have been assembled out of children's colorful building blocks. Set against a framework of thick, black horizontal and vertical lines, Léger's "mechanical elements" are composed of tightly interlocking circles, half-circles, sections of circles, ellipses, curves, diagonals, rectangles, groups of parallel wavy lines, dots, and numerous other odd shapes. The artist's palette emphasizes yellow, pink, green, and red, and Léger explained why the last two colors are never side by side: ". . . I avoid placing a red next to a

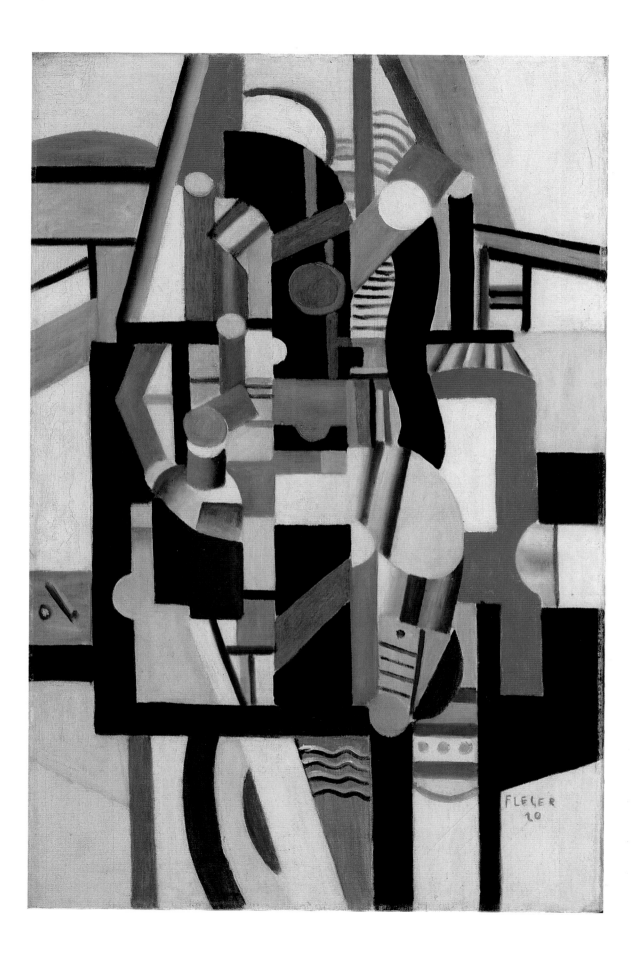

green . . . because the eye tends to merge these colors and then they lose their distinctive character."[2]

Léger's "mechanical elements" seem to anticipate modern architecture in France. His toy-like joints, levers, pistons, and conduits recall the exposed pipes painted bright red, green, blue, and white on the façade of France's national museum of modern art, erected in 1976 at the Centre Georges Pompidou.

1. Dora Vallier, "La Vie fait l'oeuvre de Fernand Léger. Propos de l'artiste recueillis," *Cahiers d'art* 34, no. 2 (October 1954), p. 152.
2. Ibid., p. 153.

Piet Mondrian

Dutch, 1872–1944

COMPOSITION

1921
Oil on canvas
19½ × 19½ in. (49.5 × 49.5 cm.)
Signed and dated (bottom left): P M *21*
Inscribed (on the reverse, on the stretcher):
P. MONDRIAN. Paris: *26* rue du Départ

I T TOOK Piet Mondrian over thirty years to change from a style of somber realism to one of pure abstraction. The latter was based on the division of a canvas, by means of black lines, into a composition of various-sized rectangles. This characteristic style, which the present work exemplifies, and which made Mondrian famous, dates to 1920, when he published a manifesto entitled *Le Néo-Plasticisme* in Paris.[1] Mondrian was the greatest proponent of Neoplasticism and continued to perfect it until his death some twenty years later in New York.

Mondrian has been described as a "slight, thin man, half-bald, with the sharp ascetic features of a Catholic priest or a scientist."[2] Indeed, it might seem that he approached both his life and his work from the perspective of either of these two vocations. He never married. Emotions or drama in art and life were anathema to him, as was resplendent nature: spring, sunshine, flowers, trees, meadows in bloom, and the color green. His bare studio, decorated with blue, red, and yellow rectangles on a white background, looked exactly like his paintings.

The artist grew up in the small town of Winterswijk, near the German border, where his father was a schoolmaster. At the age of nineteen, he was briefly torn between religion and art as a career. By the time he left for Paris late in 1911, his realistic style—evoking that of the early van Gogh—had evolved from Fauvism to a mystical Symbolism in fashion at the time in the Netherlands and in Belgium. Working in Paris from 1912 to 1914, Mondrian adopted Cubism, which he then flattened and geometrized, rendering it, according to Apollinaire, "very abstract." Back in the Netherlands between 1914 and 1919 painting seascapes and church towers, he reduced these motifs to short, black verticals and horizontals on a white ground, producing what was later called a "plus and minus" pattern. About 1914, he had begun to record his thoughts on art and theosophy. Encouraged by the Dutch painter, critic, and poet Theo van Doesburg (C. E. M. Küpper; 1883–1931), Mondrian developed these notes into essays that were published in the new art magazine *De Stijl* ("The Style"), which he co-founded, in 1917. This publication took its name from that of the group of architects, painters, and sculptors who contributed to it. Theirs became one of the most influential associations of modern artists, whose somewhat utopian vision of a new way of life

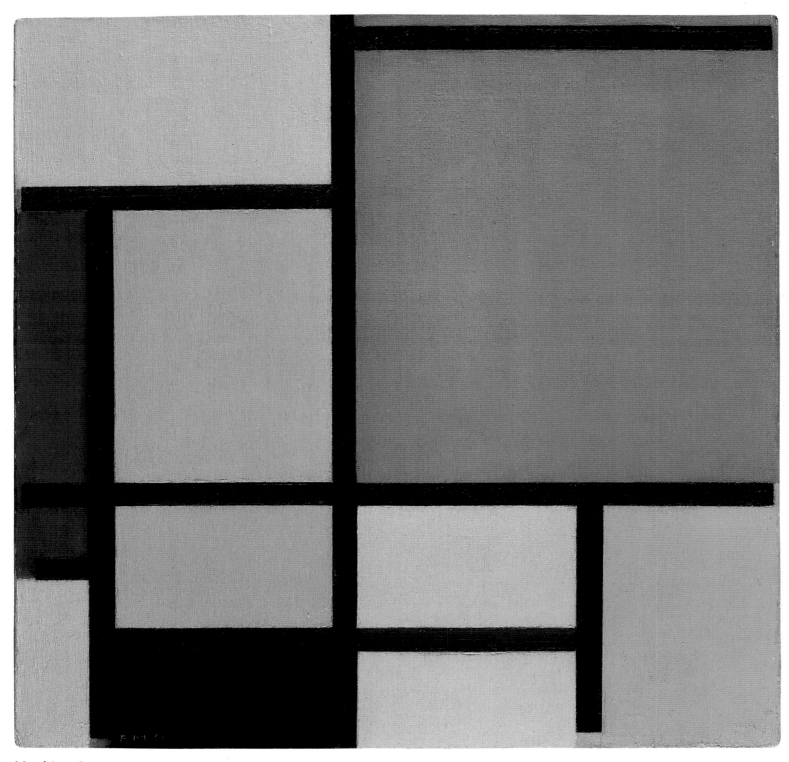

Mondrian. *Composition*

166

dominated by abstract art mainly grew out of Mondrian's concept of a "new" art based on the rectangle, the square, and the use of primary colors.

Until his involvement with the group De Stijl, Mondrian had worked more or less in isolation. His own painting had reached a point of no return during the so-called "plus and minus" phase from 1914 to 1916, but by 1917, influenced by the technique of his colleague Bart van der Leck (1876–1958), he reintroduced pure color into his work in the form of nondelineated rectangles floating against a neutral ground. In 1919, Mondrian returned to Paris, and, by 1920, when he published his manifesto on Neoplasticism, he had attained his definitive style.

On a purely visual level, one can easily follow the evolution of his technique. He pared down forms into verticals and horizontals, which intersect with each other at right angles, creating asymmetrical compositions. These rectangles, in turn, are painted in primary colors, or in the noncolors of black, white, and gray. As for the underlying theories to be found in his abundant writings, they tend toward the mystical, the esoteric, and the transcendental—which should come as no surprise since he joined the Dutch Theosophical Society in 1909. According to the Theosophists, such basic elements as verticals and horizontals are symbolic of the polarities of male and female, spirit and matter, and abstraction and reality. Mondrian believed that pure abstract form can be equated with the essential, or "spiritual," in nature, which he strove to express in his art. Therefore, his oeuvre must always be seen within the context of his theoretical writings. Dismissed by many as abstruse, these contrast starkly with the simplicity of his paintings. Also interesting to note is how differently Wassily Kandinsky and Mondrian—they did not know of one another until much later—interpreted their respective views of the "spiritual" in abstract art. The Russian Orthodox Kandinsky (see page 153) invented a kaleidoscope of abstract forms and used a rainbow of colors, while the strictly Calvinist Mondrian employed only straight lines, right angles, and primary hues.

This *Composition* is one of the earliest in Mondrian's Neoplastic style. He sectioned off the canvas, a perfect square, into eleven different rectangles, and painted some of them in primary colors—here, in red and blue. Other hues were obtained by mixing the primary colors with white, resulting in light blue and light yellow tints. The pale colors mark this work as transitional, because from about 1921 on Mondrian used pure white and primary colors almost exclusively. Incidentally, the red of the largest rectangle extends beyond the black line that constitutes the boundary of its upper edge—something rarely seen in the artist's work.

1. Published as *Le Néo-Plasticisme: Principe général de l'équivalence plastique,* under the imprint of Léonce Rosenberg's Galerie de l'Effort Moderne, Paris, 1920.

2. Cited in Michel Seuphor, *Piet Mondrian: Life and Work,* New York, n.d., p. 60.

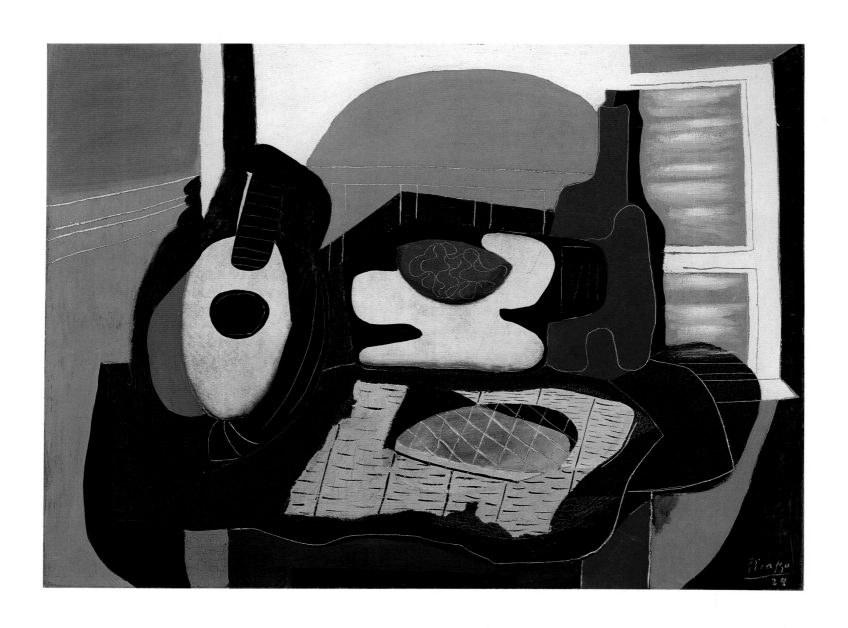

168

Pablo Picasso

Spanish, 1881–1973

STILL LIFE WITH A CAKE

May 16, 1924
Oil on canvas
38½ × 51½ in. (98 × 130.7 cm.)
Signed and dated (bottom right): <u>Picasso</u>/24

AFTER THE rigorous single-mindedness of Cubism—World War I had put an end to Picasso's Cubist collaboration with Braque, who had been drafted—Picasso worked simultaneously in various styles. He continued to experiment with Cubism, but in a more simplified, decorative fashion, while at the same time producing realistic drawings (1915–20) or working in a Neoclassical idiom (1920–23), often endowing his female figures with colossal proportions. Also monumental in scale are the still-life elements in several pictures that Picasso painted in 1924 (Zervos V, 220, 364, 445). Some of these, such as this one, include an open window or a balcony in the background.

In this picture, the most somber and uncluttered work of those painted in 1924, the objects are limited to a mandolin and a bottle of wine flanking a bowl of fruit, and a pie, or "galette," topped with a crisscross crust and set on its newspaper wrapping. With the wooden end of his paintbrush, Picasso incised the lines indicating the molding in the room, the railing outside, and the additional contours of some of the forms. In the process he exposed the light or dark underpainting in those areas.

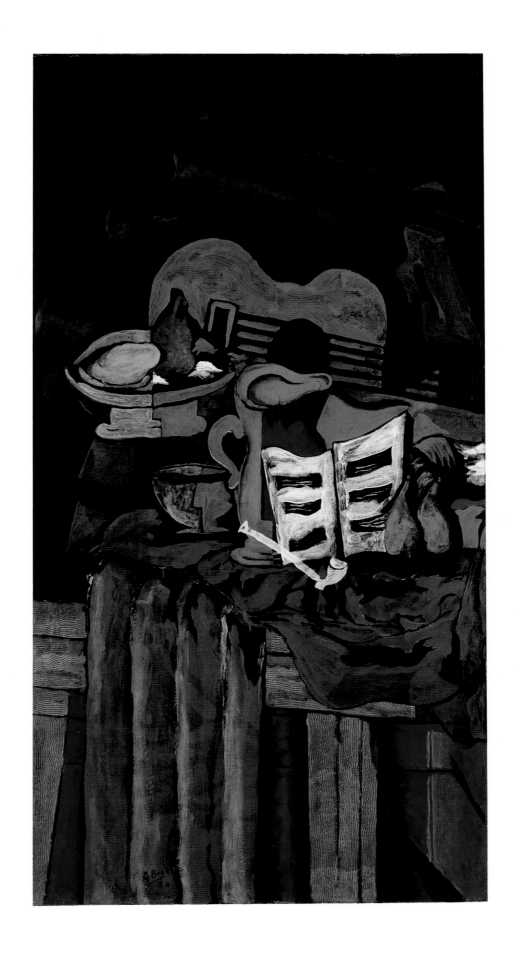

Georges Braque

French, 1882–1963

STILL LIFE WITH A GUITAR

1924
Oil on canvas
46⅛ × 24 in. (117 × 61 cm.)
Signed and dated (bottom left): <u>G Braque/24</u>

IN A LETTER written by Juan Gris on January 18, 1917, to his dealer and friend Daniel-Henry Kahnweiler, the artist discussed a banquet recently held in honor of Georges Braque: ". . . [It] was charming, spirited and full of good humour. Max [Jacob] was at his most brilliant and witty in two parodies—of a colonel and of Braque's mother. There were, naturally, a few awkward moments with people who had drunk too much. But that one expects."[1]

Braque's friends were celebrating the painter's recovery from the severe head wound that he had suffered in 1915, while fighting in World War I. He had been trepanned, and spent many months recuperating in a hospital in Paris before leaving for the south of France. In 1917 Braque resumed painting, and by 1918 he had regained his full strength. A year later, Braque surprised the Parisian art world with a large exhibition that Léonce Rosenberg (1876–1947)—temporarily replacing Kahnweiler as Braque's dealer—organized at his Galerie de l'Effort Moderne. It was the artist's first one-man exhibition in Paris since 1908, when Kahnweiler had shown his works, including the landscapes of L'Estaque that were to give rise to the term "Cubism."

The present painting belongs to the artist's series of "Guéridons," whose title refers to the French word for small, round tripod tables, such as the metal ones with marble tops found in French cafés. (One such table can be seen in photographs of Braque's studio; on it he would assemble ever-changing arrangements of still-life elements that later became the subjects of his paintings.) The fifteen or so "Guéridons" by Braque, dating from between 1922 and 1930, represent the artist's return to a theme that had first preoccupied him during his Cubist period, from 1911 to 1913, and which he had resumed again in 1918. He painted his last "Guéridon" from 1939 to 1952. Although this painting is part of the "Guéridon" series, the table is a maverick. It has a square wooden top and four legs.

By the 1920s Braque's style—although retaining the overall spatial flatness of his Synthetic Cubism phase in which the objects depicted appeared to be close to the picture plane—had become more naturalistic and also more lyrical. The artist no longer emphasized ideas and theories, as he had in the Cubist works, but, instead, focused on the more

technical and decorative aspects of painting, turning his attention to creating paint surfaces of a greater tactility and sensuousness. Here, in the finest and most harmonious work in the series, rendered in deep, warm hues of brown, green, gray, and white, Braque mixed enamel with the oil paint to produce a subtle sheen. He also ran a comb through the paint to simulate the grain of the wooden table. As for the objects placed on it, the ever-present guitar and clay pipe, bowl of fruit, cup, pitcher, and music score, they are arranged here at different levels for better visibility, as in a shop-window display.

1. *Letters of Juan Gris (1913–27)*, translated and edited by Douglas Cooper, London, 1956, p. 45.

Pierre Bonnard

French, 1867–1947

BASKET OF BANANAS
1926
Oil on canvas
23⅝ × 25¼ in. (60 × 64 cm.)
Signed (bottom left): Bonnard

IN JANUARY 1926, Pierre Bonnard purchased a house in Le Cannet, a small village near Cannes in the south of France. It must have been in the dining room of his new home that he painted this *Basket of Bananas* because the same basket appears again in the same setting in the later *Dining Room at Le Cannet with a Basket of Fruit* of 1928 (Dauberville III, 1401).

This still life demonstrates Bonnard's complete indifference to beauty in the objects that he chose to paint. Although the basket, yellow straw hat, yellow jug, and rectangular box are rather nondescript, the artist has glorified them in this decorative still-life painting by means of the brilliant colors and the skillful composition.

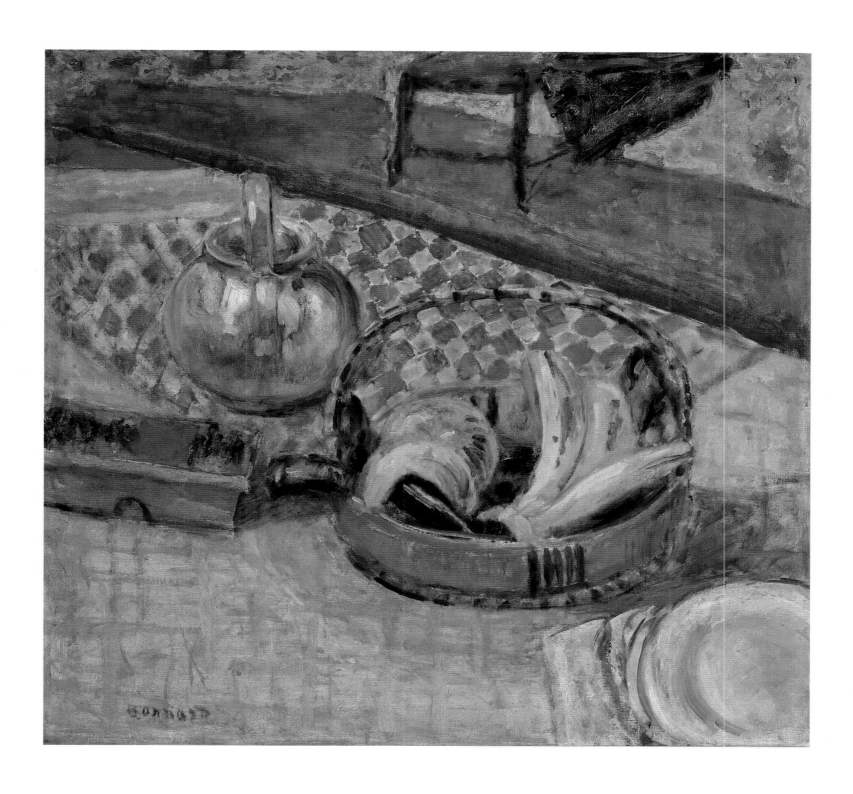

Pierre Bonnard

French, 1867–1947

POPPIES IN A VASE

1926

Oil on canvas

29⅞ × 16½ in. (76 × 42 cm.)

Signed (bottom left): Bonnard

I F THE BASKET represented in the previous still life of 1926 (see page 173) appeared in only a few of Bonnard's paintings between 1924 and 1928, the somewhat ordinary vase depicted in *Poppies in a Vase* is represented in some twenty works by the artist, painted between 1911 and 1935 (Dauberville II, 653 to III, 1537). The vase is shown in many different settings, and against various backgrounds. Here, it rests on a tabletop, with a fragment of a window, through which a narrow strip of landscape is visible, completing the area at the extreme left of the composition. Bonnard highlighted the fleeting grace of these wild red flowers—they usually wilt within a day after being picked—by placing them before a backdrop of pale pink and aquamarine tones.

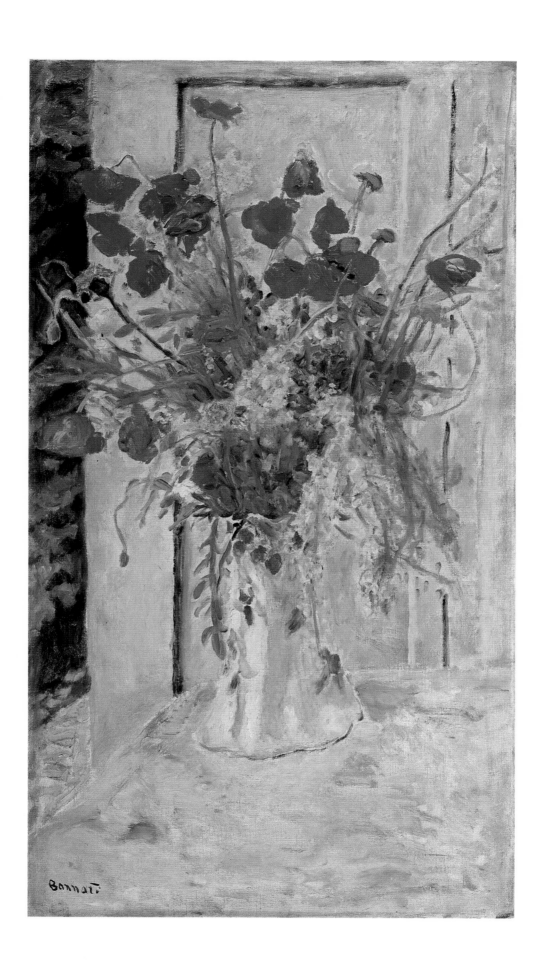

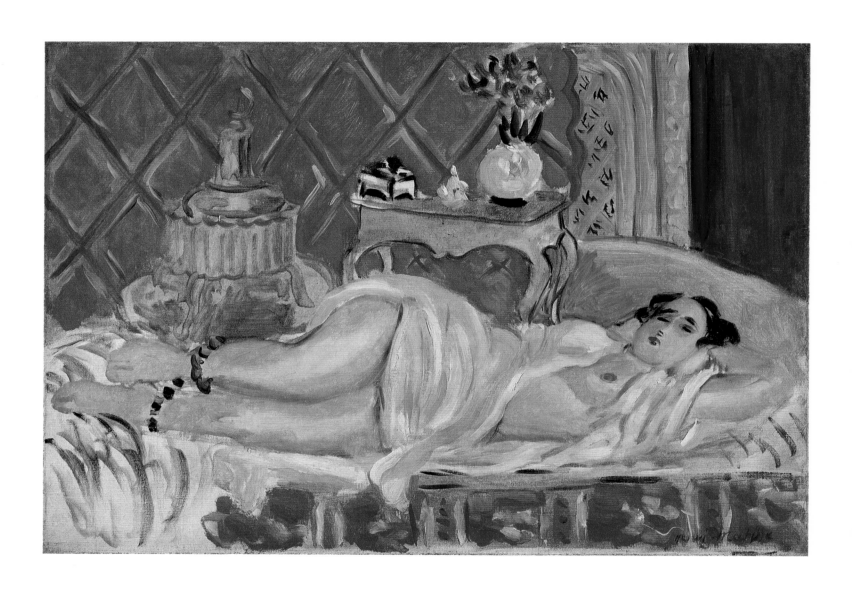

Henri Matisse

French, 1869–1954

ODALISQUE, HARMONY IN RED

about 1926–27
Oil on canvas
15⅛ × 21⅝ in. (38.4 × 55 cm.)
Signed (bottom right): Henri Matisse

"I DO ODALISQUES in order to paint nudes."[1] "I had seen them in Morocco, and so was able to put them in my pictures back in France without playing make-believe."[2] One of Henri Matisse's favorite subjects was the female nude, which he depicted throughout his long life in either paint, pencil, charcoal, crayon, or pen and ink, in woodcuts, lithographs, and, later, in paper cutouts. The languorous nude posing as an odalisque in an exotic setting is just one variant on this theme.

The model for this *Odalisque* was the twenty-five-year-old Henriette Darricarrière (b. 1901), who lived with her parents and two brothers in Nice. Besides posing for Matisse between 1920 and 1927, she also studied violin, piano, ballet, and painting.

Matisse created this small work—part of a group of six similar small-scale "Odalisques," dating from 1926–27, for which he used the same props—in his third-floor apartment at 1, Place Charles Félix, in Nice. From 1917 on, he had spent the winter months in various hotels in the city; then, in 1921, he settled in Nice permanently. (He moved from the first apartment to one on the fourth floor late in 1926 or early in 1927.)[3]

The artist had set up an "Oriental" alcove in his apartment, embellishing it with luxuriously patterned wall hangings, screens, and bedcovers to emulate the effect of the decorative wall- and floor-tiles found in Moorish interiors. Just as with stage decor, Matisse could rearrange the furnishings to create a variety of backgrounds—as can be seen in a humorous photograph of the painter Pierre Bonnard posing in this same alcove as a "Matisse Odalisque" (see fig. 1). However, Matisse's vision of the Orient incongruously includes a Russian samovar and an Italian Rococo-style table painted green.

1. Jack Cowart, "The Place of Silvered Light: An Expanded, Illustrated Chronology of Matisse in the South of France, 1916–1932," in *Henri Matisse: The Early Years in Nice* (exhib. cat.), New York, 1986, p. 37. Most of the information in this entry is from this detailed chronology of Matisse's Nice period.

2. Jack Flam, *Matisse: The Man and His Art (1869–1918)*, Ithaca, N.Y., and London, 1986, p. 442.

3. See Cowart, op. cit., pp. 29–37.

FIGURE 1. Pierre Bonnard posing as a "Matisse Odalisque" in the studio of Henri Matisse's third-floor apartment, Nice, France. Mid-1920s (Courtesy Hahnloser Archives, Winterthur, Switzerland)

Pablo Picasso

Spanish, 1881–1973

HEAD OF A WOMAN

1927
Oil on canvas
21¾ × 13¼ in. (55.3 × 33.7 cm.)
Signed (top right): P̲i̲c̲a̲s̲s̲o̲

WITH A CONTINUOUS black line on a stark background of one white and two brown bands of color, Picasso drew an image that resembles a misshapen boomerang. He then added details that evoke a ferocious female head seen in profile: two odd-sized eyes, a set of tiny nostrils, three scrawny hairs, and four nails for teeth. This particular head and at least sixteen other similarly horrific ones, all dating from 1925–27, initiate Picasso's savage deformations of the human form—never, henceforth, to be completely absent from his work—such as one sees in the figure with the mangled face at the left of his large painting *Three Dancers* of 1925 (Tate Gallery, London; Zervos V, 426). From then until about 1932, his cruel recompositions of the figure escalated, and he focused mostly on the female head and body.

Picasso had as inspiration for these brutish creatures, besides his own fertile imagination, an arsenal of sources to choose from. Among these was primitive sculpture, especially Oceanic and Eskimo art, an interest in which was reawakened by the Surrealists. Also, about 1923–24, the young Spanish painter Joan Miró, in Paris since the early 1920s, had adopted the symbols of Neolithic cave art, and some of these amorphous, abstract forms, often with sexual associations, might have intrigued Picasso.[1]

The feelings of disgust or hatred toward women, or fear of them, which Picasso seems to vent in these works, might be a response to the general air of irreverence fostered by the Surrealists. The latter, seeing women as either madonnas or demons, encouraged the free expression of what they saw as the inherent wickedness of humanity. Similarly, it has been suggested that Picasso's pictorial monsters allude to personal ones—more specifically, to his wife Olga. At the time that he was preoccupied with such imagery, his marriage was rapidly deteriorating.

1. See John Golding, "Picasso and Surrealism," in *Picasso in Retrospect*, edited by Roland Penrose and John Golding, New York and Washington, 1973, p. 92.

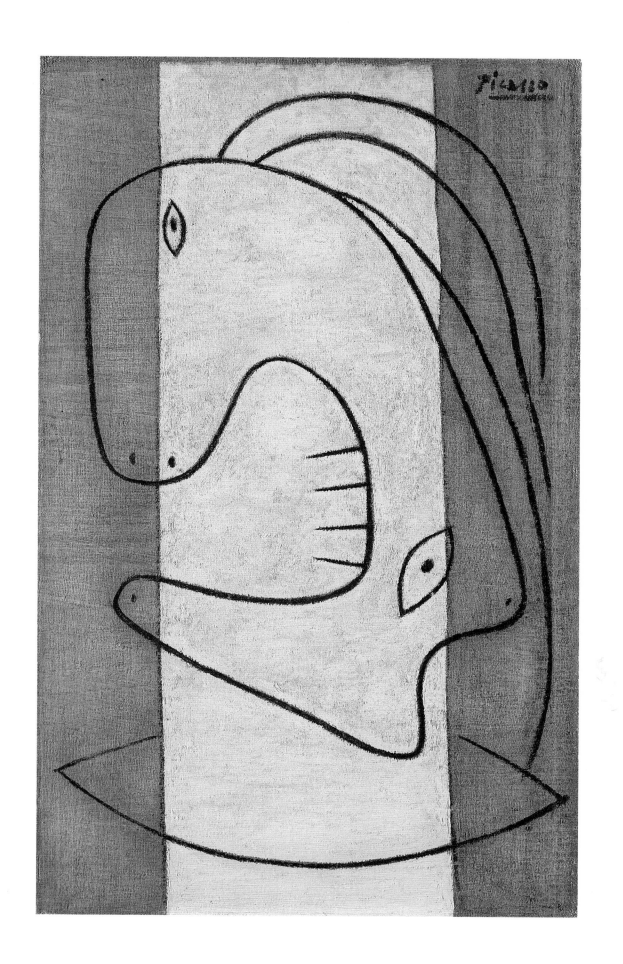

Joan Miró

Spanish, 1893–1983

ANIMATED LANDSCAPE

1927
Oil on canvas
51 × 76¾ in. (129.5 × 195 cm.)
Signed and dated (lower center): Miró/1927

MIRÓ'S DEPARTURE from a realistic style to one based upon pure fantasy was gradual, as exemplified by the span of eight years that separates the completion of the painting *Vines and Olive Trees, Tarragona* (see page 157) and this imaginary landscape. In 1919, Miró had abandoned "poetic realism," with its emphasis on minutely rendered details, choosing instead to focus only on the details themselves. Detached, out of context or scale, magnified, and, ultimately, abstracted into mere symbols, the details almost irreverently predominate, in the paintings of 1923–24. These works paved the way for the "dream pictures" of 1925–27—large canvases divided into fields of intense pure color and animated by a few evocative motifs.

This change in Miró's work can be linked to his close association, from the early 1920s, with the group of poets who later joined the Surrealist movement. They were the friends of his neighbor the painter André Masson (1896–1987). Miró and Masson occupied adjoining studios at 45, rue Blomet, in Paris, and they were in constant contact through a hole in the wall. Masson's studio served as the meeting place for the poets and writers known as the "Rue Blomet" group, among whom were Michel Leiris, Antonin Artaud, Robert Desnos, Roland Tual, Armand Salacrou, and Georges Limbour. Miró was a receptive audience, and readily contributed to the atmosphere of free association and irreverence that stimulated the imaginations of the poets and artists alike.[1] These kindred spirits sparked Miró's already fertile imagination and encouraged him to explore a world of ever-increasing fantasy. Thus, when the Surrealists finally took notice of him, about 1925, and officially invited him to join their group, he had already tapped the sources they so staunchly advocated—dreams, the subconscious, the irrational, and the fantastic.

Miró somewhat nostalgically recalled "rue Blomet" to Jacques Dupin in 1977:

> The rue Blomet was a divine place, a decisive moment for me. It was there that I discovered everything I am, everything I would become. . . . Masson's studio and mine were right next to each other. . . . It was very noisy in his and very quiet in mine. . . . I was a maniac for order and cleanliness. . . . I waxed and polished the floor. The studio was perfect, just like a ship's cabin. I lived alone in total poverty, but every time I went out I wore a monocle and white spats. I liked to leave my

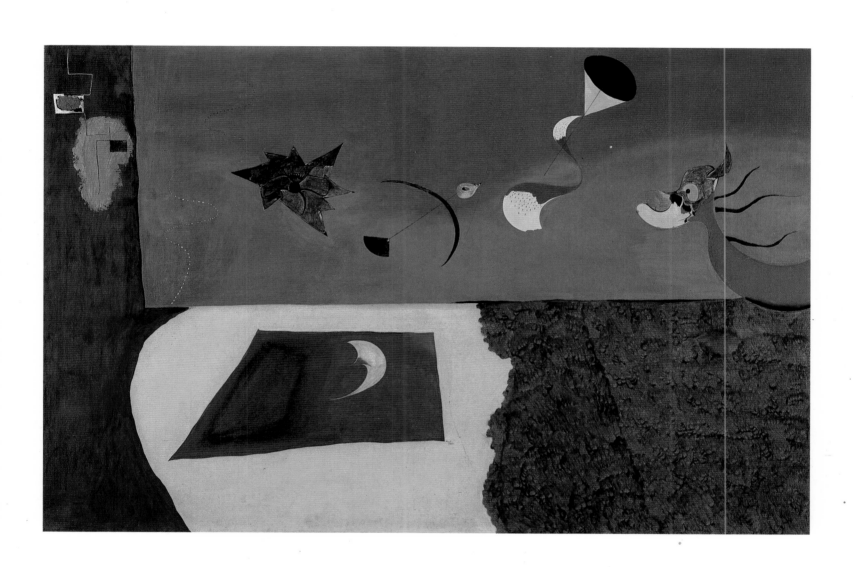

monk's cell and go to the studio next door, with its unbelievable clutter of papers, bottles, canvases, books and household objects. . . . More than anything else, the rue Blomet was friendship, an exalted exchange and discovery of ideas among a marvelous group of friends. As for Breton and Éluard, . . . They ignored my existence until my painting freed itself in the direction of poetry and dreams. . . . We attended the Surrealist meetings very faithfully. These were held at Cyrano's on the place Blanche at noon. Masson took part in the discussions, but I was usually silent.[2]

The present picture is one of six large, horizontal canvases, identical in size, that the artist began to paint at his family's farm during the summer of 1927 (Dupin 179–184). Although Miró did not title these works they have been called "landscapes" because of the meandering horizontal line that, in all but this canvas, divides the composition into what may be interpreted as sky and earth. Here, in the most colorful and ambiguous painting in the series, what begins as a straight, horizontal division turns upward at the far left, creating an indefinable space in which the upper part of the canvas might represent a view, through a window, of the sky animated by a star-shaped water lily, a bird, a kite, and a Miróesque dragon, or perhaps it is a painting-within-a-painting, set in a brown or yellow interior. The yellow crescent moon is either in a patch of blue sky visible through an opening in the yellow section of the wall, or else it is also part of the picture-within-a-picture. The odd little lines and shapes at the upper left evoke the cracks and irregularities in a wall or canvas that, as Miró often acknowledged, served as a starting point when he began a painting. The artist also included a large, marbleized and textured area at the lower right—an effect that he achieved by rubbing his brush with paint diluted with turpentine. The technique is reminiscent of the frottage favored by the Surrealists, who, as a matter of fact, thought so highly of this painting that they made certain it was reproduced in their *Dictionnaire abrégé du Surréalisme* in 1938.

1. See Miró's " 'Memories of the Rue Blomet', Transcribed by Jacques Dupin," in *Joan Miró: Selected Writings and Interviews*, edited by Margit Rowell. Translations from the French by Paul Auster; from the Spanish and Catalan by Patricia Mathews, Boston, 1986, pp. 99–104.
2. Ibid., pp. 100–102.

Joan Miró

Spanish, 1893–1983

THE POTATO

Paris, Summer 1928
Oil on canvas
39¾ × 32⅛ in. (101 × 81.7 cm.)
Signed (right center): M
Inscribed (on the reverse): Joan Miró/Pomme de Terre/1928

A S RECOUNTED by Pierre Schneider, the first time the artist showed one of his paintings to the poet Paul Éluard, in 1924, the latter exclaimed: "Oh, what a pretty sun," to which Miró, obviously vexed, replied, "It's a potato."[1] Here, Miró seems to have made sure that no misinterpretation of this sort would occur. Not only did he paint a recognizable potato—a small, brown, oval object with three tendrils growing out of its upper edge—but he also titled the work *The Potato.*

The painting represents a gigantic female figure stretching her arms wide, against a blue sky and above a patch of earth—perhaps a potato field. The billowing white shape of the figure is attached to a red post in the center of the composition like a scarecrow on a pole. Miró surrounded his merry "potato-earth-woman" with fanciful decorative objects, some of which are "earthy" and some not. The figure has one brown-and-black breast that "squirts" a long, black winding thread, as elfin creatures flutter in the sky around her. At the left, a red-bodied, yellow-winged "butterfly-woman" (so-called, in Miró's preparatory drawing; see fig. 1) takes flight from a brown banana-like nose as other creatures climb a ladder—one of Miró's favorite motifs—while, at the upper right, they play with what might be a detached, little round white breast. A large, flame-like rendering of a woman's vagina hovers above a stick also at the right.

1. Pierre Schneider, "Miró," *Horizon* 1, no. 1 (March 1959), p. 78.

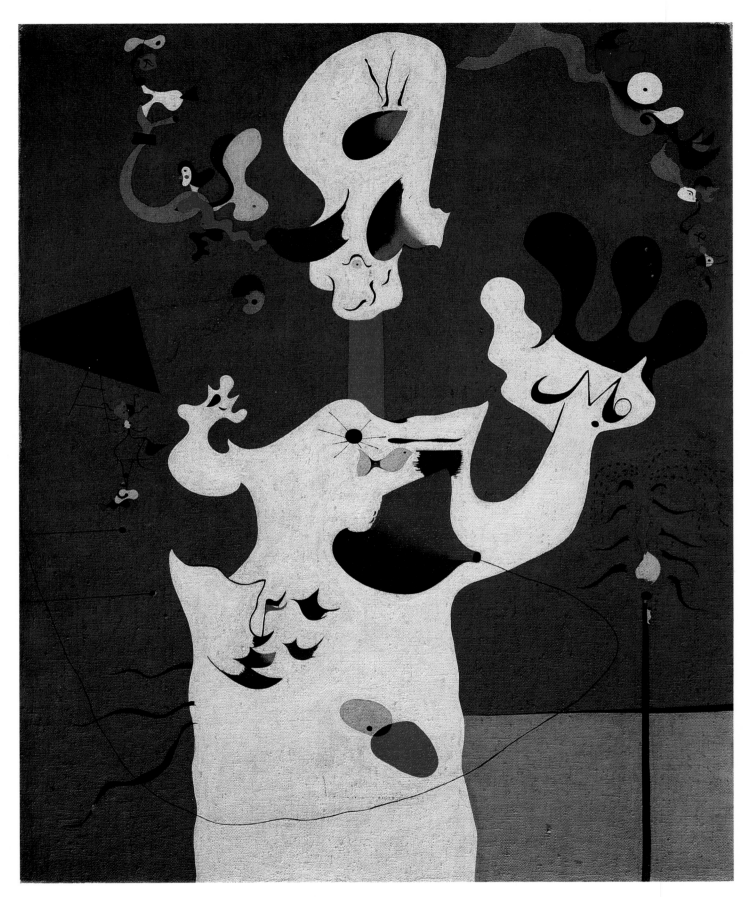

Miró. *The Potato*

FIGURE 1. Joan Miró. Study for *The Potato*. 1928. Pencil on paper, 10¾ × 8⅜ in. (27.3 × 21.2 cm.). Fundació Joan Miró, Barcelona

Salvador Dali

Spanish, 1904–1989

THE ACCOMMODATIONS OF DESIRES

1929
Oil and collage on board
8¾ × 13¾ in. (22.2 × 35 cm.)
Signed and dated (lower left): Salvador Dali *29*

SALVADOR DALI allied himself with the Surrealists in 1929. His flamboyance, flair for drama and self-promotion, and hyperactive imagination were a welcome addition to the group, which, by then, was torn apart by internal strife and had become somewhat anemic. Dali was given to hallucinations and paranoiac visions, which he cultivated and turned into the subjects of his paintings.

A meticulous technique that, at times, required a magnifying glass to execute gives to his most outrageous subjects an unsettling, clinical matter-of-factness. In the spring of 1929, Dali had collaborated with Luis Buñuel on the film *Un Chien Andalou.* The following summer, when he seems to have been in the throes of one of his particularly intense states of hysteria, Dali began a series of works—among them, the *Accommodations of Desires*—that was inspired by his sexual anxieties. The latter were aggravated by his having fallen in love with Gala, the wife of the poet Paul Éluard (1895–1952). With René Magritte and the art dealer Camille Goemans, the Éluards had visited Dali in the summer of 1929 in Cadaqués in Spain. As Dali relates, in *The Secret Life of Salvador Dali* (1942), until then he had lived in a state of autoeroticism, never having enjoyed a woman's embrace.[1] Gala (Helena Dmitrievna Diakonova; born in Russia, c. 1893–1982), about thirty-six years old at the time, apparently awakened in the twenty-five-year-old Dali violent desires as well as fears.

This melodrama—or, perhaps, psychodrama—served as the background for this little picture, which Dali painted after taking a walk alone with Gala. He wrote that, in view of what he saw lying ahead of him, he included "terrorizing" lions' heads—not so "accommodating" to his "desires" as the title of the painting facetiously suggests.[2] Dali did not paint the heads but, rather, cut them out from what must have been an illustrated children's book, slyly matching the latter's detailed style with his own. Everything in this dreamscape is aligned on a diagonal extending from the lower right to the upper left, including the small prickly rocks on what is probably the plain of Ampurdán near Cadaqués. The black shadows and the deep perspective evoke the art of de Chirico, who had greatly influenced Dali.

The shiny white surfaces of the seven enlarged pebbles act as screens for images that seem to be unrelated vignettes in some unknown story. Whatever this tale may be, it includes painted, cutout, and cut-up lions' heads, a toupee, various vessels—one in the form

of the head of a smiling woman—and ants. (The last, symbolizing decay, had been a favorite motif of the artist's since childhood, and figured most startlingly, earlier in 1929, in *Un Chien Andalou*.) In addition, emerging from a platform are three figures and yet another lion's head. A blond, bearded man; a youthful, blond male or female with a misshapen body; and a lion's head are locked in an embrace, and take great interest in each other's teeth. To their left a moustached man visible only from the shoulders up buries his head in his hands.

Dali himself supplied an explanation for the inclusion of the carnivorous animals—but what about the toupee that breaks through one of the pebbles as if the latter were an egg, and why do these people grab at each other's teeth? Steeped as the artist's works are in Freudian metaphors, it seems quite appropriate to consult the doctor's writings for possible clues to Dali's imagery. Freud attributes symbolic meaning to both hair and teeth. "Dreams with a dental stimulus"—for example, the pulling of teeth—are, so Freud wrote, "dreams of masturbation,"[3] and he regarded hair as a fetish. In a complex argument, Freud equates hair with a mother figure whose lack of a penis awakens in a little boy a fear of castration—two subjects apparently very much on Dali's mind in the summer of 1929.[4] Even the hairy, teeth-baring lions fit into this Freudian scenario.

If Dali expressed his sexual anxieties in images that might qualify as vignettes in a children's tale, Gala, just like a good fairy, was to cure him of his symptoms and to remain his muse forever after.

1. Salvador Dali, *The Secret Life of Salvador Dali*, New York, 1942, p. 242.

2. Ibid., pp. 241–42.

3. Sigmund Freud, *The Interpretation of Dreams*, translated and edited by James Strachey, 3rd rev. ed., New York, 1972, p. 423.

4. Sigmund Freud, *Collected Papers*, vol. 5, translated and edited by James Strachey, New York, 1959, pp. 198–204.

The 1930s

Joan Miró

Spanish, 1893–1983

UNTITLED

February 1931
Oil paint and black ink on wood
7¼ × 10⅜ in. (18.5 × 26.5 cm.)
Signed and dated (lower left): Miró./2.31

THIS SMALL painting and a dozen others belong to a group of modest-sized works that Miró completed early in 1931. Between 1929 and 1930, he had suffered a personal crisis and produced few paintings. According to his biographer, Jacques Dupin, in these small-scale pictures Miró "took up his palette again, but with some hesitation, like a man who has been through a long illness."[1] However, judging from this lyrical dreamscape, Miró appears to have keenly resumed work, looking at the world around him with fresh eyes.

Against a yellow ground, so thinly applied that in places the wood grain shows through, amorphous beings in exquisite shades of red, green, and white gently float in space. This picture, never previously exhibited or published, belonged to the Surrealist poet and writer Georges Hugnet (1906–1974). Hugnet was the author of an article in *Cahiers d'art* in 1931, "Miró ou l'enfance de l'art," whose no-doubt purposely ambiguous title—a Surrealist play on words—can be translated either literally as "Miró or the Childhood of Art," or colloquially as "Miró or What Is Most Elementary." Two years later, in 1933, Hugnet's book *Enfances* (*Childhoods*) appeared in print, illustrated with Miró's first etchings. It is probable that Miró gave Hugnet this little painting as a token of his friendship.

1. Jacques Dupin, *Joan Miró: Life and Work*, translated by Norbert Guterman, New York, 1962, p. 243.

Pablo Picasso

Spanish, 1881–1973

DYING BULL

Boisgeloup, July 16–17, 1934
Oil on canvas
13⅛ × 21¾ in. (33.3 × 55.2 cm.)
Inscribed (top left): Boisgeloup/16 juillet/<u>Picasso</u>/XXXIV——;
(on the reverse): Boisgeloup 17 juillet XXXIV.

P ABLO PICASSO was an old hand at representing bullfights. He had been only about seven years old when his father took him to the bullfights in his native Malaga, and the spectacles so impressed him that they became the subject of his earliest painting, dating from 1889–90 (Fabre, 4). He painted this work over forty years later, at his country home, the Château de Boisgeloup, situated about forty miles northwest of Paris. Among the twenty-odd paintings, drawings, and etchings of bullfights that he made at Boisgeloup from June to September of 1934, this picture and its preparatory drawing (Zervos VIII, 221) are unique, as they focus solely on the dying bull. We see none of the paraphernalia—or the fury—usually connected with a bullfight. There are no horses, no spectators, and no sign of the matador who has just plunged the deadly sword into the bull's right shoulder blade.

Picasso sometimes gave the human figures in his works—and especially their heads—beast-like qualities. Those paintings of his wife Olga, of 1925–32, the years when their marriage was deteriorating (see page 179), come readily to mind. It is not surprising, therefore, that his representations of animals should, in turn, seem oddly human. However exaggerated the brutishness of the body of this bull may appear, with its wrinkled, gray elephant-like skin and its dinosaurian proportions, it is set off by the animal's anguished expression. The liberties taken by Picasso with bovine anatomy—here, endowing the bull with a row of upper front teeth—are hardly the result of ignorance. It seems more likely that Picasso's early experience and fascination with bullfights led him to identify with toreros, bulls, and Minotaurs—so much so that he believed that by making the bull in the present picture more human, the spectator could better empathize with the animal's agony.

The Minotaur, the bull's mythological cousin, was the subject of numerous drawings and etchings by Picasso between 1933 and 1934. Nonchalantly holding a sword, he sits on the cover Picasso designed for the inaugural issue of *Minotaure*, the art magazine founded by the Surrealists in 1934. As Picasso's alter ego, the beast is seen in numerous ink drawings, from 1933, locked in passionate embrace with Marie-Thérèse Walter (1909–1977), the painter's mistress. The Minotaur also figures in the series of one hundred etchings in the "Vollard Suite" of 1930–37. Eight of these etchings, from 1933, show the Minotaur enjoying himself

in the company of women while, in four others, of 1933–34, he is pictured as blind and virtually helpless.

However, to the acute physical discomfort depicted in this painting Picasso added some whimsical and decorative touches. Thus, the bull expires on a pretty, blue, crinkly ground, beyond which the pink edge of the ring rises on the left, but, curiously enough, not on the right side of the canvas, where the bull's haunches and his erect tail interrupt the sweep of the ringside.

Paul Klee

German, 1879–1940

ONE WHO UNDERSTANDS

1934
Oil and gypsum on unprimed canvas
21¼ × 16 in. (54 × 40.8 cm.)
Signed (left center): Klee; *dated and numbered (bottom left):*
1934 K 20; titled (bottom right): ein Verständiger
Recorded in Klee's oeuvre catalogue as:
1934 40 K 20 Ein Verständiger Ölfarben auf Nesseltuch

THIS CEREBRAL head by Paul Klee, the *One Who Understands*, rather befittingly evokes the schematic diagrams of the human cranium found in medical textbooks. It is one of the last in a group of about thirteen works, all of 1933–34 and mostly drawings, that shows similar heads cracked like a broken windowpane. Variously titled *Undecided* (1933.40), *Still Undecided* (1933.370), *Incorrigible* (1933.437), and *Do Not Underestimate Me* (1933.410) (see fig. 1), they seem to refer not only to mental states but also to children—as, for example, the *Black Child Not Understanding Snow* (1933.429).

Klee had many talents. Besides being a painter and a draftsman he was also a master violinist, a prolific correspondent, a diarist, poet, and fastidious keeper of his oeuvre catalogue, an art and music critic, a professor at the Bauhaus, and a cook. He was fascinated by the sounds of words, so that the title he gave to a picture became a major preoccupation. Either ironic, poetic, irreverent, noncommittal, flip, or—as at the end of his life—melancholic, his choice of title set up the perspective from which Klee wanted a work to be seen. In this instance, the title, together with the simple design and the noncolor of white and the attenuated colors of rust and beige—in the areas of unprimed canvas left untouched—contributes a definite sense of austere pensiveness.

When they were neighbors in Schwabing, the artists' quarter of Munich, Klee's contact with Wassily Kandinsky in 1911 and with the latter's Blaue Reiter group—which he joined in 1912—proved to be decisive. The two artists became lifelong friends, the support of the older and respected painter providing encouragement to Klee, who, until then, had worked in relative isolation and mainly in black and white. An equally strong influence on Klee was provided by the Cubism of Picasso and Braque, and by Robert Delaunay's paintings, which employed abstract planes of translucent color.

Klee's 1914 visit to Tunisia in the company of his two painter friends Louis Moilliet (1880–1962) and August Macke (1887–1914) made him feel like a painter for the first time. As he noted in his diary—which was later published—his color sense developed in the limpid light of North Africa. Suddenly, he was able to detach color from nature and use it independently, which gave him the decisive push toward abstraction. By 1915, Klee, who had written earlier that it "bored" him to copy nature,[1] turned his back on it, and never again painted from the model.

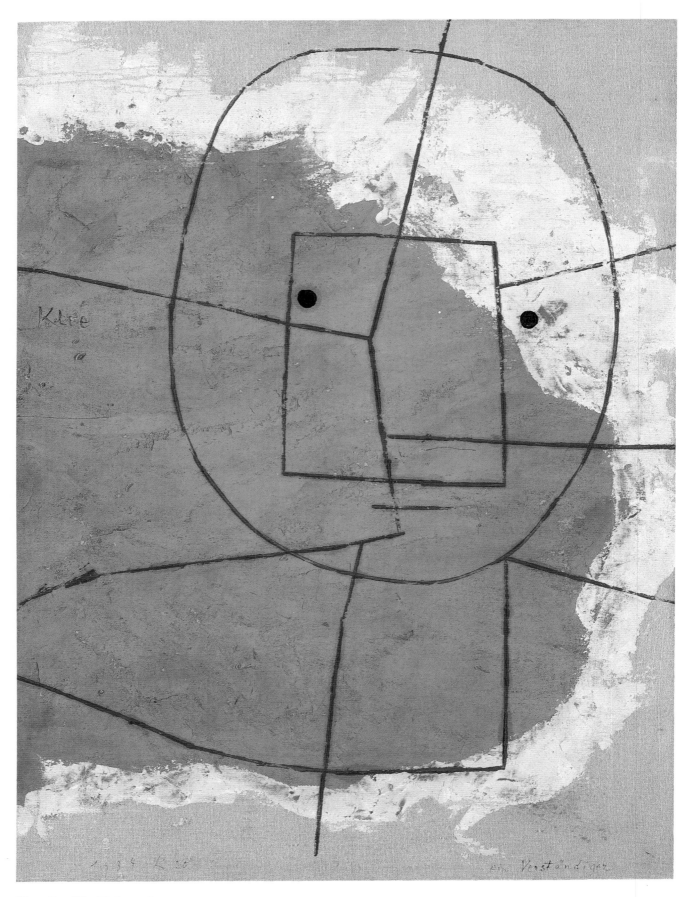

Klee. *One Who Understands*

Klee's most productive years as an artist were those from 1921 to 1931, when he taught at the Bauhaus, first in Weimar and then in Dessau. Almost half of his nearly ten thousand mainly small-scale watercolors and drawings on paper were produced during this ten-year period. From 1931 to December 1933, Klee taught at the Academy of Fine Arts in Düsseldorf, having arrived there from the Bauhaus in Dessau. His stay in Düsseldorf was a happy one until it was rudely interrupted by the National Socialists, who declared his art "degenerate." Back in 1933 in his native Bern, Klee lived in a small, three-room apartment on the outskirts of town. He was internationally known, yet had no following in his native Switzerland. He sold few of his works, and was only supported by a small group of faithful friends.

The present painting is a fine example of Klee's later style, which is characterized by an increase in scale, heavier lines, simpler colors, and broader and more general forms. These works are also less playful.

1. Felix Klee, ed., *The Diaries of Paul Klee: 1898–1918*, translated by Pierre Schneider, R. Y. Zachary, and Max Knight, Berkeley and Los Angeles, 1964, p. 228.

FIGURE 1. Paul Klee. *Do Not Underestimate Me.* 1933. Pencil on paper, mounted on cardboard, 13 × 8¼ in. (33 × 21 cm.). Kunstmuseum, Bern, Paul Klee-Stiftung

198

Max Ernst

French, born in Germany, 1891–1976

THE BARBARIANS

1937
Oil on cardboard
9½ × 13 in. (24 × 33 cm.)
Inscribed (on the reverse): <u>Max Ernst 1937/barbares</u>

BETWEEN 1919 and 1920, Max Ernst was one of the most enthusiastic leaders of the Dada movement in Cologne. Before long, he attracted the attention of André Breton, who, in 1921, organized an exhibition in Paris of Ernst's collages. By 1922, Ernst had moved to the French capital, and never again would he work in his native country. In 1924, in Paris, the thirty-three-year-old Max Ernst became one of the founding members of the Surrealist group.

While several paintings by Ernst that predate 1924 are today regarded as icons of Surrealist art, his collages of the 1920s seem even more representative of the movement. In them Ernst combined cutout details from a variety of sources, including nineteenth-century engravings from popular novels and mail-order catalogues, and botanical and scientific prints. These transformed images are fantastic, magical, sometimes disquieting, and always surprising. In 1941, Breton still referred to a collage by Ernst as the quintessence of the Surreal image.[1]

Ernst's paintings are in the same vein, steeped in Freudian metaphor, private mythology, and childhood memories. One of his major themes centered on the image of the bird, which often incorporated human elements. Although some of these birds look benign, their mere presence appears to be ominous. For example, in Ernst's famous painting *Two Children Are Threatened by a Nightingale* (1924), the nightingale in flight is the cause of inexplicable panic, despite the fact that it is the most peaceful of birds. In 1925, another gentle species, the dove, appeared in his pictures; later he would depict them, either singly or in pairs, in their cages. He first coupled birds and windblown, apocalyptic animals in a series of small works entitled "The Horde" (1927), and he resumed the theme in 1935 in a series of even smaller paintings called "The Barbarians," to which the present one belongs. In his biography of the artist, John Russell has identified these creatures as expressions of Ernst's fearful anticipation of the impending devastation in Europe.[2] In the works in the series "Barbarians Marching toward the West," which are similar to this picture, the bird-creatures probably are meant to symbolize the imminent danger from Hitler's Germany that Ernst expected would befall the West.

In this small painting, a malevolent-looking, gigantic, bird-like couple marches toward the left with seemingly mile-long strides. The dark female leads the way as her male

companion turns to look at the strange animal—perhaps their offspring—clinging to his left arm. In the distance a tiny figure of a woman stretches her arms in pursuit of some undefined winged being. The strange linear patterns comprising the surfaces of the figures—they evoke fossils or geological formations—were achieved by means of grattage (scraping), a logical extension of the artist's frottage (rubbing) technique, which he employed on paper. Ernst coated a canvas—or, in this case, a piece of cardboard—with layers of paint and, while it was still wet, pressed it against patterned forms or onto objects, which then left their imprints on its surface. Afterward, he touched up with his brush the forms thus created or scraped away layers of pigment. Here, Ernst used turquoise paint to outline the figures and the landscape at the bottom of the picture, thus creating the sky last.

1. Cited in Werner Spies, *Max Ernst-Loplop: The Artist's Other Self*, London, 1983, p. 69.

2. John Russell, *Max Ernst: Life and Work*, New York, 1967, pp. 118–20.

Balthus
(Balthasar Klossowski)

French, born 1908

THÉRÈSE DREAMING

1938
Oil on canvas
59 × 51 in. (150 × 130 cm.)
Signed and dated (lower left): Balthus . 1938 .

I N BALTHUS'S paintings boys play only passive roles as subdued mates or losing partners in card games. Girls and cats reign supreme. As a rule, the adolescents in the painter's works spend their time in closed rooms—sleeping, daydreaming, or reading. When awake, they never smile. Adults, always unwelcome, don't dare to intrude.

Balthus's model, here, is the young Thérèse Blanchard. Between 1936 and 1938, she sat for a series of paintings that might be regarded as the artist's finest portrayals of adolescence. Thérèse and her younger brother Hubert were neighbors of Balthus in the Cour de Rohan near the Place de l'Odéon in Paris, and they appear together in three paintings by the artist. The most celebrated of these is *The Children* of 1937 (once in the collection of Picasso; today, in the Musée Picasso, Paris). Balthus represented Thérèse alone, or with her cat, in some six other paintings and various drawings (see fig. 1).

Thérèse poses, lost in thought and with her eyes closed, in the painter's austere studio in the Cour de Rohan. With her pensive expression, her hands folded over her head, and her bare legs exposed, she seems to epitomize dormant adolescent sexuality. The large cat lapping up milk from a saucer may be yet another erotic metaphor. As is the case with all of the children depicted in the artist's works, Thérèse is dressed with utter simplicity. She wears a plain red skirt and a white blouse buttoned up the front. Hues are somber and subdued, and the position of each element in the picture has been carefully chosen. The simplicity of the still life—composed of two vases, a lidded container, and a bunched-up cloth—on the simple wooden table evokes similar arrangements of objects in the work of Cézanne and, later, of Giorgio Morandi (1890–1964).

Balthus—for whom painting stopped with Gustave Courbet (1819–1877)—adopts an Old Master technique that makes his work seem to exist outside of time. As he has said, he strives for a realism that is "timeless."[1]

Balthus was born into an artistic family. In 1903, his parents left Breslau, in Silesia (then part of Prussia), to live in Paris. His father was the noted art historian and painter Erich Klossowski (1875–1946), and his mother (Elisabeth Dorothea, née Spiro; 1886–1969) was a painter known as "Baladine." After his parents separated in 1917, the poet Rainer Maria Rilke (1875–1926) became a guardian angel and surrogate father to both Balthus and his older brother, the writer and artist Pierre Klossowski (b. 1905). Rilke was also instrumental in the

publication of *Mitsou*, a book of forty ink drawings in which the eleven-year-old Balthus illustrates his adventures with a stray cat. The boy's nickname, "Baltusz," appeared on the cover of *Mitsou*, and thereafter, at Rilke's suggestion, Balthus signed his works with this childhood name. Self-taught as an artist, Balthus first studied and copied the Old Masters in the Louvre. Later, he continued his education in Italy by making copies after Piero della Francesca. His early paintings reflect his admiration for the popular eighteenth-century Swiss painter Joseph Reinhart (1749–1829)—Balthus had copied the latter's work at the Historisches Museum in Bern in 1932—as well as for Courbet and the artists of the Italian Renaissance. Balthus's first one-man exhibition took place in 1934 at the Galerie Pierre in Paris, a Surrealist stronghold. He exhibited several large works whose seemingly traditional subjects were painted in muted tones, their sharp-edged eroticism nevertheless causing a scandal. Since then, Balthus has become best known for his paintings of interiors with young girls, his Parisian street scenes, and his probing portraits.

The artist's haunting representation of the ambiguous and dark side of childhood compares to the best literature on the subject—such as Emily Brontë's *Wuthering Heights* (1848). Balthus greatly admired this book, and was the first French artist to attempt to illustrate it. The results, published in the magazine *Minotaure* late in 1935, contain the seeds of many of his later paintings.

1. Conversation with the artist in Switzerland, February 22, 1983.

FIGURE 1. Balthus. Study for *Thérèse Dreaming*. 1938. Pencil on paper, 9½ × 9½ in. (24 × 24 cm.). Private collection

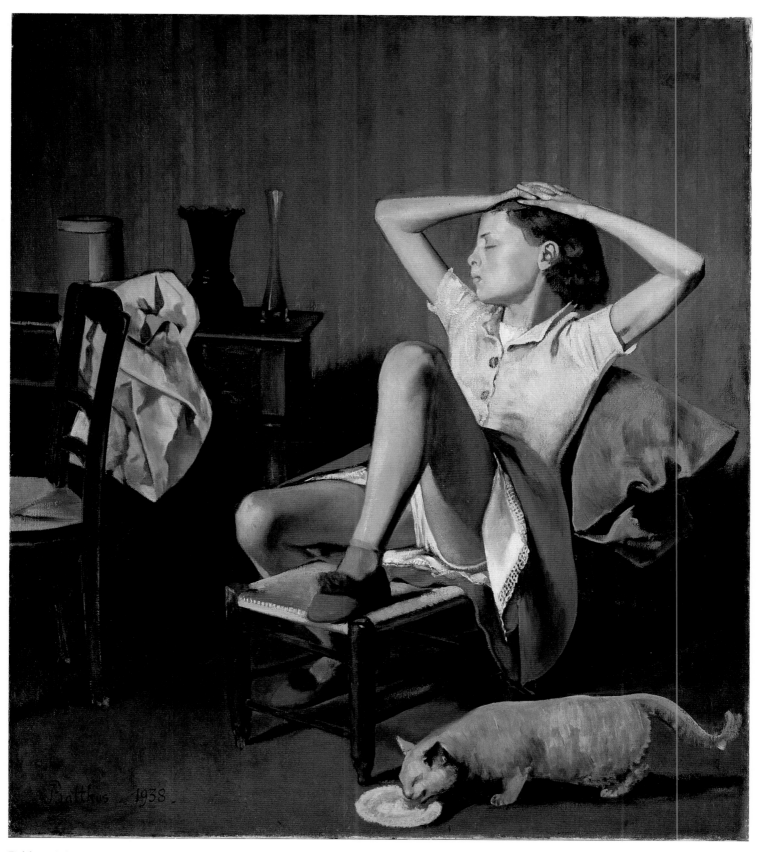

Balthus. *Thérèse Dreaming*

Pablo Picasso

Spanish, 1881–1973

DORA MAAR SEATED IN A WICKER CHAIR

Paris, April 29, 1938
Pen and ink, gouache, oil pastel, and crayon, on paper
30½ × 22⅜ in. (77.5 × 56.9 cm.)
Signed and dated (lower right): 29.4.38./ Picasso

DORA MAAR (née Markovitch), the daughter of a Croatian architect and a French mother, was born in 1909. As a young girl, she spent several years in the Argentine, and she spoke fluent Spanish. In the mid-1930s, in Paris, she became friendly with the poet Paul Éluard (1895–1952) and his second wife, Nusch (1906–1946), and with other Surrealist writers, among them Georges Bataille and René Char. Included in the informal group that centered around Éluard were Roland Penrose, the British painter and author, and Man Ray, the American painter and photographer. With her intellectual curiosity and nervous elegance, Dora Maar contributed to the dialogue of this literary and artistic company. Penrose, later one of Picasso's biographers, observed that her "quick decisive speech and low-pitched voice were an immediate indication of character and intelligence."[1]

One evening, at an informal gathering at the Café Aux Deux Magots on the boulevard Saint-Germain, Éluard introduced Picasso to Dora Maar, then an aspiring photographer. The painter was particularly fascinated by her hands and by her gloves—black, with tiny, embroidered pink flowers—which she removed to play a bizarre game. She darted a small, sharp pocketknife back and forth between her fingers, sometimes missing and sometimes cutting herself. Picasso requested a glove as a souvenir.[2] By the summer Dora Maar had become Picasso's most visible companion. His first portraits of her were photographs—the medium that she had chosen to express herself—in a technique perfected by Man Ray. It was Dora Maar who, in 1937, found the large studio apartment in the rue des Grands-Augustins that Picasso would decide to rent, and where he would paint the *Guernica* during May and the first days of June. Her photographs of his work in progress furnish an extraordinary and invaluable record of the evolution of the great mural.

In this drawing of Dora Maar and in a large group of related drawings and paintings (Zervos IX, 131, 133–134, 142, 146–149, 157, 179, 211–213, 219–221, 226, 232), Picasso decoratively exploits a schematic style of draftsmanship that he had introduced earlier in the year, using pen and ink to create a web-like overall design. Innumerable straight lines define the cumbersome wooden armchair and its wicker caning surround on which Dora Maar appears as a sort of spider-queen seated upon a throne. Her features and profile are clearly recognizable here—as they are in many other drawings and paintings in which she is also

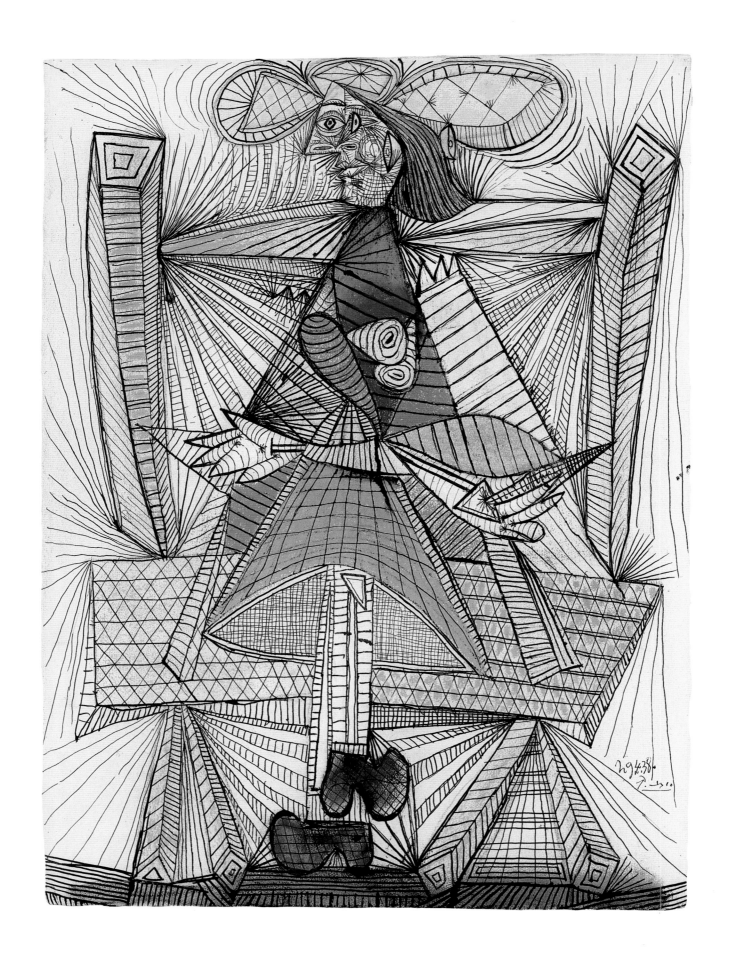

shown seated, in and out of doors, in the same or in a similar chair. She was always very fond of hats, which obviously delighted Picasso, as well.

The artist continued to be fascinated by Dora's pointed, red-nailed fingers, which often, as in this picture, resembled claws. The entire figure looks like a doll, with breasts indicated by conical shells and the ears by two little bells.

1. Roland Penrose, *Picasso: His Life and Work*, rev. ed., New York, Evanston, Ill., San Francisco, and London, 1973, p. 298.

2. Pierre Cabanne, *Pablo Picasso: His Life and Times*, translated by Harold J. Salemsome, New York, 1977, pp. 287–88.

Pablo Picasso

Spanish, 1881–1973

MAN WITH A LOLLIPOP

Mougins, July 23, 1938
Pencil on paper
12⅛ × 9⅛ in. (30.7 × 23.2 cm.)
Signed and dated (bottom right): 23.7.38. <u>Picasso</u>

O N THE SAME day in July that Picasso made this drawing of a man, he also composed a companion work—a woman similarly sucking a lollipop (Zervos IX, 187).[1] The drawing of the man became a painting that he completed a month later (see page 208), but Picasso never progressed to a painting of the woman.

In quick and strong pencil strokes, Picasso sketched the hirsute young man wearing a striped undershirt and a somewhat frazzled straw hat, and, with a certain relish, recorded his sitter's profusion of hair, which seems to sprout everywhere: a thick growth on his head, with a prominent forelock; a stubby, unruly beard; and masses on his neck, shoulders, and chest. As was Picasso's custom when presenting figures in profile or in three-quarter view—often difficult to tell apart—he gives the figure a third eye, and expands the size of the nose.

The cone-shaped lollipop, clutched in the man's twisted right hand, is not recognizable at first glance. It is partly hidden—not in, but somewhat behind, the man's mouth. The lollipop's upper edge is flush with the brim of the hat. In the painting Picasso adjusted the brim so that the lollipop becomes the focus of the composition.

1. Although the figure shows definite feminine attributes, Zervos refers to it as that of a man.

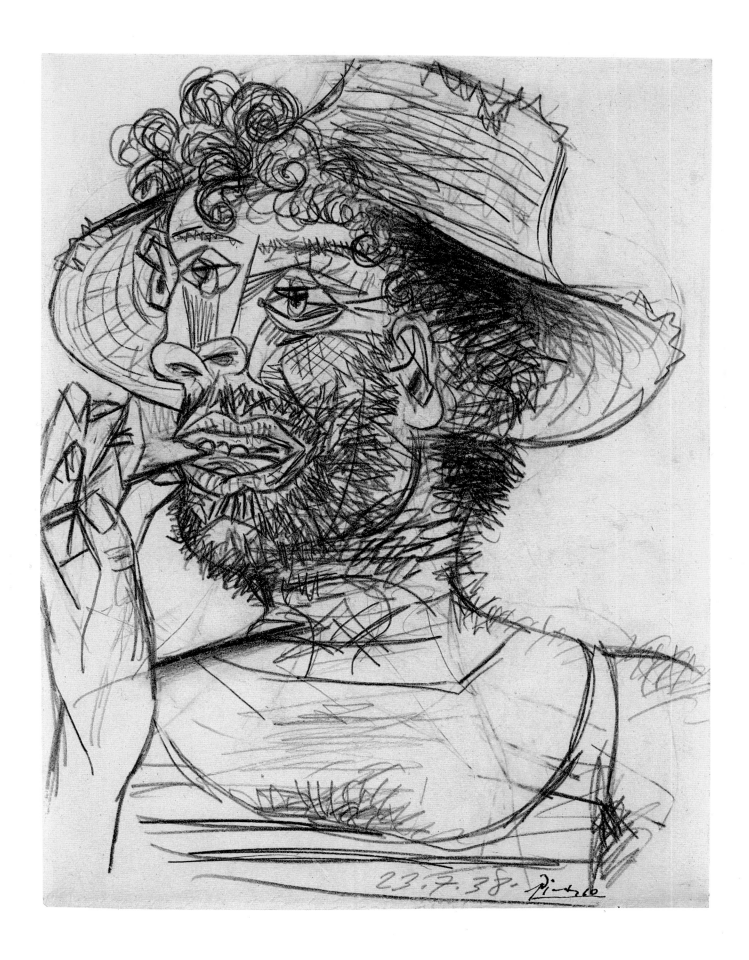

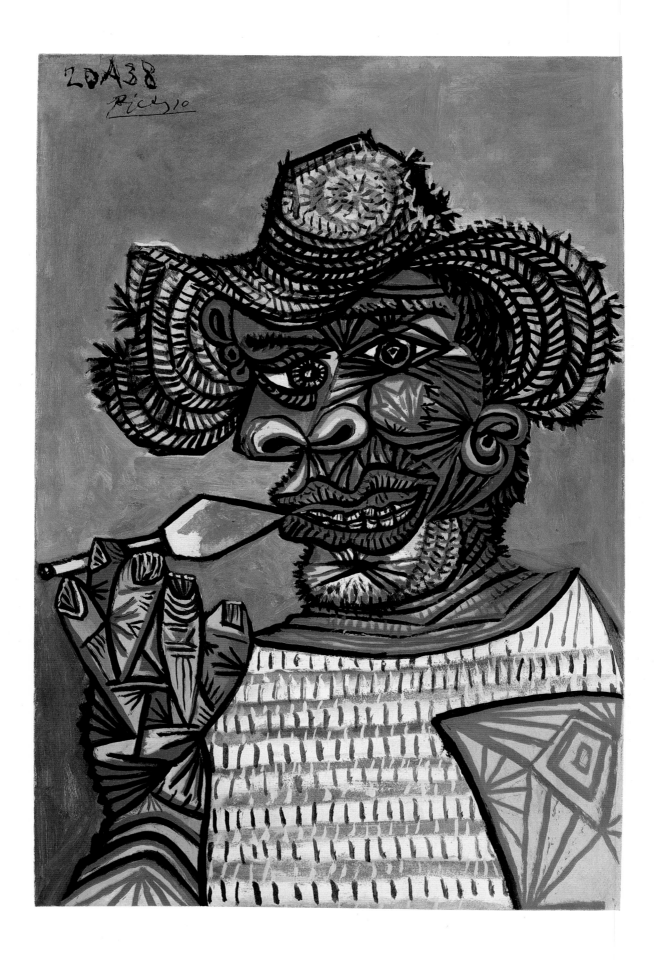

Pablo Picasso

Spanish, 1881–1973

MAN WITH A LOLLIPOP

Mougins, August 20, 1938
Oil on paper, mounted on canvas
26⅞ × 17⅞ in. (68.3 × 45.4 cm.)
Signed and dated (upper left): 20 A 38/ <u>Picasso</u>

D URING THE summer of 1938 in Mougins, a small, hilltop village a few miles inland from Cannes on the Côte d'Azur, Picasso made a number of paintings and drawings of people—men, in particular—sucking on lollipops or licking ice-cream cones (Zervos IX, 187–190, 203–206). These are not mere inventions, but are based on real people the artist observed during his holiday on the Riviera. The year 1938 marked Picasso's third summer in Mougins, where he stayed at the "Vaste Horizon" hotel, in the company of his mistress, Dora Maar, and of his poet friend Paul Éluard and Éluard's wife, Nusch.

Opinions differ as to whether these sweet-toothed men were inspired by local youths or visiting vacationers.[1] Whoever his models, Picasso always depicted them in profile or three-quarter view, giving them monstrous heads—outfitted with two full eyes and two ears; huge, inflated nostrils in double-sided noses; and large, prominent mouths—as well as gnarled, deformed hands.

It was earlier in 1938 that Picasso had first applied a basket-weave pattern to the forms in a picture (see page 205)—which, in this instance, perfectly matches the weave of the man's tattered straw hat and his striped jersey, and divides the face and hands into angular, crystalline-like shapes. The swarthy, hairy youth of the pencil drawing here becomes a weather-beaten old man whose wrinkles and furrows seem grotesque. Only the shape of the lollipop is spared Picasso's insistent overall patterning of forms, and amidst a palette of predominantly blacks, reds, and whites shines a bright emerald green.

Given Picasso's predilection toward the sexual and the macabre, one cannot help but regard the drawing of the young man as having suggestive overtones. As for the old man sucking on a lollipop, the artist might, rather crudely, be poking fun at those who, late in life, revert to child-like pleasures, perhaps seeking substitutes for erotic ones.

1. In Roland Penrose's biography of the artist, *Picasso: His Life and Work*, rev. ed., New York, Evanston, Ill., San Francisco, and London, 1973, p. 327, the author proposes that they are based on village youths; in Pierre Cabanne's biography, *Pablo Picasso: His Life and Times*, translated by Harold J. Salemsome, New York, 1977, p. 315, he refers to them as tourists.

210

Georges Rouault

French, 1871–1958

CHRIST AND THE APOSTLES

1937–38
Oil on canvas
25¼ × 39⅛ in. (64.3 × 99.4 cm.)
Signed (bottom right): G Rouault

GEORGES ROUAULT's vast oeuvre—prints, watercolors and gouaches, and paintings in oil—most frequently centers on the figure of Christ. In addition to New Testament themes, Rouault focused on circus performers—especially old and sad clowns—spent prostitutes, and those who seemed to exist on the margins of an exploitative society, and he personified the members of this society as sinister-looking judges, doctors, or overfed bourgeois (see page 214). However, Rouault lacked the incisive humor and the evil delight with which earlier artists, such as Honoré Daumier and Henri de Toulouse-Lautrec, had depicted similar subjects. Rouault was a devout Catholic, and he saw sinners as saints.

Although not a member of the Fauves himself—Rouault's version of Expressionism was, as James Thrall Soby noted, "psychological" rather than formal[1]—Rouault exhibited with the group at the Salon d'Automne in 1905. By then he had already developed those themes that would occupy him throughout his life.

Rouault was a shy, reclusive man. The son of a cabinetmaker, he was born in the Parisian working-class suburb of Belleville in 1871. When he was fourteen years old, he began a five-year apprenticeship to a maker of stained-glass windows, and also attended evening classes at the École des Arts Décoratifs. In 1890, he enrolled at the École des Beaux-Arts, and became the favorite pupil of Gustave Moreau, whose other students included Henri Matisse, Albert Marquet, and Henri Manguin. In 1903, Rouault became curator of the Musée Gustave Moreau, as stipulated in Moreau's will, which also provided for his house and collections to be bequeathed to the state.

Of later importance in Rouault's life was the art dealer Ambroise Vollard, who, in 1913, bought the artist's entire inventory, consisting of hundreds of paintings, many still unfinished. These works were completed later on in a studio provided by Vollard. The dealer also inundated the artist with commissions for book illustrations. From 1917, when Vollard became his dealer, until 1927, Rouault painted little and devoted himself almost exclusively to printmaking, illustrating *Miserere* (1912–34), published in 1948, *The Reincarnation of Père Ubu* (1917–28), published in 1932, and *Passion* (1928–37), published in 1939.

This is the only close-up representation of Christ and his apostles in Rouault's oeuvre. In his many other depictions of this theme, the figures are usually seen at a distance, and in a

landscape setting (Dorival and Rouault, 47, 81, 384, 1733, 1735, 1742, 2194–2194 *bis*, 2356). Here, the bareheaded Christ is shown cheek to cheek with the other figures, as if posed for a group portrait. Using a technique that he would employ from the early 1930s on, Rouault applied many layers of pigment to the canvas. Here the thick black outlines, as in his other works, create an effect reminiscent of a stained-glass window.

1. James Thrall Soby, *Georges Rouault: Paintings and Prints*, New York, The Museum of Modern Art, 1947, p. 14.

Georges Rouault

French, 1871–1958

THE MANAGER AND A CIRCUS GIRL

1941
Oil on canvas
39¾ × 32⅞ in. (101 × 83.5 cm.)
Signed (lower right): GRouault
Inscribed (on the reverse, in the middle of a lengthy text by the artist):
Georges Rouault/Golfe Juan–/Fin Septembre 1941

ROUAULT'S DEPICTION of a tête-à-tête between a grim-looking manager and a glum circus performer evokes similar, albeit happier, scenes of show girls and their older admirers dating from the last quarter of the nineteenth century by such artists as Manet and Degas, and later by Picasso. This new subject matter focused on modern Paris, and, in particular, on its night life, which centered around its numerous cafés and cabarets. However, in Rouault's painting we find none of the heady frivolity or the erotic tension of the works by his predecessors in this genre. Instead, the stony-faced girl elicits our sympathy for having to endure her employer's ill intentions, as he rests his left hand proprietorially on her right shoulder. Her stiff upper lip indicates resignation, and she appears rather worn out, despite the ornamental accoutrements of her profession: a turquoise costume and small cap, jewelry, heavy makeup, and, behind her ear, a pink carnation echoing the one in the man's lapel.

Rouault's simple compositions display the same formal characteristics as the stained-glass windows on which he worked as a youth. As is customary in his work, figures are shown close-up, with little background detail. The canvas is covered with layers of pigment, and forms are compartmentalized by means of their thick black outlines.

Most of Rouault's works elaborate on themes that the artist had developed by 1905. This painting is based on a gouache entitled *The Couple*, which shows a voluminous man and woman at a table. In the earlier work, however, the mood is not confrontational as here, but relaxed, with both figures facing in the same direction, their attention caught by something happening on the stage to the left, outside the picture.

Apparently, Rouault began work on this painting in Paris, where it was sold, unfinished. With the onset of World War II he took refuge in Golfe-Juan in the south of France, and the canvas was returned to him there. He completed it in 1941, after having obtained the necessary pigments and linseed oil. We are told this in a long and convoluted would-be poem written by the artist on the back of this canvas.

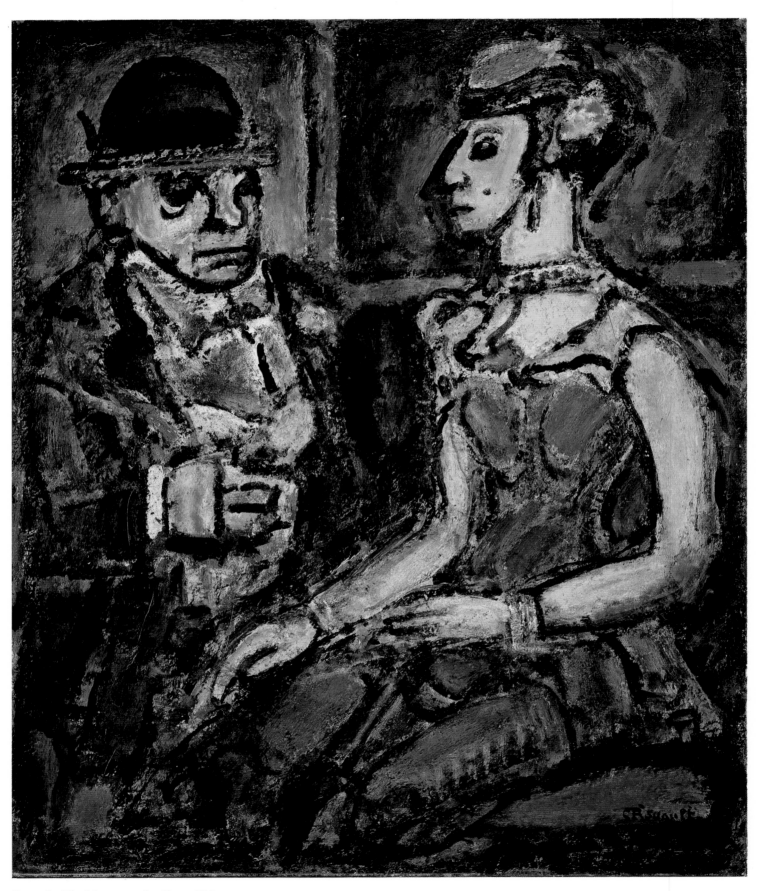

Rouault. *The Manager and a Circus Girl*

Since 1940
Part One

Fernand Léger

French, 1881–1955

DIVERS, BLUE AND BLACK

1942–43
Oil on canvas
66¼ × 50¼ in. (168.2 × 127.5 cm.)
Signed and dated (bottom right): 42–43/F.LEGER
Inscribed (on the reverse): Plongeurs en Noir et bleu/F. Léger – 42–43

IN THE MID-1930s, a troupe of robust and merry construction workers, acrobats, cyclists, gymnasts, and divers began to invade Fernand Léger's paintings. The inspiration for the "Divers" series dates to 1940, while Léger was in Marseilles awaiting passage to the United States. He was then considering a painting that would include five or six diving figures, and soon after he arrived in America he visited a swimming pool: ". . . What did I see? Not five or six divers, but at least two hundred of them. I could not make out any longer to whom this head, this leg, or that arm belonged. So, I also scattered the limbs all over in my paintings. . . ."[1] The "Divers" theme interested Léger during his entire stay in the United States (1940–45) and beyond. Comprising some twenty-five works, the series includes oil paintings, watercolors, gouaches, and drawings.

Léger's description of the experience has been accepted at face value, and his "divers" have been read as bodies hurtling through space. Yet, it seems implausible that the artist would have seen two hundred people actually diving at one time, even in a country as exuberant as the United States. It is more likely that he witnessed a crowded pool into which many swimmers were plunging, their bodies entangling in the water, before his eyes, and it is this action that he sought to recapture.

Initially, Léger represented the "divers" as a three-dimensional mass of interwoven arms, legs, torsos, and heads suspended in space. After 1942—as here—he refined the number of figures, indicating them only by means of heavy black outlines, and he dispersed them over the entire canvas above the large, brightly colored planes. The undulating patterns thus created evoke water in motion in which outlines and forms seemingly become detached from one another. The monumental scale of the work and its flat, stylized technique recall the mural paintings that Léger executed as early as the 1930s in France and later in the United States. The flat planes of color derive from the neon signs in Times Square that had fascinated Léger since he first saw them: "You are there talking to a man and, all of a sudden, he goes blue. Then, as that color fades away, another one appears, and he turns red, yellow. . . . That is what I wanted to do in my canvases. . . . I could not have invented it. I have no imagination."[2]

1. Dora Vallier, "La Vie fait l'oeuvre de Fernand Léger. Propos de l'artiste recueillis," *Cahiers d'art* 34, no. 2 (October 1954), p. 156.
 2. Ibid., p. 154.

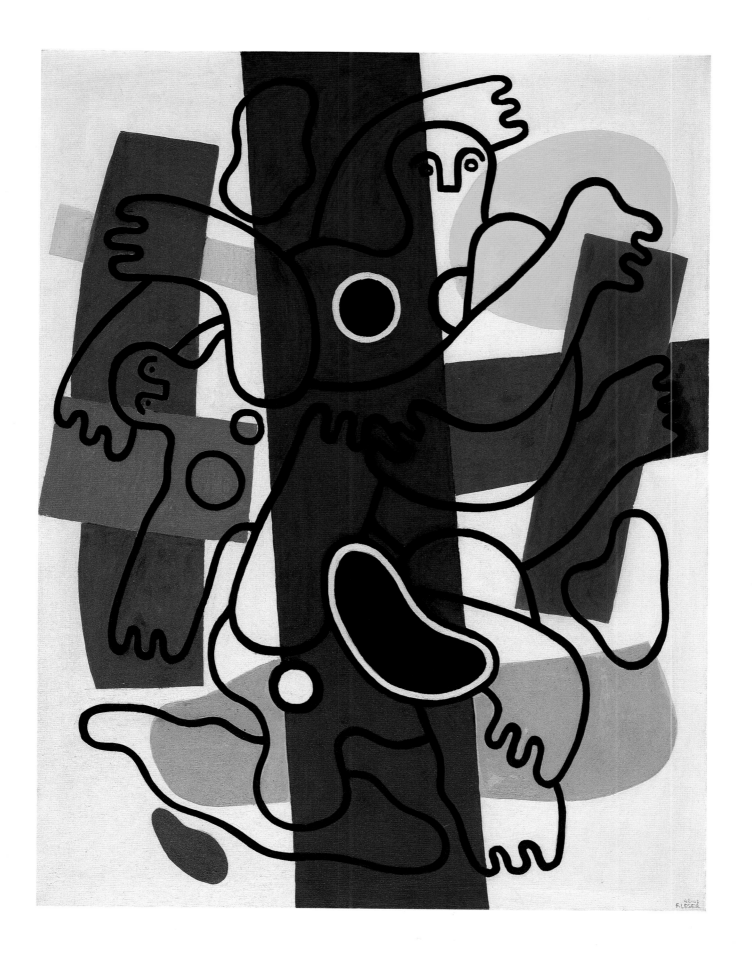

Joan Miró

Spanish, 1893–1983

CONSTELLATION: WOMEN ON THE BEACH

Varengeville, February 15, 1940
Gouache and oil wash on paper
15 × 18 in. (38.1 × 45.8 cm.)
Signed (lower center): Miró
Inscribed (on the reverse):
Joan Miró/*Femmes sur la plage*/Varengeville s/mer/15/II/1940

I N AUGUST 1939, one month before the outbreak of World War II, Joan Miró moved with his wife and daughter to a rented villa in Varengeville, on the coast of Normandy, about five miles west of Dieppe, where Georges Braque had built a country home in 1931. It was in that peaceful village, in January 1940, that Miró began the celebrated series of twenty-three gouaches, which, after they were issued as a portfolio of reproductions in 1959, became known as the "Constellations."[1] The series was produced during a period of twenty months, in three different locations—the first ten gouaches in Varengeville from January to May 1940, ten more in Palma de Mallorca between September 1940 and June 1941, and the last three in Montroig, in Spain, from July to September 1941.

Miró gave poetic titles to each of the works in the series, for which he used identically sized, specially prepared paper. Often, the grain of the paper remains visible, either through the luminous wash, as in the present example, or through "rubbed away" areas, as in a later work in the series (see page 223). As Miró told an interviewer, in 1978, after he finished one work, he wiped his "brushes on a clean sheet of paper, which provided the ground for the next one."[2] It was the color of the ground that, in turn, determined the appearance of the rest of the image. Recalling his mood at this point in his career, Miró said, "I was very pessimistic. I felt that everything was lost. After the Nazi invasion of France and Franco's victory, I was sure they wouldn't let me go on painting, that I would only be able to go to the beach and draw in the sand or draw figures with the smoke of my cigarette."[3]

Indeed, in the *Women on the Beach*, the fourth work in the series, the lines seem incised as if in the moist sand of the beach near Varengeville. As in other early gouaches in the series, the composition consists of a few, relatively large forms, which suggest three female bathers playing volleyball: at the left, a large, black-robed figure lifts its arms, an angular one with pointed breasts crouches at the right, while a third, in the center, seems to be a cross between a fish and a lobster. (Only toward the end of Miró's stay in Varengeville, from about the tenth "Constellation" on, did he cover a sheet with a multitude of equally small

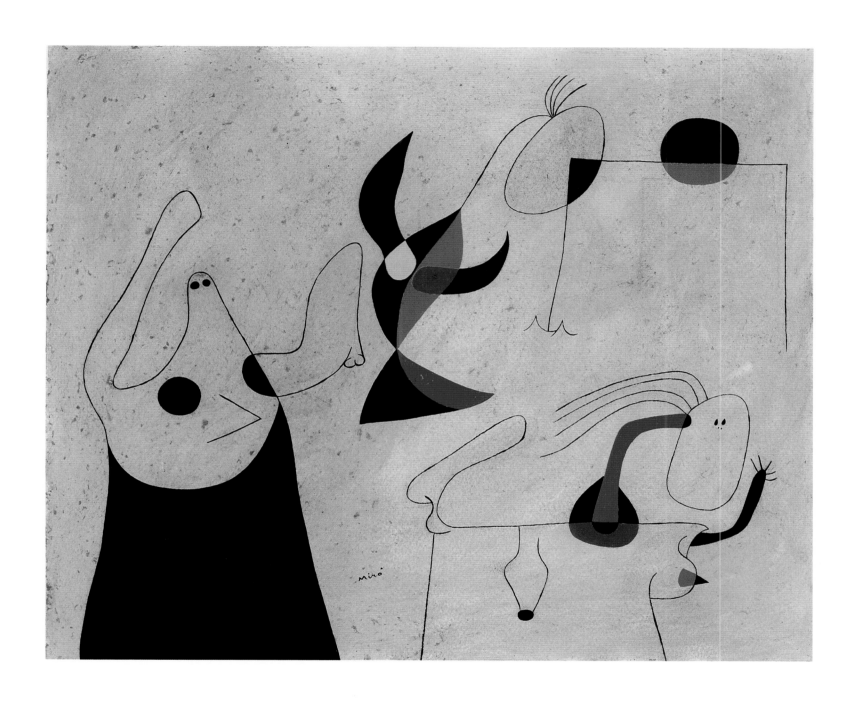

Miró. *Constellation: Women on the Beach.* Verso

220

forms, linked by thin black lines.) The theme of "Women on the Beach" was one that Miró had explored earlier, in a painting that was never realized, but for which sketches exist in one of the artist's "Carnets catalans" (1924–40) and in his "Grand cahier de Palma" (1940–41).[4]

1. See page 225, note 3.

2. *Joan Miró: Selected Writings and Interviews*, edited by Margit Rowell. Translations from the French by Paul Auster; from the Spanish and Catalan by Patricia Mathews, Boston, 1986, p. 294.

3. Ibid.

4. See *Joan Miró, Carnets catalans, dessins et textes inédits*, edited by Gaëtan Picon, vol. I, Geneva, 1976, ills. on cover and p. 100; vol. II, ill. p. [27].

Joan Miró

Spanish, 1893–1983

CONSTELLATION: TOWARD THE RAINBOW

Palma de Mallorca, March 11, 1941
Gouache and oil wash on paper
18 × 15 in. (45.8 × 38 cm.)
Signed (bottom center): Miró
Inscribed (on the reverse):
Joan Miró/*Vers l'arc-en-ciel*/Palma de majorque/11/III/1941

IN MAY 1940, after the invading German troops disturbed Miró's quiet life in Varengeville, he returned to Paris with his family, and then left at once for Spain. Sometime in June 1940 he settled in Palma de Mallorca, where he was to remain until the summer of 1941.

In Palma, Miró resumed work on his "Constellations" series, which he had temporarily abandoned when he left Varengeville, executing the eleventh picture in September 1940. The present one, *Toward the Rainbow*, is the fifteenth in the series (see also page 219). Characteristic of the works begun at the end of his stay in Varengeville and those painted in Palma, the entire sheet is covered with a multitude of forms virtually equal in size—stars, eyes, circles, triangles, crescents, hourglass shapes—that are linked by thin black lines to evoke a fantastical wrought-iron screen or perhaps a magical constellation.

Much has been written about these "Constellations." That Miró himself often referred to them indicates how much they must have meant to him. Their consistent strength, sparkling colors, gaiety, and poetry provide a striking contrast with the dark period in which they were created. In fact, these gouaches represent the artist's escape from the terrors of World War II—as Miró told James Johnson Sweeney in 1948: "At Varengeville-sur-Mer in 1939, a new stage in my work began which had its source in music and nature. It was about the time that the war broke out. I felt a deep desire to escape. I closed myself within myself purposely. The night, music and the stars began to play a major role in suggesting my paintings."[1]

If the earlier works were painted in intervals of only one or two weeks, it took Miró much longer to paint these more intricately composed pictures. He described his working method thus:

> It was a very long and extremely arduous work. I would set out with no preconceived idea. A few forms suggested here would call for other forms elsewhere to balance them. These in turn demanded others. It seemed interminable. It took a month at least to produce each watercolor, as I would take it up day after day to paint other tiny spots, stars, washes, infinitesimal dots of color in order finally to achieve a full and complex equilibrium. As I lived on the

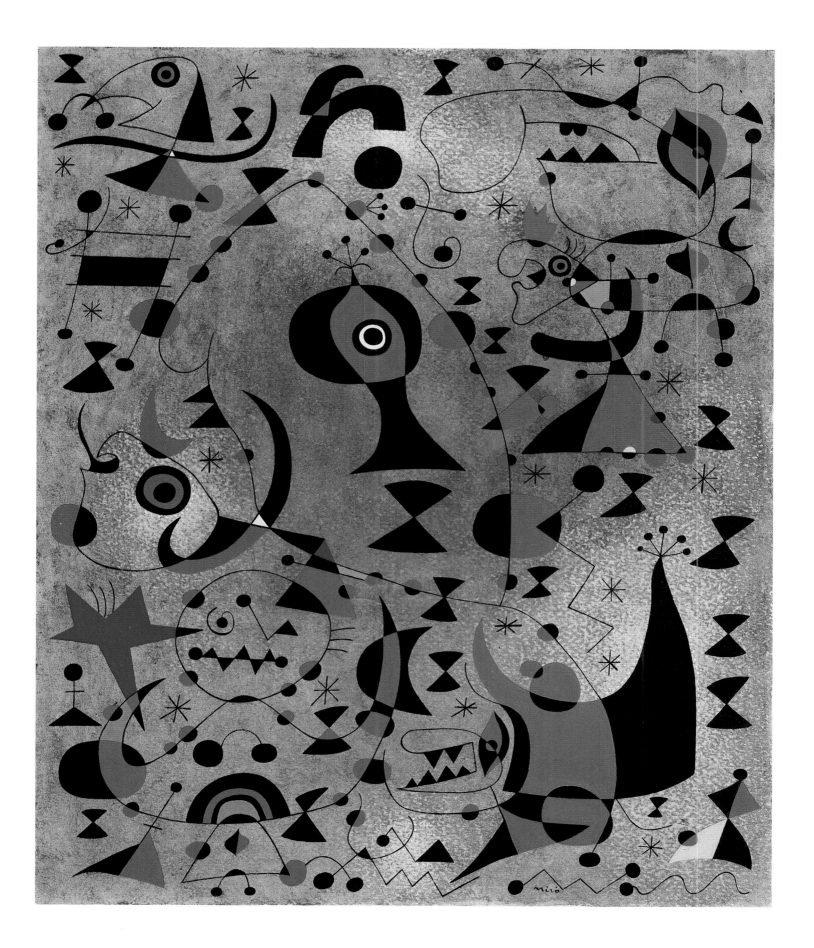

Miró. *Constellation: Toward the Rainbow.* Verso

outskirts of Palma I used to spend hours looking at the sea. Poetry and music both were now all-important to me . . . each day I would go to the cathedral to listen to the organ rehearsal. I would sit there in that empty Gothic interior, daydreaming, conjuring up forms.[2]

Miró completed the last of the twenty-three gouaches in the "Constellations" series in September 1941. Sometime later, he shipped them via the Spanish diplomatic pouch to his New York dealer and friend, Pierre Matisse, who exhibited them at his gallery in January 1945. They were the first works by a contemporary European artist to be shown in this country toward the end of the war, and they apparently made a great impression on young artists at the time. During the exhibition, these gouaches were simply called "tempera paintings" in the accompanying checklist. In 1959, Pierre Matisse published superb reproductions of each sheet in the series, which were boxed and issued in a limited edition of 350. Miró titled this portfolio "Constellations"—and the twenty-three gouaches have been known by that name ever since.[3]

1. *Joan Miró: Selected Writings and Interviews*, edited by Margit Rowell. Translations from the French by Paul Auster; from the Spanish and Catalan by Patricia Mathews, Boston, 1986, p. 209.

2. Ibid., p. 210.

3. The portfolio reproduced only twenty-two gouaches because Miró had given the twenty-third to his wife as a gift. André Breton wrote the introduction to the portfolio, as well as twenty-two texts that he called "proses parallèles." The texts were printed separately and, although they barely referred to the images, they were given Miró's titles, and were placed at the beginning of the portfolio, preceding the reproductions.

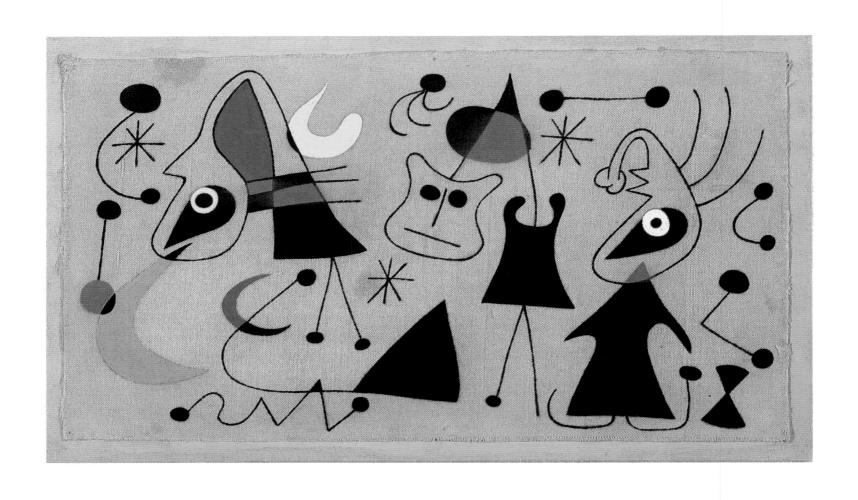

Joan Miró

Spanish, 1893–1983

WOMEN AND BIRD IN THE NIGHT

1944
Gouache on canvas
9¼ × 16¾ in. (23.5 × 42.4 cm.)
Inscribed (on the reverse):
Miró/1944/ JM/414/femmes et oiseau dans la nuit

"IT MIGHT be a dog, a woman, or whatever. I don't really care. Of course, while I am painting, I see a woman or bird in my mind, indeed, very tangibly a woman or a bird. Afterward, it's up to you."[1]

What do women and birds, stars, the moon, the sun, night, and dusk have in common? To Miró, they evoked something magical and poetic, and he made them a major and recurrent theme. He had first introduced the motif of a woman with a bird, in a realistic mode, in his paintings of 1917 (see page 154), but he did not employ that imagery again until 1934 (Dupin 369), and after that date it occurs only sporadically in his work. It was only after Miró had completed his celebrated "Constellations" series in 1941, in which women, birds, and stars prominently appear, that this theme became, according to Dupin, the sole subject matter of hundreds of drawings, pastels, and gouaches (1942–43).[2] When, in 1944, Miró started painting on canvas—after a lapse of four years—he took up this theme once more in some hundred small paintings (1944–45).

This picture—which is representative of some forty similar works that Miró painted, between 1944 and 1945, on small, often irregular unprimed canvases—might be a magnified detail of the gouache *Constellation: Toward the Rainbow* of 1941 (see page 223), for many of the same elements appear: stars; crescents; either zigzag, straight, curved, or bent lines, ending in knobs; and birds' heads, eyes, and hourglass shapes. Here, however, they are placed farther apart. What differs as well, in the present gouache, is the way in which Miró changes the color of a form to emphasize when it overlaps—or is overlapped by—a line or yet another form.

1. Joan Miró and Georges Raillard, *Ceci est la couleur de mes rêves*, Paris, 1977, p. 128.

2. Jacques Dupin, *Joan Miró: Life and Work*, translated by Norbert Guterman, New York, 1962, p. 374.

Joan Miró

Spanish, 1893–1983

WOMEN, BIRDS, AND A STAR

1949
Oil on canvas
36 × 28⅞ in. (91.5 × 73.4 cm.)
Signed (bottom right): Miró; *signed and dated (on the reverse):* Miró/1949

IN THIS painting, Miró continues to explore, on a larger scale, the theme that he had first introduced in the "Constellations" series (see pages 218–25). The merry, balloon-like faces, stars, lines and crescents, and ovoid shapes in the painting relate to those earlier works. Also, as in the "Constellations," Miró stained the ground, here, with two different colors, and then, to add texture, he rubbed off the paint in several places. The boldness of the simple forms, as well as their striking contrasts of red, black, and white, evokes the spare parts of an Alexander Calder mobile. Miró and Calder had met in Paris in 1928.

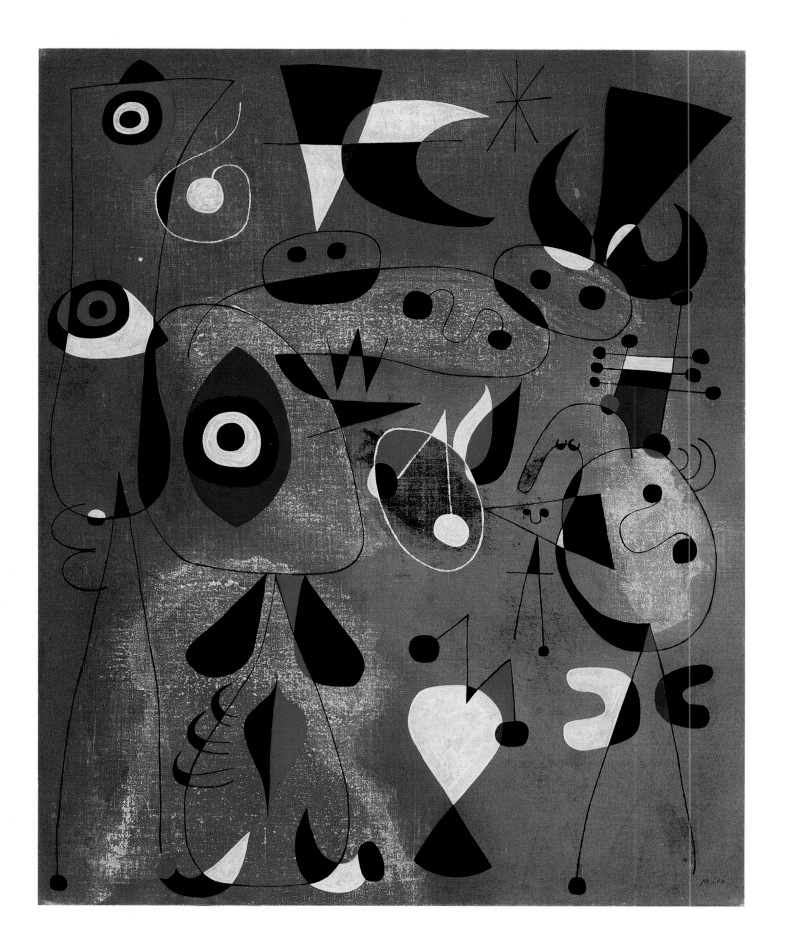

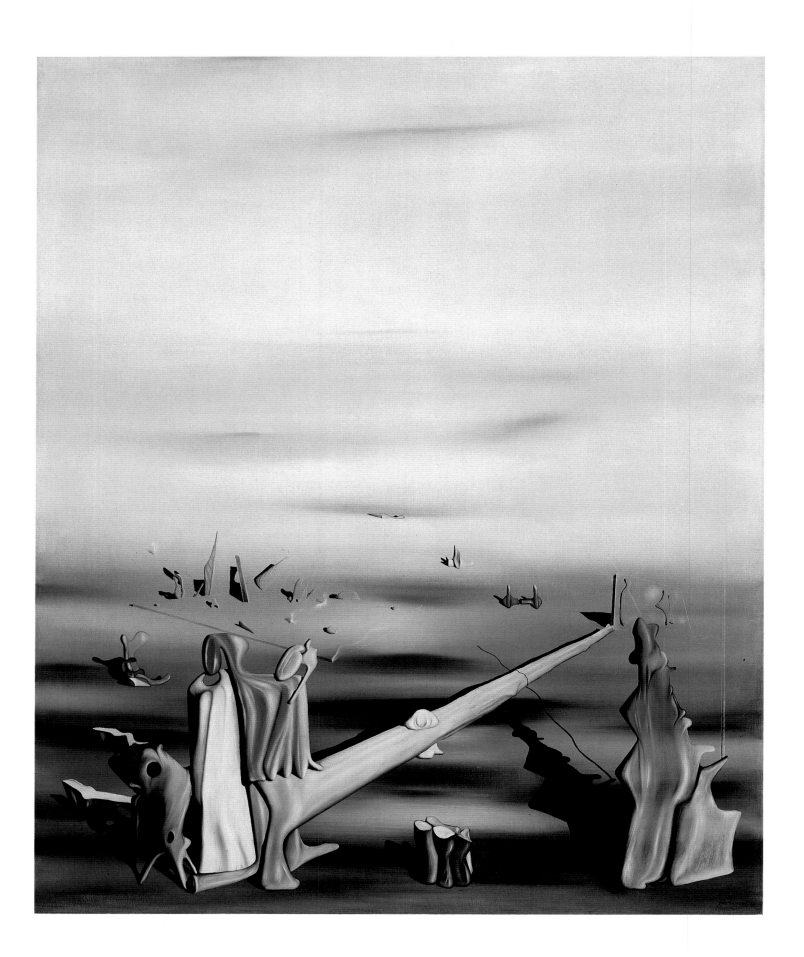

Yves Tanguy

American, born in France, 1900–1955

THE SATIN TUNING FORK

1940
Oil on canvas
39 × 32 in. (99 × 81.3 cm.)
Signed and dated (bottom right): YVES TANGUY 40

As a result of his travels during the years spent in the merchant marine (1918–20) and in the army (1920), Yves Tanguy had stored in his memory the impressions of a host of faraway, exotic places, such as Argentina, Brazil, Tunisia, and the coast of Africa. In Paris, during his early twenties, Tanguy maintained himself by working at odd jobs, none of them involving painting. He shared a house at 54, rue du Château, in Montparnasse, with Jacques Prévert (1900–1977), a close friend from military service who later became a well-known poet and filmmaker, and also with Marcel Duhamel, a wealthy young patron of the arts who was in the hotel business and contributed to the support of his two friends.[1]

In 1925, Tanguy met André Breton and joined the Surrealist group. His ensuing friendship with the older poet, who headed the Surrealist movement, proved decisive for Tanguy. Breton served him as both an influence and as an advocate. Until the artist's departure for the United States in 1939, he remained deeply devoted to Breton. The latter, in turn, regarded Tanguy as one of the purest painters among the Surrealists.

Tanguy burned most of his early works. The few that survive—primarily watercolors and other paintings dating from about 1924 to 1926—reveal the crude adaptation of a variety of styles, among them, those of the German Expressionists, and of de Chirico, Max Ernst, and Miró. This early work has the quality—to borrow William S. Rubin's apt words—"of naïve, Sunday painting."[2] By 1927, however, the self-taught Tanguy had found his own personal style and also had acquired amazing technical skill. From then until his death in 1955, he focused on the same dream-like subject: a plain stretching toward infinity—below a usually overcast sky—deserted except for various fantastical objects, the whole rendered in a precise, illusionistic technique. If Tanguy's eerie vistas were pure invention, the three-dimensional, biomorphic objects that fill these settings may have had as their sources the early reliefs by Jean Arp and the paintings of 1922–23 by Joan Miró. Both artists' works were exhibited in Paris at that time.

Tanguy's style varied little throughout the years. Even his move to the United States in 1939 had only little effect on his work, although it would bring about an important change in his life. In New York he joined the American painter Kay Sage (1898–1963), whom he had first met the previous year in Paris; they were married in 1940.

This gray landscape has about it all the desolation that makes it an ideal Surrealist stage set. As in many of Tanguy's works, there is no exact horizon line. Ground and sky fuse with one another. Characteristically, strong light strikes the Daliesque landscape from a point at the right, granting the reds, blues, greens, and whites a hard, metallic sheen. Commonplace objects, ranging from the tiniest pebble to the gigantic, spiky log in the foreground, assume a fantastical aspect as they cast black shadows. Although this indefinable space may appear to be somewhere between earth and sky, we know by the shadows that the objects rest upon the ground.

According to John Ashbery, Tanguy chose his titles arbitrarily, sometimes asking his friends for suggestions.[3] Often, instead of serving as an explanation for a picture, a title would be chosen to contrast with the subject of the work—which seems to have been the case here. Incidentally, a "satin tuning fork" is a paradox in itself.

1. The biographical information in this and the two subsequent entries on Tanguy is taken from the revised chronology of the artist's life in the exhibition catalogue *Yves Tanguy Rétrospective 1925–1955*, compiled by Agnès Angliviel de La Beaumelle and Florence Chauveau, Paris, Musée National d'Art Moderne, Centre Georges Pompidou, 1982.

2. William S. Rubin, *Dada and Surrealist Art*, New York, 1968, p. 195.

3. John Ashbery, "Tanguy—The Geometer of Dreams," in *Yves Tanguy 1900–1955* (exhib. cat.), New York, Acquavella Galleries, 1974.

Yves Tanguy

American, born in France, 1900–1955

MY LIFE, WHITE AND BLACK

1944
Oil on canvas
35¾ × 29⅞ in. (90.8 × 75.8 cm.)
Signed and dated (lower right): YVES TANGUY *44*

THE LANDSCAPES painted by Yves Tanguy have no sun or moon. They contain nothing of our world. Neither people nor animals are present, and houses and trees do not exist. Instead, fantastical biomorphic forms are rendered in a painstakingly illusionistic style, and they occupy an imaginary tract of land illuminated by what appears to be strong artificial light.

In the United States after 1939, Tanguy tended to enlarge the individual forms in his paintings, and to place them closer to the foreground, often introducing tall, intricately built constructions of prickly or round elements as well. The elaborate scaffolding in the present picture seems to be constructed of huge, antediluvian bones, evoking some gigantic monument erected by a primitive people in ancient times, after some horrific feast. Spiked and threatening, the neatly jointed, iridescent bones and other objects in pale rose, slate gray, and rust are reminiscent of the contemporary stone and marble sculptures by Isamu Noguchi (1904–1988), as can be seen in figure 1.

This is the sole painting in Tanguy's oeuvre to depict, in close-up, a single, huge "bone" scaffolding. It brings to mind another—one made out of carpentry—that appears in de Chirico's *The Jewish Angel* of 1916 (see page 146), which, in turn, is exceptional among the latter artist's works. Even if formal parallels are not apparent at first sight, some do seem to exist between the two paintings. For example, both of these unusual structures are made up of overlapping, curved and pointed three-dimensional forms, set against an empty gray ground. Similarly, the large eye in the de Chirico has as its counterpart the small, brown oval object at the top of the Tanguy. Furthermore, the two bones that form a cross-like motif at the lower right in the Tanguy might be compared to the design of crisscrossed lines on the gray stone in *The Jewish Angel*.

De Chirico's work had at one time greatly influenced Tanguy. After all, Tanguy's decision to become an artist in 1923 was the result of seeing two paintings by de Chirico in a Paris gallery that year. Also, during a visit to London in 1938, Tanguy undoubtedly would have seen *The Jewish Angel* at the home of its owner, Roland Penrose, where he was staying.

As to subject matter, however, similarities between the two paintings are nonexistent. By representing his own and his father's professional tools in *The Jewish Angel*, de Chirico was obliquely referring to his private life. In contrast, Tanguy's objects are, as always, unrelated to anything personal—let alone only faintly familiar.

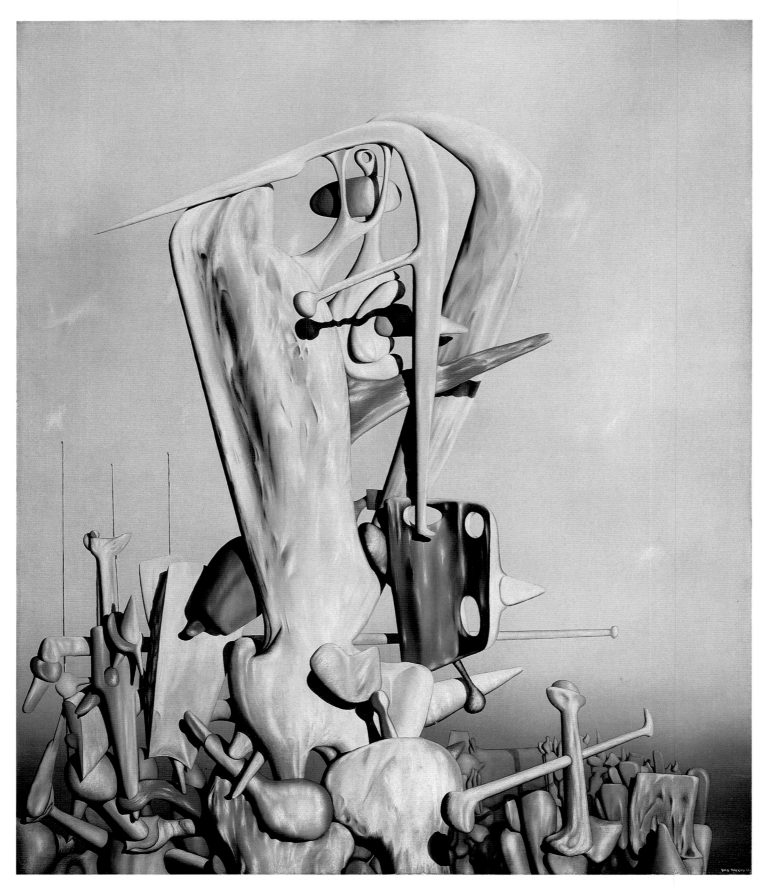

Tanguy. *My Life, White and Black*

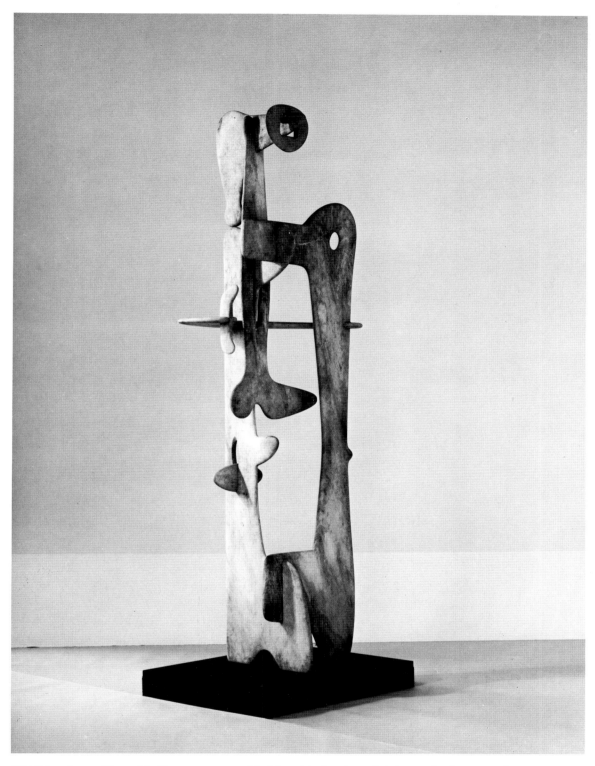

FIGURE 1. Isamu Noguchi. *Kouros.* 1944–45. Marble, with slate base, height: 117 in. (297.2 cm.). The Metropolitan Museum of Art, New York, Fletcher Fund, 53.87 a–i

Yves Tanguy

American, born in France, 1900–1955

FROM GREEN TO WHITE

1954
Oil on canvas
39 × 32 in. (99 × 81.3 cm.)
Signed and dated (bottom right): YVES TANGUY *54*

WHEN YVES Tanguy painted this apocalyptic work, he was living in Woodbury, Connecticut—a picturesque, typically New England town with white clapboard houses, white picket fences, and white-shingled churches. For Tanguy and his wife, Kay Sage, home in Woodbury was a nineteenth-century farmhouse that they had bought in 1946. Each had a separate studio, and visitors to Tanguy's commented on the pristine appearance of his. One such observer, and also a neighbor, was the filmmaker Hans Richter, who remembered:

> If the house was clean, his studio, in a remodeled barn, was antiseptic: white as white can be and completely bare. On the immaculate easel a single painting in progress, on the table a row of brushes lying like soldiers, the paint tubes and the palette in exquisite order. In front of the easel one straight chair and nothing else in the vast and high hall—except his smile of friendly mockery, as if he wanted to say, "What are you looking for—it's all unimportant."[1]

Some critics have tried to establish the source for Tanguy's surreal landscapes in the strange stone-and-rock formations near Lorconan, in the Finistère region of Brittany—where, it has always been assumed, he spent his childhood vacations in his family's house. During most of his youth, however, Tanguy lived in Paris. His mother, originally from Brittany, had bought a house in Lorconan in 1912, and had settled there permanently sometime between 1916 and 1918, when Tanguy was already at least sixteen years old. Later, in the mid-1920s, his visits to the region, in the company of his friends Jacques and Pierre Prévert and Marcel Duhamel, were casual attempts to rediscover his "Breton roots."[2] (It has also been suggested that Tanguy's fondness for alcohol and his use of other stimulants may have influenced his art.)[3]

From Green to White provides another glimpse into Tanguy's familiar visionary and totemic world. Painted in 1954, one year before his death, this work and others dating from

that same time offer an abundance of what might be truncated columns, pedestals, obelisks, and various carved stones, under a blue sky partly veiled by white clouds, all of which suggest the architectural ruins of some long-lost civilization.

1. Hans Richter, "In Memory of Two Friends: Fernand Léger, 1881–1955, Yves Tanguy, 1900–1955," *College Art Journal* no. 4 (Summer 1956), p. 345.

2. See Robert Lebel's essay, "La Morphologie conjuratoire de Tanguy," and the chronology of the artist's life in *Yves Tanguy Rétrospective 1925–1955* (exhib. cat.), compiled by Agnès Angliviel de La Beaumelle and Florence Chauveau, Paris, Musée National d'Art Moderne, Centre Georges Pompidou, 1982, pp. 31–38, 163 ff.

3. Ibid., p. 38.

Since 1940
Part Two

Jean Dubuffet

French, 1901–1985

VIEW OF PARIS WITH FURTIVE PEDESTRIANS

February 1944
Oil on canvas
35 × 45⅝ in. (88.9 × 115.9 cm.)
Signed (bottom right): Février 44/ J.Dubuffet

JEAN DUBUFFET had twice renounced painting but, in 1942, at the age of forty-one, he made a firm commitment. By then, he had worked at various careers and had become quite erudite in the pursuit of art history, languages, philosophy, literature, and music. In 1918, he had enrolled at the Académie Julian in Paris, but left after only six months to work independently. In 1924, after a year of military service as a meteorologist in Saint-Cyr and on the Eiffel Tower, he was employed as a technical draftsman in Buenos Aires. Dubuffet earned a living off and on as a wine merchant, first in his parents' business in Le Havre (1925–30) and then on his own in Paris (1930–34 and 1937–42).

In 1923, after reading Hans Prinzhorn's *Bildnerei der Geisteskranken* (1922), in which the art of the mentally ill was first considered to have aesthetic value, Dubuffet became interested in pictures made by those without formal training—the uninitiated, the alienated, and, especially, the insane.[1] Many years later, in 1945, he started a collection of these pictures, which he called "Art Brut" ("Raw Art"), that eventually comprised five thousand items.

Dubuffet, however, went much further than Prinzhorn. Not only did he regard "Art Brut" as a more authentic, genuine, imaginative, and spontaneous form of artistic expression, but he also came to reject the methods and values of traditional art. "Beautiful" and "ugly" had no meaning for him, and he tirelessly defended his "anti-art" and "anti-culture" theories in lectures and in two volumes of essays (1967). He wanted his subject matter to be accessible to simple people and to relate to their daily lives, and thus his first paintings were of Parisians riding the crowded *métro*. These pictures were followed by a series of formidable bicyclists.

This painting, part of yet another series of some fourteen oils and gouaches, focuses on pedestrians in various back alleys of Paris. Emulating the features of "Art Brut," Dubuffet intentionally adopted a crude style. The street, sidewalks, and houses are stacked in rows, one above the other, without perspective, depth, or modeling. Windows and shop signs are stuck at random onto façades. The overall effect evokes the backdrop of a puppet theater at a

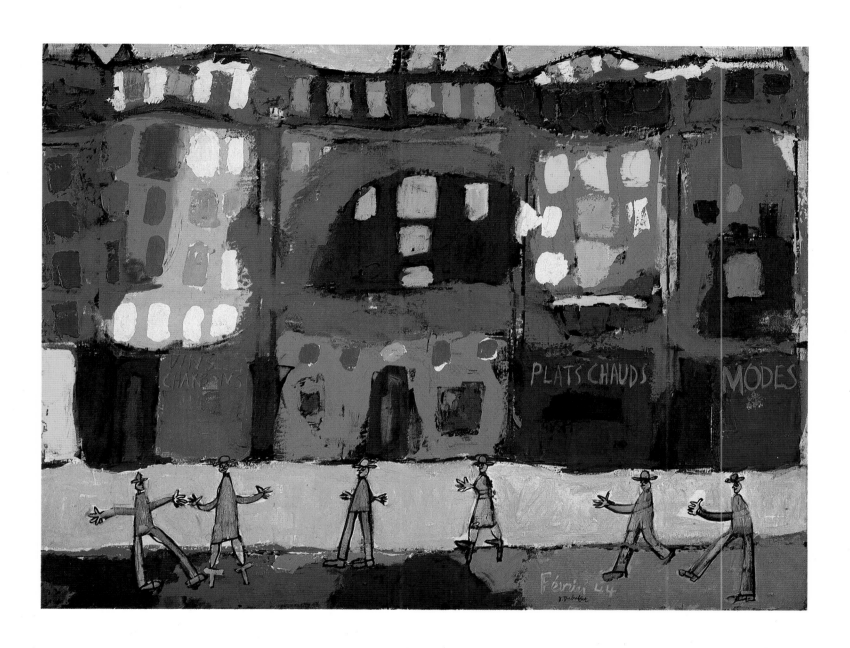

provincial fair—such as Dubuffet himself had built and decorated during his previous interlude as a painter, lasting from 1934 to 1937, when he also carved and painted marionettes. While the gray stone buildings of Paris are rendered, here, in hot, vibrant colors, the stick-figure pedestrians are uniformly mouse gray. Seen only in profile, they wear funny hats, and the women totter on ridiculously exaggerated wooden platform soles and high heels. With their arms and hands outstretched, they appear to be frolicking, not at all furtive as the title suggests.

1. See Margit Rowell, "Jean Dubuffet: An Art on the Margins of Culture," in *Jean Dubuffet: A Retrospective* (exhib. cat.), New York, The Solomon R. Guggenheim Museum, 1973, p. 17.

Jean Dubuffet

French, 1901–1985

JEAN PAULHAN

September 1946
Chalk and titanium white, with acrylic and oil binders, on Masonite
42⅞ × 34⅝ in. (109 × 88 cm.)
Inscribed (on the reverse, on the upper bar of the stretcher):
Maast à crinière (portrait de Jean Paulhan)

I N HIS LETTERS, Dubuffet would sometimes affectionately call his friend the writer and critic Jean Paulhan (1884–1968) "Monsieur Maast" (see fig. 1). Between 1944 and 1947, Paulhan signed some of his essays with the pseudonym "Maast." He had first used the name in his autobiographical war novel *Guerrier appliqué* (1917) for the eighteen-year-old hero "Jacques Maast." (Apparently, Paulhan, an airplane signalman during World War I, was stationed in a small village called Maast, north of Paris, between Soissons and Braisne.)[1]

Jean Paulhan was the editor of the prestigious French literary magazine *La Nouvelle Revue Française* from 1925 until his death in 1968. His collected works fill five volumes, and they encompass books on modern painting; essays on rhetoric, language, logic, and love; and prefaces to erotic literature, including the works of Sade and Pauline Réage's *Histoire d'O* (1954), believed by many to have been written by Paulhan himself.

Paulhan and Dubuffet met in Paris late in 1943, and remained friends until 1957. Through Paulhan, Dubuffet was introduced to the art dealer René Drouin, who, in the autumn of 1944, organized the painter's first exhibition in Paris. Among the works included were Dubuffet's colorful views of the French capital (see the previous entry). Dubuffet then focused on the grimy surfaces and the gritty textures of the walls themselves, and these subsequently became the subjects of his paintings. This fascination, no doubt, was related to his admiration for what he called "Art Brut," whose untrained practitioners used crude, unconventional materials. In 1945, Dubuffet began to create paintings that he referred to as "Hautes Pâtes," in which a thick paste served as the ground. The paste was made of tar, asphalt, and white lead, often enriched with cement, plaster, or varnishes, to which sand, coal dust, pebbles, and pieces of glass or straw might also be added.[2] Gradually, color virtually disappeared from his work. In this portrait, the ground and the paint surface are built up with heavy chalk, thus continuing the influence of the "Hautes Pâtes" technique of the previous year.

Between July 1945 and August 1947, Dubuffet drew and painted some twenty-eight portraits of Paulhan in oil, gouache, crayon, and ink. This work was part of a large series of some 170 portraits of the writers, poets, and painters who were his friends—his sole subject matter at that time—a selection of which was exhibited at the Galerie René Drouin in October 1947. Consistent with his "anti-art" position, Dubuffet rejected traditional

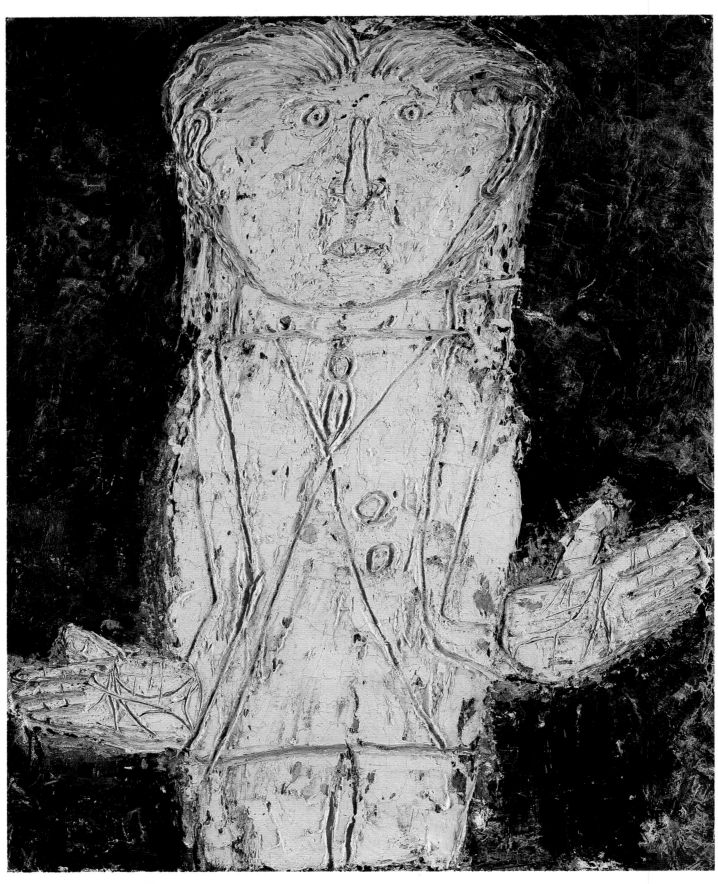

Dubuffet. *Jean Paulhan*

portraiture, which he regarded as facile imitation. Instead of conveying a sitter's likeness or personality, he focused on certain odd features, which he then exaggerated. Yet, however outlandish his distortions might be, the sitter can always be identified.

This is one of Dubuffet's finest portraits of Paulhan, whose intense, close-set eyes, long nose, broad upper lip, two prominent upper front teeth, and thick mane of unruly hair are easily recognizable. His strangely monolithic form seems to emerge from plaster or chalk that has been smeared onto a dark wall in which the lines of his face and hands, and his tie, jacket, and buttons have been scratched, like graffiti.

1. Jacqueline Paulhan, the writer's daughter-in-law, supplied this information in Paris on January 13, 1989.

2. Peter Selz, *The Works of Jean Dubuffet*, New York, 1962, p. 22.

FIGURE 1. Jean Paulhan. Paris, 1954 (Photograph: Lipnitzki-Viollet, Paris)

Henri Matisse

French, 1869–1954

MODEL STANDING IN THE ARTIST'S STUDIO

1948
Brush and black ink on paper
22¼ × 30 in. (56.4 × 76.3 cm.)
Signed and dated (bottom right): H. Matisse 48

I N 1943, an air raid took place over Cimiez, the suburb of Nice where Matisse had lived since 1938. For safety's sake, he left Nice that same year and moved twenty miles further inland to the outskirts of the ancient hill town of Vence, where he lived in the Villa "Le Rêve."

In the winter and spring of 1948, Matisse painted six large works depicting studio interiors with flowers and fruit. Related to these in their large scale as well as in their motifs is the group of bold black-and-white brush-and-ink drawings to which this picture belongs.

In this quick sketch, we see three of Matisse's favorite themes: the artist's studio—the walls are dotted with pictures by him; the model in the studio—she stands as lifeless as the leopard rug on the floor; and the view through a window—here, of the trees and shrubs outside.

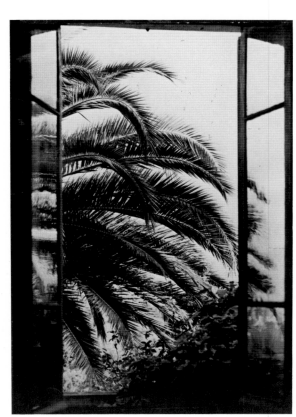

FIGURE 1. View from a window in Henri Matisse's studio in the Villa "Le Rêve." Vence, France, 1946 (Photograph: Hélène Adant; Courtesy Musée Matisse, Nice)

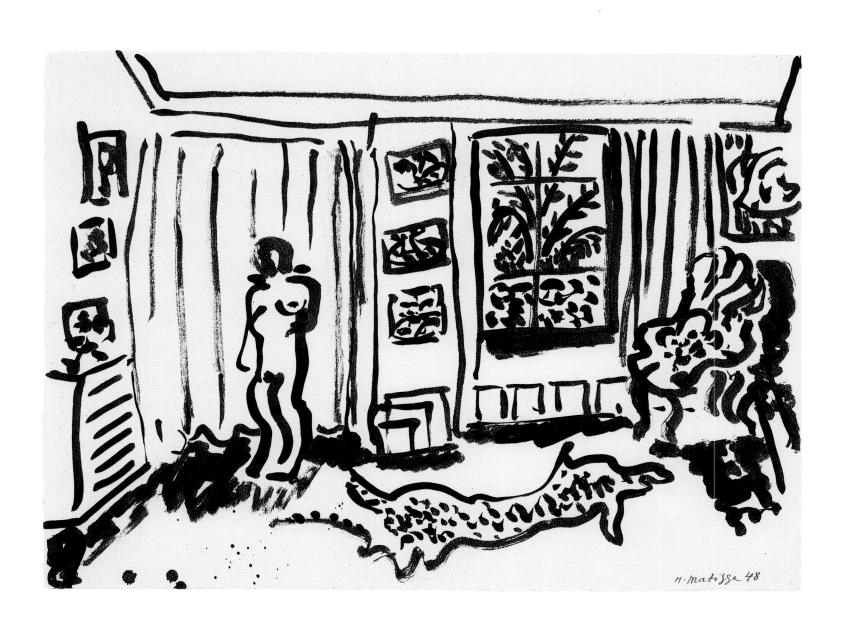

Henri Matisse

French, 1869–1954

SNOW FLOWERS

1951
Watercolor and gouache, on cut-and-pasted papers
68½ × 31¾ in. (174 × 80.7 cm.)
Inscribed (lower right): Fleurs de Neige Henri Matisse / 1951

D URING THE last decade of his long life, Henri Matisse produced some 270 paper cutouts. Although they constitute independent works, many also served as maquettes for projects as different in scale and purpose as book illustrations—the most notable of which are those in his portfolio *Jazz* (1943–44)—or designs for the liturgical vestments and stained-glass windows for the chapel at Vence (1948–52).

During the 1930s, Matisse had already used paper models to help him compose his paintings. Then, after two serious intestinal operations in 1941 left him in poor health, the artist worked more and more with paper cutouts—something he could do sitting up in bed or in an armchair.

With scissors, Matisse cut shapes from sheets of paper that his assistants first had colored with gouache. These would then be pinned, and, once their positions had been determined, glued onto a white or multicolored ground. When he worked on a larger scale—from the late 1940s on—he would have his assistants pin the cutouts onto backgrounds that had been put up earlier against a wall, directing them as he created the composition that he desired. Sometimes he would ask that the cutouts be affixed to the wall itself, and when he was satisfied with the arrangement the assistants would glue the pieces onto an appropriate support.[1]

In January 1949, Matisse left Vence and returned to his apartment at the Hôtel Regina in Cimiez, on the outskirts of Nice, which he had left in 1943 to escape the war. By 1951, the date of this work, Matisse had stopped painting, and devoted himself exclusively to making large-scale paper cutouts and drawings. On account of the distance between the invalid artist, in his bed or chair, and the wall that held the work in progress, his cutout shapes became bolder and more simplified—as they are here. In this work, the "snow flowers"—a mixture of plant- and bone-like shapes—are placed against a patchwork of rectangles of brilliant violet, orange, pink, and, to further accentuate their whiteness, deep green, blood red, and indigo blue. Its title, *Snow Flowers*, could be a poetic allusion to the very whiteness of the cutout shapes. However, at the very bottom of the composition is a form that might depict a snowdrop—the frosty-white, bell-shaped little flower that blooms in early spring.

1. This information is taken from Antoinette King, "Technical Appendix," in *Henri Matisse Paper Cut-Outs* (exhib. cat.), compiled by Jack Cowart, Jack D. Flam, Dominique Fourcade, and John Hallmark Neff, Saint Louis Art Museum, 1977, pp. 272 ff.

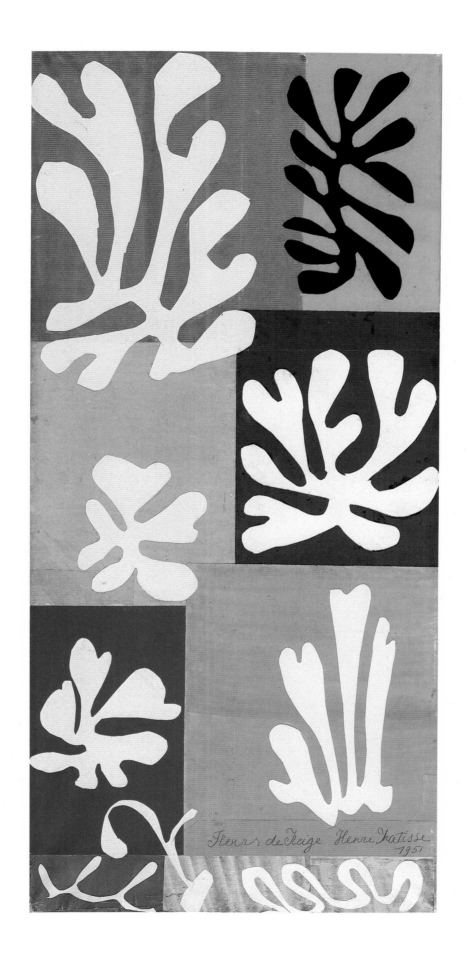

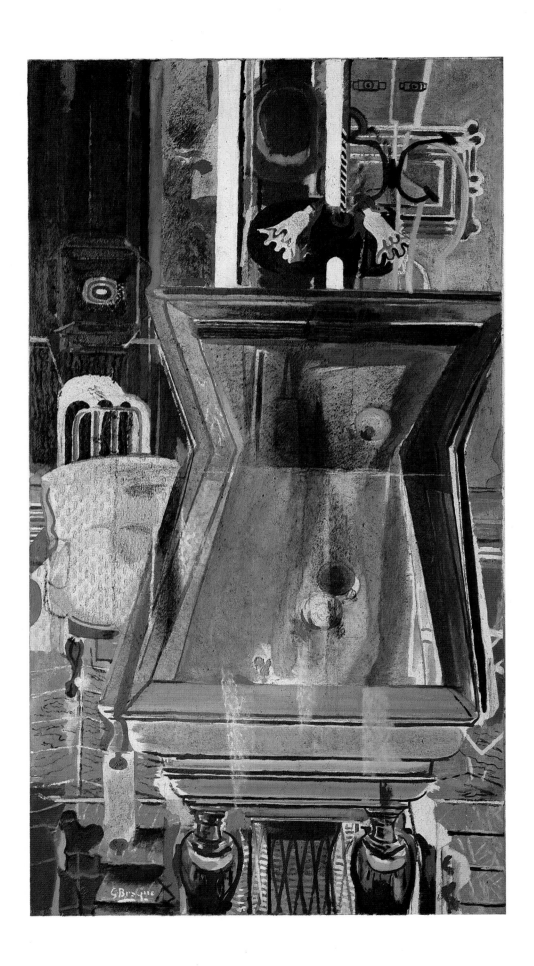

Georges Braque

French, 1882–1963

THE BILLIARD TABLE

1944–52
Oil, sand, and charcoal on canvas
71¼ × 38½ in. (181 × 97.8 cm.)
Signed (bottom left): G Braque

D URING World War II, Georges Braque for the most part remained in Paris. After Liberation in September 1944, he returned to Varengeville, a picturesque village inland from the coast of Normandy, near Dieppe. There, in 1931, he had built a typical Normandy farmhouse complete with thatched roof, so that it might harmonize with the other houses scattered throughout the idyllic landscape of lush green meadows dotted with cows.

In September 1944, Braque began the series entitled "Billiard Tables," comprising seven paintings on which he would work, intermittently, until 1952. Together with the eight pictures in the "Studio" series, painted between 1949 and 1956, they represent both the artist's largest and his last major works. Of these seven paintings of billiard tables, there are four small pictures dating from 1944–45 and three much larger ones—each measuring at least seventy-one inches in length: one was painted in 1944; another, between 1948 and 1949; and the third, the present picture, was begun in 1944, later reworked, and completed only in 1952.[1] Unlike the two other large versions that show the billiard table horizontally, the table in this painting—the most unusual in format of the three—is rendered vertically, its far side appearing as if it were folded and flipped forward.

Curiously enough, Braque did not own a billiard table, nor was he a fanatic billiards player, although occasionally he might have enjoyed a friendly game with his brother-in-law.

In the works in the "Billiards" series, Braque played all sorts of visual tricks with the table, either "folding" it or, as in the smaller pictures, including only one of its corners, shown obliquely. In addition, the table is always brought up eerily close to the picture plane, perhaps to approximate the actual strange viewpoints of a player bending over the table during a game. Braque represented these green billiard tables in interiors whose muted browns, tans, grays, rusts, and greens are played off or echo the colors of the table, and he often added highlights of red and white (the balls) and sometimes, as in this version, even a few touches of blue and pink. The artist also mixed sand with his paint, here, to create a mat, fresco-like surface.

In his review of a recent Braque exhibition, Robert Hughes aptly compared one of the horizontally foreshortened billiard tables in this series to a "foundering . . . sinking ship."[2] However, the huge, monolithic form that appears to push all of the objects in this picture to the edges of the canvas is reminiscent, instead, of a monumental casket. Indeed, its forward-

tilted shape recalls a contemporary work by the Surrealist painter René Magritte (1898–1967), of about 1950 (see fig. 1), in which—in a spoof on Jacques-Louis David's famous painting *Mme Récamier* (1800)—he replaced the languid, female figure reclining on her settee with a bent coffin.

The early version of this *Billiard Table* is known from a 1945 photograph by Brassaï of Braque's studio (see fig. 3) that shows the picture on an easel behind the artist. A comparison of the painting in its present state with how it appears in the photograph reveals that the area above the billiard table, except for two broad white stripes, has remained the same, containing then, as now, a light fixture, a hat on a rack, and a small, framed picture. However, Braque later changed and reworked the left side of the painting, adding the chair with the large green-and-white cushion that, like the rest of the objects, is aligned with the vertical table. The inclusion of the chair is more faithful to the original sketch for this painting—as shown in a 1944 drawing (see fig. 2). Braque also replaced the round fishbowl on a tripod with what looks like a black telephone.

1. See Nadine Pouillon and Isabelle Monod-Fontaine, *Braque: Oeuvres de Georges Braque, Collections du Musée National d'Art Moderne*, Paris, Centre Georges Pompidou, 1982, pp. 134–37.

2. Robert Hughes, "Glimpses of an Unsexy Tortoise," *Time* (August 1, 1988), p. 53.

FIGURE 1. René Magritte. *Perspective: Madame Récamier by David*. About 1950. Oil on canvas, 25½ × 31⅞ in. (64.8 × 80.9 cm.). Private collection, Brussels

FIGURE 2. Georges Braque. Study for *The Billiard Table* of 1944–52, from one of the artist's sketchbooks (Courtesy Archives Laurens, Paris)

opposite
FIGURE 3. Brassaï. Georges Braque in his studio in Varengeville, France. 1945 (Photograph: Brassaï, © Gilberte Brassaï, 1989)

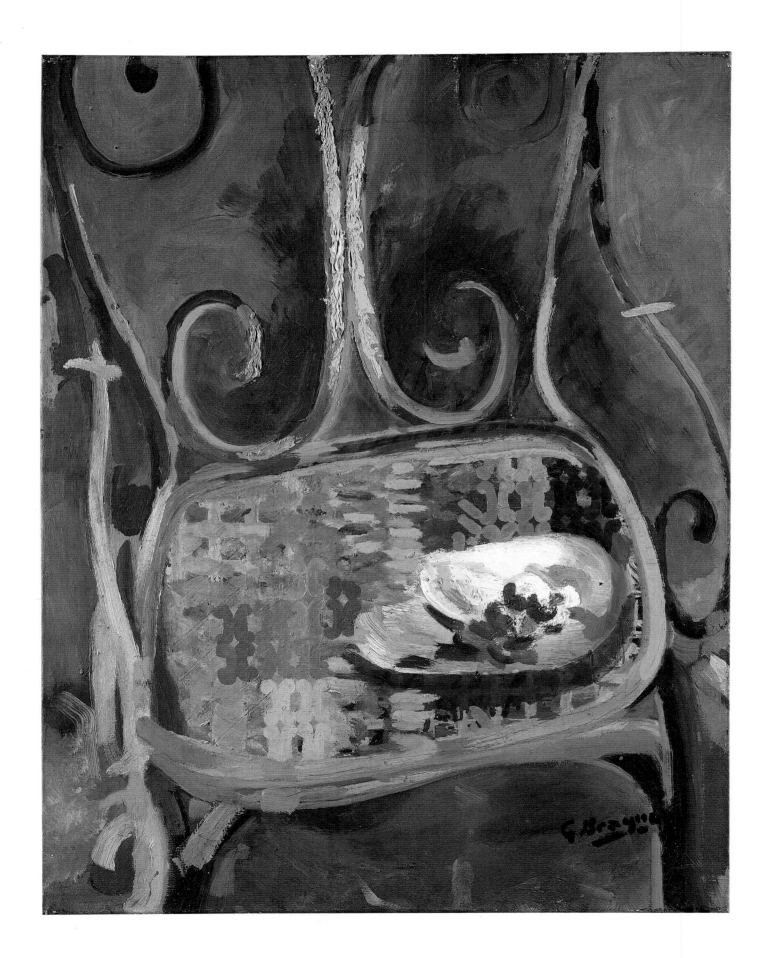

Georges Braque

French, 1882–1963

THE GARDEN CHAIR

1947–60
Oil on canvas
25⅝ × 19¾ in. (65 × 50.3 cm.)
Signed (lower right): GBraque

FROM THE 1920s on, Georges Braque bound his drawings together in sketchbooks, which he consulted when he needed ideas for a picture. This painting of a garden chair—part of a series of six—is based on a drawing he made in 1943 of one of the metal chairs at his country house in Varengeville in Normandy (see fig. 1).[1] In selecting this motif, Braque cannot have been unaware of van Gogh's famous painting entitled *Gauguin's Chair* (1888), in which the artist turned a plain wooden chair laden with books and with a candle into a moving evocation of his soon-to-be-absent friend. Yet, Braque's chair has no such hidden or symbolic meaning. It is purely painterly and decorative, with just a palette covered with bright spots of paint lying on the seat.

1. See Nadine Pouillon and Isabelle Monod-Fontaine (op. cit., p. 252), pp. 138–41.

FIGURE 1. Georges Braque on the terrace of his house in Varengeville, France (Photograph: Felix H. Man; © Mrs. Noya Brandt; Courtesy Edwynn Houk Gallery, Inc., Chicago)

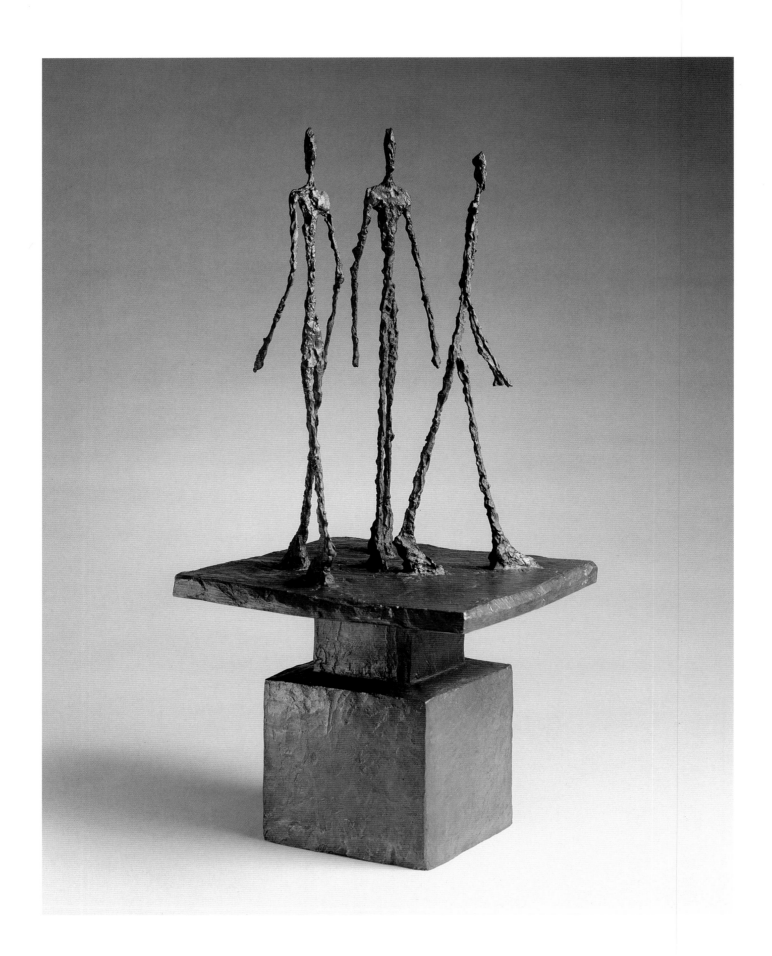

Alberto Giacometti

Swiss, 1901–1966

THREE MEN WALKING II

1949
Patinated bronze
30⅛ × 13 × 12¾ in. (76.5 × 33 × 32.5 cm.)
cast no. 1/6
Signed and numbered (on the plinth): A. Giacometti 1/6
Inscribed (on the base): Alexis Rudier Fondeur Paris

A SCULPTOR and a painter, Alberto Giacometti was born into an artistic family in the small village of Borgonovo, north of Stampa, in the most Italian canton of Switzerland. His father and uncle were the Post-Impressionist painters Giovanni (1868–1933) and Augusto (1877–1947) Giacometti. From an early age, Alberto drew, painted, and modeled portrait heads, his brother, Diego, serving as his first sitter. Although, after 1946, he would devote himself equally to painting and sculpture, until then it was sculpture that took precedence.

Settling in Paris in 1922, Giacometti attended classes, over a three-year period, given by Rodin's pupil Émile-Antoine Bourdelle at the Académie de la Grande Chaumière. In 1925, for the first time, he began to experience difficulties in working directly from nature, and the impossibility of "reproducing what he saw" became an intellectual predicament that would haunt him all his life. During the next twenty years, he would alternate between working from the imagination—from 1930 to 1935 he was a member of the Surrealists—and from the model.

It was Giacometti's preoccupation with perception *versus* realization that would contribute to his practice of building, destroying, and then rebuilding the same sculpture, over a period of weeks or sometimes months. Even a work that he later had cast in plaster or in bronze he considered as never really finished, but rather simply as the last version of a "work in progress," and this same method and attitude applies to his paintings, as well (see page 275).

In 1945, Giacometti decided to abandon the figures only one or two inches tall that he was making, in favor of larger ones. By 1947, he had adopted what was to become his characteristic style, creating extremely thin and attenuated figures that ". . . achieved a resemblance only when long and slender."[1] Within this style, three main themes would interest him: the walking man; the standing, nude woman; and the bust, or head—or all three, combined in various groupings. (There are examples of each in the Gelman collection.) Without volume or mass, the figures appear weightless and remote, their eerie

otherworldliness accentuated by the mat shades of gray and beige paint, sometimes accented with touches of pink or blue, that the artist applied to their bronze patinas. Often, the rough and gritty surfaces of these figures—reduced, as they are, to their very core—evoke lone trees in winter that have lost their foliage.

Giacometti designed the placement of these three walking men with the precision of a choreographer. Two figures of the same height, with their right feet forward, and coming from opposite directions, are on the verge of passing each other. The third, smaller figure is walking away at a ninety-degree angle to them. Their steps are equally wide, and they do

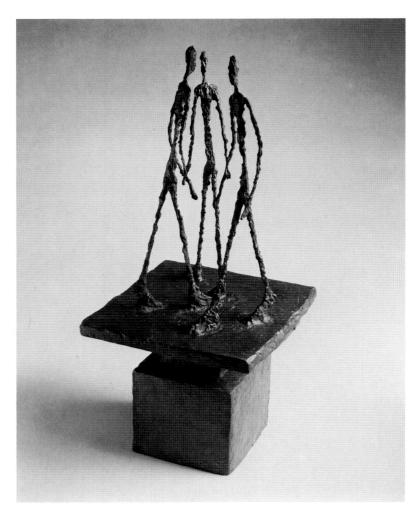

FIGURE 1. Alberto Giacometti. *Three Men Walking II*. Alternate view

not look at one another. The figure in the center is about to occupy the place being vacated by the smaller figure. If we imagine all three men going backward two steps, the figure on the outside at the left would then be in the spot that the smaller figure has just left.

Three Men Walking exists in two versions. There are six casts of each.

1. Alberto Giacometti, "A Letter from Alberto Giacometti," in *Alberto Giacometti* (exhib. cat.), New York, Pierre Matisse Gallery, 1948, p. 44 (in French and English).

FIGURE 2. Alberto Giacometti. *Three Men Walking*. 1949. Graphite on graph paper, 6⅛ × 4⅜ in. (15.5 × 11 cm.). Acquavella Galleries, New York. This drawing seems to have been made after the first version of the sculpture, in which the three figures are placed farther apart, and on a lower base.

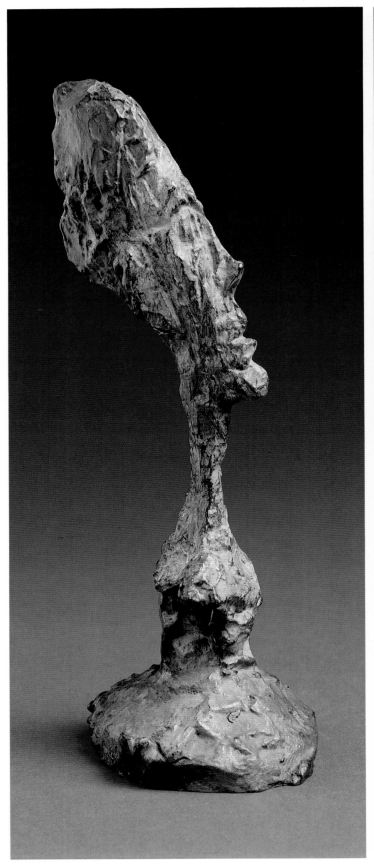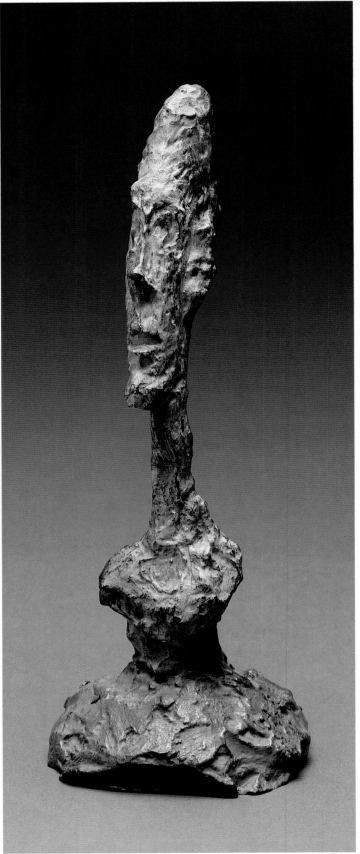

Alberto Giacometti

Swiss, 1901–1966

HEAD OF DIEGO

1950
Painted bronze
11 × 4 × 3½ in. (28 × 10 × 9 cm.)
cast no. 4/6
Signed (on the base, at the right):
A Giacometti; *numbered (on the inside of the base): 4/6*

WHEN THE thirteen-year-old Giacometti began to sculpt, it was a head of his brother, Diego (1902–1985)—one year his junior—that he modeled in Plasticine. At those times when Alberto worked only from nature, Diego would always serve as his model: "Diego sat for me 10,000 times. . . . He's posed for me over a longer period of time and more often than anyone else. From 1935 to 1940 he posed for me every day, and again after the war for years. So when I draw or sculpt or paint a head from memory it always turns out to be more or less Diego's head, because Diego's head I've done most often from life."[1]

Diego Giacometti shared Alberto's studio at 46, rue Hippolyte-Maindron—a small room facing a narrow courtyard, in an artisans' quarter off the rue d'Alésia in Paris. He had led a rather colorful life before becoming his brother's assistant in 1929. That year, in order to ease his financial situation, Alberto had begun to make vases, lamps, and ornamental objects in plaster and bronze for the fashionable Parisian decorator Jean-Michel Frank. Since he was also busy painting and sculpting, he needed Diego to tend to technical matters. Diego eventually became indispensable, preparing armatures, making plaster casts, carving stone, arranging for bronze casting, and working patinas—a collaboration that lasted until Alberto's death in 1966. However, Diego was also famous as an artisan in his own right. His extremely elegant metal furniture and objects, decorated with classical details or naïve animal or plant forms, have become coveted collector's items today. Diego's last major project was to design and produce the furniture and lighting fixtures for the new Musée Picasso in Paris, inaugurated in 1985.

This extremely narrow, elongated *Head of Diego* rests on its long, thin neck like a decorative lamp atop its stem. Giacometti believed that a great discrepancy existed between a person's profile and his appearance head on, each view unrelated to the other. By making this head as thin as a wedge he may have been trying to minimize what he regarded as a trick of nature.

1. Cited in James Lord, *A Giacometti Portrait*, New York, The Museum of Modern Art, 1965, pp. 24–25, and in Reinhold Hohl, *Alberto Giacometti*, Stuttgart, 1971, p. 175.

Alberto Giacometti

Swiss, 1901–1966

THE CAT

1954
Bronze
11 × 31½ × 5¼ in. (28 × 80 × 13 cm.)
cast no. 1/8

Signed and numbered *(on the top of the base, at the right):* Alberto Giacometti *1/6 [sic]*
Inscribed *(on the front of the base):* Susse Fondeur/Paris

I N ADDITION to this cat and a dog, Giacometti made only two other sculptures of animals, and both of these were of horses. The inspiration for this work was the cat that belonged to his brother, Diego. As Giacometti explained to James Lord: "I'd seen that cat of Diego's so often coming across the bedroom toward my bed in the morning before I got up that I had it in my mind exactly as it is. All I had to do was to make it. But only the head can even pretend to be a likeness, because I always saw it head on, coming toward my bed."[1]

Many years later, Giacometti told Gualtiero di San Lazzaro that he had been impressed by the way in which this cat could squeeze between two objects that were close together without ever touching them. It seemed to him that the cat "passed just like a ray of light."[2] If Giacometti's bronze cat had been of normal size instead of wire-thin, it would never have been able to wind its way between those objects as Diego's live and supple cat had supposedly done.

1. James Lord, *A Giacometti Portrait*, New York, The Museum of Modern Art, 1965, p. 21.

2. Gualtiero di San Lazzaro, "Giacometti," *XX^e Siècle* 75, no. 26 (May 1966), n.p.

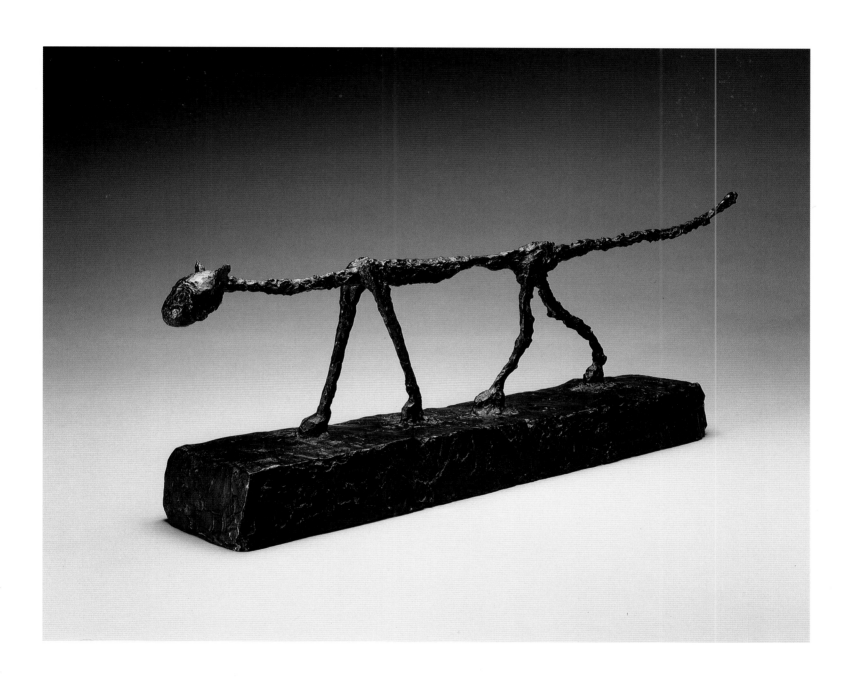

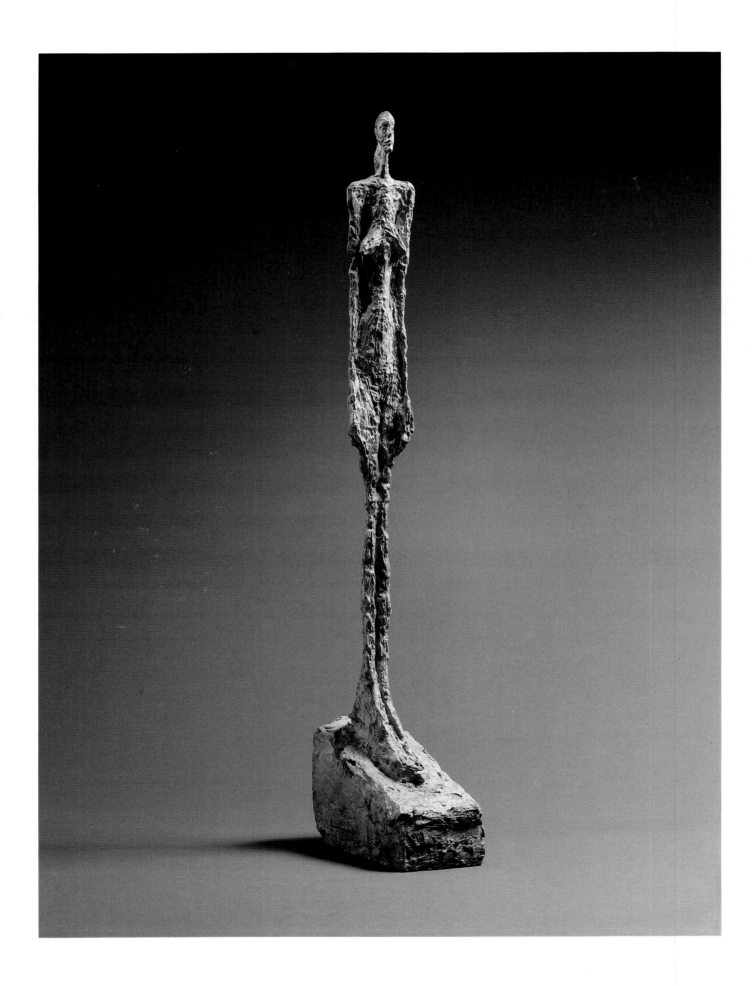

Alberto Giacometti

Swiss, 1901–1966

WOMAN OF VENICE II

1956
Painted bronze
47⅞ × 12⅝ × 5½ in. (121.5 × 32 × 14 cm.)
cast no. 1/6
Signed and numbered (on the base, at the left): Alberto Giacometti *1/6*
Inscribed (on the back of the base): Susse Fondeur Paris

WHILE Giacometti usually spent many weeks or even months on a single sculpted figure, revising and reworking it endlessly, he proceeded differently with this sculpture, and with the entire series to which it belongs.

Early in 1956, in preparation for an exhibition of his work at the Venice Biennale and the Kunsthalle in Bern, Giacometti produced a large group of sculptures of female figures. Ten of these figures, in plaster, were shown in Venice, and five in Bern. Of the fifteen, it appears that only nine were later cast in bronze. They became known as the "Women of Venice," regardless of whether the actual plaster had been exhibited in Venice or in Bern.[1] According to David Sylvester, all fifteen figures were modeled from the same clay, on the same armature. When Giacometti was pleased with a particular state, he had his brother, Diego, make a plaster cast of it. Then, using the clay over again, he made yet another version. As he told Sylvester: "The last of the states was no more definitive than its predecessors. All were provisional . . . all the standing figures and heads are states."[2]

Each of the nine bronze figures is between forty-one and fifty-two inches high. Because they are so thin and gaunt, they appear much taller—an effect that many critics regard as the artist's attempt to distance them from the viewer. Supported on stilt-like legs held tightly together, they stand motionless. Enormous feet anchor their extremely emaciated, concave bodies on plinths of various thicknesses. Some figures are set at an angle, like this one. All have tiny heads, which accentuate their extreme attenuation. The figures look as if they have withstood centuries of rough weather, which has left their surfaces crusty and eroded.

Woman of Venice II is the only one of the nine bronzes that is painted. It is a mat beige color. The figure's hair, drawn back severely into a bun, renders the sculpture even more austere, despite the painted blue eyes and red mouth.

1. See Valerie J. Fletcher, *Alberto Giacometti 1901–1966* (exhib. cat.), Washington, The Hirshhorn Museum and Sculpture Garden, 1988, p. 200.

2. David Sylvester, "Giacometti: An Inability to Tinker," *The Sunday Times* [London] *Magazine*, July 4, 1965, p. 25.

Victor Brauner

Romanian, 1903–1966

PRELUDE TO A CIVILIZATION

1954
Encaustic, and pen and ink, on Masonite
51 × 79¾ in. (129.5 × 202.5 cm.)
Signed and dated (lower right): VICTOR BRAUNER/IIIx 1954
Inscribed (on the reverse): Prélude à une Civilisation/Victor Brauner, 1954

VICTOR BRAUNER grew up in a small town in Romania. His father, a passionate devotee of Spiritualism, regularly organized séances and kept in touch with the famous mediums of his day. As an observer as well as a participant, young Victor acquired a taste for the esoteric, which his art distinctly reflects.

In 1930, Brauner settled in Paris, where he joined the Surrealists group in 1933. The subjects of his paintings of that period seem either to derive from the occult or to be rooted in private myths. Bizarre creatures with huge, totemic heads, and one or several eyes, are attached to plants, or to the bodies of animals or human beings, and sprout snakes, wings, or other animate or inanimate forms. The artist himself described these paintings as an "unknown world . . . peopled with somnambulists, incubi, succubi . . . phantoms, specters, sorcerers, seers, mediums, and a whole fantastic population."[1]

In 1948, after he broke with the Surrealists, the influence of Brauner's private obsessions on his work gave way to images in his paintings that in many instances were inspired by relics of archaic and primitive civilizations. Visitors to his studio at 72, rue Lepic, in Montmartre often commented on his collection of primitive art, which comprised Oceanic cult objects as well as Central and North American Indian artifacts. Gradually, his imagery became more heraldic, stark, and simplified; while often evoking Egyptian or Pre-Columbian art, it sometimes relates to a specific source, as here.

Prelude to a Civilization represents a gigantic white animal in profile against a blue-and-green ground, and bears stylized renditions of some forty animals, figures, masks, and abstract symbols. As Evan Maurer has suggested, Brauner may have based this composition on the pictographic robes of Plains Indians. Such a robe—fashioned of hide—retains the overall form of the animal (see fig. 1), and its warrior-owner's exploits are recorded in decorative inscriptions covering its surface.[2] Actual hides of this type are usually white, like the one in this picture. Although the creatures Brauner depicts resemble Mexican codex illustrations, as also suggested by Maurer, they seem to be pure fantasy, and evoke the art of both Paul Klee and Max Ernst.

Brauner executed this work in encaustic, a technique inherited from the Greeks in which paint is mixed with molten wax. Into the resulting hardened surface the artist incised the figures with pen and ink. He had first employed this medium after he was forced to take refuge from World War II in the Pyrenees, and was unable to obtain his usual working materials. Brauner began to experiment with candle wax, and became intrigued with the pleasing mat surface that he could achieve with it. Here, the overall effect suggests a fresco or an ancient cave painting.

1. Cited in William S. Lieberman, ed., *Modern Masters: Manet to Matisse*, New York, The Museum of Modern Art, 1975, p. 200.

2. Evan Maurer, "Dada and Surrealism," in *"Primitivism" in 20th-Century Art* (exhib. cat.), edited by William Rubin, vol. 2, New York, The Museum of Modern Art, 1984, p. 577.

FIGURE 1. Elk hide painted by the Indians of the Central Plains. 77 × 70 in. (195.5 × 177.8 cm.). Collection Amelia Elizabeth White, Santa Fe

Balthus
(Balthasar Klossowski)

French, born 1908

GIRL AT A WINDOW

1957
Oil on canvas
63 × 63¾ in. (160 × 162 cm.)

SOMETIME in the early 1950s, Balthus discovered the Château de Chassy while driving through the hilly region of the Morvan in the *département* of Nièvre in central France. The château, an unassuming, three-storied structure, has thick walls and massive round towers on all four sides. Surrounded by tall old trees, it is isolated in an austere but not unpleasant landscape. When Balthus took over the château in 1953, it was run-down and in need of serious repair. Frédérique Tison (b. 1938), Balthus's niece by marriage and his favorite model at Chassy, remembers: "There was no electricity or running water, though we had the well in the courtyard. The rooms were empty, the sun and rain came in through the roof, and the only heat came from fireplaces."[1]

Balthus rented Chassy and then was able to buy the château with funds from the sale of his paintings to a syndicate formed by a small group of French dealers and collectors. He restored Chassy, painting the walls luminous pastel colors and filling the interiors with fine antique furniture and objects that he obtained from the renowned Parisian decorator Henri Samuels in exchange for paintings.

After Balthus left Paris for Savoy and then Switzerland (1940–46), his work took a turn toward the decorative. Then, in Chassy, his stark, haunting Parisian interior scenes from the late 1940s were once again abandoned in favor of more elaborate compositions. Of the eighty or so paintings completed in Chassy between 1954 and 1960, more than twenty are landscapes. Balthus never went in search of motifs but found them by merely looking out his windows. In fact, all but two landscapes are views from Chassy's various windows. Since Balthus cared little for the bright colors of summer, most of these landscapes were painted during the winter and the spring.

The present work is an exception because the sitter, Frédérique, is shown contemplating a fine, early summer morning from an open window in the main salon on the ground floor of the château. She looks toward the garden and the gate enclosing the courtyard of the farm beyond (see fig. 1). Like a filter of fine gauze, sunlight softens the contours and the colors of all the forms. Rays of light strike the window and the wall at the left, illuminating Frédérique's hair, which blends with the pale brick color of the farm sheds outside.

1. As told to Jean Clair, in "The Lure of Chassy," *Architectural Digest* (December 1984), p. 186.

FIGURE 1. The courtyard of the Château de Chassy, France. 1956 (Photograph: Loomis Dean; Courtesy *Life* magazine; © Time, Inc.)

Balthus. *Girl at a Window*

Recent Works
1960–1980

Alberto Giacometti

Swiss, 1901–1966

ANNETTE

1961
Oil on canvas
45⅝ × 35¼ in. (116 × 89.5 cm.)
Signed and dated (bottom right): Alberto Giacometti *1961*

FROM THE early 1920s, the principal subjects of Alberto Giacometti's paintings were the still life and the portrait. Once in a while, he would paint a landscape or a nude. In his portraits, the sitter was always shown facing front, and usually in half length, with more life-like proportions than those of his extremely gaunt sculptures. The earlier paintings were concerned with a full-length figure in an interior. By the late 1950s, he had moved the figure close to the picture plane, and, instead of suggesting an interior setting, enframed the model with a painterly backdrop, achieving an effect of a painting-within-a-painting. The backgrounds of these pictures are painted with loose, broad brushstrokes, but the figures are delineated with thin, spidery, black-and-white lines that resemble the eroded surfaces of Giacometti's sculptures. His palette was usually limited to a monochromatic gray, but at times it might be enlivened with subtle shades of pink, yellow, or green. In fact, visitors to the artist's Paris studio at 46, rue Hippolyte-Maindron, in the 14th *arrondissement*, often commented on the gray walls, diffuse gray light, and on the gray sculptures "interspersed with the sepia accent of wood and the dull glint of bronze."[1]

In addition to Giacometti's brother, Diego, his wife, Annette (née Arm; born 1923), served most often as his model. Annette had first met Giacometti in the autumn of 1943 in Geneva. She joined him in Paris in 1946, and they were married in 1949. In 1955, the thirty-two-year-old Annette was described as: ". . . about five feet four, like a slender girl of fourteen. . . . She has the naïve and innocent expression of a child; her hair is pale brown, parted in the middle . . . she dresses simply—a grey skirt with a blouse."[2]

Posing for Giacometti was not a thing to be taken lightly. As with his sculptures, he never regarded a painted portrait as "finished," but subjected each one to an endless process of "rubbing out" and "painting in," although usually changing only the face. For his model this involved daily sittings lasting from three to four hours that might stretch over a period of weeks or even months. Sometimes it was only the imminent departure of the sitter or the deadline of an exhibition that would make him part with the work.

In an earlier version of this portrait, shown at the Galerie Maeght in Paris in May 1961

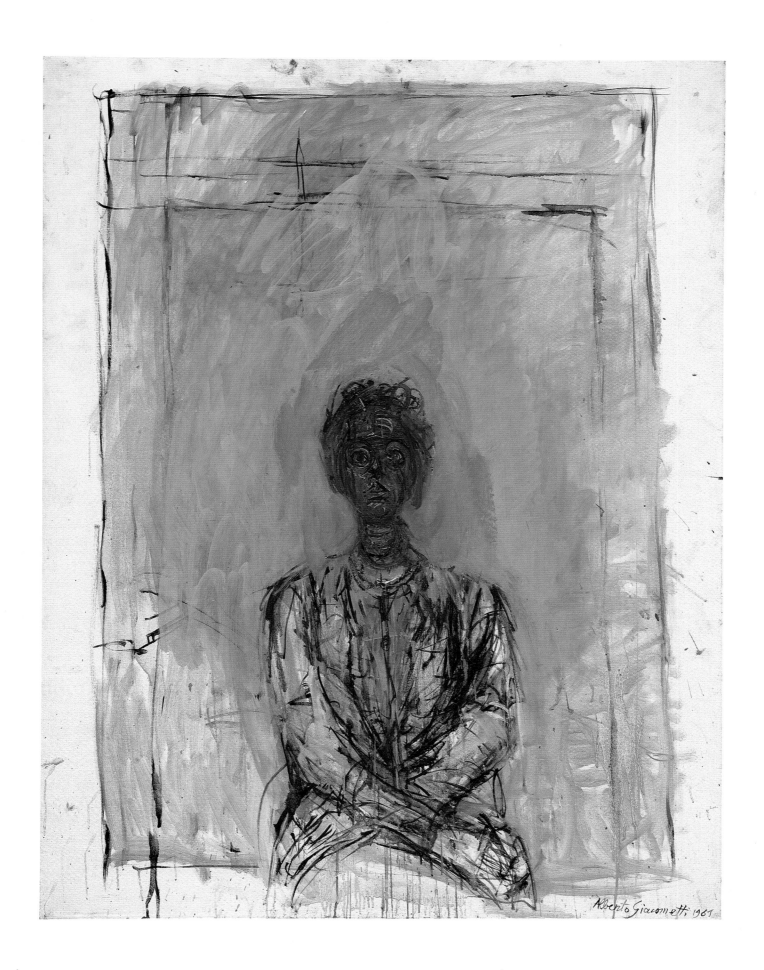

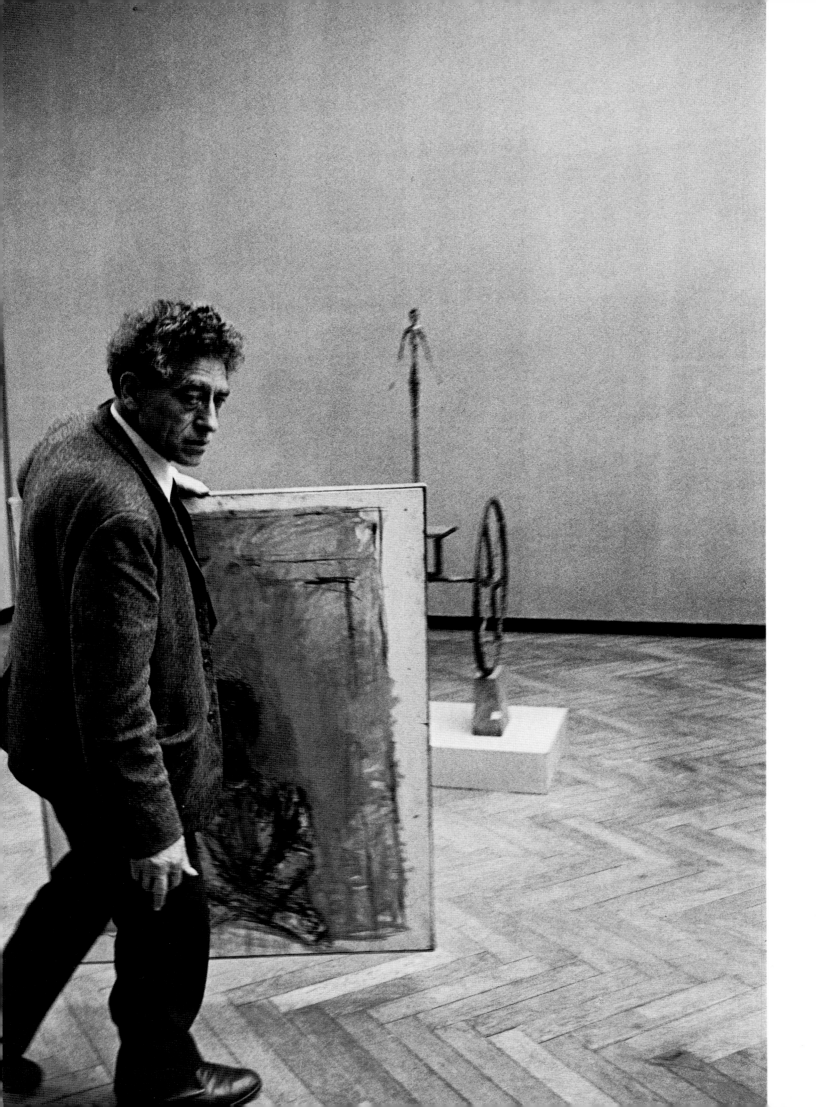

(see fig. 2), Annette's face looked more conventionally pretty, younger, and also more relaxed. In the present version, however, her wide-open, staring eyes provide an unsettling note. Asked recently why Giacometti took the work back after it had been exhibited, all Annette could remember was that he had wanted to "change the nose."[3]

1. Alexander Liberman, "Giacometti," *Vogue* 125, no. 1 (January 1, 1955), p. 146.

2. Ibid., p. 178.

3. Conversation with Annette Giacometti, Paris, January 12, 1989.

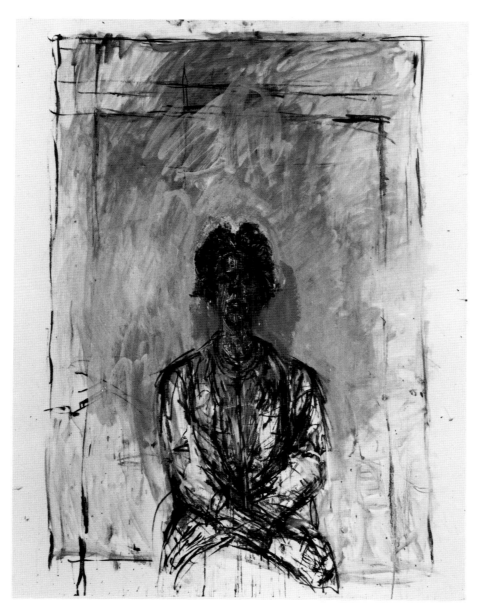

FIGURE 2. *Annette*. First version, 1961 (© Annette Giacometti, ADAGP, Paris)

FIGURE 1. Alberto Giacometti at the Venice Biennale, holding the present version of *Annette* under his arm. 1962 (Photograph: Ugo Mulas; Courtesy Antonia Mulas)

Pablo Picasso

Spanish, 1881–1973

THE CAVALIER AND THE SEATED NUDE

February 22–28, and March 1, 1967
Oil on canvas
39⅜ × 31⅞ in. (100 × 81 cm.)
Signed and dated (top left): 22.2.67./Picasso; dated (on the reverse): 1.3/28/27/26/25/24/23;
also dated (on the stretcher): 22.2.67.

I N NOVEMBER 1965, at the age of eighty-four, Picasso underwent an operation that left him incapacitated in many ways. Perhaps as compensation, during the final years of his life his art became more graphically erotic. His most sexually explicit etchings, the "Suite 347," date from this period.

The Cavalier and the Seated Nude illustrates this libidinous strain in Picasso's work. Along with its preparatory oil sketches (Zervos XXV, 279–285), it is the first painting the artist produced following his illness. Similarly, it marks the first instance, in a painting, of Picasso's rakish alter ego, the cavalier or musketeer—a lustful, older man outfitted with periwig and goatee, ruff, and pipe. (This character would become the artist's new leading man, and we can follow his progress, in subsequent works, from one amorous adventure to another.) Here, he is about to enjoy the embraces of a voluptuous young woman. Picasso aligns her pink bottom, thigh, lower leg, and foot in such a way that they form a succulent display of flesh.

An elderly male figure shown gazing at a nude woman appeared among the drawings that the artist made during his convalescence (Zervos XXV, 230). In fact, in these, the cavalier or musketeer alternates with a little, bald old man who, no doubt, represents an attempt at self-mockery on the part of the artist (Zervos XXV, 202, 224, 231, 250, 254). The drawings, in their self-deprecating irony, are reminiscent of the one hundred and eighty that Picasso composed between 1953 and 1954 on the theme of the painter and his model, also following a personal crisis.

From where do these womanizing soldiers and adventurers sporting seventeenth-century dress come? According to the artist's widow, Jacqueline, they derive from the works of Rembrandt, which Picasso studied in depth during his recovery.[1] Rembrandt was one of a number of Old Masters with whom Picasso entered into a dialogue during the last twenty-five years of his life. Among those painters whose pictures he paraphrased and from whom

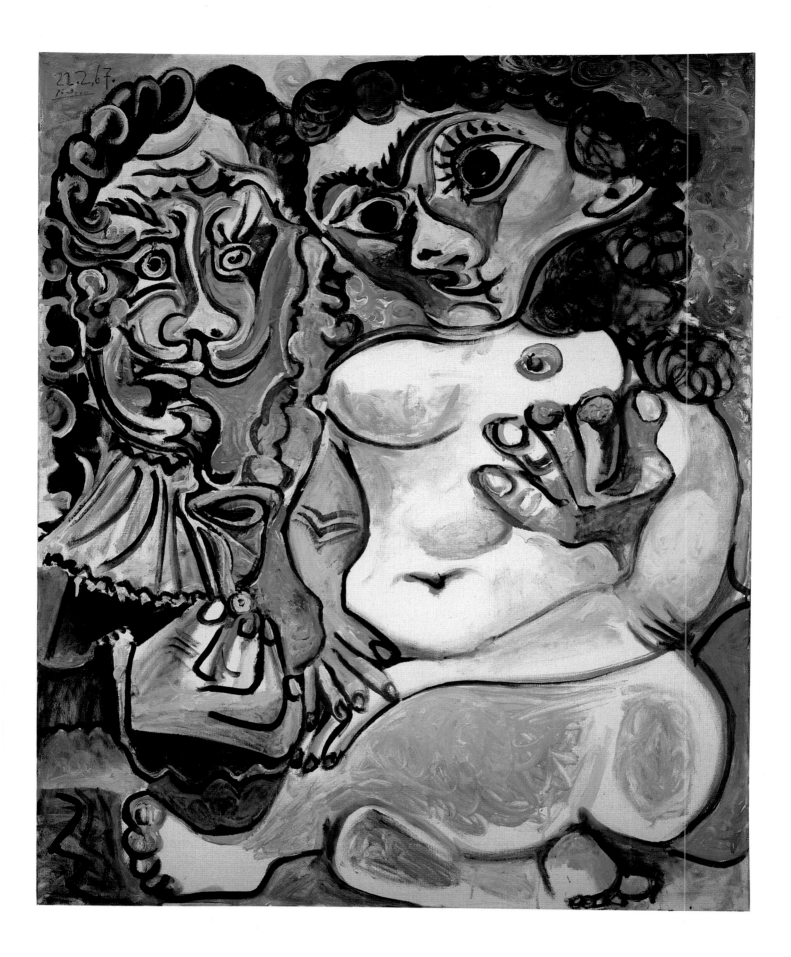

he quoted are Cranach, El Greco, Poussin, Velázquez, Delacroix, and Manet. Indeed, the swashbuckling manner and the anachronistic appearance of these seemingly seventeenth-century male figures are quite well matched to Picasso's late style, for, while it is characterized by an impassioned and speedy execution, distortion and flatness of forms, and gaudy colors, a Baroque floridness also seems not absent.

1. As told by Jacqueline Picasso to André Malraux.
See Gert Schiff, *Picasso: The Last Years, 1963–1973*,
New York, 1983, p. 31.

Sam Szafran

French, born 1934

INTERIOR I
February 1972
Pastel on paper
47 × 31½ in. (119.4 × 80.1 cm.)
Signed (bottom left): Szafran

INTERIOR II
May 1972
Pastel on paper
47 × 32 in. (119.4 × 81.3 cm.)
Signed (bottom left): Szafran

THE WORKS of both Sam Szafran and François Rouan (see page 286) are better known in France than in the United States. As an artist, Szafran is self taught. Born in Paris to Polish-Jewish parents, he moved with his mother to Melbourne, Australia, in 1947. Returning to Paris about 1951, Szafran attended sketching classes at the Académie de la Grande Chaumière, and supported himself with odd jobs. Among the artists that he met in Montmartre was Alberto Giacometti, whose generosity with advice instilled in Szafran a

lasting admiration. A box of pastels given to him in 1960 proved a revelation, and he abandoned his paintbrushes forever, soon becoming a master in the medium in which he now works almost exclusively.

In the early 1970s, Szafran began a series depicting large and intricate interiors: rooms filled with enormous plants, print workshops, artists' studios, and stairwells. No doubt what fascinated him about these spaces were the repetitive patterns of ceiling beams or floorboards, vertiginously winding stairs and banisters, or row upon row of sticks of color. In the series devoted to staircases, he employed a perspective scheme that, like a sophisticated camera lens, expanded to 180- or 360-degree wide-angles, and he rendered these wide-angle views with eerie precision, as if seen through a distorting mirror, often including more than a normal glance would take in.

These pastels, part of a group of eleven, depict the studio of the American painter Irving Petlin (b. 1938; see fig. 1). While Petlin was in New York, from February to October 1968, Szafran lived in this former work shed in the rue de Crussol, near the Cirque d'Hiver, in the 11th *arrondissement* of Paris. However, he began the series, which dates to between December 1970 and June 1972, after having left Petlin's studio, working from memory and from drawings made on site.

The overall view of the studio remains the same in all eleven works. Yet, Szafran uses subtle means, such as slight shifts in perspective, whimsical figures, and accumulations of clutter, to make each composition different. Asked if these last details have any meaning, the artist has explained that the various states of order or disarray express a range of emotions from stability and serenity to anger or drama.[1]

In the earlier picture shown here, all seems in order. Petlin's paintings are stacked at the left, front sides turned to the wall, and the magnificent sticks of color are lined up in rows in the foreground. Szafran shops at La Maison du Pastel in the rue de Rambuteau, a family-run enterprise that carries as many as 1,600 colors, and once supplied Degas. In homage to that master, Szafran has suspended from the ceiling one of those round zinc bathtubs so familiar from Degas's pastels of bathing women. The bent-over, ghostly figure at the back is meant to be imaginary, and represents "the etcher of death."[2] Very much alive, however, is Philippe Petit, who is balancing on his tightrope in the distance. In 1968, Petit practiced in Petlin's studio for his aerial walk between the two towers of Notre-Dame.

In the later pastel, the perspective has shifted further to the left. Papers are scattered everywhere—on the floor, on every available piece of furniture, and even wafting through the air. Tubes of paint and other objects are thrown on top of the pastels at the right. It would seem that here the mood is akin to anger. One of Szafran's friends poses on the chaise longue in the center. The banderole issuing from her mouth contains an inscription in mirror writing that reads, "achetez-vous La Délirante?" ("do you buy La Délirante?")—a reference to a poetry magazine, for which Szafran has designed covers, published by Fouad El-Etr, a friend of the artist. The round tub suspended from the ceiling bears four names: "Topor" (for Roland Topor), "Olivier O." (for Olivier O. Olivier), "Zeimert" (for Christian Zeimert),

Szafran. *Interior I*

Szafran. *Interior II*

and "Idaye." The first three are those of fellow members of "Panique," a group of artists with neo-Dada leanings, to which Szafran belonged from 1972 to 1973. The bearer of the last name has not been identified.

The skylight appears pitch black, heightening in it the reflection of the sticks of color arranged on the table below—unlike the earlier *Interior*, in which the murky light beyond the skylight suggests that it is dusk or early evening.

1. Conversation with the artist in Paris, January 13, 1989.
2. Ibid.

FIGURE 1. The Paris studio of American artist Irving Petlin, where Sam Szafran lived from February to October 1968. The identity of the man in the photograph is unknown (Photograph: Courtesy Sam Szafran)

François Rouan

French, born 1943

SEASON V

1976–78
Oil on woven canvas
78¼ × 63⅛ in. (198.7 × 160.3 cm.)
Inscribed (on the reverse, on the bar of the stretcher):
F. Rouan Lunghezza *976*—Laversine *78* "Saisonis V"

NOW AT mid-career, François Rouan is the youngest artist represented in the Gelman collection. Although his works remain little known in the United States, they have been widely exhibited in France and in Germany.

Rouan grew up in Montpellier, and briefly studied typography, drama, and music, in addition to taking courses at the local art school. In 1961, he settled in Paris, and enrolled at the École des Beaux-Arts, but, bored by its stifling atmosphere, he was, as he says, "a bad student and left after only one week."[1] A period followed when he was on his own, working at odd jobs to maintain himself while also becoming involved with political student groups. Perhaps the turning point in his life as an artist was in 1966, when he saw the exhibition of Balthus's paintings at the Musée des Arts Décoratifs in Paris. It so impressed him that he decided to study in Rome, where Balthus was then director of the French Academy at the Villa Medici. Not until 1971, however, did Rouan submit some work to the jury in charge of admissions to the Prix de Rome—an award that enables the recipient to become a pensionnaire at the French Academy. He was accepted, and began a three-year fellowship at the Villa Medici, where he became an intimate of Balthus. Their friendship persists to this day.

Rouan was able to prolong his stay in Rome until 1978. The years spent in Italy have proven to be decisive for Rouan's growth as an artist, for, during that time, he refined the unique painting style called "*tressage*" that he had invented about 1966. Translated literally, the term means "braiding," but in actual fact the process consists of interweaving vertical and horizontal strips cut from two canvases painted different colors. This creates a checkerboard-patterned ground on which the artist then paints another pattern. Asked about the origins of this technique, he admitted that he had observed a child playfully doing the very same thing.[2]

The Gelman canvas belongs to the "Seasons," a series of ten paintings that occupied Rouan from 1976 until 1983. Initially, he had planned to interpret only the four seasons of the year. However, before he knew it he had added a fifth season—this one—to be followed by five more. All are the same size and oval in format, yet each contains different designs and colorings. The motifs suggested were inspired by the art and antiquity of Rome—by its marble façades and figures—as well as by its landscapes and trees.

Rouan. *Season V*

The sophistication and cerebral nature of Rouan's works, and the technical precision with which the "surface" image and the "ground" are interwoven, contrast sharply with his rather handcrafted process of execution. Recently, however, Rouan has modified his methodology. Sometimes the weaving is merely simulated, or else he might combine in one picture patterns cut from several works—thus producing an infinite variety of intricate, brilliantly colored designs.

1. Conversation with the artist in Laversine, France, January 15, 1989.

2. *Idem*.

Francis Bacon

British, born 1909

THREE STUDIES FOR A SELF-PORTRAIT

1979–80
Oil on canvas: three canvases,
each, 14¾ × 12½ in. (37.5 × 31.8 cm.)
Inscribed (on the reverse of each canvas):
Study for a Self-Portrait, Francis Bacon, 1979; left; right; center

"I LOATHE my own face. . . . I've done a lot of self-portraits, really because people have been dying around me like flies and I've nobody else left to paint but myself. . . . But now I shall give up doing self-portraits." Francis Bacon made this disclosure to his friend the writer David Sylvester, in 1975.[1] Whether he was not altogether serious then, or else later changed his mind, he continued to make more portraits of himself, and fewer of his friends.

Bacon had begun to paint close-up portraits in 1961, filling canvases measuring about 14 × 12 inches with a head, slightly smaller than life-size. In their startling immediacy these portraits are akin to those that the Fauves painted of each other some fifty years before (see page 79). After a while, Bacon began to combine three such canvases, turning these portraits into triptychs.

The triptych, in fact, is central to Bacon's approach to painting. His first and perhaps most famous was the *Three Studies for Figures at the Base of a Crucifixion* (Tate Gallery, London), completed about 1944 and recently reinterpreted by the artist. In such large, narrative compositions all three canvases are usually of equal size, with those at the sides reserved for the figures that act either as voyeurs or merely as bystanders detached from the action in the center.

The models for Bacon's portraits are chosen from among his close friends, and are often artists or writers whom he paints over and over again. While they may sit for him occasionally, he prefers to work from snapshots or from memory. As he once told Sylvester, he feels uncomfortable painting in the presence of his sitters, even should they be friends. Still less does he welcome portrait commissions from strangers, because, as he says, ". . . I couldn't attempt to do a portrait from photographs of somebody I didn't know."[2] Bacon is not interested in rendering an exact likeness, disdaining what he calls "literal" painting. He attempts, rather, to create on canvas an abbreviated yet more intense perception of his model. To that end he uses distortion, fragmentation, and a swift and fluid painting style that invites accidents and chance. In the process, as John Russell has noted, ". . . the face as we know it . . . disappear[s] altogether in the jewelled slime of the paint, leaving behind it an eye-socket, or the deep cave of a nostril, or an irreducible patch of hair. . . . we are at a

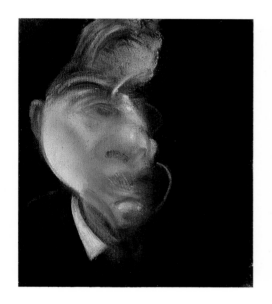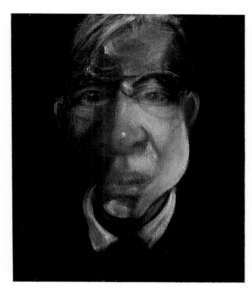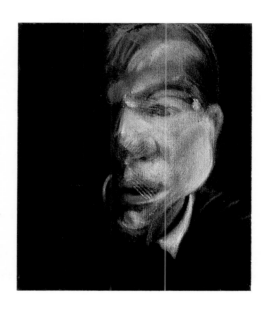

dentist's distance from the eyes, nose, mouth and teeth, and the rest of the world is blocked out."[3]

In the *Three Studies for a Self-Portrait* Bacon's own features are rather clearly defined, unlike those in many of his other paintings of friends or of himself. His eyes are not half closed or lowered, but are wide open. As usual, the artist appears ageless, not a day older than in his first self-portrait, painted in 1956, although here he is about seventy.

Bacon has compared his method of arranging his portraits as a triptych to police "mug shots," with the difference that he does not combine a full-face and a profile view as they do. He never paints profiles but, instead, on either side of the central canvas he shows frontal views or fractions thereof. The rather normally proportioned face in the center painting is flanked by grotesquely distorted ones at the sides. Specifically, the artist's jowls in the center work fade into the dark background, while in the outer canvases they are enlarged to the point of exaggeration. The overall effect is of the artist having subjected himself to a quick yet searching self-examination in a mirror, accentuated by the use of the word "studies" in the title. Bacon does not make preparatory pencil or oil sketches but regards most of his finished works themselves as "studies," employing this word repeatedly—in particular, when referring to portraits.

1. David Sylvester, *Interviews with Francis Bacon 1969–1979*, London, 1980, p. 129. Sequence of quotations emended.

2. Ibid., p. 38.

3. John Russell, *Francis Bacon*, London, 1971, p. 158.

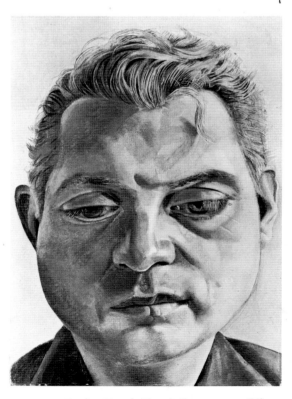

FIGURE 1. Lucian Freud. *Francis Bacon*. 1952. Oil on copper, 7 × 5 in. (17.8 × 12.8 cm.). Trustees of the Tate Gallery

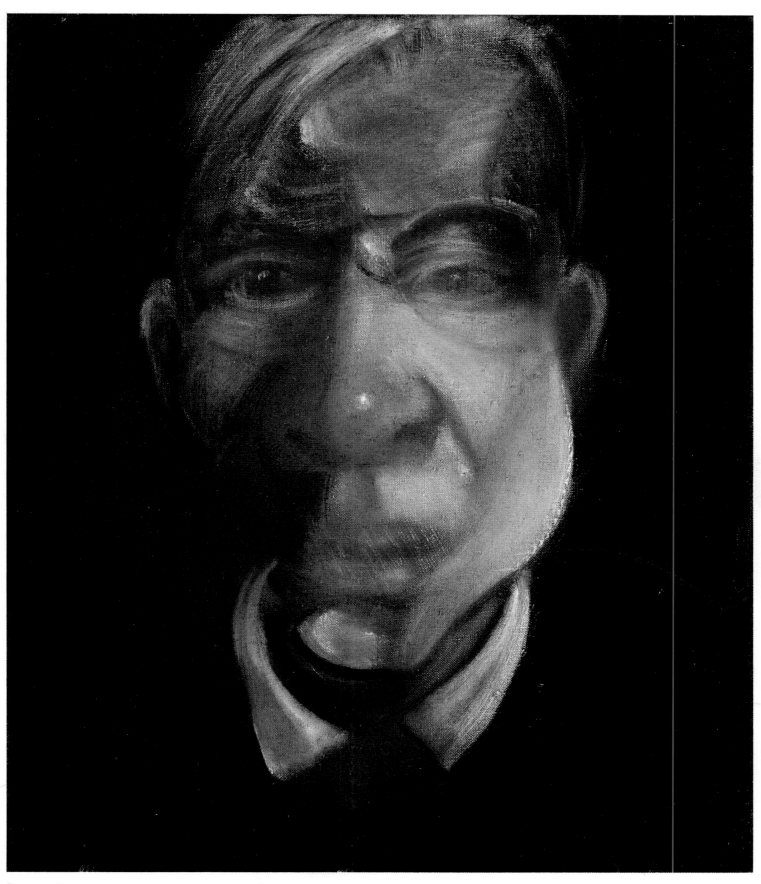

Bacon. *Three Studies for a Self-Portrait.* Center panel

Provenances, Exhibitions, and Bibliographic References

Although efforts have been made to trace the history of each work, inevitable gaps remain. Thus, the listings for most works should not be regarded as complete. The names of former owners are given with the inclusive dates, when available.

Francis Bacon PAGE 288
Three Studies for a Self-Portrait
1979–80

PROVENANCE
The artist, to the Marlborough Gallery, New York, 1980; Jacques and Natasha Gelman, 1980.

EXHIBITIONS
New York, 1980, cat. no. 13, ill. p. 30; London, 1985, cat. no. 109, ill.; Stuttgart, 1985–86, cat. no. 109, ill.; Berlin, 1986, cat. no. 109, ill.

BIBLIOGRAPHY
Sylvester, 1980, no. 111, ills. p. 144 [right-hand panel only], frontispiece [center panel only], ill. p. 145; Leiris, 1983, no. 126, ill.; Ades and Forge, 1985, no. 109, ill.; Schmied, 1985, no. 127, ill. p. 86; Sylvester, 1987, no. 111, ill. p. 144.

Balthus (Balthasar Klossowski) PAGE 201
Thérèse Dreaming
Thérèse rêvant
1938

PROVENANCE
The artist, to the Pierre Matisse Gallery, New York, 1938; The Reverend James McLane, Los Angeles, 1951; Louis McLane, Phoenix, 1979; Pierre Matisse Gallery, New York, 1979; Jacques and Natasha Gelman, 1979.

EXHIBITIONS
New York, 1942, cat. no. 1; New York, 1949, cat. no. 16, ill.; New York, 1956–57, cat. no. 10, ill. p. 19; Cambridge, Massachusetts, 1964, cat. no. 10, ill.; London, 1968, cat. no. 12, ill. p. 55; Marseilles, 1973, cat. no. 5, ill.; Paris, 1983–84, cat. no. 14/52, ills. pp. 137, 348; New York, 1984, cat. no. 19, ill. p. 93.

BIBLIOGRAPHY
Bonnefoy, 1980, p. 49; Leymarie, 1982, ill. p. 130; Klossowski de Rola, 1983, pl. 22; Dauriac, 1984, ill. p. 186; Micha, 1984, ill. p. 6; Rewald, 1984, fig. 67, p. 41, ill. p. 42.

Balthus (Balthasar Klossowski) PAGE 269
Girl at a Window
Jeune Fille à la fenêtre
1957

PROVENANCE
Baronne Alix de Rothschild, Paris; David de Rothschild, France; Galerie Beyeler, Basel, 1983; Jacques and Natasha Gelman, 1983.

EXHIBITIONS
Turin, 1961, cat. no. 13; Paris, 1966, cat. no. 32, and Knokke-le-Zoute, 1966, cat. no. 30; New York, 1977, cat. no. 7, ill.; Paris, 1983–84, cat. no. 52/178, ills. pp. 195, 369; New York, 1984, cat. no. 40, ill. p. 136.

BIBLIOGRAPHY
Watt, 1963, ill. p. 144; Leymarie, 1982, p. 82, ill. p. 79; Klossowski de Rola, 1983, pl. 56; Rewald, 1984, p. 50; Sauré, 1984, ill. p. 45.

Pierre Bonnard PAGE 61
Street Scene, Place Clichy
Place Clichy
about 1895

PROVENANCE
The artist, to the Galerie Bernheim-Jeune, Paris; Thadée Natanson, Paris: sale, Paris, Hôtel Drouot, *Collection Thadée Natanson, Oeuvres de Bonnard,* June 13, 1908, no. 5; Antoine Salomon, Paris; Carstairs Gallery,

New York, 1950; Jacques and Natasha Gelman, 1951.

EXHIBITIONS
Paris, 1902, no. 1 [as *Place Clichy*]; New York, 1964, cat. no. 6, p. 32 [as *Street Scene with Two Dogs (Rue à Éragny-sur-Oise)*].

BIBLIOGRAPHY
Coquiot, 1922, p. 23; Natanson, 1951, fig. 5, p. 113; Dauberville, 1966, vol. I, cat. no. 101, ill. p. 154.

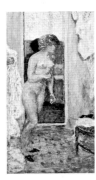

Pierre Bonnard PAGE 131
After the Bath
Femme à la toilette
1910

PROVENANCE
The artist, to the Galerie Bernheim-Jeune, Paris, 1910; Émile Bernheim, Paris, 1910; Galerie Bernheim-Jeune, Paris, 1923; Henri Canonne, Paris: sale, Paris, Hôtel Drouot,

June 5, 1942, no. 8; Sam Salz, New York, 1951; Jacques and Natasha Gelman, 1951.

EXHIBITIONS
Paris, 1910, no. 20 [as *Cabinet de toilette au matin*]; New York, 1964, cat. no. 23, ill. p. 40 [as *Nude Leaving the Bath*].

BIBLIOGRAPHY
Dauberville, 1968, vol. II, cat. no. 596, ill. p. 190; Pickvance, 1965, ill. p. 273.

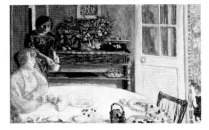

Pierre Bonnard PAGE 141
The Dining Room, Vernonnet
L'Heure du café
about 1916

PROVENANCE
The artist, to the Galerie Bernheim-Jeune, Paris, 1916; Gaston Bernheim de Villers, Paris; Sam Salz, New York, 1949; Jacques and Natasha Gelman, 1949.

EXHIBITIONS
London, 1935, no. 17 [as *La Desserte fleurie*]; Stockholm, 1939, no. 18 [as *Fin de journée*].

BIBLIOGRAPHY
Fosca, 1919, pl. 15, ill.; Masuda, 1932, pl. 21, ill.; Dauberville, 1974, vol. IV, cat. no. 02094, ill. p. 370.

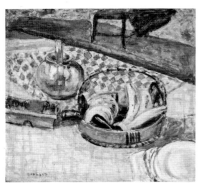

Pierre Bonnard PAGE 172
Basket of Bananas
La Corbeille de bananes
1926

PROVENANCE
The artist, to the Galerie Bernheim-Jeune, Paris; L'Art Moderne, Lucerne; private collection, Switzerland; Sam Salz, New York, 1949; Mrs. Albert Lasker, New York; Sam Salz, New York; Jacques and Natasha Gelman, 1953.

EXHIBITIONS
Paris, 1926, no. 14 [as *Pêches et bananes*]; New York, 1948, cat. no. 45, ill. p. 90; New York, 1964, cat. no. 28, ill. p. 44 [as *Still Life with Basket of Bananas*].

BIBLIOGRAPHY
Beer, 1947, p. 116, ill. no. 96 [as *Les Bananes*]; Dauberville, 1973, vol. III, cat. no. 1312, ill. p. 256.

Pierre Bonnard PAGE 174
Poppies in a Vase
Les Coquelicots
1926

PROVENANCE
The artist, to the Galerie Bernheim-Jeune, Paris, 1927; Gaston Bernheim de Villers, Paris; Percy Moore Turner, London; Mrs. Pleydell [Bouverie], London; Sam Salz,

New York; Jacques and Natasha Gelman, 1952.

EXHIBITIONS
New York, 1964, cat. no. 38, ill. p. 79.

BIBLIOGRAPHY
Fierens, 1932, ill. p. 580; Courthion, 1945, ill. p. 37; Dauberville, 1973, vol. III, cat. no. 1354, p. 287, ill. p. 288.

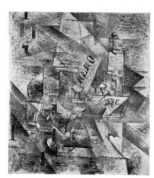

Georges Braque PAGE 110
Still Life with Banderillas
Nature morte aux banderilles
Céret, Summer 1911

PROVENANCE
[Note: The following information is taken from Douglas Cooper and Gary Tinterow, *The Essential Cubism: Braque, Picasso & Their Friends, 1907–1920* (exhib. cat.), London, Tate Gallery, 1983, p. 260.] The artist, to the Galerie Kahnweiler, Paris, 1911; sequestered Kahnweiler stock, Paris, 1914–21: second Kahnweiler sale, Paris, Hôtel Drouot, November 17–18, 1921, no. 26; Galerie Simon, Paris, 1921; Jacques Zoubaloff, Paris, 1924: sale of the Zoubaloff collection, Paris, Hôtel Drouot, November

27–28, 1935, no. 124; Armand Salacrou, Paris and Le Havre; Galerie Louise Leiris, Paris, 1955; Mr. and Mrs. Leigh B. Block, Chicago, c. 1959; E. V. Thaw & Co., Inc., and Acquavella Galleries, New York, 1979; Jacques and Natasha Gelman, 1979.

EXHIBITIONS
Paris, Musée des Arts Décoratifs, 1952, cat. no. 19, ill.; Washington, and Los Angeles, 1967, cat. no. 47, ill.; Saint-Paul-de-Vence, 1980, cat. no. 40, ill. p. 65; London, 1983, cat. no. 18, ill. p. 71.

BIBLIOGRAPHY
Janneau, 1929, pl. 2; Isarlov, 1932, no. 110, p. 17; Lipman, 1970, p. 112, ill.; Gee, 1981, Appendix, p. 54, no. 93; Worms de Romilly and Laude, 1982, no. 91, ill. p. 128.

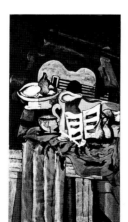

Georges Braque PAGE 171
Still Life with a Guitar
Guitare, fruits, pipe, cahier de musique
1924

PROVENANCE
The artist, to Paul Rosenberg, Paris; Dr. G. F. Reber, Lausanne, c. 1927; Douglas Cooper, London, 1937; sale, London, Sotheby's, July 1, 1980, no. 72; private collection, Madrid, 1980; Sandra Canning Kasper, Inc., New York, 1986; Jacques and Natasha Gelman, 1986.

EXHIBITIONS
Frankfurt-am-Main, 1927; Basel, 1933, cat. no. 112; Edinburgh, and London, 1956, cat.

no. 54, ill.; Munich, 1963, cat. no. 69, ill.; Chicago, 1972, cat. no. 7, ill. p. 58.

BIBLIOGRAPHY
Bulletin de "l'Effort Moderne," 1924, ill.; "Les expositions à Paris et ailleurs," 1927, ill. p. 7; Cassou, 1928, p. 9, ill.; Isarlov, 1932, no. 331; *Cahiers d'art*, 1933, ill. p. 50; Einstein, 1934, pl. 60; Raynal, 1950, ill. p. 145; Richardson, 1959, p. 21, ill.; Rosenblum, 1960, p. 106, ill. p. 105; Mangin, 1968, no. 5, ill.; Valsecchi and Carrà, 1971, no. 208, ill. p. 96; Cooper, 1972, pp. 58–59, fig. 36, ill. p. 58; Judkins, 1976, ill. p. 516; Pouillon and Monod-Fontaine, 1982, p. 88, ill. p. 90; Kosinski, 1987, pp. 22, 44, n. 22, ill. p. 17.

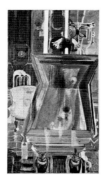

Georges Braque PAGE 251
The Billiard Table
Le Billard
1944–52

PROVENANCE
The artist, to Aimé Maeght, Paris, c. 1952–53; Galerie Maeght, Paris, c. 1953–54; Jacques and Natasha Gelman, 1954.

EXHIBITIONS
Paris, Maeght, 1952, cat. no. 2; Tokyo, 1952, cat. no. 15, ill.; Bern, 1953, cat. no. 108; New York, 1953[?]; Munich, 1963, cat. no. 123, ill.; New York, 1964, cat. no. 35, ill.; Chicago, 1972, cat. no. 30, pl. 13, ill. p. 84; Paris, 1973–74, p. xii, cat. no. 110, ills. pp. 16, 145; Saint-Paul-de-Vence, 1980, cat. no. 123, ill. p. 137; Washington, 1982, and San Francisco, Minneapolis, and Houston, 1983, cat. no. 14, ill. p. 54; New York, 1988, cat. no. 71, ill. and cover ill.

BIBLIOGRAPHY
Rydbeck-Zuhr, 1947, ill. p. 205; George, 1952, ill. p. 13; *Le Point*, 1953, ill. p. 36; Laufer, 1954, no. 45, ill; Richardson, 1955, ill. [pp. 164–65]; Cartier, 1956, p. 91, ill. p. 92; Gieure, 1956, pp. 63, 65, pl. 117; Cogniat, 1957, ill. p. 35; Mangin, 1959, no. 37, ill.; Russell, 1959, p. 126; Richardson, 1960, p. 22, pl. 52; Leymarie, 1961, p. 110; Tono, 1966, no. 71, ill.; Mullins, 1968, p. 149, no. 119, ill. p. 153; Pouillon, 1970, pl. 13; Cooper, 1972, p. 84, pl. 13, ill. p. 84; Hughes, 1972, p. 69, ill. p. 68; Peppiatt, 1973, ill. p. 52; Cogniat, 1980, p. 146, no. 65, ill. p. 65; Pouillon and Monod-Fontaine, 1982, pp. 134, 136, ill. p. 136; Brenson, 1988, p. 41; Zurcher, 1988, p. 190, ill. p. 194.

Georges Braque PAGE 255
The Garden Chair
La Chaise de jardin mauve
1947–60

PROVENANCE
The artist, to the Galerie Maeght, Paris, c. 1960–63; Jacques and Natasha Gelman, 1963.

EXHIBITIONS
Paris, 1961, cat. no. 44, ill. p. 142; New York, 1964, cat. no. 40, ill.; Paris, 1973–74, cat. no. 113, ill. p. 142; Saint-Paul-de-Vence, 1980, cat. no. 145, ill. p. 152; Washington, 1982, and San Francisco, Minneapolis, and Houston, 1983, cat. no. 18, ill. p. 58.

BIBLIOGRAPHY
Damase, 1963, ill. p. 60; Fumet, 1965, ill. p. 158; Ponge, Descargues, and Malraux, 1971, ill. p. 17; Pouillon and Monod-Fontaine, 1982, p. 140, ill. p. 141.

Victor Brauner PAGE 266
Prelude to a Civilization
Prélude à une civilisation
1954

PROVENANCE
Alexander Iolas Gallery, New York; Jacques and Natasha Gelman, 1959.

EXHIBITIONS
Paris, 1954; Venice, 1954, cat. no. 42; Chicago, 1958, cat. no. 7, ill.; New York, 1968, cat. no. 32, ill. p. 137; New York, 1975, cat. no. 15, ill. p. 201.

BIBLIOGRAPHY
Juin, 1954, p. 243, ill. p. 239; Gállego, 1955, p. 132; Vallier, 1963, ill. p. 37; Dienst, 1968, p. 30, ill. p. 31; Rubin, 1968, p. 313, pl. 321, ill. p. 306; Bozo, 1972; Bozo, 1975; Gercke, 1980, ill. p. 19; Maurer, 1984, p. 577, ill. p. 584; Urbinati, 1985, p. 119.

Marc Chagall PAGE 134
The Lovers
Les Amoureux
1913–14

PROVENANCE
Gustave Coquiot, Paris; private collection, California, c. 1951; Adolphe A. Juviler, New York, c. 1956; heirs of Adolphe Juviler, New York; Stephen Hahn, New York, and Acquavella Galleries, New York, 1972; Galerie Rosengart, Lucerne, 1975; private collection, Switzerland, 1976; Galleria Marescalchi, Milan, c. 1983; private collection,

Italy, 1984; Galerie Beyeler, Basel, 1984; Jacques and Natasha Gelman, 1984.

EXHIBITIONS
New York, 1956, cat. no. 3; Hamburg, and Munich, 1959, cat. no. 33, ill.; Paris, 1959, cat. no. 42, ill.; Basel, 1984–85, cat. no. 6, ill.

BIBLIOGRAPHY
Coquiot, 1923, ill. [pp. 10–11]; Estienne, 1951, ill. p. 19; Kloomok, 1951, pl. 12; Meyer, 1963, p. 204, ill. p. 213; Cassou, 1965, no. 32, ill. p. 53; Compton, 1985, p. 37, n. 39, p. 191, ill. p. 16.

Giorgio de Chirico PAGE 145
The Jewish Angel
L'Ange juif
1916

PROVENANCE
René Gaffé, Brussels; Roland Penrose, London, 1937; E. V. Thaw & Co., Inc., New York, 1978; Jacques and Natasha Gelman, 1978.

EXHIBITIONS
Brussels, 1928; Paris, 1928, cat. no. 16 [as *L'Ange juif*]; London, 1936, cat. no. 58; London, 1937, cat. no. 10, ill.; London, 1938, ill. p. 18; Paris, 1938, no. 40; Cambridge, England, 1954, cat. no. 6; New York, 1968, cat. no. 43, ill.; London, 1978, cat. no. 1.15, ill.; Cleveland, 1979, ills. on back cover and p. 55; Rome, 1981–82, ill. p. 73; New York, 1982, ills. pp. 68, 175;

Venice, 1987, ill. p. 255; London, 1989, cat. no. 49, ill.

BIBLIOGRAPHY
Queneau, 1928, p. 42; Bardi, 1929; Courthion, 1929; Nino, 1929, ill. p. 131; Read, 1936, no. 20, ill.; Soby, 1941, p. 66, pl. 52, ill.; de Chirico, 1942, ill. p. 28; Gaffé, 1946, p. 10, no. 14, ill.; Read, 1948, fig. 86, ill.; Lassaigne, 1950, ill. p. 108; Gaffé, 1951, pp. 211–12, ill. p. 212; Soby, 1955, p. 113, ill. p. 22; Gaffé, 1963, p. 102, ill. p. 112; Ashbery, 1968, p. 44, ill. p. 43; Rubin, 1968, pp. 126, 217, ill. p. 139; Bruni, 1971, I, pl. 33, ill.; *Artemis, 1977–78*, 1978, no. 20, ill. p. 49; Henning, 1980, ill. p. 123; Penrose, 1981, pl. 442, ill. p. 176; Henning, 1982, ill. p. 73; Rubin, 1982, fig. 20, ill. p. 64; Siegel, 1982, ill. p. 102; Rubin, 1983, ill. p. 26; Fagiolo dell'Arco, 1984, no. 106, ill. p. 98, pl. 26; Heyd, 1988, fig. 1, ill. p. 108.

Salvador Dali PAGE 187
The Accommodations of Desires
Les Accommodations des désirs
1929

PROVENANCE
The artist, to the Galerie Goemans, Paris, 1929; André Breton, Paris, 1929; Julien Levy Gallery, New York, 1931; Wright Ludington, Santa Barbara, c. 1945; Julien Levy, Bridgewater, Connecticut, 1960s; sale, New York, Sotheby's, November 4, 1981, no. 32; Jacques and Natasha Gelman, 1981.

EXHIBITIONS
Paris, 1929, cat. no. 2 [as *Les Accommodations des désirs*]; Paris, 1931; Tenerife, 1935, cat. no. 5 [as *La Libre inclinación del deseo*]; Hartford, 1938, cat. no. 35, ill.; New York, 1941–42, ill. p. 35; Chicago, 1958; Los Angeles, 1964, cat. no. 11, ill. p. 35; New York, 1965–66, cat. no. 245, ill. p. 39; New York, 1968, cat. no. 58, ill.; New York, 1969, cat. no. 8, ill.; Rotterdam, 1970–71, cat. no. 11, ill.; Cleveland, 1979, cat. no. 55, ill.; Paris, 1979–80, ill. p. 129.

BIBLIOGRAPHY
La Révolution Surréaliste, 1929, ill. p. 18;

Levy, 1936, fig. 54, ill. p. 24; Dali, 1942, pp. 241–42, ill. [between pp. 166–67]; Breton, 1945, ill.; Goudy, 1948, ill. p. 45; Gaya Nuño, 1950, pl. 9, ill. p. 20; Breton, 1952, p. 155; Cirlot, 1955, p. 59; Morse, 1958, no. 15, ill. p. 25; Jean, 1960, ill. p. 202; Descharnes, 1962, p. 222, ill. p. 154; Janis and Blesh, 1962, p. 87, ill. p. 86; Tomkins, 1966, p. 138, ill. p. 139; Walton, 1967, p. 23, pl. 6, ill.; Gérard, 1968, no. 150, ill.; Ooka, 1968, pl. 51, ill. p. 73; Rubin, 1968, pp. 213, 218, 226, fig. 31, ill. p. 215; Wescher, 1968, p. 198; Lake, 1969, p. 67; Chadwick, 1970, p. 419; Dali, 1970, p. 23; Solier, 1971, ill. p. 157; Descharnes, 1976, p. 222, ill. p. 154; Pari-naud, 1976, pp. 92, 292; Arnason, 1977, p. 367, pl. 162, ill. p. 378; Levy, 1977, pp. 72, 145; Passeron, 1978, p. 141; Gómez de la Serna, 1979, p. 57; Maddox, 1979, pp. 16, 18; Passeron, 1979, p. 105; Calas, 1980, p. 94, ill. p. 90; Chadwick, 1980, p. 80; Wilson, 1980, fig. 3, ill.; *Art in America*, 1981, ill. p. 33; Gasman, 1981, vol. II, p. 663; Ades, 1982, pp. 7, 65, 78–80, 120, fig. 65, ill. p. 86; Gateau, 1982, fig. 37, ill. p. 74; Matthews, 1982, p. 83; Ratcliff, 1982, p. 33; Ajame, 1984, p. 111; *I Dalì di Salvador Dalì*, 1984, p. 22; Balakian, 1986, p. 204; Secrest, 1986, pp. 112, 137.

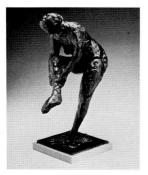

Edgar Degas　　PAGE 57
Woman Putting on a Stocking
Danseuse enfilant son bas
1895–1910

PROVENANCE
A. A. Hébrard, Paris; Buchholz Gallery (Curt Valentin), New York, 1945; Jacques and Natasha Gelman, 1945.

EXHIBITIONS
New York, 1945, cat. no. 41.

BIBLIOGRAPHY
Rewald, 1944, no. LVIII, p. 27; Rewald, 1956, pp. 24, 154, no. LVIII, pl. 73; Russoli and Minervino, 1970, p. 142, S 14; Millard, 1976, pp. 35, 69.

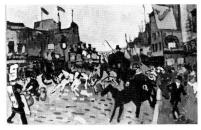

André Derain　　PAGE 81
Regent Street, London
1906

PROVENANCE
The artist, to Ambroise Vollard, Paris, c. 1906; Alphonse Kann, Saint-Germain-en-Laye, France; private collection, Paris; sale, Paris, Hôtel Drouot, April 3, 1925, no. 22; private collection, France, 1925; Sidney Janis Gallery, New York; Jacques and Natasha Gelman, 1953.

EXHIBITIONS
New York, 1958, cat. no. 20, ill.; New York, 1963, cat. no. 61, ill.; New York, San Francisco, and Fort Worth, 1976, ill. p. 45; London, 1978, cat. no. 5, ill.

BIBLIOGRAPHY
Les Chroniques du jour, 1931, p. 17; Raynal, 1947, pl. 18, ill.; Raynal, 1950, ill. p. 39; Hilaire, 1959, pp. 71, 191, ill.; Sutton, 1959, p. 18; Diehl, 1964, p. 36; Elderfield, 1976, ill. p. 45; Gee, 1981, pp. 94, 248.

Jean Dubuffet　　PAGE 240
View of Paris with Furtive Pedestrians
Vue de Paris aux piétons furtifs
February 1944

PROVENANCE
The artist, to the Galerie René Drouin, Paris; Mr. and Mrs. Charles Zadok, New York; sale, London, Sotheby's, June 22, 1965, no. 22; Robert Elkon Gallery, New York, and Robert Fraser Gallery, London; E. V. Thaw & Co., Inc., New York, 1967; Jacques and Natasha Gelman, 1967.

EXHIBITIONS
Paris, 1944 [presumed included]; New York, 1955, ill. p. 18; Milwaukee, 1956, cat. no. 11; New York, 1959, no. 8, ill.; London, 1966, cat. no. 8, ill. p. 20; Amsterdam, 1966, cat. no. 5, ill.

BIBLIOGRAPHY
Limbour, 1953, p. 99, ill. p. 28; Ragon, 1958, ill. p. 15; Loreau, 1966, fasc. 1: *Marionettes de la ville et de la campagne*, no. 225, ill. p. 126.

Jean Dubuffet PAGE 243
Jean Paulhan
Maast à crinière (*portrait de Jean Paulhan*)
September 1946

PROVENANCE
The artist, to the Galerie René Drouin, Paris, c. 1947; Mr. and Mrs. Arnold H. Maremount, Winnetka, Illinois; private collection, Europe; sale, London, Sotheby's, June 30, 1988, no. 648 A; Stephen Hahn, New York, 1988; Natasha Gelman, 1989.

EXHIBITIONS
Paris, 1947, no. 5 [as *Maast à crinière*]; New York, 1948, no. 11 [erroneously dated 1947]; New York, 1959, cat. no. 19, ill. [erroneously dated 1947]; New York, 1962, cat. no. 35; New York, 1969–70, cat. no. 7, ill. p. 20; New York, 1973, cat. no. 26, ill. p. 65; Paris, 1973, cat. no. 23, ill.; Saint-Paul-de-Vence, 1985, cat. no. 17, ill. p. 49; New York, 1987.

BIBLIOGRAPHY
Arnaud, 1960; Loreau, 1966, fasc. 3: *Plus beaux qu'ils croient—portraits*, no. 45, ill. p. 38.

Max Ernst PAGE 199
The Barbarians
Barbares
1937

PROVENANCE
John Davenport, London; Rex de Charembac Nan Kivell, Redfern Gallery, London, by 1967; Galerie Beyeler, Basel, 1975; private collection, Mülheim, 1975; Galerie Beyeler, Basel, 1988; Natasha Gelman, 1989.

EXHIBITIONS
London, 1952–53, no. 41; London, 1967, no. 161; London, 1968, no. 101; Darmstadt, 1975, cat. no. 11, ill. p. 16.

BIBLIOGRAPHY
Spies, 1979, vol. 4, cat. no. 2278, ill. p. 375.

Alberto Giacometti PAGE 257
Three Men Walking II
Trois Hommes qui marchent II
1949

PROVENANCE
H. Arnold, 1950; Pierre Matisse Gallery, New York, 1950; Marens Rice, Saint Louis, 1950; E. V. Thaw & Co., Inc., New York, c. 1965; Jacques and Natasha Gelman, 1965.

EXHIBITIONS
New York, 1950, ill. p. 4.

BIBLIOGRAPHY
Leiris, 1949, ill.; Joray, 1955, vol. I, no. 72, ill.; Sartre, 1955, ill. p. 26; Negri, 1956, ill. p. 42; Courtois, 1962, ill. p. 39; Dupin, 1962, ill. p. 245; Genêt, 1963, ill.; Watt, 1964, ill. p. 22; Meyer, 1968, pp. 156, 160; Hohl, 1971, ill. p. 126; Hohl, 1974, pp. 31–32; Loercher, 1974, F, p. 6; Rowell, 1986, p. 180, no. 208, ill. p. 183; Fletcher, 1988, p. 138, ill. p. 138.

Alberto Giacometti PAGE 261
Head of Diego
Tête de Diego
1950

PROVENANCE
The artist, to the Pierre Matisse Gallery, New York, c. 1950; Leland Hayward, New York, 1952; Pierre Matisse Gallery, 1963; Jacques and Natasha Gelman, 1963.

EXHIBITIONS
New York, 1950, ill. p. 23; New York, 1965, cat. no. 39.

BIBLIOGRAPHY
Giedion-Welcker, 1955, ill. p. 97 [original plaster]; Hohl, 1971, ill. p. 195 [erroneously dated 1951].

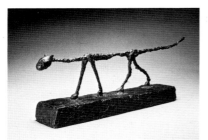

Alberto Giacometti PAGE 262
The Cat
Le Chat
1954

PROVENANCE
The artist, to the Pierre Matisse Gallery,
New York, 1955; Leland Hayward, New
York, 1956; Marlborough Gallery, New
York, 1968; Jacques and Natasha Gelman,
1968.

EXHIBITIONS
New York, 1955; Washington, 1963, cat.
no. 18.

BIBLIOGRAPHY
Ponge, 1951, ill. p. 75 [original plaster];
Joray, 1955, vol. I, no. 76, ill.; Scheidegger,
1958, ill. p. 117 [original plaster]; Bucarelli,
1962, fig. 46, ill.; *Du*, 1962, ill. p. 14;
Habasque, 1962, ill. pp. 32–33; Genêt, 1963,
ill. [original plaster]; *Art News*, 1965, ill.
p. 61; Meyer, 1968, pp. 162–63; Hohl, 1971,
ill. p. 121 [original plaster]; Rosenberg, 1974,
p. 70; Dupin, 1978, p. 35; Brenson, 1979,
pp. 119–20, ill. p. 118; Lamarche-Vadel,
1984, p. 143, ill. p. 142; Schneider, 1987, ill.
p. 28.

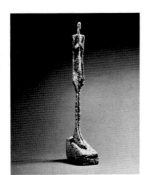

Alberto Giacometti PAGE 265
Woman of Venice II
Femme de Venise II
1956

PROVENANCE
The artist, to the Pierre Matisse Gallery,
New York, 1957; James W. Alsdorf, Chi-
cago, 1957; Herbert West Gallery, Chicago;
Milton Ratner, Fort Lee, New Jersey; sale,
New York, Christie's, November 3, 1982,
no. 63; Jacques and Natasha Gelman, 1982.

EXHIBITIONS
New York, 1965, cat. no. 50, ill. p. 68; New
York, 1974, cat. no. 77, ill. p. 103; Chicago,
1974–75, cat. no. 44, ill. p. 14; New York,
1976, cat. no. 12, ill.

BIBLIOGRAPHY
Dupin, 1962, ill. p. 283; Genêt, 1963; Forge,
1965, p. 131; Sylvester, 1965, pp. 23, 25, ill.
p. 27; Meyer, 1968, p. 143; Freund, 1969, p.
44; Hohl, 1971, pp. 142–43, 281, ill. p. 119;
Forge, 1974, ill. p. 39; Rosenberg, 1974, p.
70; Svendsen, 1977, fig. 5, ill. p. 17;
Lamarche-Vadel, 1984, p. 144; Lord, 1985,
pp. 355–56, 358, 382, 485, ill.; Matter, 1987,
ills. pp. 118, 120; Fletcher, 1988, p. 45; Hohl,
1988, p. 60.

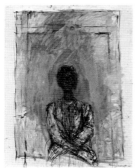

Alberto Giacometti PAGE 274
Annette
1961

PROVENANCE
The artist, to the Pierre Matisse Gallery,
New York, c. 1962; Jacques and Natasha
Gelman, 1963.

EXHIBITIONS
Paris, 1961, cat. no. 16; Venice, 1962, cat. no.
31; New York, 1965, cat. no. 98, ill. p. 89;
Paris, 1969–70, cat. no. 191; Mexico City,
1987, cat. no. 84, ill. p. 44; Washington,
1988, cat. no. 96, ill. p. 223.

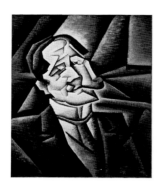

Juan Gris PAGE 109
Juan Legua
1911

PROVENANCE
The artist, to Juan Legua, Paris, c. 1911;
Galerie Jacques Dubourg, Paris; Jacques and
Natasha Gelman, 1954.

EXHIBITIONS
New York, 1956, cat. no. 11, ill.; Dortmund,

1965, cat. no. 4, ill.; Cologne, 1965–66, cat.
no. 4, ill.; Paris, 1974, cat. no. 7, ill. p. 76.

BIBLIOGRAPHY
Cooper, 1949, p. 6; Cooper, 1956, p. 115;
Golding, 1959, p. 99, ill.; Leymarie, 1974,
p. 14; Gaya Nuño, 1975, p. 18, ill. p. 17;
Cooper and Potter, 1977, p. xiii, no. 5, ills.
pp. 11, 469; Rosenthal, 1983, pp. 19, 50; Gaya
Nuño, 1986, pl. 21; Grazia Messina and
Nigro Covre, 1986, p. 348, fig. 158, ill.

Juan Gris PAGE 119
The Smoker
Étude pour *Le Fumeur*
1913

PROVENANCE
The artist, to Frank Haviland, Céret,
c. 1913; Buchholz Gallery (Curt Valentin),
New York; G. David Thompson, Pitts-
burgh, mid-1950s; E. V. Thaw & Co., Inc.,
New York, c. 1960; Pedro Vallenilla-Echever-
ría, Caracas, c. 1966; E. V. Thaw & Co.,
Inc., New York, after 1975; Rolf and Mar-
grit Weinberg, Switzerland; Thomas Am-
mann Fine Art, Zurich, 1988; Natasha
Gelman, 1988.

EXHIBITIONS
New York, 1950, cat. no. 37 [dated 1913];

New York, 1958, p. 27, ill. p. 30; New York,
1960, cat. no. 11, ill.; Paris, 1965, cat. no. 15,
ill. p. 22; Dortmund, 1965, and Cologne,
1965–66, cat. no. 111, ill.; Caracas, 1966, cat.
no. 4, ill.; Caracas, 1968, cat. no. 6, ill.;
Caracas, 1970, pl. 7, ill.; Bordeaux and
Paris, 1973, cat. no. 83; Rome, 1973–74, cat.
no. 41, ill.; Caracas, 1974, cat. no. 48, ill.;
Paris, 1974, cat. no. 123, ill. p. 117; Winter-
thur, Hanover, and Ludwigshafen-am-Rhein,
1980, p. 50, ill. p. 51; Washington, 1983, and
Berkeley and New York, 1984, cat. no. 89,
ill. p. 32; Madrid, 1985, cat. no. 121, ill.
p. 333.

BIBLIOGRAPHY
Soby, 1958, p. 27, ill. p. 30; Preston, 1960,
p. 549, ill. p. 547; Rosenthal, 1983, p. 34, ill.
p. 32.

Juan Gris PAGE 122
Still Life with a Guitar
Guitare sur un table
Céret, September 1913

PROVENANCE
The artist, to the Galerie Kahnweiler, Paris,
1913; sequestered Kahnweiler stock, Paris,
1914–22: third Kahnweiler sale, Paris, Hôtel
Drouot, July 4, 1922, no. 96; Ohn collec-
tion, 1922; Galerie Simon, Paris; Galerie
Louise Leiris, Paris, July 1953; Jacques Lin-
don, Gallery of Modern Art, Inc., New

York, 1953; Jacques and Natasha Gelman,
1953.

EXHIBITIONS
Dortmund, 1965, and Cologne, 1965–66,
cat. no. 16, ill.; Paris, 1974, cat. no. 17, ills.
pp. 26, 80.

BIBLIOGRAPHY
Golding, 1959, p. 132, cover ill. and pl. C
[between pp. 132–33]; Spies, 1974, ill. p. 25;
Gaya Nuño, 1975, no. 249, ill. p. 213;
Cooper and Potter, 1977, no. 53, ill. p. 93.

Wassily Kandinsky PAGE 132
Rain Landscape
Regenlandschaft
1911

PROVENANCE
Felix Muche, Ramholz, Germany, 1916; Galerie Berggruen et Cie, Paris; Suzanne Feigel, Basel; Mrs. M. Winter Chanin, New York, early 1950s; E. V. Thaw & Co., Inc., New York, 1959; Jacques and Natasha Gelman, 1959.

EXHIBITIONS
New York, 1963, cat. no. 8, ill.

BIBLIOGRAPHY
Der Ararat, 1920, p. 74, ill.; Grohmann, 1958 [?], p. 346, ill. p. 76; Washton Long, 1980, pp. 133, 185, pl. 192.

Paul Klee PAGE 195
One Who Understands
Ein Verständiger
1934

PROVENANCE
Buchholz Gallery (Curt Valentin), New York; George L. K. Morris, New York; Leland Hayward, New York; Marlborough Gallery, New York, 1967; Jacques and Natasha Gelman, 1968.

EXHIBITIONS
New York, 1940, cat. no. 80; New York, 1941, cat. no. 56, ill.; Beverly Hills, 1948, cat. no. 15, ill.; New York, 1949, ill. p. 32.

BIBLIOGRAPHY
Adler, 1942, ill. [between pp. 264–65]; Miller, 1945, ill. p. 56; Spiller, 1957, ill.

Fernand Léger PAGE 151
The Bargeman
Le Marinier
1918

PROVENANCE
The artist, to Léonce Rosenberg, Paris; Roland Balay and Louis Carré, Paris, 1938; Paul Willert, New York, 1939; Theodore Schempp, New York; Sidney Janis, New York; Mr. and Mrs. Leigh B. Block, Chicago; Marlborough Fine Art Ltd., London; sale, London, Christie, Manson & Woods Ltd., July 2, 1974, no. 105; Acquavella Galleries, New York; Heinz Berggruen, Paris; Jacques and Natasha Gelman, 1983.

EXHIBITIONS
Geneva, 1920, cat. no. 92 [?]; New York, Sidney Janis Gallery, 1957, cat. no. 5, ill.; Paris, 1975, cat. no. 3, ill.; Paris, 1980, cat. no. 19, ill.; New York, 1987, cat. no. 12, ill.; Saint-Paul-de-Vence, 1988, cat. no. 28, ill. p. 73.

BIBLIOGRAPHY
Apollo, 1974, ill. p. 345; Herbert, 1974, ill. p. 145; Daulte, 1980, ill. p. 48.

Fernand Léger PAGE 162
Mechanical Elements
Éléments mécaniques
1920

PROVENANCE
Earl Stendahl, Los Angeles; Sidney Janis Gallery, New York; private collection, Chicago, c. 1953; Stephen Mazoh & Co., New York, 1986; Heinz Berggruen, Paris, 1986; Natasha Gelman, 1987.

EXHIBITIONS
New York, Sidney Janis Gallery, 1957, cat. no. 12, ill.; Chicago, 1985, cat. no. 84, ill. p. 74; New York, 1987, cat. no. 20, ill.; Saint-Paul-de-Vence, 1988, cat. no. 33, ill. p. 83.

Fernand Léger PAGE 216
Divers, Blue and Black
Plongeurs en noir et bleu
1942–43

PROVENANCE
The artist, to Valentine Dudensing, New York; Valentine Gallery, New York; Sidney

Janis Gallery, New York; Jacques and Natasha Gelman, 1957.

EXHIBITIONS
New York, 1945, cat. no. 65; New York, World House Galleries, 1957, cat. no. 42; New York, 1962, cat. no. 19, ill.

BIBLIOGRAPHY
Bernstein, 1977, pp. 143–44, ill. p. 143.

Henri Matisse PAGE 72
Still Life with Vegetables
Nature morte
1905–6

PROVENANCE
Oskar Moll, Breslau; Galerie Bernheim-Jeune, Paris; Josef von Sternberg, Germany and Los Angeles; sale, New York, Parke-Bernet Galleries [now Sotheby's], November 22, 1949, no. 88; Mr. and Mrs. Max Miller, United States, 1949; Mrs. Geoffrey Bennett, New York; sale, London, Sotheby's, April 15, 1970, no. 49; private collection, San Diego, 1970; sale, London, Sotheby's, June 27, 1977, no. 26; Jacques and Natasha Gelman, 1977.

EXHIBITIONS
Los Angeles, 1943, cat. no. 26, ill.; Chicago, 1946, no. 10; New York, 1950, no. 31; Palm Beach, 1953, cat. no. 6; San Diego, 1973; San Diego Fine Arts Gallery [now San Diego Museum of Art], on loan to the permanent collection, 1974–77.

BIBLIOGRAPHY
Schacht, 1922, ill. p. 59; Basler, 1924, ill.; Basler, November 1924, ill. p. 1003; *Art at Auction*, 1971, p. 152, ill. p. 168; Luzi and Carrà, 1971, no. 94, ill. p. 89; *Art at Auction*, 1977, ill. p. 147; Seghers, 1977, p. 171, ill.; Carrà and Derying, 1982, no. 94, ill. p. 89; Schneider, 1984, ill. p. 231.

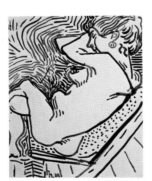

Henri Matisse PAGE 84
Seated Nude Asleep
Nue assise
1906

PROVENANCE
The artist, to the Atelier Auguste Clot, Paris, 1906; heirs of Auguste Clot, Paris; E. V. Thaw & Co., Inc., and Stephen Hahn,

New York, c. 1979; Jacques and Natasha Gelman, 1979.

EXHIBITIONS
London, 1984–85, and New York, 1985, cat. no. 15, ill. p. 148.

BIBLIOGRAPHY
Gowing, 1979, ill. p. 67; Schneider, 1984, ill. p. 212.

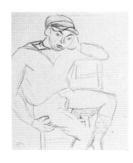

Henri Matisse PAGE 86
Study for **The Young Sailor I**
Étude pour *Le Jeune Marin I*
Collioure, 1906

PROVENANCE
The artist, to Mme Henri Matisse, Paris,

1954; Pierre Matisse, New York, 1958; Jacques and Natasha Gelman, c. 1980–81.

BIBLIOGRAPHY
Schneider, 1984, ill. p. 236.

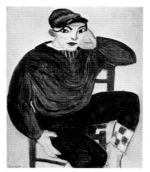

Henri Matisse PAGE 89
The Young Sailor II
Le Jeune Marin II
1906

PROVENANCE
Collection of the artist, until c. 1913; Leopold Zborowski, Paris, 1922; J. B. Neumann, New York; Hans Seligmann, Basel, 1923; Pierre Matisse Gallery, New York, 1952; Mr. and Mrs. Leigh B. Block, Chicago, 1952; Marlborough Gallery, New York, 1969; Jacques and Natasha Gelman, 1969.

EXHIBITIONS
Paris, 1908, no. 902; London, 1912, cat. no. 36; New York, 1913, cat. no. 405; Chicago, 1913, cat. no. 241; Boston, 1913, cat. no. 122; New York, 1915, cat. no. 63; Barcelona, 1920, cat. no. 51, ill.; Berlin, 1930, cat. no. 18 [either *The Young Sailor I* or *II*]; Basel, 1931, cat. no. 14, ill. p. 8; New York, 1931, cat. no. 14, ill. p. 46; Philadelphia, 1948, cat. no. 10, ill.; Lucerne, 1949, cat. no. 34; Bern, 1950, cat. no. 97; Milan, 1950, cat. no. 16; Venice, 1950, cat. no. 45, ill.; New York, 1951–52, and Cleveland, Chicago, and San Francisco, 1952, cat. no. 15; Los Angeles, Chicago, and Boston, 1966, cat. no. 24, ill. p. 53; New York, 1966, cat. no. 12, ill. p. 26; Washington, 1967, cat. no. 31, ill.; Paris, 1970, cat. no. 82, ill. p. 155; New York, 1973, cat. no. 5, ill.; New York, Sydney, and Melbourne, 1975, cat. no. 64, ills. cover, pp. 22, 87; New York, San Francisco, and Fort Worth, 1976, ill. p. 96.

BIBLIOGRAPHY
Sembat, 1920, ill. p. 31; Schacht, 1922, ill. p. 30; Zervos, 1931, ill. [pp. 14–15]; Scheiwiller, 1933, pl. 2, ill.; Fry, 1935, pl. 7, ill.; Wilenski, 1940, pp. 201, 233, ill. p. 198; Swane, 1944, fig. 11, ill.; Caspers, 1948, ill. p. 9; *Art News*, 1950, ills. cover, p. 5; Georges-Michel, 1950, ill. p. 10; Myers, 1950, pp. 279–81, ill. p. 280; Raynal, 1950, ill. p. 30; Barr, 1951, pp. 82, 93–94, 97, 128, 149–50, 157, 163, 179, 194, 246, ill. p. 335; Myers, 1951, p. 71, ill. p. 71; Matisse, 1954, ill. p. 91; Francastel, 1955, ill. p. 133; Duthuit, 1956, no. 5, ill.; Diehl, 1958, pp. 41, 101, pl. 26; Apollonio, 1959, ill. p. 17; Lassaigne, *Matisse*, 1959, p. 60; Crespelle, 1962, no. 8, ill.; *Armory Show . . .* 1963, p. 197; Brown, 1963, p. 267; Chassé, 1963, no. 11, ill.; Seldis, 1966, p. 252; Leymarie, 1967, ill. p. 317; Muller, 1967, no. 36, ill. p. 52; Gowing, 1968, p. 18; Negri, 1969, pl. 38, ill. p. 64; Ferrier, 1970, ill. p. 40; Radulescu, 1970, no. 8, ill.; Luzi and Carrà, 1971, pl. 14, no. 86, ill. p. 88; Aragon, 1972, vol. I, p. 301, pl. 46, ill. p. 311; Daval, 1973, ill. p. 195; Russell, 1976, p. 9, ill. p. 9; Arnason, 1977, p. 117, ill. p. 118; Gowing, 1979, p. 206, no. 42, ill. p. 59; Carrà and Derying, 1982, pl. 46, ill. p. 331; Daix, 1982 a, p. 26, ill. p. 27; Daix, 1982 b, ill. p. 23; Giry, 1982, p. 149, ill. p. 141; Noël, 1983, no. 12; Flam, 1984, vol. I, ill. p. 221; Schneider, 1984, pp. 281, 372, 393, 410, 414, 592, ill. p. 237; Watkins, 1984, p. 119, ill. p. 122; Klein, 1985, pp. 360, 367; Flam, 1986, pp. 175, 178, no. 167, ill. p. 177; Selz, 1989, ill.

Henri Matisse PAGE 92
View of Collioure
Vue de Collioure
1907–8

PROVENANCE
Michael and Sarah Stein, Paris; Marie Cuttoli, Paris; Helena Rubinstein, Paris: sale, New York, Parke-Bernet Galleries [now Sotheby's], April 20, 1966, no. 48; E. V. Thaw & Co., Inc., New York, 1966; Jacques and Natasha Gelman, 1967.

EXHIBITIONS
Paris, 1910, no. 43 [or 45]; Paris, 1937, cat. no. 44; Paris, 1970, cat. no. 88, ill. p. 160; New York, 1970–71, p. 163, pl. 2, ill.; New York, 1973, cat. no. 7, ill.; New York, Sydney, and Melbourne, 1975, cat. no. 65, ill. p. 89.

BIBLIOGRAPHY
Flanner, 1957, ill. p. 31; França, 1970, p. 23, ill. p. 22; Taillandier, 1970, ill. p. 89; Luzi and Carrà, 1971, pl. 16, no. 114, ill. p. 90; Russell, 1976, p. 14, ill. p. 15; Carrà and Derying, 1982, pl. 16, no. 114, ill. p. 90; Daix, 1982 a, p. 36, ill. p. 37; Hohl, 1982, p. 29, ill. p. 29; Schneider, 1984, pp. 322, 450, ill. p. 443; Flam, 1986, p. 234, ill. p. 235; Grazia Messina and Nigro Covre, 1986, p. 221, fig. 29, ill.

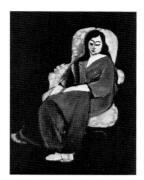

Henri Matisse PAGE 143
**Laurette in a Green Robe,
 Black Background**
Laurette sur fond noir, robe verte
1916

PROVENANCE
The artist, to Mme Henri Matisse, Paris,
1954; Pierre Matisse, New York, 1958;
Jacques and Natasha Gelman, 1969.

EXHIBITIONS
New York, 1931, cat. no. 34, ill.; Provi-
dence, 1931, cat. no. 15; Lucerne, 1949, cat.
no. 48, ill.; Paris, 1950, cat. no. 43; New
York, 1951–52, Chicago, Cleveland, and San
Francisco, 1952, cat. no. 46, and Los An-
geles, 1952, cat. no. 29; Paris, 1955, cat. no.
171, ill. p. 27; Paris, 1956, cat. no. 44, ill.;
Los Angeles, Chicago, and Boston, 1966,
cat. no. 43, ill. p. 75; New York, 1966, cat.
no. 30, ill. p. 36; London, 1968, cat. no. 62,
ill. p. 98; Copenhagen, 1970, cat. no. 40, ill.;
Paris, 1970, cat. no. 132, ill. p. 202; Wash-
ington, 1986–87, cat. no. 8, ills. pp. 63, 278;
Venice, 1987, cat. no. P 29, ill. p. 77.

BIBLIOGRAPHY
Fry, 1935, no. 30, ill.; Mushakojo, 1939, fig.
80, ill. p. 44; Wilenski, 1940, ill. p. 259;
Raynal, 1947, pl. 11, ill.; Barr, 1951, p. 191,
ill. p. 412; Diehl, 1954, ill. p. 69; Charmet,
1955, p. 10; Selz, 1964, ill. p. 40; Guichard-
Meili, 1967, no. 77, ill. p. 89; Sutton, 1970,
ill. p. 359; Luzi and Carrà, 1971, pl. 35, no.
218, ill. p. 95; Aragon, 1972, vol. II, p. 98,
ill. p. 101; Flam, 1973, unpaginated; Laude,
1974, pp. 19, 20, 24, 25, n. 30; Watkins,
1977, pl. 24, ill.; Monod-Fontaine, 1979, p.
45; Carrà and Derying, 1982, pl. 35, no.
218, ill. p. 95; Mannering, 1982, ill. p. 54;
Fourcade, 1983, p. 32, n. 20, p. 38, ill. p. 29;
Noël, 1983, no. 33, ill.; Schneider, 1984, ill.
p. 428; Watkins, 1984, p. 138, ill.; Freund,
1985, ill. p. 172; Flam, 1986, p. 441, ill. p.
446; Fourcade, 1986, pp. 74–76, ills. pp. 79,
80; Lebensztejn, 1986, pp. 84, 91, ills. pp.
79, 80.

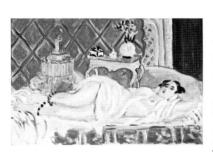

Henri Matisse PAGE 177
Odalisque, Harmony in Red
Odalisque, harmonie rouge
about 1926–27

PROVENANCE
The artist, to Mme Henri Matisse, Paris,
1954; Pierre Matisse, New York, 1958;
Jacques and Natasha Gelman, c. 1970.

EXHIBITIONS
Pittsburgh, 1931, cat. no. 198; Paris, 1950,
cat. no. 48; Knokke-le-Zoute, 1952, cat. no.
28, ill.; Paris, 1970, cat. no. 174, ill. p. 231.

BIBLIOGRAPHY
Gros, 1927, ill. p. 273; Raynal, 1950, ill. p.
54; Marchiori, 1967, no. 91; Guichard-Meili,
1970, ill. p. 68; Luzi and Carrà, 1971, pl. 61,
no. 438, ill. p. 104; Carrà and Derying, 1982,
pl. 61, no. 438, ill. p. 104; Schneider, 1984, p.
527.

Henri Matisse PAGE 246
**Model Standing in the Artist's
 Studio**
Modèle dans l'atelier
1948

PROVENANCE
Curt Valentin Gallery, New York, c. 1953;
The Art Institute of Chicago, 1955; Richard
L. Feigen & Co., New York, c. 1974;
Galerie Berggruen et Cie, Paris; Galerie
Beyeler, Basel; Galerie Issert, Saint-Paul-de-
Vence; Galerie Berggruen et Cie, Paris; John
Gaines, Lexington, Kentucky; Galerie Her-
bage, Cannes; E. V. Thaw & Co., Inc., New
York, 1983; Jacques and Natasha Gelman,
1983.

EXHIBITIONS
Paris, 1949, cat. no. 16 [?]; New York, 1953,
cat. no. 58, ill.; Basel, 1980, cat. no. 45, ill.;
Cannes, 1981, cat. no. 27, ill.; New York,
1984–85, cat. no. 140, ill. p. 236.

BIBLIOGRAPHY
Jacobus, 1972, ill. p. 74.

Henri Matisse PAGE 248
Snow Flowers
Fleurs de neige
1951

PROVENANCE
Mme Henri Matisse, Paris, 1954; Pierre Matisse, New York, 1958; Pierre Noël Matisse, Los Angeles, 1960; Galerie d'Art Moderne, Basel; private collection, Los Angeles, 1968; Acquavella Galleries, New York, and Richard Gray, Chicago; Jacques and Natasha Gelman, 1975.

EXHIBITIONS
Bern, 1959, cat. no. 3, ill.; Amsterdam, 1960, cat. no. 4; Paris, 1961, cat. no. 9; New York, 1961, and Chicago and San Francisco, 1962, cat. no. 5, ill. p. 21; Los Angeles, Chicago, and Boston, 1966, cat. no. 338; Baltimore, 1968, cat. no. 127, ill. p. 151; Buffalo, 1970, Dayton, 1970–71, and Cleveland, 1971, cat. no. 34, ill. p. 41; New York, 1973, cat. no. 57, ill.; Washington, 1977, cat. no. 117, ill. p. 173.

BIBLIOGRAPHY
Duthuit and Reverdy, 1958, ill. p. 21; Lassaigne, 1959, ill. p. 10; Lassaigne, *Matisse*, 1959, p. 122; Marmer, 1966, ill. p. 33; Seldis, 1966, ill. p. 254; Cowart, 1975, p. 55; Guichard-Meili, 1984, no. 20, ill.; Schneider, 1984, p. 697.

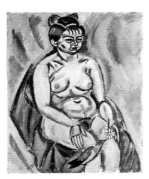

Joan Miró PAGE 155
Seated Nude Holding a Flower
El Nu de l'aucell i la flor
1917

PROVENANCE
The artist, to the Galería Dalmau, Barcelona, 1918; Helena Rubinstein, Paris and New York: sale, New York, Parke-Bernet Galleries [now Sotheby's], April 20, 1966, no. 51; E. V. Thaw & Co., Inc., New York, 1966; Jacques and Natasha Gelman, 1967.

EXHIBITIONS
Barcelona, 1918, cat. no. 44 [as *El Nu de l'aucell i la flor*].

BIBLIOGRAPHY
Dupin, 1962, p. 80; Lubar, 1988, fig. 31, p. 302.

Joan Miró PAGE 156
Vines and Olive Trees, Tarragona
Arbres et montagnes à Tarragone
1919

PROVENANCE
Pierre Matisse Gallery, New York, 1937; Mr. and Mrs. Leigh B. Block, Chicago, 1951; E. V. Thaw & Co., Inc., New York, 1987; Natasha Gelman, 1987.

EXHIBITIONS
Paris, 1921, cat. no. 24 [as *Arbres et montagnes à Tarragone*]; New York, 1940, cat. no. 4, ill.; New York, 1941–42, ill. p. 17; San Francisco, 1948, cat. no. 42, ill.; Minneapolis, 1951, p. 126; New York, 1951, cat. no. 12; New York, 1959, cat. no. 12, ill.; Los Angeles, 1959, cat. no. 11; Paris, 1962, cat. no. 13, ill.; London, 1964, cat. no. 24, ill.; Washington, 1967, cat. no. 62, ill.; Santa Barbara, 1978, cat. no. 5, ill.

BIBLIOGRAPHY
Greenberg, 1948, p. 15, pl. IV, ill. p. 50; *The Minneapolis Institute of Art Bulletin*, 1951, p. 126; H[ess], 1952, ill. p. 40; Rosenblum, 1960, p. 257, pl. 183, ill. p. 252; Dupin, 1962, no. 64, ills. pp. 89, 506; Lassaigne, 1963, pp. 27–28, ill. p. 25; Bucci, 1968, pp. 18–20, fig. 11, ill. p. 18; Perucho, 1968, pp. 60–61, pl. 37, ill.; Penrose, 1970, p. 24, fig. 16, ill. p. 27; Marchiori, 1972, p. 18; Krauss, 1973, p. 16; Diehl, 1974, p. 16; Rowell, 1976, p. 23, ill. p. 22; Miró, 1986, pp. 62–63, n. 57, p. 309, nn. 66–67, p. 310, fig. 6, ill.; Lubar, 1988, pp. 164, 167, 210, 314, fig. 67.

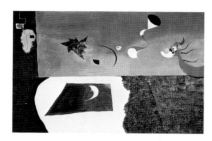

Joan Miró PAGE 180
Animated Landscape
Paysage animé
1927

PROVENANCE
The artist, to the Galerie Pierre, Paris,
c. 1928; Pierre Matisse Gallery, New York,
c. 1935; Mrs. Marcel Duchamp, Villiers-
sous-Grez, France, 1949; The New Gallery,
New York, 1959; Jacques and Natasha
Gelman, 1959.

EXHIBITIONS
Paris, 1928; New York, 1936, *Large Painting*
. . . , no. 4; New York, 1941, cat. no. 1;
New York, 1948, cat. no. 2; Dallas, 1959,
ill.; London, 1964, cat. no. 72, ill.

BIBLIOGRAPHY
Cary, 1936, p. 9; *Dictionnaire abrégé du
Surréalisme*, 1938, no. 49, ill. [as *Paysage*];
Hugnet, 1938, fig. 7, ill. p. 10; Greenberg,
1948, pl. XVIII, p. 61; Kramer, 1959, p. 49;
Rubin, 1959, p. 37; Dupin, 1962, no. 182, ill.
p. 515; Bonnefoy, 1967, fig. 23; Rubin, 1968,
p. 160, ill. p. 162; Marchiori, 1972, ill. p. 29;
Miró, 1986, p. 96, n. 8, p. 312.

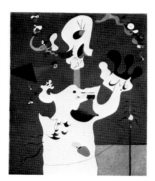

Joan Miró PAGE 183
The Potato
Pomme de terre
Paris, Summer 1928

PROVENANCE
The artist, to the Valentine Gallery, New
York, c. 1930; Pierre Matisse, New York,
1931; Thomas Laughlin, New York, c. 1932;
James B. Laughlin, New York, 1955; Pierre
Matisse Gallery, 1975; Jacques and Natasha
Gelman, 1975.

EXHIBITIONS
Paris, 1930, no. 4; Chicago, 1931, no. 10;
Hartford, 1931, cat. no. 33; New York,
1936 b, no. 10; New York, 1941–42, ills.
frontispiece and jacket; Venice, 1954, cat.
no. 12; Los Angeles, 1959, cat. no. 35; New
York, 1959, cat. no. 37; Paris, 1962, cat. no.
49; London, 1964, cat. no. 80, ill.; New
York, 1972, cat. no. 19, ill.; Paris, 1974, cat.
no. 35; London, 1978, cat. no. 9.61, ill.

BIBLIOGRAPHY
Cahiers d'art, 1934, ill. p. 42; Davidson,
1936, pp. 11, 26; Zervos, 1938, ill. p. 426;
Art News, 1945, ill. p. 16; Greenberg, 1948,
p. 33, ill. p. 63; Cirici-Pellicer, 1949, p. 27,
no. 33, ill.; Cirlot, 1949, p. 42; Dupin, 1962,
p. 192, no. 237, ill. p. 226; G.H., 1962, ill. p.
51; Baro, 1964, p. 41; Penrose, 1970, fig. 40,
ill. p. 63; Rubin, 1973, p. 119; Diehl, 1974,
p. 36; Georgel and Monod-Fontaine, 1978,
p. 35; Rose, 1982, p. 25; Dupin, Malet, and
Tàpies, 1983, ill. p. 69; Rowell, 1987, cat.
no. 64, p. 25.

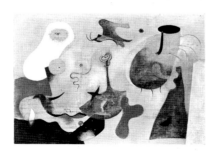

Joan Miró PAGE 190
Untitled
Peinture
February 1931

PROVENANCE
The artist, to Georges Hugnet, Paris,
probably 1931; D. Nahmad, Paris; Thomas
Ammann Fine Art, Zurich, 1986; Natasha
Gelman, 1988.

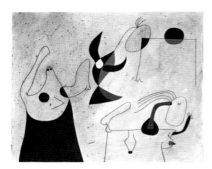

Joan Miró PAGE 218
Constellation: Women on the Beach
Femmes sur la plage
Varengeville, February 15, 1940

PROVENANCE
The artist, to the Pierre Matisse Gallery,
New York, 1945; Jacques and Natasha
Gelman, 1968.

EXHIBITIONS
New York, 1945, cat. no. 4; Los Angeles,
1959, cat. no. 75; London, 1964, cat.
no. 168.

BIBLIOGRAPHY
Breton, 1958, ill. p. 52; Dupin, 1962, no.
541, ill. p. 541; Baro, 1964, ill. p. 43; Burr,
1964, fig. 1, ill. p. 238; Teixidor, 1972, p. 41;
Picon, 1976, vol. II, p. 141; Matthews, 1980,
pp. 363–65, 369.

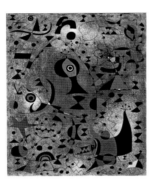

Joan Miró PAGE 222
Constellation: Toward the Rainbow
Vers l'Arc-en-ciel
Palma de Mallorca, March 11, 1941

PROVENANCE
The artist, to the Pierre Matisse Gallery,
New York, 1945; Mrs. Patricia Kane
Matisse, New York, 1945; Jacques and
Natasha Gelman, 1968.

EXHIBITIONS
New York, 1945, cat. no. 15; Venice, 1954,
cat. no. 19; Paris, 1962, cat. no. 138;
London, 1964, cat. no. 173; Tokyo, 1966,
cat. no. 65, ill.

BIBLIOGRAPHY
Greenberg, 1948, pl. 64, ill. p. 103; Breton,
1958, ill. p. 53; Dupin, 1962, no. 553, p. 541,
ill. p. 344; Teixidor, 1972, p. 41; Picon, 1976,
vol. I, ill. p. 120 [erroneously titled], vol. II,
ill. p. 30; Matthews, 1977, p. 252; Gimferrer,
1978, no. 188, ill. p. 207; Matthews, 1980, p.
370.

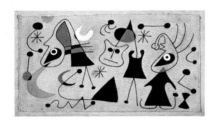

Joan Miró PAGE 227
Women and Bird in the Night
Femmes et oiseau dans la nuit
1944

PROVENANCE
The artist, to the Pierre Matisse Gallery,
New York; E. V. Thaw & Co., Inc., New
York, c. 1966; Jacques and Natasha Gelman,
1966.

BIBLIOGRAPHY
Tzara, 1945–46, ill. p. 283; Cirlot, 1949, fig.
35, ill.; Cirlot, 1955, p. 52; Dupin, 1962, p.
378, no. 633, ill. p. 548.

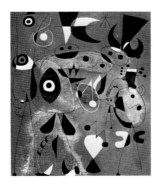

Joan Miró PAGE 228
Women, Birds, and a Star
Peinture
1949

PROVENANCE
Galerie Berggruen et Cie, Paris; Pierre
Matisse Gallery, New York, 1960; David E.
Bright, Los Angeles, 1960; Dolly Bright
Carter, Los Angeles, 1965; Pierre Matisse
Gallery, New York, 1982; Jacques and
Natasha Gelman, 1982.

BIBLIOGRAPHY
Dupin, 1962, p. 556, no. 732, ill. p. 416 [as
Painting].

Amedeo Modigliani PAGE 148
Boy in a Striped Sweater
Le Chandail rayé
1918

PROVENANCE
Paul Guillaume, Paris, by 1931; Sam Salz,
New York; Jacques and Natasha Gelman,
1952.

EXHIBITIONS
Brussels, 1933, cat. no. 47, ill. p. 38; Basel,
1934, cat. no. 39.

BIBLIOGRAPHY
Formes, 1931, ill.; Franchi, 1946, pl. 11;
Lassaigne, 1950, ill. p. 33; Pfannstiel, 1956,
no. 305, p. 156; Lanthemann, 1970, no. 316,
ill. p. 243; Piccioni and Ceroni, 1970, no.
215, ill. p. 99; Cachin and Ceroni, 1972, no.
215, ill. p. 99; Roy, 1985, ill. p. 91; Diehl,
1989, ill. p. 81.

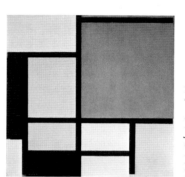

Piet Mondrian PAGE 165
Composition
1921

PROVENANCE
The artist, to J. H. Gosschalk, The Hague,
c. 1925; E. Polak, Amsterdam, 1948; Sidney
Janis Gallery, New York, 1948; Maurice E.
Culberg, Chicago, 1948; Mrs. Arthur C.
Rosenberg, Chicago, c. 1954; Richard L.
Feigen & Co., New York, 1969; Stephen

Hahn, New York, 1970; Natasha Gelman,
1988.

EXHIBITIONS
Amsterdam, 1946, cat. no. 95; Basel, 1947,
cat. no. 19; New York, 1949, no. 19; New
York, 1951, no. 9; New York, 1971, cat. no.
87; New York, 1982, cat. no. 22.

BIBLIOGRAPHY
Ottolenghi, 1974, p. 110, no. 333, ill. p. 108;
Ottolenghi, 1976, p. 110, no. 333, ill. p. 108;
Holtzman and James, 1986, no. 152, ill.

Pablo Picasso PAGE 68
Girl in Profile
Jeune Fille à la fleur rouge
1901

PROVENANCE
The artist, to Ignacio Zuloaga, Paris;
Antonio Zuloaga; Jacques and Natasha
Gelman, c. 1952.

EXHIBITIONS
Paris, 1950, cat. no. 79 [as *Jeune Femme à la
fleur rouge*]; New York, "Picasso: An Amer-
ican Tribute," 1962, cat. no. 5, ill.; Tokyo,
1964, cat. no. 4, ill.

BIBLIOGRAPHY
Zervos, 1954, vol. VI, pl. 1461, ill. p. 174;
Daix and Boudaille, 1966, p. 42, no. V.60,
ill. p. 182; Palau i Fabre, 1981, pl. 636, ills.
pp. 245, 249.

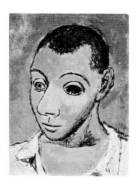

Pablo Picasso PAGE 98
Self-Portrait
Tête de jeune homme
Paris, Autumn 1906

PROVENANCE
The artist, to Gertrude Stein, Paris; Alice B.
Toklas, Paris, c. 1946; heirs of Gertrude
Stein, Paris and San Francisco, c. 1967;
André Meyer, New York, 1968; sale, New
York, Sotheby Parke-Bernet, October 22,
1980, no. 33; private collection, New York,

1980; Sandra Canning Kasper, Inc., New
York, 1986; Jacques and Natasha Gelman,
1986.

EXHIBITIONS
New York, 1970–71, p. 168; Ottawa, 1971,
cat. no. 8, ill.

BIBLIOGRAPHY
Zervos, 1932, vol. I, pl. 371, ill. p. 177;
Zennström, 1948, fig. 13, ill.; Sutton, 1955,
ill. p. 9; Elgar and Maillard, 1956, p. 46, ill.
p. 51; Buchheim, 1959, ill. p. 43; Daix and
Boudaille, 1966, no. XVI.27, ill. p. 327.

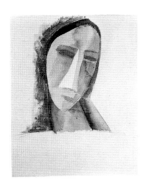

Pablo Picasso PAGE 100
Head of a Woman
Tête de femme
Early 1908

PROVENANCE
Helena Rubinstein, Paris, by 1942: sale,
New York, Parke-Bernet Galleries [now

Sotheby's], April 28, 1966, no. 80; E. V.
Thaw & Co., Inc., New York, 1966; Jacques
and Natasha Gelman, 1966.

BIBLIOGRAPHY
Level, 1928, p. 54, no. 14, ill. p. 30; Zervos,
1942, vol. II², pl. 682, ill. p. 303; Russoli and
Minervino, 1972, no. 52, ill. p. 90; Daix and
Rosselet, 1979, p. 216, no. 137, ills. pp. 8, 216.

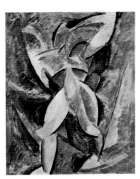

Pablo Picasso PAGE 103
Standing Nude
Étude pour le tableau "Trois Femmes"
Paris, early 1908

PROVENANCE
The artist, to the Galerie Kahnweiler, Paris;
E. Berl, Paris; Alfred Richet, Paris, 1929;
E. V. Thaw & Co., Inc., New York, 1979;
Jacques and Natasha Gelman, 1980.

EXHIBITIONS
Paris, 1953, cat. no. 14; Lyons, 1953, cat. no.
17; Milan, 1953, cat. no. 14, ill. [as *Grande
donna nuda con il braccio alzato*].

BIBLIOGRAPHY
Zervos, 1942, vol. II¹, pl. 102, ill. p. 49;
Russoli, 1953, fig. 14, ill.; Russoli and
Minervino, 1972, no. 187, ill. p. 97; Daix
and Rosselet, 1979, cat. no. 115, ill. p. 212.

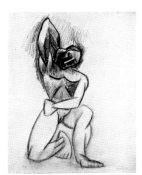

Pablo Picasso PAGE 104
Kneeling Nude
Étude pour le tableau "Trois Femmes"
Paris, Autumn 1908

PROVENANCE
Yvonne Zervos, Paris, c. 1942; Galerie
Berggruen et Cie, Paris; Curt Valentin, New
York; Nelson A. Rockefeller, New York,
c. 1957; Harold Diamond, New York, 1978;
Jacques and Natasha Gelman, 1978.

EXHIBITIONS
New York, 1957, ill. p. 36; Philadelphia,

1958, cat. no. 47, ill.; New York, 1969; New
York, 1980, ill.

BIBLIOGRAPHY
Zervos, 1942, vol. II², pl. 707, ill. p. 311;
Leymarie, 1967, ill. p. 32; Russoli and
Minervino, 1972, no. 189, ill. p. 96; Daval,
1973, ill. p. 202; Steinberg, 1978, p. 120, ill.
p. 122; Weisner et al., 1979, cat. no. 26, ill.;
Combalia Dexeus, 1981, pp. 57, 59, fig. 23,
ill.; Miller, 1981, ill. p. 73; Daix, 1982, ill. p.
44; Steinberg, 1988, p. 221, fig. 18, ill. p. 140.

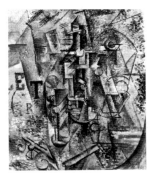

Pablo Picasso PAGE 113
Still Life with a Bottle of Rum
La Bouteille de rhum
Céret, Summer 1911

PROVENANCE
[Note: The following information is taken
from Douglas Cooper and Gary Tinterow,
*The Essential Cubism: Braque, Picasso & Their
Friends, 1907–1920* (exhib. cat.), London,
Tate Gallery, 1983, p. 260.] The artist, to the

Galerie Kahnweiler, Paris, 1911; sequestered
Kahnweiler stock, Paris, 1914–21: second
Kahnweiler sale, Paris, Hôtel Drouot, No-
vember 17–18, 1921, no. 189; Amédée
Ozenfant, Paris, 1921; Charles-Édouard
Jeanneret [Le Corbusier], Paris, c. 1921–63;
Fondation Le Corbusier, Paris, 1963–69;
sale, Paris, Palais Galliéra, December 9,
1969, no. A; Stephen Hahn, and E. V. Thaw
& Co., Inc., New York, 1969; Jacques and
Natasha Gelman, 1971.

EXHIBITIONS
Munich, 1913, cat. no. 61; Vienna, 1914, cat. no. 21; London, 1937, cat. no. 24; New York, 1971, cat. no. 13; New York, 1980, ill.; London, 1983, cat. no. 125, ill.

BIBLIOGRAPHY
Raynal, 1921, pl. 40, ill.; Zervos, 1942, vol. II¹, pl. 267, ill. p. 132; Crastre, 1950, p. 56, ill. no. 5 [as *Le "porrón"*]; Kahnweiler, 1950, no. 28, ill.; Payró, 1957, ill. p. 21; *Art News*, 1969, ill. p. 13; *Connaissance des arts*, 1970, ill. p. 79; *Connoisseur*, 1970, ill. p. 193; Seghers, 1970, ill. p. 258; Russoli and Minervino, 1972, p. 107, no. 415, ill. p. 108; Daix, 1977, p. 113, n. 33, p. 116; Daix and Rosselet, 1979, cat. no. 414, p. 89, ill. p. 268; Gee, 1981, p. 42; Daix, 1982, p. 28; Farr, 1983, p. 508, ill. p. 509; Wood, 1983, ill. p. 276.

Pablo Picasso PAGE 117
Man with a Hat and a Violin
Personnage
Paris, December 1912

PROVENANCE
The artist, to the Galerie Kahnweiler, Paris, c. 1913; René Gaffé, Brussels; Roland Penrose, London, July 1937; Curt Valentin, New York, c. 1953; G. David Thompson, Pittsburgh, c. 1957; Harold Diamond, New York, c. 1962; Jacques and Natasha Gelman, 1982.

EXHIBITIONS
Paris, 1932, cat. no. 74 [as *Personnage*]; Zurich, 1932, cat. no. 71; London, Zwemmer Gallery, 1937, no. 26; London, 1938, cat. no. 6; London, 1939, cat. no. 22, ill.; New York, 1939–40, cat. no. 106, ill.; New York, The Museum of Modern Art, 1941; London, 1947, cat. no. 25; London, 1951, cat. no. 20, ill.; São Paulo, 1953–54, cat. no. 5, ill.; New York, 1957, ill.; Philadelphia, 1958, cat. no. 66, ill.; Norfolk, 1973; New York, 1980, ill.; Tübingen, 1986, cat. no. 81, ill.

BIBLIOGRAPHY
Estrada, 1936, no. 74, p. 56; Zervos, 1942, vol. II², pl. 399, ill. p. 190; Kahnweiler, 1949, ill. p. 30; Hunter, 1957, ill.; Gaffé, 1963, ill. p. 74; Rosenblum, 1971, p. 606, n. 23; Russoli and Minervino, 1972, no. 562, ill. p. 114; *Chrysler Museum Bulletin*, 1973, p. 2; Daix and Rosselet, 1979, cat. no. 535, ill. p. 116; Perry, 1982, p. 188; Leighten, 1983, pp. 229, 248, fig. 106, ill.; Leighten, 1985, p. 665, ill. p. 667; Hohl, 1986, ill. p. 26; Leighten, 1989, p. 127, fig. 84, ill.

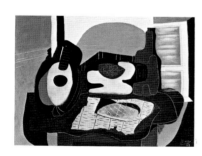

Pablo Picasso PAGE 169
Still Life with a Cake
La Galette
May 16, 1924

PROVENANCE
Alphonse Kann, Saint-Germain-en-Laye, France; Galerie Paul Rosenberg, Paris, 1942; The Museum of Modern Art, New York, 1942; Jacques and Natasha Gelman, 1977.

EXHIBITIONS
Paris, 1932, cat. no. 146 [as *La Galette*]; New York, 1939–40, cat. no. 185, ill.; New York, The Museum of Modern Art, 1941; New York, The Museum of Modern Art, 1942, cat. no. 489, ill.; Paris, 1942, cat. no. 3; New York, The Museum of Modern Art, 1944, p. 223; Newark, 1948; New York, 1950, no. 48; New York, 1954–55; New York, The Museum of Modern Art, 1962; Pittsburgh, 1963–64; Portland, Oregon, 1970, cat. no. 26, ill.; New York, 1972, ill.; Basel, 1976, cat. no. 48, ill.; Tokyo, 1976, cat. no. 83, ill.

BIBLIOGRAPHY
Bulletin de "l'Effort Moderne," 1925, ill. [opposite p. 8]; *Documents*, 1930, ill. p. 164; Zervos, 1930, ill. p. 291; *Cahiers d'art*, 1932, ill. p. 158; Estrada, 1936, no. 146, p. 58; Cheney, 1941, ill. p. 458; Bonfante and Ravenna, 1945, pl. 25, ill.; Barr, 1946, p. 282, ill. p. 134; Gómez Sicre, 1947, ill. p. 9; Zervos, 1952, vol. V, pl. 185, ill. p. 90; Raynal, 1953, ill. p. 83; Camón Aznar, 1956, ill. p. 201; Rosenblum, 1960, p. 108, pl. 66, ill. p. 92; Daulte, 1966, p. 38, ill. p. 39; Leymarie, 1972, ill. p. 51; Daix, 1977, p. 191; Daix, 1983, ill. p. 126.

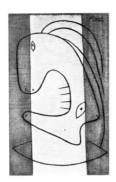

Pablo Picasso PAGE 178
Head of a Woman
Tête de femme
1927

PROVENANCE
Galerie Pierre, Paris, c. 1938; Wolfgang
Paalen, Mexico City; Jacques and Natasha
Gelman, 1940s.

EXHIBITIONS
Tokyo, 1964, cat. no. 39, ill.

BIBLIOGRAPHY
La Révolution Surréaliste, 1927, ill. p. 20;
Cahiers d'art, 1938, ill. p. 108; Zervos, 1955,
vol. VII, pl. 119, ill. p. 52; Daix, 1977, p. 221,
n. 20; Cowling, 1985, pp. 98, 104, n. 82.

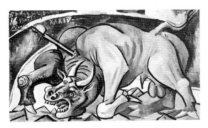

Pablo Picasso PAGE 193
Dying Bull
La Mort du taureau
Boisgeloup, July 16–17, 1934

PROVENANCE
The artist, to Paul Rosenberg, Paris, c. 1936;
Rosenberg & Helft, London, 1937; Oswald
T. Falk, Esq., London, 1937; Bignou Gal-
lery, New York, c. 1941; Keith Warner, New
York, c. 1946; G. David Thompson, Pitts-
burgh, c. 1961; Richard L. Feigen Gallery,
New York, 1961; Kirk Douglas, Los An-
geles, 1961; Heinz Berggruen, Paris, c. 1977;
Jacques and Natasha Gelman, 1982–83.

EXHIBITIONS
Paris, 1936, cat. no. 20 [as *La Mort du taureau*];

London, Rosenberg & Helft, 1937, cat.
no. 25; New York, Bignou Gallery,
1941, cat. no. 13; Los Angeles, 1961, cat. no.
27, ill.; Dallas, 1967, cat. no. 56; Tokyo,
1977, cat. no. 43, ill.; New York, 1980, ill.

BIBLIOGRAPHY
Cahiers d'art, 1935, ill. p. 157; Haesaerts,
1938, cover detail, and ill. p. 8; Mackenzie,
1940, pl. 18; Bonfante and Ravenna, 1945,
pl. 30, ill.; Barr, 1946, p. 186, ill. p. 187;
Merli, 1948, no. 47, ill.; Cassou, 1949, fig.
38, ill.; Vinchon, 1951, ill. p. 15; Camón
Aznar, 1956, ill. p. 503; Zervos, 1957, vol.
VIII, pl. 228, ill. p. 105; *Du*, 1958, ill. p. 18;
Champris, 1960, no. 30, ill. p. 127; Parmelin,
1963, ill.

Pablo Picasso PAGE 204
**Dora Maar Seated in a Wicker
 Chair**
Femme assise
Paris, April 29, 1938

PROVENANCE
The artist, to Mrs. Meric Callery, Boulogne-
sur-Seine, France, c. 1939; Harold Diamond,
New York, c. 1972–73; Jacques and Natasha
Gelman, 1981.

EXHIBITIONS
New York, 1939–40, cat. no. 352, ill.; New
York, 1945, cat. no. 22; Philadelphia, 1945,
p. 39; New York, 1980, ill.; Tübingen, 1986,
cat. no. 173, ill.

BIBLIOGRAPHY
Cahiers d'art, 1938, ill. p. 145; Bille, 1945, ill.
p. 58; Barr, 1946, ill. p. 220; Merli, 1948, no.
508, ill.; Zervos, 1958, vol. IX, pl. 132, ill.
p. 64; Daix, 1977, p. 286.

Pablo Picasso PAGE 206
Man with a Lollipop
Homme à la sucette
Mougins, July 23, 1938

PROVENANCE
The artist, to the Galerie Kate Perls, Paris,
1938; Lee Ault, New York, c. 1944; E. V.
Thaw & Co., Inc., New York, 1962; private
collection, Greenwich, Connecticut, c. 1963;
E. V. Thaw & Co., Inc., New York, c. 1976;
Jacques and Natasha Gelman, 1977.

EXHIBITIONS
New York, 1944, cat. no. 44 [as *Pêcheur*];
New York, 1962, cat. no. 37, ill.; New
Haven, 1971–72, no. 15, ill.; Tübingen,
1986, cat. no. 177, ill.

BIBLIOGRAPHY
Cahiers d'art, 1938, ill. p. 164; Zervos, 1958,
vol. IX, pl. 188, ill. p. 90; Daix, 1977, p. 290,
n. 19.

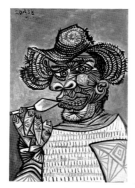

Pablo Picasso PAGE 209
Man with a Lollipop
Homme à la sucette
Mougins, August 20, 1938

PROVENANCE
The artist, to the Galerie Kate Perls, Paris, 1938; Walter P. Chrysler, Jr., New York, and Warrenton, Virginia, 1938–39; sale, New York, Parke-Bernet Galleries [now Sotheby's], February 16, 1950, no. 61; Edward Bragaline, New York, 1950; E. V. Thaw & Co., Inc., New York, c. 1983; private collection, United States, c. 1984; Acquavella Galleries, New York, c. 1985; Jacques and Natasha Gelman, 1985.

EXHIBITIONS
New York, 1939–40, cat. no. 355, ill.;

Richmond, 1941, cat. no. 187, ill.; New York, 1953, cat. no. 14; New York, 1957, ill.; Philadelphia, 1958, cat. no. 198, ill.; New York, "Picasso: An American Tribute," 1962, cat. no. 17, ill.; New York, 1963, cat. no. 26, ill.; New York, 1971, cat. no. 55, ill.

BIBLIOGRAPHY
Cahiers d'art, 1938, ill. p. 179; Frankfurter, 1939, ill. p. 20; Soby, 1939, p. 8, ill. p. 12; Cassou, 1940, ill. p. 140; Mackenzie, 1940, pl. 19, ill.; *Art News*, 1941, ill. p. 17; *Museum Bulletin*, 1941, p. 1; Barr, 1946, p. 219, ill. p. 218; LeClerc, 1947, ill. p. 41; Merli, 1948, no. 520, ill.; Elgar, 1956, pp. 174–75; Hunter, 1957, ill.; Zervos, 1958, vol. IX, pl. 203, ill. p. 98; Penrose, 1967, pl. 24, ill.; Glueck, 1971, p. 119, ill. p. 118; Lipton, 1976, pp. 226, 380, pl. 29, ill.; Daix, 1977, p. 290, n. 19; Jaffé, 1980, ill. p. 28.

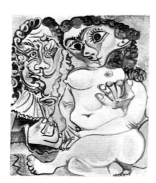

Pablo Picasso PAGE 278
The Cavalier and the Seated Nude
Homme et femme nue
February 22–28 and March 1, 1967

PROVENANCE
The artist, to Galerie Louise Leiris, Paris, 1968; Saidenberg Gallery, New York; private collection, United States; Thomas Ammann Fine Art, Zurich, c. 1988; Natasha Gelman, 1988.

EXHIBITIONS
New York, 1971, cat. no. 99, ill.; Menton, 1974, cat. no. 8, ill.; Montauban, 1975, cat. no. 15, ill.; Tokyo, 1977, cat. no. 77, ill.; Basel, 1981, cat. nos. 19, 23, ill.; Madrid, 1981, cat. no. 134, ill.; New York, 1984, cat. no. 28, fig. 41, ill.; Mexico City, 1984, cat. no. 13.

BIBLIOGRAPHY
Zervos, 1972, vol. XXV, pl. 292, ill. p. 129; Meyer et al., 1976, p. 172; Cohen, 1983, fig. 8, ill. p. 120.

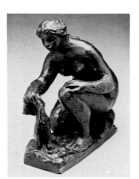

Pierre-Auguste Renoir
 PAGE 137
Washerwoman
La Petite Laveuse ou l'Eau
1916

PROVENANCE
Buchholz Gallery (Curt Valentin), New York; Jacques and Natasha Gelman, 1945.

BIBLIOGRAPHY
Meier-Graefe, 1929, pp. 395–96; Vollard, 1934, p. 1; Drucker, 1944, p. 111; Haesaerts, 1947, pp. 29–30, cat. no. 20; Cabanne, 1970, p. 173.

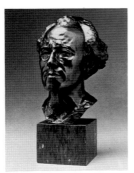

Auguste Rodin PAGE 126
Gustav Mahler
1909

PROVENANCE
Carl Moll, Vienna; Galerie St. Etienne, New York, before 1938; sale, Parke-Bernet Galleries [now Sotheby's], January 17, 18, 1945, no. 151; Richard Zinser; Jacques and Natasha Gelman, 1945.

EXHIBITIONS
New York, 1940, no. 8.

BIBLIOGRAPHY
Lami, 1921, p. 169; Watkins, 1929 [?], ill. no. 27; Jewell, 1940, p. 16; Elsen, 1963, p. 125; Tancock, 1969, ill. no. 91; Tancock, 1976, pp. 552–55, ill. p. 553; Grunfeld, 1987, pp. 534–37.

François Rouan PAGE 285
Season V
Saisonis V
1976–78

PROVENANCE
The artist, to the Pierre Matisse Gallery, New York; Jacques and Natasha Gelman, 1982.

EXHIBITIONS
Düsseldorf, 1979–80, cat. no. 11, ill.; New York, 1982, cat. no. 8, ill.; Paris, 1983–84, ill. p. 43.

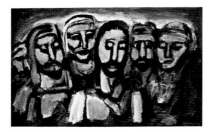

Georges Rouault PAGE 211
Christ and the Apostles
Christ et les docteurs [sic]
1937–38

PROVENANCE
The artist, to Ambroise Vollard, Paris; Mme de Galéa, France; Sam Salz, New York; Jacques and Natasha Gelman, 1952.

EXHIBITIONS
New York, and Cleveland, 1953, ill. p. 19 [as *Christ and the Apostles*].

BIBLIOGRAPHY
Maritain, 1954, plates 23, 24; Brillant, 1971, ill. p. 74; Dorival and Rouault, 1988, no. 1544, ill. p. 86 [as *Christ et les docteurs*].

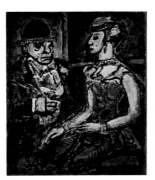

Georges Rouault PAGE 213
The Manager and a Circus Girl
Le Manager et fille de cirque aussi dit:
 La Loge
1941

PROVENANCE
Pierre Matisse Gallery, New York, c. 1947; Alexina Duchamp, New York; Jacques and Natasha Gelman, 1952.

EXHIBITIONS
New York, 1947, cat. no. 1, ill.

BIBLIOGRAPHY
Dorival and Rouault, 1988, no. 2222, ill. p. 210.

Sam Szafran PAGE 280
Interior I
Intérieur I
February 1972

PROVENANCE
The artist, to the Galerie Claude Bernard,
Paris, 1972; Jacques and Natasha Gelman,
1972.

EXHIBITIONS
Paris, Galerie Claude Bernard, 1972, cat. no.
10, ill.; Paris, Grand Palais, 1972, cat. no. 69.

Sam Szafran PAGE 280
Interior II
Intérieur II
May 1972

PROVENANCE
The artist, to the Galerie Claude Bernard,
Paris, 1972; Jacques and Natasha Gelman,
1972.

EXHIBITIONS
Paris, Galerie Claude Bernard, 1972, cat. no.
15, ill.

BIBLIOGRAPHY
Lord, 1972, ill. p. 44.

Yves Tanguy PAGE 231
The Satin Tuning Fork
Le Diapason de satin
1940

PROVENANCE
The artist, to the Pierre Matisse Gallery,
New York, 1940; Lee Ault, New York, 1941;
Pierre Matisse Gallery, New York, c. 1944;
Jacques and Natasha Gelman, 1958.

EXHIBITIONS
New York, 1942, cat. no. 1; Cincinnati,

1943; New York, 1944, cat. no. 55; New
York, 1946, cat. no. 9; Beverly Hills, 1948,
cat. no. 7; Hartford, 1954, cat. no. 14; New
York, 1974, cat. no. 21, ill.; Paris, 1982, cat.
no. 80, ill. p. 125; Baden-Baden, 1982–83,
cat. no. 77, ill. p. 199; New York, 1983, cat.
no. 80.

BIBLIOGRAPHY
Breton, 1946, ill. p. 26; Sage, 1963, no. 251,
ill. p. 117.

Yves Tanguy PAGE 233
My Life, White and Black
Ma Vie, blanche et noire
1944

PROVENANCE
The artist, to the Pierre Matisse Gallery,
New York, 1944; Jacques and Natasha
Gelman, 1958.

EXHIBITIONS
New York, 1944, cat. no. 26; New York,
1945, cat. no. 12; New York, 1946, cat. no.
18; San Francisco, 1947–48, p. 26, ill. p. 42;
Beverly Hills, 1948, cat. no. 15; New York,
1955, ill. p. 49; New York, 1968, cat. no.
319, ill. p. 104; New York, 1974, cat. no. 35,

ill.; Paris, 1982, cat. no. 97, ill. p. 39; Baden-
Baden, 1982–83, cat. no. 85, ill. p. 207;
New York, 1983, cat. no. 97, ill. p. 12.

BIBLIOGRAPHY
Bazin and Sterling, 1945, ill. p. 41; Breuning,
1945, p. 9; *Cahiers d'art*, 1945–46, ill. p. 387;
Breton, 1946, ill. p. 23; Fried, 1947, ill. p. 61;
The Tiger's Eye, 1948, ill. p. 104; Soby, 1949,
p. 7, ill. p. 6; Levy, 1954, ill. p. 25; Coates,
1955, p. 159; Waldberg, 1962, ill. p. 52; Sage,
1963, no. 328, ill. p. 151; Rubin, 1968, p.
374, ill. p. 387; Ashbery, 1974, ill. p. 73;
L'Œil, 1974, ill. p. 57; *Connaissance des arts*,
1982, ill. p. 14; Micha, 1982, ill. p. 47;
Preston, 1982, ill. p. 574; Catoir, 1983, ill. p.
45; Onslow-Ford, 1983, ill. p. 21.

Yves Tanguy PAGE 236
From Green to White
Du Vert au blanc
1954

PROVENANCE
Kay Sage Tanguy, Woodbury, Connecticut;
Pierre Matisse Gallery, New York, 1958;
Jacques and Natasha Gelman, 1958.

EXHIBITIONS
Hartford, 1954, cat. no. 31, ill.; New York,
1974, cat. no. 53, ill.; Paris, 1982, cat. no.
117, ill. p. 155; Baden-Baden, 1982–83,
cat. no. 101, ill. p. 223; New York, 1983, cat.
no. 117.

BIBLIOGRAPHY
Jean, 1955, p. 378; Sage, 1963, no. 461, ill. p.
190; Onslow-Ford, 1983, p. 23.

Maurice de Vlaminck PAGE 75
The Seine at Chatou
La Seine à Chatou
1906

PROVENANCE
The artist, to Ambroise Vollard, Paris, c.
1906; heirs of Ambroise Vollard, Paris, c.
1939; Wildenstein & Co., London; the earl
of Jersey, London, c. 1946; Artemis,

Brussels, 1978; Jacques and Natasha
Gelman, 1978.

EXHIBITIONS
Paris, Galerie Bernheim-Jeune, 1918;
London, 1978, cat. no. 9, cover ill. and
unpaginated ill.

BIBLIOGRAPHY
Fels, 1928, p. 36, ill.; *Artemis 1977–78*, 1978,
no. 7, ill. p. 41.

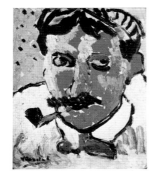

Maurice de Vlaminck PAGE 78
André Derain
1906

PROVENANCE
The artist, to André Derain, Paris, c. 1906;
sale, Paris, Galerie Charpentier, *Collection
André Derain*, March 22, 1955, no. 21;
private collection, France, c. 1955; Sam Salz,
New York; Jacques and Natasha Gelman,
1959.

EXHIBITIONS
New York, 1963, cat. no. 60, ill.; New
York, 1968, cat. no. 118, cover ill.; New
York, San Francisco, and Fort Worth, 1976,
ills. on cover and p. 48.

BIBLIOGRAPHY
Duthuit, 1949, p. 63, ill.; Fels, 1950, p. 176,
ill.; Loucheim, 1952, ill. p. 28; Dorival,
1953, ill. p. 119; Stabile, 1954, ill. p. 3;
Derain, 1955, cover ill.; Vlaminck, 1955, ill.
p. 473; Sauvage, 1956, ill. no. 46; Cailler,
1959, p. 4; Leymarie, 1959, p. 74, ill. p. 51;
Sauvage, 1959, no. 9, ill.; Selz, 1961 [?], ill.
p. 19; Leymarie, 1967, ill. p. 239; Muller,
1967, p. 4; Rosenstein, 1968, p. 53, ill. p. 52;
Russell, 1969, ill. p. 63; Lee, 1970, p. 53, ill.
p. 52; Daval, 1973, ill. p. 185; Elderfield,
1976, ills. on cover and p. 48; Leymarie,
1987, ill. p. 37.

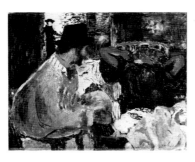

Édouard Vuillard PAGE 64
Conversation
La Conversation
about 1897–98

PROVENANCE
Jacques Roussel, Paris, 1940; Galerie Renou
et Colle, Paris; Sam Salz, New York;
Jacques and Natasha Gelman, 1951.

EXHIBITIONS
New York and Cleveland, 1954, ill.

BIBLIOGRAPHY
Roger-Marx, 1946, p. 61; Ritchie, 1954, ill.
p. 40; Cooper, 1963, p. 255, ill. p. 252
[another version, in the collection of Jean
Davray].

List of Exhibitions

Francis Bacon

LONDON. 1985. Tate Gallery. "Francis Bacon." May 22–August 18, 1985. Exhibition catalogue: compiled by Richard Francis; foreword by Alan Bowness; essays by Dawn Ades, Andrew Durham, and Andrew Forge. Also shown in Stuttgart, Staatsgalerie, October 10, 1985–January 5, 1986, and Berlin, Nationalgalerie, February 7–March 31, 1986.

NEW YORK. 1980. Marlborough Gallery. "Francis Bacon: Recent Paintings." April 26–June 7, 1980. Exhibition catalogue.

Balthus (Balthasar Klossowski)

CAMBRIDGE, MASSACHUSETTS. 1964. The New Hayden Gallery, Massachusetts Institute of Technology. February 10–March 2, 1964. Exhibition catalogue.

LONDON. 1968. Tate Gallery. "Balthus." October 4–November 11, 1968. Exhibition catalogue: by John Russell, for The Arts Council of Great Britain.

MARSEILLES. 1973. Musée Cantini. "Balthus." July–September 1973. Exhibition catalogue: forewords by Jean Leymarie and Albert Camus (the Camus text was originally published as the introduction to the catalogue of the Balthus exhibition at the Pierre Matisse Gallery, New York, 1949).

NEW YORK. 1942. Pierre Matisse Gallery. "Figure Pieces in Modern Painting." January 20–February 14, 1942. Exhibition catalogue.

NEW YORK. 1949. Pierre Matisse Gallery. "Balthus." March 8–April 1, 1949. Exhibition catalogue: introduction by Albert Camus.

NEW YORK. 1956–57. The Museum of Modern Art. "Balthus." December 9, 1956–February 3, 1957. Exhibition catalogue: by James Thrall Soby.

NEW YORK. 1977. Pierre Matisse Gallery. "Balthus: Paintings and Drawings 1934 to 1977." November 15–December 15, 1977. Exhibition catalogue: introduction by Federico Fellini.

PARIS. 1966. Musée des Arts Décoratifs. "Balthus." May 12–June 27, 1966. Exhibition catalogue: introduction by Gaëtan Picon. Also shown in Knokke-le-Zoute, Casino Communal, July–September 1966.

PARIS. 1983–84. Centre Georges Pompidou, Musée National d'Art Moderne. "Balthus." November 5, 1983–January 23, 1984. Exhibition catalogue: preface by Dominique Bozo; illustrations by Balthus from *Mitsou* and *Wuthering Heights*; essays by Octavio Paz, Jean Clair, Marc Le Bot, and Sylvia Colle-Lorant; statements by Boris Kochno, Jean Starobinski, Raymond Mason; reprints of texts by Antonin Artaud, Piero Bigongiari, Pierre Jean Jouve, John Russell, Jean Starobinski, René Char, Pierre Loeb, Paul Éluard, Albert Camus, Cyril Connolly, Pierre Klossowski, Yves Bonnefoy, Jean Cassou, Gaëtan Picon, Jean Clair, Florian Rodari, and Federico Fellini. Also shown in New York, The Metropolitan Museum of Art, February 29–May 13, 1984. Exhibition catalogue: by Sabine Rewald.

TURIN. 1961. Galleria Civica d'Arte Moderna. "7ième Biennale—Peintres d'aujourd'hui: France–Italie." September–November 1961. Exhibition catalogue: introduction by Jacques Lassaigne; reprint of essay by Albert Camus (written for the catalogue of the Balthus exhibition at the Pierre Matisse Gallery, New York, 1949).

Pierre Bonnard

LONDON. 1935. Alex Reid & Lefèvre Ltd. "Pierre Bonnard." May 1935.

NEW YORK. 1948. The Museum of Modern Art. "Pierre Bonnard." May 10–September 6, 1948. Exhibition catalogue: introduction by Charles Terrasse; essay by John Rewald. Shown first at The Cleveland Museum of Art, March 3–April 11, 1948.

NEW YORK. 1964. The Museum of Modern Art. "Bonnard and his Environment." October 7–November 29, 1964. Exhibition catalogue: preface and acknowledgments by James Elliott and

Monroe Wheeler; introduction by James Thrall Soby; essays by Monroe Wheeler and James Elliott. Also shown at The Art Institute of Chicago, January 8–February 28, 1965, and the Los Angeles County Museum of Art, March 30–May 30, 1965.

PARIS. 1902. Galerie Bernheim-Jeune. "Exposition d'oeuvres nouvelles par Bonnard, Maurice Denis, Maillol, K.-X. Roussel, Vallotton et Vuillard." May 15–25, 1902. Checklist.

PARIS. 1910. Galerie Bernheim-Jeune. "Exposition Bonnard." March 7–26, 1910. Checklist.

PARIS. 1926. Galerie Bernheim-Jeune. "Bonnard: oeuvres récentes." November 24–December 17, 1926. Checklist.

STOCKHOLM. 1939. Svensk-Franska Konstgalleriet. "Pierre Bonnard." March 1939. Checklist.

Georges Braque

BASEL. 1933. Kunsthalle. "Georges Braque." April 9–May 14, 1933. Exhibition catalogue: essay by Carl Einstein.

BERN. 1953. Kunsthalle. "Georges Braque." April 24–May 31, 1953. Exhibition catalogue: essay by Arnold Rüdlinger.

CHICAGO. 1972. The Art Institute of Chicago. "Braque: The Great Years." October 7–December 3, 1972. Exhibition catalogue: by Douglas Cooper.

EDINBURGH. 1956. Sponsored by the Edinburgh Festival Society and arranged by The Arts Council of Great Britain and The Royal Scottish Academy. The Royal Scottish Academy. "An Exhibition of Paintings: G. Braque." August 18–September 15, 1956. Exhibition catalogue: foreword by Robert Ponsonby; essay by Douglas Cooper. Also shown in London, Tate Gallery, September 28–November 11, 1956.

FRANKFURT-AM-MAIN. 1927. Kunstverein. Exhibition of the collection of Dr. G. F. Reber. February 1927.

LONDON. 1983. Tate Gallery. "The Essential Cubism: Braque, Picasso & Their Friends: 1907–1920." April 27–July 10, 1983. Exhibition catalogue: by Douglas Cooper and Gary Tinterow; foreword by Alan Bowness.

MUNICH. 1963. Haus der Kunst. "Georges Braque." October 18–December 15, 1963. Exhibition catalogue: foreword by Douglas Cooper.

NEW YORK. 1953[?]. Theodore Schempp & Co. "Braque: The First Exhibition in a Decade of Important Recent Paintings by Georges Braque." February 20–March 14, 1953[?]. Checklist.

NEW YORK. 1964. Saidenberg Gallery, Perls Galleries, Paul Rosenberg and Co., and M. Knoedler & Co., Inc. "Georges Braque, 1882–1963: An American Tribute." April 7–May 2, 1964. Exhibition catalogue: by John Richardson.

NEW YORK. 1988. The Solomon R. Guggenheim Museum. "Georges Braque." June–September 1988. Exhibition catalogue: compiled by Jean Leymarie; preface by Thomas M. Messer; with essay and entries by Jean Leymarie (translated by Jean-Marie Clarke), and essays by Carla Schulz-Hoffmann and Magdalena M. Moeller (translated by Joel Agee).

PARIS. 1952. Musée des Arts Décoratifs. "Cinquante ans de peinture française dans les collections particulières: de Cézanne à Matisse." March–April 1952. Checklist.

PARIS. 1952. Galerie Maeght. "Georges Braque." June–July 1952. Exhibition catalogue: published as Derrière le Miroir, nos. 48–49 (June–July 1952), with statements by Alberto Giacometti and Jean Grenier.

PARIS. 1961. Musée du Louvre. "L'Atelier de Braque." November 1961. Exhibition catalogue: preface by Jean Cassou; edited by Gabrielle Vienne.

PARIS. 1973–74. Orangerie des Tuileries. "Georges Braque." October 16, 1973–January 14, 1974. Exhibition catalogue: essay by Jean Leymarie.

SAINT-PAUL-DE-VENCE. 1980. Fondation Maeght. "Georges Braque." July 5–September 30, 1980. Exhibition catalogue: introduction by Jean-Louis Prat; essays by Jean Paulhan, Claude Esteban, Francis Ponge, and Nicolas Calas.

TOKYO. 1952. Organized by the magazine Yomiuri and the National Museum of Tokyo. "Georges Braque." September–October 1952. Exhibition catalogue: preface by Nagatake Asano and Shoji Yasuda.

WASHINGTON. 1967. National Gallery of Art. "100 European Paintings and Drawings from the Collection of Mr. and Mrs. Leigh B. Block." May 4–June 11, 1967. Exhibition catalogue: foreword by John Walker and Ken Donahue; introduction by John Rewald. Also shown at the Los Angeles County Museum of Art, September 21–November 2, 1967.

WASHINGTON. 1982. The Phillips Collection. "Georges Braque: The Late Paintings 1940–1963." October 9–December 12, 1982. Exhibition catalogue: by Hershel B. Chipp; foreword by Laughlin Phillips; introduction by Robert C. Cafritz. Also shown in San Francisco, California Palace of the Legion of Honor, January 1–March 15, 1983; Minneapolis, Walker Art Center, April 14–June 14, 1983; Houston, The Museum of Fine Arts, July 7–September 14, 1983.

Victor Brauner

CHICAGO. 1958. The Arts Club of Chicago. "Surrealism, Then and Now." October 1–30, 1958. Exhibition catalogue: introduction by Joseph Randall Shapiro.

NEW YORK. 1968. The Museum of Modern Art. "Dada, Surrealism and Their Heritage." March 27–June 9, 1968. Exhibition catalogue: by William S. Rubin. Also shown at the Los Angeles County

Museum of Art, July 16–September 8, 1968, and The Art Institute of Chicago, October 19–December 8, 1968.

NEW YORK. 1975. Organized by the International Council of The Museum of Modern Art. The Museum of Modern Art. "Modern Masters: Manet to Matisse." August 4–September 1, 1975. Exhibition catalogue: compiled and with a preface by William S. Lieberman; foreword by Richard E. Oldenburg and August Heckscher; texts by Susana Leval, Roland Penrose, Stuart Preston, Bernice Rose, John Russell, Virginia Spate; and with reprinted commentaries by other authors. Also shown in Sydney, Art Gallery of New South Wales, April 10–May 11, 1975, and Melbourne, National Gallery of Victoria, May 28–June 22, 1975.

PARIS. 1954. Galerie des "Cahiers d'Art." Spring 1954. "Exposition d'oeuvres récentes de Victor Brauner."

VENICE. 1954. "La XXVII Biennale di Venezia." June 19–October 17, 1954. Exhibition catalogue: preface by Angelo Spanlo; introductions by Rodolfo Pallucchini and Elio Zorzi.

Marc Chagall

BASEL. 1984–85. Galerie Beyeler. "Marc Chagall." November 1984–February 1985. Exhibition catalogue: poem by Blaise Cendrars; excerpts from Chagall's *Ma Vie* and text by the artist (originally published in Robert B. Heywood, ed., *The Work of the Mind*, Chicago, 1946).

HAMBURG. 1959. Organized under the auspices of UNESCO. Kunstverein. "Marc Chagall." February 6–March 22, 1959. Exhibition catalogue: foreword by Alfred Hentzen; biography and bibliography by François Mathey. Shown in expanded form in Munich, Haus der Kunst, April 7–May 31, 1959; in reduced form in Paris, Musée des Arts Décoratifs, June–October 1959.

NEW YORK. 1956. Perls Galleries. "Marc Chagall." March 12–April 14, 1956. Exhibition catalogue.

PARIS. 1959. Musée des Arts Décoratifs. "Marc Chagall." June–October 1988. Exhibition catalogue: introduction by Jacques Guerin; text by Marc Chagall; biography and bibliography by François Mathey.

Giorgio de Chirico

BRUSSELS. 1928. Galerie du Centaure. "Giorgio de Chirico." March 8–20, 1928. Checklist.

CAMBRIDGE, ENGLAND. 1954. The Arts Council of Great Britain. The Arts Council Gallery. "Cubist and Surrealist Paintings 1903–1938, from the Collection of Mr. and Mrs. Roland Penrose." July 7–20, 1954. Exhibition brochure: foreword by Roland Penrose. Also shown in Wisbech, England, Peckover House, July 24–31, 1954.

CLEVELAND. 1979. The Cleveland Museum of Art. "The Spirit of Surrealism." October 3–November

25, 1979. Exhibition catalogue: foreword by Sherman E. Lee; introduction and essay by Edward B. Henning.

LONDON. 1936. New Burlington Galleries. "The International Surrealist Exhibition." June 11–July 4, 1936. Exhibition catalogue: preface by André Breton and Herbert Read.

LONDON. 1937. Zwemmer Gallery. "De Chirico—Picasso." June 1937. Checklist.

LONDON. 1938. London Gallery Ltd. "Giorgio de Chirico." October 14–November 12, 1938. Checklist (published in *London Bulletin* no. 6 [October 1938], p. 13).

LONDON. 1978. The Arts Council of Great Britain and The Hayward Gallery. The Hayward Gallery. "Dada and Surrealism Reviewed." January 11–March 27, 1978. Exhibition catalogue: compiled by Dawn Ades; introduction by David Sylvester; essays by Dawn Ades and Elizabeth Cowling.

LONDON. 1989. Royal Academy of Arts. "Italian Art in the 20th Century." January 14–April 9, 1989. Exhibition catalogue: edited by Emily Braun; essays by Alberto Asor Rosa, Paolo Baldacci, Carlo Bertelli, Emily Braun, Giuliano Briganti, Maurizio Calvesi, Philip V. Cannistraro, Luciano Caramel, Germano Celant, Ester Coen, Enrico Crispolti, Anna Maria Damigella, Mario De Michel, Jole De Sanna, Joan M. Lukash, Adrian Lyttelton, Norman Rosenthal, Wieland Schmied, Caroline Tisdall, Pia Vivarelli, and Stuart Woolf; translated by David Britt, John Mitchell, Meg Shore, and Sharon Wasserman.

NEW YORK. 1968. The Museum of Modern Art. "Dada, Surrealism and Their Heritage." March 27–June 9, 1968. Exhibition catalogue: by William S. Rubin. Also shown at the Los Angeles County Museum of Art, July 16–September 8, 1968, and The Art Institute of Chicago, October 19–December 8, 1968.

NEW YORK. 1982. The Museum of Modern Art. "De Chirico." March 20–June 29, 1982. Exhibition catalogue: compiled by William Rubin; foreword by Maurizio Fagiolo dell'Arco; essays by Joan M. Lukash, Marianne W. Martin, Laura Rosenstock, William Rubin, and Wieland Schmied.

PARIS. 1928. Galerie Surréaliste. "Giorgio de Chirico." February 15–March 1, 1928. Exhibition catalogue: introduction by Louis Aragon (reprinted in *Giorgio de Chirico der Metaphysiker* [exhib. cat.], compiled by William Rubin, Wieland Schmied, and Jean Clair; translated by Doris and Helga Contzen. Munich, Haus der Kunst, 1982, pp. 263–64).

PARIS. 1938. Galerie des Beaux-Arts. "Exposition internationale du surréalisme." January–February 1938. Checklist.

ROME. 1981–82. Galleria d'Arte Moderna. "Giorgio de Chirico 1888–1978." November 11, 1981–January 3, 1982. Exhibition catalogue: introduction by Giorgio de Marchis; essays by Anna Maria del Monte and Nicolas Cardano.

VENICE. 1987. Palazzo Grassi. "Effetto Arcimboldo." February 14–May 31, 1987. Exhibition catalogue: introduction by Yasha David; essays by Pontus Hulten, R. J. W. Evans, Alfonso E. Pérez Sánchez, Sven Alfons, Thomas DaCosta Kaufmann, Maurice Rheims, Eliška Fučiková, Aomi Okabe, Jean Clair, Paolo Fabbri, Massimo Cacciari, Salvador Dali, Vittorio Sgarbi, René Thom, Ilya Prigogine, Tonino Tornitore, and František Makeš; translated by Maria Grazia Andreotti Saibene, Giulia Calligaris, Doretta Chioatto, and Sergio Corduas.

Salvador Dali

CHICAGO. 1958. Richard L. Feigen & Co. "Homage to Julien Levy." Exhibition catalogue: introduction by Richard L. Feigen.

CLEVELAND. 1979. The Cleveland Museum of Art. "The Spirit of Surrealism." October 3–November 25, 1979. Exhibition catalogue: compiled and with an essay by Edward B. Henning; foreword by Sherman E. Lee.

HARTFORD. 1938. Wadsworth Atheneum. "The Painters of Still Life." January 25–February 15, 1938. Exhibition catalogue: foreword by jrs.[sic]

LOS ANGELES. 1964. Dickson Art Center, University of California. "From the Ludington Collection." March 16–April 12, 1964. Exhibition catalogue: by Henri Dorra.

NEW YORK. 1941–42. The Museum of Modern Art. "Salvador Dali." November 19, 1941–January 11, 1942. Exhibition catalogue: foreword by Monroe Wheeler; essay by James Thrall Soby. Also shown in Indianapolis, The John Herron Museum, April 5–May 3, 1942, and in San Francisco, California Palace of the Legion of Honor, May 16–June 14, 1942.

NEW YORK. 1965–66. Gallery of Modern Art. "Salvador Dali 1910–1965: an exhibition in the Gallery of Modern Art including the Huntington Hartford Collection with the Reynolds Morse Collection." December 18, 1965–February 28, 1966. Exhibition catalogue: foreword by Theodore Rousseau; introduction by Carl J. Weinhardt, Jr.; essays by Francisco Javier Sánchez Cantón and Salvador Dali.

NEW YORK. 1968. The Museum of Modern Art. "Dada, Surrealism and Their Heritage." March 27–June 9, 1968. Exhibition catalogue: by William S. Rubin. Also shown at the Los Angeles County Museum of Art, July 16–September 8, 1968, and The Art Institute of Chicago, October 19–December 8, 1968.

NEW YORK. 1969. Sidney Janis Gallery. "Exhibition of Selected Works by XXth Century Artists." January 8–February 1, 1969. Checklist.

PARIS. 1929. Galerie Goemans. "Dali." November 20–December 5, 1929. Exhibition catalogue: introduction by André Breton.

PARIS. 1931. Galerie Pierre Colle. "Dali." June 3–15, 1931.

PARIS. 1979–80. Centre Georges Pompidou, Musée National d'Art Moderne. "Salvador Dali rétrospective 1920–1980." December 18, 1979–April 14, 1980. Exhibition catalogue: compiled by Daniel Abadie; introduction by Pontus Hulten; texts by Julien Green, Daniel Abadie, Antonina Rodrigo, José Pierre, Federico García Lorca, André Breton, Gilbert Lascault, Patrice Schmitt, James Bigwood, Robert Descharnes, Anne Bernard; with reprinted essays by other authors; translated by Anny Amberni, Catherine de Leobardy, Sophie Mayoux, Solange Schnall, Roser Segura, Didier Pemerle, Édmond Raillard, Marie Laffranque, Paul Éluard, and Louis Parrot.

ROTTERDAM. 1970–71. Museum Boymans-van Beuningen. "Exposition Dali." November 21, 1970–January 10, 1971. Exhibition catalogue: introduction by R. Hammacher-van den Brande and J. C. Ebbinge Wubben; essays by Patrick Waldberg, Robert Descharnes, and Gerrit Komrij.

TENERIFE, CANARY ISLANDS. 1935. "Exposición Surrealista." May 11–21, 1935. Exhibition catalogue: preface by André Breton.

Edgar Degas

NEW YORK. 1945. Buchholz Gallery (Curt Valentin). "Edgar Degas: Bronzes, Drawings, Pastels." January 3–27, 1945. Exhibition catalogue.

André Derain

LONDON. 1978. The Lefevre Gallery. "Les Fauves." November 16–December 21, 1978. Exhibition catalogue: foreword by Denys Sutton.

NEW YORK. 1958. Sidney Janis Gallery. "Ten Years of Janis: 10th Anniversary Exhibition." September 29–November 1, 1958. Exhibition catalogue.

NEW YORK. 1963. Leonard Hutton Galleries. "Exhibition: Der Blaue Reiter." February 19–March 30, 1963. Exhibition catalogue: foreword by Will Grohmann; introduction by Leonard Hutton Hutschnecker; essay by Peter Selz; translated by Ilse Falk.

NEW YORK. 1976. The Museum of Modern Art. "The 'Wild Beasts': Fauvism and Its Affinities." March 26–June 1, 1976. Exhibition catalogue: by John Elderfield. Also shown at the San Francisco Museum of Modern Art, June 29–August 15, 1976, and in Fort Worth, Kimbell Art Museum, September 11–October 31, 1976.

Jean Dubuffet

AMSTERDAM. 1966. Stedelijk Museum. "Jean Dubuffet." June 10–August 28, 1966. Exhibition catalogue: with statements by Jean Dubuffet; translated by Miep Veenis-Pieters.

LONDON. 1966. The Arts Council of Great Britain, and Tate Gallery. "Jean Dubuffet, Paintings." April 23–May 30, 1966. Exhibition catalogue: preface by Gabriel White; text by Alan Bowness.

MILWAUKEE. 1956. Milwaukee Art Institute. "The Collection of Mr. and Mrs. Charles Zadok." December 1956. Exhibition catalogue: introduction by Gordon Bailey Washburn.

NEW YORK. 1948. Pierre Matisse Gallery. "Jean Dubuffet: Paintings, Gouaches, 1946–48." November 20–December 31, 1948. Illustrated checklist.

NEW YORK. 1955. The Museum of Modern Art. "The New Decade: 22 European Painters and Sculptors." May 10–August 7, 1955. Exhibition catalogue: text by Andrew Carnduff Ritchie; statements by each of the artists included. Also shown at the Minneapolis Institute of Art, September 21–October 30, 1955; the Los Angeles County Museum of Art, November 21, 1955–January 7, 1956; and the San Francisco Museum of Modern Art, February 2–March 15, 1956.

NEW YORK. 1959. Pierre Matisse Gallery. "Jean Dubuffet: Retrospective Exhibition 1943–1959." November 10–December 12, 1959. Exhibition catalogue (in French and English): essay by Georges Limbour; English translation by Ilse Falk.

NEW YORK. 1962. The Museum of Modern Art. "The Work of Jean Dubuffet." February 21–April 8, 1962. Exhibition catalogue: essay by Peter Selz; two essays by Jean Dubuffet, "Landscaped Tables, Landscapes of the Mind, Stones of Philosophy" (originally written for an exhibition at the Pierre Matisse Gallery, New York, 1952; translated by the artist with Marcel Duchamp), and "Memoir on the Development of My Work from 1952," translated by Louise Varèse. Also shown at The Art Institute of Chicago, May 11–June 17, 1962, and the Los Angeles County Museum of Art, July 10–August 12, 1962.

NEW YORK. 1969–70. Richard L. Feigen & Co. "Dubuffet and the Anti-Culture." November 25, 1969–January 3, 1970. Exhibition catalogue: introduction by Richard L. Feigen; contributions by George Cohen and Claes Oldenburg; and facsimile reprint of Dubuffet's lecture "Anticultural Positions" (first delivered at The Chicago Arts Club, October 20, 1951).

NEW YORK. 1973. The Solomon R. Guggenheim Museum. "Jean Dubuffet: A Retrospective." April 27–July 29, 1973. Exhibition catalogue: by Margit Rowell; introduction by Thomas M. Messer.

NEW YORK. 1987. M. Wildenstein & Co. "Jean Dubuffet: A Retrospective." April 22–May 29, 1987. Checklist.

PARIS. 1944. Galerie René Drouin. "Exposition de tableaux et dessins de Jean Dubuffet." October 20–November 18, 1944. Brochure: introduction, "Lettre à Jean Dubuffet," by Jean Paulhan.

PARIS. 1947. Galerie René Drouin. "Les gens sont bien plus beaux qu'ils croient vive leur vraie figure: Portraits à ressemblance extraite, à ressemblance cuite et confite dans la mémoire, à ressemblance éclatée dans la mémoire de Mr Jean Dubuffet peintre." October 7–31, 1947. Illustrated checklist.

PARIS. 1973. Galeries Nationales d'Exposition du Grand Palais. "Jean Dubuffet." September 20–December 20, 1973. Exhibition catalogue: prefaces by Blaise Gautier and Germaine Viatte; introductions by Thomas M. Messer and Blaise Gautier; extracts from Jean Dubuffet's *Prospectus et tous écrits suivants* (originally published in 2 vols., Paris, 1967).

SAINT-PAUL-DE-VENCE. 1985. Fondation Maeght. "Jean Dubuffet rétrospective: peintures, sculptures, dessins." July 6–October 6, 1985. Exhibition catalogue: introduction by Jean-Louis Prat; essay by Hubert Damisch.

Max Ernst

DARMSTADT. 1975. Kunsthalle. "Realismus und Realität." May 24–July 6, 1975. Exhibition catalogue: introduction by H. W. Sabais; text by Bernd Krimmel.

LONDON. 1952–53. Institute of Contemporary Arts. "Max Ernst." December 10, 1952–January 24, 1953. Checklist.

LONDON. 1967. Redfern Gallery. "47th Summer Exhibition." Summer 1967. Checklist.

LONDON. 1968. Redfern Gallery. "Summer Exhibition 1968." June–September 1968. Checklist.

Alberto Giacometti

CHICAGO. 1974–75. The Art Institute of Chicago. "The Milton D. Ratner Family Collection." November 24, 1974–January 12, 1975. Exhibition catalogue: introduction by Leigh B. Block and Harold Joachim; essay by Milton D. Ratner. Exhibition traveled throughout the United States during 1975.

MEXICO CITY. 1987. Centro Cultural Arte Contemporáneo A.C., Fundación Cultural Televisa A.S. "Giacometti Familia: Giovanni 1868–1933, Augusto 1877–1947, Alberto 1901–1966, Diego 1902–1985." April–June 1987. Exhibition catalogue: compiled and with a preface by Pierre Schneider; foreword by Robert R. Littman; essays by Reinhold Hohl, Daniel Marchesseau, and Beat Stutzer; translated by Leticia Leduc and Elsa Cecilia Frost.

NEW YORK. 1950. Pierre Matisse Gallery. "Alberto Giacometti." November 1950. Exhibition catalogue: with excerpts from a letter by Alberto Giacometti to Pierre Matisse.

NEW YORK. 1955. The Solomon R. Guggenheim Museum. "Alberto Giacometti." June 7–July 17, 1955. Checklist.

NEW YORK. 1965. The Museum of Modern Art. "Alberto Giacometti, Sculpture, Paintings, Drawings, 1913–1965." June 9–October 10, 1965. Exhibition catalogue: by Peter Selz; chronology by Irene Gordon; and reprint of a letter of 1947 from Alberto Giacometti to Pierre Matisse (originally published in the catalogue to the Giacometti exhibition at the Pierre Matisse Gallery, New York, 1948). Also shown at The Art Institute of Chicago, November 5–December 12, 1965; the Los Angeles County Museum of Art, January 11–February 20, 1966; and the San Francisco Museum of Modern Art, March 10–April 24, 1966.

NEW YORK. 1974. The Solomon R. Guggenheim Museum. "Alberto Giacometti: A Retrospective Exhibition." April 5–June 23, 1974. Exhibition catalogue: by Reinhold Hohl; preface by Thomas M. Messer. Shown in reduced form in Minneapolis, Walker Art Center, July 13–September 1, 1974; The Cleveland Museum of Art, September 24–October 27, 1974; Ottawa, The National Gallery of Canada, November 15, 1974–January 5, 1975; the Des Moines Art Center, January 27–March 2, 1975; and in Montreal, Musée d'Art Contemporain, March 27–May 4, 1975.

NEW YORK. 1976. Sidney Janis Gallery. "Alberto Giacometti." January 8–31, 1976. Exhibition catalogue: by James Lord.

PARIS. 1961. Galerie Maeght. "Alberto Giacometti." May 1961. Exhibition catalogue: published as *Derrière le Miroir*, no. 127 (May 1961), with essays by Isaku Yanaihara, Lena Leclercq, and Olivier Larronde.

PARIS. 1969–70. Orangerie des Tuileries. "Alberto Giacometti." October 15, 1969–January 12, 1970. Exhibition catalogue: compiled and with an introduction by Jean Leymarie; excerpts from writings by André Breton, Jean Genêt, and Alberto Giacometti.

VENICE. 1962. "La XXXI Biennale di Venezia." June–October 1962. Exhibition catalogue: preface by Italo Siciliano; introduction by Gian Alberto dell'Acqua; essay by Palma Bucarelli on Alberto Giacometti.

WASHINGTON. 1963. The Phillips Collection. "Alberto Giacometti: A Loan Exhibition." February 2–March 4, 1963. Exhibition catalogue: introduction by Duncan Phillips; excerpts from Jean-Paul Sartre's essay on Giacometti, "The Search for the Absolute" (originally published as the introduction to the catalogue of the Giacometti exhibition at the Pierre Matisse Gallery, New York, 1948).

WASHINGTON. 1988. The Hirshhorn Museum and Sculpture Garden. "Alberto Giacometti 1901–1966." September 15–November 13, 1988. Exhibition catalogue: compiled by Valerie Fletcher; foreword by James T. Demetrion; essays by Silvio Berthoud and Reinhold Hohl. Also shown at the San Francisco Museum of Modern Art, December 15, 1988–February 5, 1989.

Juan Gris

BORDEAUX. 1973. Galerie des Beaux-Arts. "Les cubistes." May 4–September 1, 1973. Exhibition catalogue: preface by Gilberte Martin-Mery and Jacques Lassaigne; introduction by Jean Cassou; and 1961 interview with Georges Braque by Jean Lassaigne. Also shown at the Musée d'Art Moderne de la Ville de Paris, September 26–November 10, 1973.

CARACAS. 1966. Museo de Bellas Artes. "Obras cubistas y 'Collages', Colección Pedro Vallenilla Echeverría, Caracas." February 1966. Exhibition catalogue (no. 4 in a series on private collections in Caracas): introduction by Miguel G. Arroyo C.; entry on Gris's *The Smoker* by Juan Calzadilla.

CARACAS. 1968. Fundación Eugenio Mendoza, Sala de Exposiciones. "Pinturas cubistas y 'Collages'." August 1968.

CARACAS. 1970. Museo de Bellas Artes. "Obras cubistas y 'Collages' II. Colección Pedro Vallenilla Echeverría, Caracas." 1970. Exhibition catalogue (no. 6 in a series on private collections in Caracas): introduction by Miguel G. Arroyo C.; entry on Gris's *The Smoker* by Juan Calzadilla.

CARACAS. 1974. Museo de Arte Contemporáneo. "Espacio Soto/Colección de Obras Cubistas y 'Collages' Pedro Vallenilla Echeverría/Exposición Temporaria 'Veinte Contemporaneos'." February 1974. Exhibition catalogue: preface by Gustavo Rodriguez Amengual.

DORTMUND. 1965. Museum am Ostwall. "Juan Gris." October 23–December 4, 1965. Exhibition catalogue: foreword by John Richardson; introduction by Leonie Reygers; essay by Daniel-Henry Kahnweiler. Also shown in Cologne, Wallraf-Richartz-Museum, December 29, 1965–February 13, 1966.

MADRID. 1985. Salas Pablo Ruiz Picasso. "Juan Gris (1887–1927)." September 20–November 24, 1985. Exhibition catalogue: compiled and with an introduction by Gary Tinterow; essays by Marilyn McCully, Pierre Daix, Lewis Kachur, Kenneth Silver, Mark Rosenthal, Julián Gállego, René de Costa, Christopher Green, Ann Temkin, Francisco Calvo Serraller, Gerardo Diego, Juan Larrea, and Paul Éluard; chronology by Elise Goldstein; appendixes by Rosario Maseda and Anne M. P. Norton.

NEW YORK. 1950. Buchholz Gallery (Curt Valentin). "Juan Gris." January 16–February 11, 1950. Exhibition catalogue: with excerpts from a letter by Gris to Daniel-Henry Kahnweiler.

NEW YORK. 1956. Sidney Janis Gallery. "Cubism, 1910–1912." January 3–February 4, 1956. Exhibition catalogue.

NEW YORK. 1958. The Museum of Modern Art. "Juan Gris." April 9–June 1, 1958. Exhibition

catalogue: by James Thrall Soby. Also shown at the Minneapolis Institute of Art, June 24–July 24, 1958; the San Francisco Museum of Modern Art, August 11–September 14, 1958; and the Los Angeles County Museum of Art, September 29–October 26, 1958.

NEW YORK. 1960. The New Gallery, Inc. "Modern Master Drawings." October 1960. Exhibition catalogue.

PARIS. 1965. Galerie Louise Leiris. "Juan Gris: dessins et gouaches 1910–1927." June 17–July 17, 1965. Exhibition catalogue: introduction by Daniel-Henry Kahnweiler.

PARIS. 1974. Orangerie des Tuileries. "Juan Gris." March 14–July 1, 1974. Exhibition catalogue: preface by Jean Leymarie; with a reprint of the lecture by Gris "Des possibilités de la peinture" delivered at a conference on May 15, 1924, and his article "Chez les cubistes (l'enquête)" (originally published in the *Bulletin de la vie artistique* 6, no. 1 [January 1925], pp. 15–17).

ROME. 1973–74. Galleria Nazionale d'Arte Moderna. "Il Cubismo." December 6, 1973–January 13, 1974. Exhibition catalogue: preface by Palma Bucarelli; essay by Jacques Lassaigne.

WASHINGTON. 1983. Organized by the University Art Museum, University of California, Berkeley. National Gallery of Art. "Juan Gris." October 16–December 31, 1983. Exhibition catalogue: by Mark Rosenthal. Also shown in Berkeley, University Art Museum, University of California, February 1–April 8, 1984, and New York, The Solomon R. Guggenheim Museum, May 18–July 15, 1984.

WINTERTHUR. 1980. Kunstmuseum. "'Rot Konstruiert' und 'Super Table': Eine Schweizer Sammlung moderner Kunst, 1909–1939." March 2–April 13, 1980. Exhibition and catalogue: conceived by Margit Staber; coordinated and edited by Rudolf Koella: foreword by Carl Haenlein; interview with the collector by Rudolf Koella; essays and entry on Gris's *The Smoker* by Margit Staber. Also shown with different title, "Meisterwerke des XX. Jahrhunderts: De Chirico, Magritte. Mondrian, u.a., Eine Schweizer Samm-lung moderner Kunst," in Hanover, Kestner-Gesellschaft, April 25–June 15, 1980, and Ludwigs-hafen-am-Rhein, Wilhelm-Hack-Museum, June 29–August 17, 1980.

Wassily Kandinsky

NEW YORK. 1963. Leonard Hutton Galleries. "Der Blaue Reiter." February 19–March 30, 1963. Exhibition catalogue: foreword by Will Grohmann; essay by Peter Selz.

Paul Klee

BEVERLY HILLS. 1948. The Modern Institute of Art. "Klee: 30 Years of Paintings, Water Colors, Drawings and Lithographs by Paul Klee and in a Klee-Like Mood: 2,000 Years of Coptic, Persian, Chinese, European and Peruvian Textiles." September 3–October 6, 1948. Exhibition catalogue: with excerpt of a statement by the artist.

NEW YORK. 1940. Buchholz Gallery (Curt Valentin) and Willard Gallery. "Paul Klee." October 9–November 2, 1940. Exhibition catalogue: essays by James Johnson Sweeney and Julia and Lyonel Feininger.

NEW YORK. 1941. Traveling exhibition prepared by the Department of Circulating Exhibitions, The Museum of Modern Art, selected in part from the memorial exhibition held at the Buchholz Gallery and the Willard Gallery, New York, 1940. "Paul Klee." Exhibition catalogue: introduction by Alfred H. Barr, Jr.; essays by James Johnson Sweeney and Julia and Lyonel Feininger. Shown in Northampton, Massachusetts, Smith College Museum of Art, January 1–22, 1941; The Arts Club of Chicago, January 31–February 28, 1941; Oregon, Portland Art Museum, March 10–April 9, 1941; San Francisco Museum of Modern Art, April 14–May 5, 1941; Los Angeles, Stendahl Galleries, May 8–18, 1941; St. Louis, City Art Museum, May 24–June 21, 1941; New York, The Museum of Modern Art, June 30–July 27, 1941; Wellesley, Massachusetts, Wellesley College Museum, October 13–November 3, 1941.

NEW YORK. 1949. The Museum of Modern Art. "Modern Art in Your Life." October 5–December 4, 1949. Exhibition catalogue: by Robert Goldwater, in collaboration with René d'Harnoncourt.

Fernand Léger

CHICAGO. 1985. The Art Institute of Chicago. "The Mr. and Mrs. Joseph Randall Shapiro Collection." February 23–April 14, 1985. Exhibition catalogue: foreword by James N. Wood; introduction by Joseph Randall Shapiro; essays by Katherine Kuh and Dennis Adrian.

GENEVA. 1920. Galerie Moos. "La jeune peinture française, les cubistes." February 1920. Exhibition catalogue: essay by Léonce Rosenberg.

NEW YORK. 1945. Whitney Museum of American Art. "European Artists in America." March 13–April 11, 1945. Exhibition catalogue: foreword by Herman More.

NEW YORK. 1957. Sidney Janis Gallery. "Léger: Major Themes." January 2–February 2, 1957. Exhibition catalogue.

NEW YORK. 1957. World House Galleries. "The Struggle for New Form." January 22–February 23, 1957. Exhibition catalogue: foreword by Herbert Mayer; introduction by Frederick J. Kiesler and Armand P. Bartos.

NEW YORK. 1962. The Solomon R. Guggenheim Museum. "Fernand Léger: Five Themes and

Variations." February 28–April 29, 1962. Exhibition catalogue: by Thomas M. Messer.

NEW YORK. 1987. Acquavella Galleries, Inc. "Fernand Léger." October 23–December 12, 1987. Exhibition catalogue: essay by Jack Flam.

PARIS. 1975. Galerie Berggruen & Cie. "F. Léger: huiles, aquarelles & dessins." May 1975. Exhibition catalogue.

PARIS. 1980. Galerie Daniel Malingue. "Maîtres impressionnistes et modernes." June 12–July 19, 1980. Exhibition catalogue.

SAINT-PAUL-DE-VENCE. 1988. Fondation Maeght. "Fernand Léger rétrospective." July 2– October 2, 1988. Exhibition catalogue: essays by Adrien Maeght, Jean-Louis Prat, Werner Schmalenbach, Maurice Jardot, and Pierre Reverdy.

Henri Matisse

AMSTERDAM. 1960. Stedelijk Museum. "Henri Matisse: les grandes gouaches découpées/De Grote Uitgeknipte Gouaches." April 29–June 20, 1960. Exhibition catalogue: by Franz Meyer.

BALTIMORE. 1968. Baltimore Museum of Art. "From El Greco to Pollock: Early and Late Works by European and American Artists." October 22–December 8, 1968. Exhibition catalogue: edited by Gertrude Rosenthal; entry on Matisse by Frank A. Trapp.

BARCELONA. 1920. Galería Dalmau. "Exposició d'Art Frances d'Avantguarda, que es celebra à les Galeries Dalmau de Barcelona." October 26– November 14, 1920. Exhibition catalogue: preface by Maurice Raynal.

BASEL. 1931. Kunsthalle. "Henri Matisse." August 9–September 15, 1931. Exhibition catalogue: statements by the artist from 1908 and 1929; essay by Carl Egger.

BASEL. 1980. Galerie Beyeler. "Matisse." June– September 1980. Exhibition catalogue: with excerpts from writings by Matisse from "Henri Matisse: écrits et propos sur l'art," edited by Dominique Fourcade, Paris, 1972.

BERLIN. 1930. Moderne Galerie Thannhauser. "Henri Matisse." February 15–March 19, 1930. Exhibition catalogue: introduction by Hans Purrmann.

BERN. 1950. Kunsthalle. "Les Fauves: Braque, Derain, Dufy, Friesz, Manguin, Marinot, Marquet, Matisse, Valtat, van Dongen, Vlaminck; und die Zeitgenossen: Amiet, Giacometti, Jawlensky, Kandinsky, Kirchner, Pechstein, Schmidt-Rotluff." April 29–May 29, 1950. Exhibition catalogue: introduction and essay by Arnold Rüdlinger.

BERN. 1959. Kunsthalle. "Les grandes gouaches découpées, 1950–1954." July 25–September 20, 1959. Exhibition catalogue: by Franz Meyer.

BUFFALO. 1970. Albright-Knox Art Gallery. "Color and Field, 1890–1970." September 15–November 1, 1970. Exhibition catalogue: preface and intro-duction by Priscilla Colt. Also shown in Ohio, Dayton Art Institute, November 20, 1970– January 10, 1971, and The Cleveland Museum of Art, February 4–March 28, 1971.

CANNES. 1981. Galerie Herbage. "Henri Matisse: dessins, lithographies, sculptures, collages, 1906–1952." March 31–June 27, 1981. Exhibition catalogue: preface by Douglas Cooper.

CHICAGO. 1946. The Arts Club of Chicago. "Exhibition of Paintings and Drawings from the Josef von Sternberg Collection." November 1–27, 1946. Checklist.

COPENHAGEN. 1970. Statens Museum for Kunst. "Matisse, En retrospektiv udstilling." October 10–November 29, 1970. Exhibition catalogue: introduction by Hanne Finsen; essays by Denys Sutton and Pierre Soulages.

KNOKKE-LE-ZOUTE. 1952. Grande Salle des Expositions de "La Réserve." "Henri Matisse." July 12–August 31, 1952. Exhibition catalogue: preface by Georges Duthuit.

LONDON. 1912. Grafton Galleries. "Second Post-Impressionist Exhibition." October 5–December 31, 1912. Exhibition catalogue: introduction by Roger Fry; essays by Clive Bell and Roger Fry.

LONDON. 1968. Organized by The Arts Council of Great Britain. The Hayward Gallery. "Matisse 1869–1954: A Retrospective Exhibition." July 3– September 8, 1968. Exhibition catalogue: introduction by Lawrence Gowing.

LONDON. 1984–85. Organized by The Arts Council of Great Britain, with the collaboration of The Museum of Modern Art, New York. The Hayward Gallery. "The Drawings of Henri Matisse." October 4, 1984–January 6, 1985. Exhibition catalogue: by John Elderfield; introduction by John Golding; entries by Magdalena Dabrowski. Also shown in New York, The Museum of Modern Art, February 27–May 14, 1985.

LOS ANGELES. 1943. Los Angeles County Museum of History, Science, and Art. "The Collection of Josef von Sternberg." May 17–September 5, 1943. Exhibition catalogue: introduction by Josef von Sternberg.

LOS ANGELES. 1966. Organized by the UCLA Art Council and UCLA Art Galleries. UCLA Art Galleries. "Henri Matisse: Retrospective 1966." January 5–February 27, 1966. Exhibition catalogue: essays by Jean Leymarie, Herbert Read, and William S. Lieberman. Also shown at The Art Institute of Chicago, March 11–April 24, 1966, and the Boston Museum of Fine Arts, May 11–June 26, 1966.

LUCERNE. 1949. Musée des Beaux-Arts. "Henri Matisse." July 9–October 2, 1949. Exhibition catalogue: essays by Jean Cassou and H. L. Landolt.

MILAN. 1950. Palazzo Reale. "Mostra di Matisse." November 1–21, 1950. Exhibition catalogue: introduction by Raymond Cogniat.

NEW YORK. 1913. Organized by the Association of American Painters and Sculptors, Inc. The Armory

of the Sixty-Ninth Infantry. "International Exhibition of Modern Art." February 15–March 15, 1913. Exhibition catalogue: preface by Frederick James Gregg. Shown in reduced form at The Art Institute of Chicago, March 24–April 16, 1913, and in Boston, Copley Hall, April 28–May 19, 1913.

NEW YORK. 1915. Montross Gallery. "Henri Matisse Exhibition." January 20–February 27, 1915. Checklist.

NEW YORK. 1931. The Museum of Modern Art. "Henri Matisse: Retrospective Exhibition." November 3–December 6, 1931. Exhibition catalogue: by Alfred H. Barr, Jr.; with a statement dating from 1908 by the artist.

NEW YORK. 1950. Sidney Janis Gallery. "Les Fauves." November–December 1950. Exhibition catalogue.

NEW YORK. 1951–52. The Museum of Modern Art. "Henri Matisse." November 13, 1951–January 13, 1952. Exhibition catalogue: by Alfred H. Barr, Jr. Also shown at The Cleveland Museum of Art, February 5–March 16, 1952; The Art Institute of Chicago, April 1–May 4, 1952; the San Francisco Museum of Modern Art, May 22–July 6, 1952; and in reduced form at the Los Angeles Municipal Art Department, July 24–August 17, 1952.

NEW YORK. 1953. Curt Valentin Gallery. "The Sculpture of Henri Matisse." February 10–28, 1953. Exhibition catalogue: introduction by Alfred H. Barr, Jr.

NEW YORK. 1961. The Museum of Modern Art. "The Last Works of Henri Matisse, Large Cut-Out Gouaches." October 17–December 3, 1961. Exhibition catalogue: by Monroe Wheeler. Also shown at The Art Institute of Chicago, January 10–February 13, 1962, and the San Francisco Museum of Modern Art, March 12–April 22, 1962.

NEW YORK. 1966. The Museum of Modern Art. "Henri Matisse: 64 Paintings." July 18–September 25, 1966. Exhibition catalogue: by Lawrence Gowing.

NEW YORK. 1970–71. The Museum of Modern Art. "Four Americans in Paris: The Collections of Gertrude Stein and Her Family." December 19, 1970–March 1, 1971. Exhibition catalogue: foreword by John B. Hightower; introduction by Margaret Potter; essays by Irene Gordon, Lucile M. Golson, Leon Katz, Douglas Cooper, and Ellen Hirschland. Shown in altered form at the Baltimore Museum of Art, April 4–June 13, 1971; Ottawa, National Gallery of Canada, June 25–August 15, 1971; and at the San Francisco Museum of Modern Art, September 15–October 31, 1971.

NEW YORK. 1973. Acquavella Galleries, Inc. "Henri Matisse." November 2–December 1, 1973. Exhibition catalogue: essay by Clement Greenberg.

NEW YORK. 1975. The Museum of Modern Art. "Modern Masters: Manet to Matisse." August 4–September 1, 1975. Exhibition catalogue: edited by William S. Lieberman. Also shown in Sydney, Gallery of New South Wales, April 10–May 11, 1975, and Melbourne, National Gallery of Victoria, May 28–June 22, 1975.

NEW YORK. 1976. The Museum of Modern Art. "The 'Wild Beasts': Fauvism and Its Affinities." March 26–June 1, 1976. Exhibition catalogue: by John Elderfield. Also shown at the San Francisco Museum of Modern Art, June 29–August 15, 1976, and Fort Worth, Kimbell Art Museum, September 11–October 31, 1976.

PALM BEACH. 1953. Society of the Four Arts. "Matisse." February 6–March 1, 1953. Exhibition catalogue.

PARIS. 1908. Grand Palais des Champs-Élysées. Salon d'Automne. October 1–November 8, 1908. Checklist.

PARIS. 1910. Galerie Bernheim-Jeune & Cie. "Exposition Henri Matisse." February 14–22, 1910. Checklist.

PARIS. 1937. Organized by the Musée du Jeu de Paume, with the concurrence of a committee composed of Georges Braque, Jean Cassou, Mme Cuttoli, André Dézarrois, Paul Éluard, Henri Laugier, Fernand Léger, Louis Marcoussis, Henri Matisse, Pablo Picasso, Maurice Raynal, Georges-Henri Rivière, and Christian Zervos. Musée du Jeu de Paume. "Origines et développement de l'art international indépendant." July 30–October 31, 1937. Exhibition catalogue.

PARIS. 1949. Musée National d'Art Moderne. "Henri Matisse: oeuvres récentes 1947–48." June–September 1949. Exhibition catalogue: introduction by Jean Cassou.

PARIS. 1950. Maison de la Pensée Française. "Henri Matisse—chapelle, peinture, dessins, sculptures." July 5–September 24, 1950. Exhibition catalogue: introduction by Louis Aragon.

PARIS. 1955. Grand Palais des Champs-Élysées. Salon d'Automne. "Henri Matisse rétrospective." November 5–30, 1955. Exhibition catalogue: introduction by Pierre Dubreuil.

PARIS. 1956. Musée National d'Art Moderne. "Rétrospective Henri Matisse," July 28–November 18, 1956. Exhibition catalogue: essay by Jean Cassou.

PARIS. 1961. Musée des Arts Décoratifs. "Henri Matisse: les grandes gouaches découpées." March 22–May 25, 1961. Exhibition catalogue: essay by Jacques Lassaigne.

PARIS. 1970. Galeries Nationales d'Exposition du Grand Palais. "Henri Matisse, exposition du centenaire." April–September 1970. Exhibition catalogue: by Pierre Schneider.

PHILADELPHIA. 1948. Philadelphia Museum of Art. "Henri Matisse: Retrospective Exhibition of Paintings, Drawings, and Sculpture." April 3–May 9, 1948. Exhibition catalogue: preface by Henry Clifford; essay by Louis Aragon.

PITTSBURGH. 1931. Department of Fine Arts, Carnegie Institute. "Thirtieth Annual International

Exhibition of Paintings." October 15–December 6, 1931. Exhibition catalogue.

PROVIDENCE. 1931. Rhode Island School of Design. "Henri Matisse." December 14–28, 1931. Exhibition catalogue: introduction by L[incoln]. K[irstein].

SAN DIEGO. 1973. University of California, San Diego, Art Gallery. "The UCSD Collection." April 24–May 16, 1973. Exhibition brochure: introduction by W. D. Elroy and David Antin.

VENICE. 1950. "La XXV Biennale di Venezia: 'Fauves'." June 8–October 15, 1950. Exhibition catalogue: introduction by Robert Longhi.

VENICE. 1987. Museo Correr. "Henri Matisse: Matisse et l'Italie." May 30–October 18, 1987. Exhibition catalogue: compiled by Pierre Schneider; essays by Pierre Schneider, Attilio Codognato, Xavier Girard, Christian Arthaud, and Giandomenico Romanelli; entries by Tamara Préaud.

WASHINGTON. 1967. National Gallery of Art. "100 European Paintings and Drawings from the Collection of Mr. and Mrs. Leigh B. Block." May 4–June 11, 1967. Exhibition catalogue: foreword by John Walker and Kenneth Donahue; introduction by John Rewald. Also shown at the Los Angeles County Museum of Art, September 21–November 2, 1967.

WASHINGTON. 1977. Organized by the St. Louis Art Museum. National Gallery of Art. "The Paper Cut-outs of Henri Matisse." September 10–October 23, 1977. Exhibition catalogue: essays by Jack Cowart, Jack Flam, Dominique Fourcade, and John Neff. Also shown at The Detroit Institute of Arts, November 23, 1977–January 8, 1978, and the St. Louis Art Museum, January 29–March 12, 1978.

WASHINGTON. 1986–87. National Gallery of Art. "Henri Matisse: The Early Years in Nice, 1916–1930." November 2, 1986–March 29, 1987. Exhibition catalogue: compiled by Jack Cowart and Dominique Fourcade; foreword by J. Carter Brown; essays by Jack Cowart, Dominique Fourcade, and Margrit Hahnloser-Ingold; entries by Dominique Fourcade, Jack Cowart, and Marla Price.

Joan Miró

BARCELONA. 1918. Galería Dalmau. "Miró." February 16–March 3, 1918. Exhibition catalogue: preface by José María Junoy.

CHICAGO. 1931. The Arts Club of Chicago. "Joan Miró." January 27–February 17, 1931. Checklist.

DALLAS. 1959. The Dallas Museum for Contemporary Art. "Signposts of Twentieth-Century Art." October 28–December 7, 1959. Exhibition catalogue: introduction and essay by Katherine Kuh.

HARTFORD. 1931. Wadsworth Atheneum. "Newer Super-Realism." November 1931. Exhibition brochure: essays by André Breton and Samuel Putnam.

LONDON. 1964. The Arts Council of Great Britain, and Tate Gallery. "Joan Miró." August 27–October 11, 1964. Exhibition catalogue: by Roland Penrose. Also shown in Zurich, Kunsthaus, October 31–December 6, 1964.

LONDON. 1978. The Arts Council of Great Britain, and The Hayward Gallery. "Dada and Surrealism Reviewed." January 11–March 27, 1978. Exhibition catalogue: compiled by Dawn Ades; introduction by David Sylvester; essays by Dawn Ades and Elizabeth Cowling.

LOS ANGELES. 1959. Los Angeles County Museum of Art. "Joan Miró." June 10–July 21, 1959. Checklist. Also shown in New York, The Museum of Modern Art, March 18–May 10, 1959.

MINNEAPOLIS. 1951. Minneapolis Institute of Art. "Van Gogh and Modern Painting." October 6–November 4, 1951.

NEW YORK. 1930. Valentine Gallery. "Joan Miró." October 20–November 8, 1930. Checklist.

NEW YORK. 1936 a. Pierre Matisse Gallery. "Large Painting—Eight Moderns." January 14–February 18, 1936. Checklist.

NEW YORK. 1936 b. Pierre Matisse Gallery. "Joan Miró Retrospective." November 30–December 26, 1936. Illustrated checklist.

NEW YORK. 1940. Pierre Matisse Gallery. "Early Paintings of Joan Miró 1918–1925." March 1940. Checklist.

NEW YORK. 1941. Pierre Matisse Gallery. "Joan Miró." March 4–29, 1941. Checklist.

NEW YORK. 1941–42. The Museum of Modern Art. "Joan Miró." November 8, 1941–January 11, 1942. Exhibition catalogue: by James Johnson Sweeney.

NEW YORK. 1945. Pierre Matisse Gallery. "Joan Miró: Ceramics 1944, Tempera Paintings 1940–41, Lithographs 1944." January 9–February 3, 1945. Checklist.

NEW YORK. 1948. Pierre Matisse Gallery. "Joan Miró." March 16–April 20, 1948. Checklist.

NEW YORK. 1951. Pierre Matisse Gallery. "The Early Paintings of Joan Miró." November 1951. Illustrated checklist.

NEW YORK. 1959. The Museum of Modern Art. "Joan Miró." March 18–May 10, 1959. Exhibition catalogue: by James Thrall Soby. Also shown in altered form at the Los Angeles County Museum of Art, June 10–July 21, 1959.

NEW YORK. 1972. Acquavella Galleries, Inc. "Joan Miró." October 18–November 18, 1972. Exhibition catalogue: introduction by Douglas Cooper.

PARIS. 1921. Galerie La Licorne. "Exposition de peintures et dessins de Joan Miró." April 21–May 15, 1921. Exhibition catalogue: introduction by Maurice Raynal.

PARIS. 1928. Georges Bernheim et Cie. "Joan Miró." May 1–15, 1928.

PARIS. 1930. Galerie Pierre. "Joan Miró: intérieurs hollandais et d'autres oeuvres récentes." March 7–22, 1930. Checklist.

PARIS. 1962. Musée National d'Art Moderne. "Joan Miró." June–November 1962. Exhibition catalogue: compiled by Antoinette Huré; preface by Jean Cassou.

PARIS. 1974. Galeries Nationales d'Exposition du Grand Palais. "Joan Miró." May 17–October 13, 1974. Exhibition catalogue: preface by Jean Leymarie; essay by Jacques Dupin; texts and poems about Miró by André Breton, René Char, Paul Éluard, André Frénaud, Alberto Giacometti, Michel Leiris, Jacques Prévert, and Raymond Queneau.

SAN FRANCISCO. 1948. San Francisco Museum of Modern Art. "Picasso, Gris, Miró: The Spanish Masters of Twentieth-Century Painting." September 14–October 17, 1948. Exhibition catalogue: essays by Donald Gallup, Juan Larrea, Man Ray, Sidney Janis, Herbert Read, and Daniel-Henry Kahnweiler; with statements by the artists. Also shown in Oregon, Portland Art Museum, October 26–November 28, 1948.

SANTA BARBARA. 1978. Santa Barbara Museum of Art. "Works by Living Artists from the Collection of Mr. and Mrs. Leigh B. Block." February 11–April 9, 1978. Exhibition catalogue: by Katherine Harper Mead.

TOKYO. 1966. National Museum of Modern Art. "Joan Miró." August 26–October 9, 1966. Exhibition catalogue: compiled by Shuzo Takiguchi; introduction by Jacques Dupin. Also shown in Kyoto, National Museum of Modern Art, October 20–November 30, 1966.

VENICE. 1954. "La XXVII Biennale di Venezia." June 19–October 17, 1954. Exhibition catalogue: preface by Angelo Spanio; introduction by Rodolfo Pallucchini and Elio Zorzi.

WASHINGTON. 1967. National Gallery of Art. "100 European Paintings and Drawings from the Collection of Mr. and Mrs. Leigh B. Block." May 4–June 11, 1967. Exhibition catalogue: introduction by John Rewald. Also shown at the Los Angeles County Museum of Art, September 21–November 2, 1967.

Amedeo Modigliani

BASEL. 1934. Kunsthalle. "Modigliani." January 7–February 4, 1934. Exhibition catalogue: introduction by Charles-Albert Cingria.

BRUSSELS. 1933. Palais des Beaux-Arts. "Modigliani." November 1933. Exhibition catalogue: introduction by Maud Dale.

Piet Mondrian

AMSTERDAM. 1946. Stedelijk Museum. "PM: Piet Mondrian Herdenkingstentoonselling." November 6–December 15, 1946. Exhibition catalogue: essays by Michel Seuphor, T. Brugman, Peter Alma, C. van Eesteren, and J. J. P. Oud.

BASEL. 1947. Kunsthalle. "Piet Mondrian 1872–1944." February 6–March 2, 1947. Exhibition catalogue: with essay "Lebenserinnerungen und Gedanken über die 'Neue Gestaltung'" by Mondrian.

NEW YORK. 1949. Sidney Janis Gallery. "Piet Mondrian Paintings 1910 through 1944." October 10–November 12, 1949. Checklist.

NEW YORK. 1951. Sidney Janis Gallery. "Painters of De Stijl 1917–1921." May 7–June 2, 1951. Checklist.

NEW YORK. 1971. The Solomon R. Guggenheim Museum. "Piet Mondrian 1872–1944 Centennial Exhibition." October 8–December 12, 1971. Exhibition catalogue: preface by Thomas M. Messer; introduction by L. J. F. Wijsenbeek; essays by Robert P. Welsh, Joop Joosten, Nelly van Doesburg, and Max Bill; interview with Charmion von Wiegand by Margit Rowell. Also shown in Bern, Kunstmuseum, February 9–April 9, 1972.

NEW YORK. 1982. Sidney Janis Gallery. "Loan Exhibition of Works by Brancusi and Mondrian." December 2–31, 1982. Exhibition catalogue.

Pablo Picasso

BASEL. 1976. Kunstmuseum. "Picasso aus dem Museum of Modern Art, New York, und Schweizer Sammlungen." June 15–September 12, 1976. Exhibition catalogue: introduction by Franz Meyer; essays by William Rubin (translated by Rolf Herzog), Zdenek Felix, and Reinhold Hohl.

BASEL. 1981. Kunstmuseum. "Pablo Picasso: Das Spätwerk." September 6–November 8, 1981. Exhibition catalogue: foreword by Christian Geelhaar; essays by Richard Hasli, Franz Meyer, Christian Geelhaar, Kim Levin, and Dieter Koepplin.

DALLAS. 1967. Dallas Museum of Fine Arts, and Fort Worth Art Center Museum. "Picasso, Two Concurrent Retrospective Exhibitions." February 8–March 26, 1967. Exhibition catalogue: preface by Merrill C. Rueppel and Donald A. Burrows; introduction and essay by Douglas Cooper.

LONDON. 1937. Rosenberg & Helft Ltd. "Recent Works of Picasso." April 1–30, 1937. Checklist.

LONDON. 1937. Zwemmer Gallery. "Chirico—Picasso." June 1–31, 1937. Checklist.

LONDON. 1938. London Gallery Ltd. "Pablo Picasso." May 5–31, 1938. Checklist (reproduced in *London Bulletin* 2 [May 1938], p. 21).

LONDON. 1939. London Gallery Ltd. "Picasso in English Collections." May 16–June 3, 1939. The magazine *London Bulletin* 2, nos. 15–16 (May 15, 1939), served as the exhibition catalogue: with statements about Picasso by Anthony Bertram, Maurice Raynal, T. W. Earp. R. H. Wilenski, Gertrude Stein, Naum Gabo, Siegfried Giedion, Paul Éluard, André Breton, Robert Melville, and Conroy Maddox.

LONDON. 1947. London Gallery Ltd. "The Cubist Spirit in Its Time." March 18–May 3, 1947. Exhibition catalogue: foreword by Robert Melville;

with excerpts from *Les Peintres Cubistes* by Guillaume Apollinaire, Paris, 1913.

LONDON. 1951. Institute of Contemporary Arts. "Drawings and Watercolors since 1893: Homage to Picasso on His 70th Birthday." October 11–November 24, 1951. Exhibition catalogue: essays by Roland Penrose and Paul Éluard.

LONDON. 1983. Tate Gallery. "The Essential Cubism: Braque, Picasso & Their Friends 1907–1920." April 27–July 10, 1983. Exhibition catalogue: by Douglas Cooper and Gary Tinterow; foreword by Alan Bowness.

LOS ANGELES. 1961. UCLA Art Galleries. "'Bonne Fête' Monsieur Picasso from Southern California Collections." October 25–November 12, 1961. Exhibition catalogue: introduction by Franklin D. Murphy; essay by Daniel-Henry Kahnweiler.

LYONS. 1953. Musée de Lyon. "Picasso." July 1–September 27, 1953. Exhibition catalogue: essays by Jean Cassou, Daniel-Henry Kahnweiler, Christian Zervos, René Jullian, and Marcel Michaud.

MADRID. 1981. Museo Español de Arte Contemporáneo. "Picasso: 1881–1973. Exposición Antologíca." November–December 1981. Exhibition catalogue: introduction by Javier Tusell; with contributions by Ana Beristain, Rosa M. Subirana, José Martínez-Novillo, M. Teresa Llorens, Francisco Javier Escudero, and Concha de Marco. Also shown in Barcelona, Museo Picasso, January–February 1982.

MENTON. 1974. Palais de l'Europe. "Dixième biennale internationale d'art de Menton." July–September 1974. Exhibition catalogue: introduction by Émile Marze.

MEXICO CITY. 1984. Museo Rufino Tamayo. "Picasso: Su Ultima Decada." June–July 1984. Exhibition catalogue: introduction by Robert R. Littman; essays by Gert Schiff, John Richardson, and David Hockney; translated by Flora Botton-Burlá, Leticia Leduc, Carlota Rafful, and Ana Zagury.

MILAN. 1953. Palazzo Reale. "Pablo Picasso." September 23–December 31, 1953. Exhibition catalogue: essay by Franco Russoli.

MONTAUBAN. 1975. Musée Ingres. "Picasso (nus, portraits, compositions)." June 27–September 7, 1975. Exhibition catalogue: essays by Pierre Barousse and Hélène Parmelin.

MUNICH. 1913. Moderne Galerie Thannhauser. "Ausstellung Pablo Picasso." February 1913. Checklist.

NEWARK. 1948. The Newark Museum. "Seeing Modern Art." January 5–February 24, 1948.

NEW HAVEN. 1971–72. Yale University Art Gallery. "Picasso Drawings from the Bareiss Collection." November 4, 1971–January 2, 1972. Checklist.

NEW YORK. 1939–40. The Museum of Modern Art. "Picasso: Forty Years of His Art." November 15, 1939–January 7, 1940. Exhibition catalogue: foreword by Alfred H. Barr, Jr.; reprint of Picasso's 1923 statement (originally published as "Picasso Speaks," in *Arts Magazine* 3, no. 5 [May 1923], p. 315) and his 1935 remarks to Christian Zervos (published as "Conversations avec Picasso," in *Cahiers d'art* 10, nos. 7–10 [1935], pp. 173–78). Also shown at The Art Institute of Chicago, February 1–March 5, 1940; the City Art Museum of St. Louis, March 16–April 14, 1940; Boston, Museum of Fine Arts, April 26–May 25, 1940; the San Francisco Museum of Art, June 25–July 22, 1940; the Cincinnati Museum of Art, September 28–October 27, 1940; The Cleveland Museum of Art, November 7–December 8, 1940; New Orleans, Isaac Delgado Museum, December 20, 1940–January 17, 1941; The Minneapolis Institute of Art, February 1–March 2, 1941; and Pittsburgh, Carnegie Institute of Art, March 15–April 13, 1941.

NEW YORK. 1941. Bignou Gallery. "Picasso: Early and Late." February 10–March 1, 1941. Checklist.

NEW YORK. 1941. The Museum of Modern Art. "Masterpieces of Picasso." July 15–September 7, 1941. Checklist.

NEW YORK. 1942. Paul Rosenberg and Co. "Loan Exhibition of Masterpieces by Pablo Picasso (from 1881 to 1926)." February 11–March 7, 1942. Checklist.

NEW YORK. 1942. The Museum of Modern Art. "New Acquisitions and Extended Loans: Cubist and Abstract Art." March 25–May 3, 1942. Checklist.

NEW YORK. 1944. Valentine Gallery. "The Lee Ault Collection." April 10–29, 1944. Checklist.

NEW YORK. 1944. The Museum of Modern Art. "Art in Progress: Fifteenth Anniversary Exhibition." May 24–October 15, 1944. Exhibition catalogue: essays by George Amberg, Iris Barry, Serge Chermayeff, Elodie Courtier, Victor d'Amico, René d'Harnoncourt, Elizabeth Mock, Nancy Newhall, James Thrall Soby, and Monroe Wheeler.

NEW YORK. 1945. Buchholz Gallery (Curt Valentin). "Picasso: Paintings and Drawings from a Private Collection." February 27–March 17, 1945. Exhibition catalogue: essays by Alfred H. Barr, Jr., and Paul Éluard.

NEW YORK. 1950. The Museum of Modern Art. "Three Modern Styles." July 11–September 5, 1950. Checklist. Traveled throughout the United States from October 1949 to May 1952.

NEW YORK. 1953. Perls Galleries. "Picasso: The Thirties." January 5–February 7, 1953. Checklist.

NEW YORK. 1954–55. The Museum of Modern Art. "Paintings from the Museum Collection: Twenty-Fifth Anniversary Exhibition." October 19, 1954–February 6, 1955. Checklist.

NEW YORK. 1957. The Museum of Modern Art. "Picasso 75th Anniversary Exhibition." May 22–September 8, 1957. Exhibition catalogue: by Alfred H. Barr, Jr. Also shown at The Art Institute

of Chicago, October 29–December 8, 1957, and the Philadelphia Museum of Art, January 8–February 23, 1958.

NEW YORK. 1962. M. Knoedler & Co., Inc., Saidenberg Gallery, Paul Rosenberg and Co., Duveen Brothers, Inc., Perls Galleries, Staempfli Gallery, Inc., Cordier-Warren Gallery, The New Gallery, Otto Gerson Gallery. "Picasso: An American Tribute." April 25–May 12, 1962. Exhibition catalogue: by John Richardson.

NEW YORK. 1962. The Museum of Modern Art. "Eightieth-Birthday Exhibition: Picasso, The Museum Collection Present and Future." May 14–September 18, 1962. Checklist.

NEW YORK. 1963. M. Knoedler & Co., Inc. "Twentieth-Century Masters from the Bragaline Collection for the Benefit of the Museum of Early American Folk Art." November 6–23, 1963. Illustrated checklist.

NEW YORK. 1969. The Museum of Modern Art. "Twentieth-Century Art from the Nelson Aldrich Rockefeller Collection." May 26–September 1, 1969. Exhibition catalogue: preface by Nelson A. Rockefeller; foreword by Monroe Wheeler; essay by William S. Lieberman.

NEW YORK. 1970–71. The Museum of Modern Art. "Four Americans in Paris: The Collections of Gertrude Stein and Her Family." December 19, 1970–March 1, 1971. Exhibition catalogue: foreword by John B. Hightower; introduction by Margaret Potter; essays by Irene Gordon, Lucile M. Golson, Leon Katz, Douglas Cooper, and Ellen Hirschland. Shown in altered form at the Baltimore Museum of Art, April 4–June 13, 1971; Ottawa, National Gallery of Canada, June 25–August 15, 1971; and at the San Francisco Museum of Modern Art, September 15–October 31, 1971.

NEW YORK. 1971. Marlborough Gallery, and Saidenberg Gallery. "Homage to Picasso." October 1–31, 1971. Exhibition catalogue: by John Richardson.

NEW YORK. 1972. The Museum of Modern Art. "Picasso in the Museum Collection." February 3–April 2, 1972. Exhibition catalogue: compiled by William Rubin; essays by William Rubin, Elaine L. Johnson, and Riva Castleman.

NEW YORK. 1980. The Museum of Modern Art. "Pablo Picasso: A Retrospective." May 22–September 6, 1980. Exhibition catalogue: by William Rubin; introduction by Dominique Bozo; chronology by Jane Fluegel.

NEW YORK. 1984. The Solomon R. Guggenheim Museum. "Picasso: The Last Years, 1963–1973." March 2–May 6, 1984. Exhibition catalogue: by Gert Schiff.

NORFOLK. 1973. The Chrysler Museum. "Picasso Retrospective." June 17–July 21, 1973.

OTTAWA. 1971. National Gallery of Canada. "Gertrude Stein & Picasso & Juan Gris." June 25–August 15, 1971. Exhibition catalogue: foreword by Margaret Potter; introduction by Jean Sutherland Boggs; essay by Douglas Cooper; with excerpts from Gertrude Stein's *Picasso*, Paris, 1938. Shown in altered form in New York, The Museum of Modern Art, December 19, 1970–March 1, 1971.

PARIS. 1932. Galerie Georges Petit. "Exposition Picasso." June 16–July 30, 1932. Exhibition catalogue: introduction by Charles Vranken.

PARIS. 1936. Galerie Paul Rosenberg. "Exposition d'oeuvres récentes de Picasso." March 3–31, 1936. Exhibition catalogue: with reprint of the article "Il y a soixante ans" by Albert Wolff (originally published in *Le Figaro* 23, no. 94 [April 3, 1876], p. 1).

PARIS. 1942. Galerie Paul Rosenberg. "Loan Exhibition of Masterpieces by Pablo Picasso (from 1918 to 1926)." February 11–March 7, 1942. Checklist.

PARIS. 1950. Galerie Charpentier. "Cent portraits de femmes du XVᵉ siècle à nos jours." Exhibition catalogue: essay by Henry de Montherlant.

PARIS. 1953. Musée National d'Art Moderne. "Le Cubisme 1907–1914." January 30–April 9, 1953. Exhibition catalogue: essay by Jean Cassou.

PHILADELPHIA. 1945. Philadelphia Museum of Art. "The Callery Collection: Picasso—Léger." January 10–February 20, 1945. Special issue of the *Philadelphia Museum of Art Bulletin* (40, no. 204 [January 1945]) served as the exhibition catalogue: with excerpts from *Nuovi Saggi di Estetica* by Benedetto Croce, Bari, 1920.

PHILADELPHIA. 1958. Philadelphia Museum of Art. "Picasso: A Loan Exhibition of His Paintings, Drawings, Sculpture, Ceramics, Prints, and Illustrated Books." January 8–February 23, 1958. Exhibition catalogue: preface by Henry Clifford; essay by Carl Zigrosser.

PITTSBURGH. 1963–64. Museum of Art, Carnegie Institute. "Works of Art from the Collection of The Museum of Modern Art." December 17, 1963–February 9, 1964. Checklist.

PORTLAND, OREGON. 1970. Portland Art Museum. "Picasso for Portland." September 20–October 25, 1970. Exhibition catalogue: introduction by Francis J. Newton.

RICHMOND. 1941. Virginia Museum of Fine Arts. "Collection of Walter P. Chrysler, Jr." January 16–March 4, 1941. Exhibition catalogue: introduction by Henry McBride. Also shown at the Philadelphia Museum of Art, March 29–May 11, 1941.

SÃO PAULO. 1953–54. Museu de Arte Moderna. "Exposição Picasso." December 13, 1953–February 20, 1954. Exhibition catalogue: introduction by Maurice Jardot.

TOKYO. 1964. National Museum of Modern Art. "Picasso." May 23–July 5, 1964. Exhibition catalogue: essays by Daniel-Henry Kahnweiler and Alfred H. Barr, Jr. Also shown in Kyoto, National Museum of Modern Art, July 10–August 2, 1964, and Nagoya, Prefectural Museum of Art, August 7–18, 1964.

TOKYO. 1976. National Museum of Modern Art. "Cubism." October 2–November 14, 1976. Exhibition catalogue: essays by Jacques Lassaigne and Tamon Miki. Also shown in Kyoto, National Museum of Modern Art, November 25–December 19, 1976.

TOKYO. 1977. Museum of the City of Tokyo. "Exposition Picasso." October 15–December 4, 1977. Exhibition catalogue: essays by Roland Penrose, Pontus Hulten, and Dominique Bozo. Also shown in Nagoya, Prefectural Museum of Art, December 13–26, 1977; Fukuoka, Cultural Center, January 5–22, 1978; and Kyoto, National Museum of Modern Art, January 28–March 5, 1978.

TÜBINGEN. 1986. Kunsthalle. "Picasso: Pastelle, Zeichnungen, Aquarelle." April 5–May 25, 1986. Exhibition catalogue: by Werner Spies; introduction by Gotz Adriani and Werner Schmalenbach. Also shown in Düsseldorf, Kunstsammlung Nordrhein-Westfalen, June 6–July 27, 1986.

VIENNA. 1914. Galerie Miethke. "Pablo Picasso." February–March 1914. Checklist.

ZURICH. 1932. Kunsthaus. "Picasso." September 11–October 30, 1932 (extended to November 13, 1932). Exhibition catalogue: essay by W. Wartmann.

Auguste Rodin

NEW YORK. 1940. Galerie St. Etienne. "French Masters of the 19th and 20th Century." February 9–March 23, 1940. Checklist.

François Rouan

DÜSSELDORF. 1979–80. Städtische Kunsthalle. "François Rouan: Gemälde und Zeichnungen." December 7, 1979–January 6, 1980. Exhibition catalogue: introduction and text by Jürgen Harten; essay by Dominique Bozo.

NEW YORK. 1982. Pierre Matisse Gallery. "Rouan: Paintings and Drawings 1973 to 1981." February 1982. Exhibition catalogue: essay by Edward F. Fry.

PARIS. 1983–84. Musée National d'Art Moderne. "Rouan." October 27, 1983–January 2, 1984. Exhibition catalogue: introduction by Dominique Bozo; essays by Isabelle Monod-Fontaine, Hubert Damisch, Didier Sicard, André Fermigier, Jean Clair, Dominique Bozo, Edward F. Fry, and Jacques Lacan; with a statement by the artist.

Georges Rouault

NEW YORK. 1947. Pierre Matisse Gallery. "Georges Rouault: Paintings." March 11–April 5, 1947. Brochure.

NEW YORK. 1953. The Museum of Modern Art. "Rouault: Retrospective Exhibition 1953." March 31–May 3, 1953. Exhibition catalogue: foreword by Jacques Maritain. Also shown at The Cleveland Museum of Art, January 27–March 4, 1953, and in

reduced form at the Los Angeles County Museum of Art, July 2–August 16, 1953.

Sam Szafran

PARIS. 1972. Galeries Nationales d'Exposition du Grand Palais. "72: Douze ans d'art contemporain." May 17–September 18, 1972. Exhibition catalogue: preface by François Mathey; essays by Daniel Cordier, Serge Lemoine, and Maurice Eschapasse; chronology by Viviane Huchard.

PARIS. 1972. Galerie Claude Bernard. "Szafran: pastels: 1970–72." October–November 1972. Exhibition catalogue: poems by Jean Paget and Georges Schehadé; statements by Fouad El-Etr and E. M. Cioran.

Yves Tanguy

BADEN-BADEN. 1982–83. Staatliche Kunsthalle. "Yves Tanguy, Retrospektive 1925–1955." October 17, 1982–January 2, 1983. Exhibition catalogue: compiled by Agnès Angliviel de La Beaumelle and Florence Chauveau; foreword by Katharina Schmidt; essays by Reinhold Hohl, Marianne Kesting, Robert Lebel, Roland Penrose, José Pierre, Katharina Schmidt, and Thomas T. Solley; translated by Doris and Helga Contzen, Manon Maren Grisebach, Friedhelm Kemp, and Brigitte Stranz-Wersche. Also shown in Paris, Centre Georges Pompidou, Musée National d'Art Moderne, June 15–September 27, 1982, and New York, The Solomon R. Guggenheim Museum, January 21–February 27, 1983.

BEVERLY HILLS. 1948. Copley Galleries. "Yves Tanguy: Paintings and Gouaches." Winter 1948. Illustrated checklist.

CINCINNATI. 1943. Organized by the Cincinnati Modern Art Society. Cincinnati Art Museum. "12 Surrealists." April 20–May 23, 1943. Exhibition brochure: essay by Marion R. Becker.

HARTFORD. 1954. Wadsworth Atheneum. "Yves Tanguy–Kay Sage." August 10–September 28, 1954. Exhibition catalogue: preface by C. E. Buckley.

NEW YORK. 1942. Pierre Matisse Gallery. "Recent Paintings by Yves Tanguy." April 21–May 9, 1942. Checklist (published in *View* 2, no. 2 [May 1942]).

NEW YORK. 1944. Valentine Gallery. "The Lee Ault Collection: Modern Paintings." April 10–29, 1944. Illustrated checklist.

NEW YORK. 1944. Pierre Matisse Gallery. "Homage to the 'Salon d'Automne' 1944, 'Salon de la Libération'." December 9–31, 1944. Illustrated checklist.

NEW YORK. 1945. Pierre Matisse Gallery. "Yves Tanguy, Paintings." May 8–June 2, 1945. Checklist.

NEW YORK. 1946. Pierre Matisse Gallery. "Yves Tanguy, Retrospective Exhibition of Paintings and Gouaches, 1927–1946." November 5–30, 1946. Exhibition concurrent with the publication of

André Breton's *Yves Tanguy*, a collection of essays and poems, by Pierre Matisse Editions. Checklist.

NEW YORK. 1955. The Museum of Modern Art. "Yves Tanguy: A Retrospective Exhibition." September 7–October 30, 1955. Exhibition catalogue: by James Thrall Soby.

NEW YORK. 1968. The Museum of Modern Art. "Dada, Surrealism and Their Heritage." March 27–June 9, 1968. Exhibition catalogue: by William S. Rubin. Also shown at the Los Angeles County Art Museum, July 16–September 8, 1968, and The Art Institute of Chicago, October 19–December 8, 1968.

NEW YORK. 1974. Acquavella Galleries, Inc. "Yves Tanguy." November 7–December 7, 1974. Exhibition catalogue: by John Ashbery.

NEW YORK. 1983. The Solomon R. Guggenheim Museum. "Yves Tanguy: A Retrospective." January 21–February 27, 1983. Exhibition brochure. Also shown in Paris, Centre Georges Pompidou, Musée National d'Art Moderne, June 15–September 27, 1982, and Baden-Baden, Staatliche Kunsthalle, October 17, 1982–January 2, 1983.

PARIS. 1982. Centre Georges Pompidou, Musée National d'Art Moderne. "Yves Tanguy: rétrospective 1925–55." June 17–September 27, 1982. Exhibition catalogue: compiled by Agnès Angliviel de La Beaumelle and Florence Chauveau; preface by Dominique Bozo; essays by Robert Lebel, Jean Maurel, Roland Penrose (translated by Anne Hindry), and José Pierre; texts by Benjamin Péret, Thomas T. Solly, André Breton et al.

SAN FRANCISCO. 1947–48. California Palace of the Legion of Honor. "Second Annual Exhibition of Painting." November 19, 1947–January 4, 1948. Exhibition catalogue: foreword by Thomas Carr Howe, Jr.; introduction by Jermayne MacAgy.

Maurice de Vlaminck

LONDON. 1978. The Lefevre Gallery. "Les Fauves." November 16–December 21, 1978. Exhibition catalogue: foreword by Denys Sutton.

NEW YORK. 1963. Leonard Hutton Galleries. "Der Blaue Reiter." February 19–March 30, 1963. Exhibition catalogue: foreword by Will Grohmann; introduction by Leonard Hutton Hutschnecker; essay by Peter Selz; translated by Ilse Falk.

NEW YORK. 1968. Leonard Hutton Galleries. "Fauves and Expressionists." April 18–June 12, 1968. Exhibition catalogue: introduction by Leonard Hutton Hutschnecker; essay by Bernard Dorival.

NEW YORK. 1976. The Museum of Modern Art. "The 'Wild Beasts': Fauvism and Its Affinities." Exhibition catalogue: by John Elderfield. Also shown at the San Francisco Museum of Modern Art, June 29–August 15, 1976, and Fort Worth, Kimbell Art Museum, September 11–October 31, 1976.

Édouard Vuillard

NEW YORK. 1954. The Museum of Modern Art. "Édouard Vuillard." April 6–June 6, 1954. Exhibition catalogue: by Andrew Carnduff Ritchie; notes on Vuillard as a printmaker by William S. Lieberman: bibliography by Bernard Karpel. Also shown at The Cleveland Museum of Art, January 26–March 14, 1954.

Selected Bibliography

Francis Bacon

Ades, Dawn, and Andrew Forge. *Francis Bacon*.
London and New York, 1985.

Leiris, Michel. *Francis Bacon: Full Face and in Profile*.
Translated by John Weightman. Oxford, England,
and New York, 1983.

Schmied, Wieland. *Francis Bacon: Vier Studien zu
einem Porträt*. Berlin, 1985.

Sylvester, David. *Interviews with Francis Bacon: 1969–
1979*. Enlarged ed. London, 1980.

———. *The Brutality of Fact: Interviews with Francis
Bacon*. 3rd ed. London, 1987.

Balthus (Balthasar Klossowski)

Bonnefoy, Yves. "L'invention de Balthus." In *L'im-
probable et autres essais*. Rev. and enlarged ed. Paris,
1980, pp. 39–59.

Dauriac, Jacques Paul. "Paris, Centre Georges Pom-
pidou. Exposition: Balthus." *Pantheon* 42 (1984),
pp. 185–87.

Klossowski de Rola, Stanislas. *Balthus*. New York,
1983.

Leymarie, Jean. *Balthus*. Translated by James Em-
mons. 2nd enlarged ed. Geneva and New York,
1982.

Micha, René. "Balthus: des gloses essentielles sur l'un
des grands peintres de ce temps." *Art International*
27, no. 2 (1984), pp. 3–6.

Rewald, Sabine. *Balthus* (exhib. cat.). New York, The
Metropolitan Museum of Art, 1984.

Sauré, Wolfgang. "Pariser Ausstellungen: Balthus."
Das Kunstwerk 37, no. 2 (1984), p. 45.

Watt, Alexander. "Balthus and Realism." *Studio* 166,
no. 846 (1963), pp. 144–47.

Pierre Bonnard

Beer, François-Joachim, and Louis Gillet. *Pierre Bon-
nard*. Preface by Raymond Cogniat. Marseilles,
1947.

Coquiot, Gustave. *Bonnard*. Paris, 1922.

Courthion, Pierre. *Bonnard: peintre du merveilleux*.
Lausanne, 1945.

Dauberville, Jean, and Henry Dauberville. *Bonnard:
catalogue raisonné de l'oeuvre peint, 1888–1947*. 4
vols. Paris, 1965–74.

Fierens, Paul. "La grâce dans la peinture française."
L'Art vivant no. 167 (1932), pp. 576–80.

Fosca, François [Georges de Traz]. *Bonnard*. Geneva,
1919.

Masuda, Y. *Bonnard*. Tokyo, 1932.

Natanson, Thadée. *Le Bonnard que je propose*. Geneva,
1951.

Pickvance, Ronald. "A New Look at Bonnard at the
Los Angeles County Museum of Art." *The Con-
noisseur* 158 (1965), pp. 272–75.

Georges Braque

Brenson, Michael. "What Does a Museum Owe an
Artist?" *The New York Times* (July 10, 1988), Arts
and Leisure section, pp. 33, 41.

Bulletin de "l'Effort Moderne" no. 9 (November 1924),
ill.

Cahiers d'art 8, nos. 1–2 (1933). Special issue devoted
to Georges Braque. With contributions by C.
Zervos, L. Vauxcelles, G. Apollinaire, A. Salmon,
Bissière, B. Cendrars, A. Lhote, A. Soffici, J.
Cassou, H. S. Ede, A. Breton, and C. Einstein.

Cartier, Jean Albert. "La poétique de Braque." *Le
Jardin des arts* no. 26 (December 1956), pp. 87–92.

Cassou, Jean. "Georges Braque." *Cahiers d'art* 3
(1928), pp. 5–11.

Cogniat, Raymond. "Braque à 75 ans." *Prisme des arts:
revue internationale d'art contemporain* no. 13 (1957),
pp. 33–36.

———. *Georges Braque*. Translated by I. Mark Paris.
New York, 1980.

Cooper, Douglas. *Braque: The Great Years* (exhib.
cat.). Chicago, The Art Institute of Chicago, 1972.

Damase, Jacques. *Georges Braque*. Paris, 1963.

Einstein, Carl. *Georges Braque*. Translated by M. E.
Zipruth. Paris, 1934.

Feuilles volantes 2, no. 1 (1927), pp. 6–8. Supplement

to *Cahiers d'art* 2 (1927): "Les expositions à Paris et ailleurs."

Fumet, Stanislas. *Braque.* Paris, 1965.

Gee, Malcolm. *Dealers, Critics, and Collectors of Modern Painting: Aspects of the Parisian Art Market between 1910 and 1930.* New York and London, 1981.

George, Waldemar. "Braque, l'ouvrier." *Art et industrie* no. 25 (October 1952), pp. 12–13.

Gieure, Maurice. *Georges Braque.* Paris and New York, 1956.

Hughes, Robert. "Objects as Poetics." *Time* 100, no. 15 (October 9, 1972), pp. 66–69.

Isarlov, Georges. *Catalogue des oeuvres de Georges Braque.* Paris, 1932.

Janneau, Guillaume. *L'Art cubiste: théories et réalisations. Étude critique.* Paris, 1929.

Judkins, Winthrop. *Fluctuant Representations in Synthetic Cubism: Picasso, Braque, Gris, 1910–1920.* New York and London, 1976.

Kosinski, Dorothy M. *Douglas Cooper und die Meister des Kubismus/Douglas Cooper and the Masters of Cubism* (exhib. cat.). Basel, Kunstmuseum, 1987.

Laufer, Fritz. *Braque.* Bern, 1954.

Leymarie, Jean. *Braque.* Translated by James Emmons. Geneva, 1961.

Lipman, Jean et al., comps. *The Collector in America.* Introduction by Alan Pryce-Jones. New York, 1970.

Mangin, Nicole S. *Catalogue de l'oeuvre de Georges Braque: peintures, 1948–1957.* Paris, 1959.

———. *Catalogue de l'oeuvre de Georges Braque: peintures 1924–1927.* Paris, 1968.

Mullins, Edwin. *The Art of Georges Braque.* New York, 1968.

Peppiatt, Michael. "Paris." *Art International* 17, no. 10 (1973), pp. 52–54.

Le Point [Souillac] no. 46 (October 1953). Special issue devoted to Georges Braque. With essays by S. Fumet, G. Limbour, and G. Ribémont-Dessaignes.

Ponge, Francis, Pierre Descargues, and André Malraux. *G. Braque.* Translated by Richard Howard and Lane Dunlop. New York, 1971.

Pouillon, Nadine. *Braque.* Paris, 1970.

———, and Isabelle Monod-Fontaine. *Braque: Oeuvres de Georges Braque (1882–1963)* (exhib. cat.). Paris, Musée National d'Art Moderne, Centre Georges Pompidou, 1982.

Raynal, Maurice. "Georges Braque." In *From Picasso to Surrealism* (*History of Modern Painting*, vol. III). Translated by Douglas Cooper. Geneva, 1950, pp. 144–48.

Richardson, John. "The Ateliers of Braque." *The Burlington Magazine* 97 (1955), pp. 164–70.

———. *Georges Braque.* Harmondsworth, Middlesex, 1959.

———. *Georges Braque.* Milan, 1960.

Rosenblum, Robert. *Cubism and Twentieth-Century Art.* New York, 1960.

Russell, John. *G. Braque.* London, 1959.

Rydbeck-Zuhr, Ingrid. "Samtal i en ateljé." *Konstrevy* 23 (1947), pp. 202–10.

Tono, Yoshiaki. *Picasso–Braque.* Tokyo, 1966.

Valsecchi, Marco, and Massimo Carrà. *L'opera completa di Braque dalla scomposizione cubista al recupero dell'oggetto: 1908–1929.* Milan, 1971.

Worms de Romilly, Nicole, and Jean Laude. *Braque: le cubisme fin 1907–1914.* Paris, 1982.

Zurcher, Bernard. *Georges Braque: Life and Work.* Translated by Simon Nye. New York, 1988.

Victor Brauner

Bozo, Dominique. *Victor Brauner* (exhib. cat.). Paris, Musée National d'Art Moderne, 1972.

———, and Pierre Georgel. *Les dessins de Victor Brauner au Musée National d'Art Moderne* (exhib. cat.). Paris, 1975.

Dienst, Rolf-Gunter. "Ausstellungen in New York." *Das Kunstwerk* 21, nos. 7–8 (1968), pp. 23–33.

Gállego, Julián. "Crónica de Paris." *Goya* no. 8 (1955), pp. 130–36.

Gercke, Hans. "Das Tier in der Kunst unseres Jahrhunderts." *Das Kunstwerk* 33, no. 4 (1980), pp. 3–47.

Juin, Hubert. "Qui va au-devant de la matière. À propos de l'exposition d'oeuvres récentes de Victor Brauner à la galerie des 'Cahiers d'art'." *Cahiers d'art* 29, no. 1 (October 1954), pp. 238–45.

Maurer, Evan. "Dada and Surrealism." In *"Primitivism" in 20th Century Art: Affinity of the Tribal and the Modern.* Edited by William Rubin. Vol. 2. New York, The Museum of Modern Art, 1984, pp. 535–93.

Rubin, William S. *Dada and Surrealist Art.* New York, 1968.

Urbinati, Giulio. *Victor Brauner: miti, presagi, simboli. Opere dal 1929 al 1965* (exhib. cat.). Lugano, Villa Malpensata, 1985.

Vallier, Dora. "Petite introduction à la peinture de Brauner." *XXᵉ Siècle* 25, no. 22 (1963), pp. 29–38.

Marc Chagall

Cassou, Jean. *Chagall.* Translated by Alisa Jaffa. New York and Washington, 1965.

Compton, Susan. *Chagall* (exhib. cat.). London, Royal Academy of Arts, 1985.

Coquiot, Gustave. *Cubistes, futuristes, passéistes: essai sur la jeune peinture et la jeune sculpture.* Paris, 1923.

Estienne, Charles. *Chagall.* Paris, 1951.

Kloomok, I. *Marc Chagall: His Life and Work.* New York, 1951.

Meyer, Franz. *Marc Chagall: Life and Work.* Translated by Robert Allen. New York, 1963.

Giorgio de Chirico

Artemis 1977–78 (Consolidated Audited Annual Report, 1977–78). Luxembourg, 1978.

Ashbery, John. "Growing Up Surreal." *Art News* 67, no. 3 (1968), pp. 40–44, 65.

Bardi, Angelo. "La vie de Giorgio de Chirico."

Sélection: chronique de la vie artistique ser. 3, no. 8 (1929), pp. 20–26.

Bruni, Claudio. *Giorgio de Chirico: Catalogo generale. (Opere dal 1908 al 1930,* vol. I). Venice, 1971.

de Chirico, Giorgio. "A Fragment of Hebdomeros." *Arson: An Ardent Review* [London] (1942), p. 29.

Courthion, Pierre. "L'art de Giorgio de Chirico." *Sélection: chronique de la vie artistique* ser. 3, no. 8 (1929), pp. 3–19.

Fagiolo dell'Arco, Maurizio. *L'opera completa di de Chirico, 1908–1924.* Milan, 1984.

Gaffé, René. *Giorgio de Chirico: le voyant.* Brussels, 1946.

————. "Confessions of a Collector." *Magazine of Art* 44, no. 6 (1951), pp. 207–15.

————. *À la verticale: réflexions d'un collectionneur.* Brussels, 1963.

Henning, Edward B. "Surrealism: In the Footsteps of Freud." *Art News* 79, no. 5 (1980), pp. 122–24.

————. "Giorgio de Chirico: The Metaphysical Paintings." *Museum* 3, no. 2 (1982), pp. 70–73.

Heyd, Milly. "De Chirico: *The Greetings of a Distant Friend.*" In *Psychoanalytic Perspectives in Art*, vol. III. Edited by Mary Mathews Gedo. Hillsdale, New Jersey, 1988, pp. 107–27.

Lassaigne, Jacques. "Giorgio de Chirico." In Maurice Raynal. *From Picasso to Surrealism (History of Modern Painting*, vol. III). Translated by Douglas Cooper. Geneva, 1950, pp. 104–5, ill. p. 108.

Nino, Frank. "Giorgio de Chirico et Alberto Savinio." *Cahiers de Belgique* [Brussels] 2, no. 4 (1929), pp. 130–37.

Penrose, Roland. *Scrap Book, 1900–1981.* New York, 1981.

Queneau, Raymond. "À propos de l'exposition Giorgio de Chirico à la Galerie Surréaliste." *La Révolution Surréaliste* no. 11 (March 15, 1928), p. 42.

Read, Herbert, ed. *Surrealism.* With contributions by André Breton, Hugh Sykes Davies, Paul Éluard, and Georges Hugnet. New York, 1936.

————. *Art Now: An Introduction to the Theory of Modern Painting and Sculpture.* 3rd ed. rev. and enlarged. Glasgow, 1948.

Rubin, William S. *Dada and Surrealist Art.* New York, 1968.

————. "De Chirico und der Modernismus." In *Giorgio de Chirico der Metaphysiker* (exhib. cat.). Compiled by William S. Rubin, Wieland Schmied, and Jean Clair. Munich, Haus der Kunst, 1982, pp. 47–78.

————. "De Chirico et la modernité." In *Giorgio de Chirico* (exhib. cat.). Compiled by William Rubin, Wieland Schmied, and Jean Clair. Paris, Musée National d'Art Moderne, Centre Georges Pompidou, 1983, pp. 9–37.

Siegel, Jeanne. "The Image of the Eye in Surrealist Art and Its Psychoanalytic Sources, Part One: The Mythic Eye." *Arts Magazine* 56, no. 6 (1982), pp. 102–6.

Soby, James Thrall. *The Early Chirico.* New York, 1941.

————. *Giorgio de Chirico.* New York, The Museum of Modern Art, 1955.

Salvador Dali

Ades, Dawn. *Dalí and Surrealism.* New York, 1982.

Ajame, Pierre. *La double vie de Salvador Dali: récit.* Paris, 1984.

Arnason, H. H. *The History of Modern Art: Painting, Sculpture, Architecture.* Rev. ed. New York, 1977.

Art in America 69, no. 8 (1981), p. 33, ill.

Balakian, Anna E. *Surrealism, the Road to the Absolute.* 3rd ed. Chicago, 1986.

Breton, André. *Le Surréalisme et la peinture.* 2nd ed. New York, 1945.

————. *Entretiens 1913–1952.* Paris, 1952.

Calas, Nicolas. "Salvador Dali, mythomaniac." Special issue of *XXᵉ Siècle* no. 54 (1980), pp. 89–96, devoted to Salvador Dali.

Chadwick, Whitney. "Masson's *Gradiva*: The Metamorphosis of a Surrealist Myth." *The Art Bulletin* 52, no. 4 (1970), pp. 415–22.

————. *Myth in Surrealist Painting: 1929–1939* (Studies in the Fine Arts: The Avant-Garde, 1). Ann Arbor, Michigan, 1980.

Cirlot, Juan-Eduardo. *La Pintura surrealista.* Barcelona, 1955.

Dali, Salvador. *The Secret Life of Salvador Dali.* Translated by Haakon M. Chevalier. New York, 1942.

————. *Dali by Dali.* Translated by Eleanor R. Morse. New York, 1970.

I Dalì di Salvador Dalì (exhib. cat.). Ferrara, Galleria Civica d'Arte Moderna, Palazzo dei Diamanti, 1984.

Descharnes, Robert. *The World of Salvador Dali.* Translated by Albert Field and Haakon M. Chevalier. New York, 1962.

————. *Salvador Dali.* Translated by Eleanor R. Morse. New York, 1976.

Gasman, Lydia. "Mystery, Magic and Love in Picasso, 1925–1938: Picasso and the Surrealist Poets." 6 vols. Ph.D. diss., Columbia University, 1981.

Gateau, Jean-Charles. *Paul Éluard et la peinture surréaliste (1910–1939).* Geneva, 1982.

Gaya Nuño, Juan Antonio. *Salvador Dalí.* Barcelona, 1950.

Gérard, Max, ed. *Dali.* Translated by Eleanor R. Morse. New York, 1968.

Gómez de la Serna, Ramón. *Dalí.* Translated by Nicholas Fry and Elisabeth Evans. New York, 1979.

Goudy, Alice M. "San Francisco Sees the Ludington Collection." *Art News* 47, no. 4 (1948), p. 45.

Janis, Harriet, and Rudi Blesh. *Collage: Personalities, Concepts, Techniques.* Philadelphia, 1962.

Jean, Marcel. *The History of Surrealist Painting.* Translated by Simon Watson Taylor. New York, 1960.

Lake, Carlton. *In Quest of Dali.* New York, 1969.

Levy, Julien. *Surrealism.* New York, 1936.

————. *Memoir of an Art Gallery.* New York, 1977.

Maddox, Conroy. *Dali*. New York, 1979.

Matthews, J. H. *Eight Painters: The Surrealist Context*. Syracuse, 1982.

Morse, A. Reynolds. *Dali: A Study of His Life and Work*. Greenwich, Connecticut, 1958.

Ooka, Makato. "Ernst, Miró, Dali." *L'Art du monde* [Tokyo] 23 (1968).

Parinaud, André, ed. *The Unspeakable Confessions of Salvador Dali*. Translated by Harold J. Salemson. New York, 1976.

Passeron, René. *Phaidon Encyclopedia of Surrealism*. Translated by John Griffiths. New York, 1978.

———. *Salvador Dali: Selected Works from the Collection of Mr. and Mrs. A. Reynolds Morse*. New York, 1979.

Ratcliff, Carter. "Swallowing Dali." *Artforum* 21, no. 1 (1982), pp. 33–39.

La Révolution Surréaliste 5, no. 12 (1929), p. 18, ill.

Rubin, William S. *Dada and Surrealist Art*. New York, 1968.

Secrest, Meryle. *Salvador Dali*. New York, 1986.

de Solier, René. "Dali le fétichiste." *XXᵉ Siécle* n.s., no. 36 (1971), pp. 157–59.

Tomkins, Calvin. *The World of Marcel Duchamp, 1887–1968*. New York, 1966.

Walton, Paul H. *Dali–Miró*. New York, 1967.

Wescher, Herta. *Collage*. Translated by Robert E. Wolf. New York, 1968.

Wilson, Simon. "Salvador Dali." In *Salvador Dali* (exhib. cat.). London, Tate Gallery, 1980, pp. 9–20.

Edgar Degas

Millard, Charles W. *The Sculpture of Edgar Degas*. Princeton, 1976.

Rewald, John. *Degas Sculpture*. New York, 1956.

———, ed. *Degas: Works in Sculpture. A Complete Catalogue*. New York, 1944.

Russoli, Franco, and Fiorella Minervino. *L'opera completa di Degas*. Milan, 1970.

André Derain

Les Chroniques du jour no. 8 (January 1931): "Pour ou contre André Derain: enquête, opinions, documents." Special issue devoted to André Derain. With contributions by G. Rouault, P. Courthion, A. Farcy, W. George, A. Salmon, M. Georges-Michel, R. Brielle, J. E. Blanche, Y. Alix, F. de Pisis.

Diehl, Gaston. *Derain*. Translated by A.P.H. Hamilton. New York, 1964.

Elderfield, John. *The "Wild Beasts": Fauvism and Its Affinities* (exhib. cat.). New York, The Museum of Modern Art, 1976.

Gee, Malcolm. *Dealers, Critics, and Collectors of Modern Painting: Aspects of the Parisian Art Market between 1910 and 1930*. New York and London, 1981.

Hilaire, Georges. *Derain*. Geneva, 1959.

Raynal, Maurice. *Peintres du XXᵉ siècle*. Geneva, 1947.

———. "Vlaminck and Derain." In *Matisse, Munch, Rouault: Fauvism, Expressionism (History of Modern Painting*, vol. II). Translated by Douglas Cooper. Geneva, 1950, pp. 35–39.

Sutton, Denys. *André Derain*. London, 1959.

Jean Dubuffet

Limbour, Georges. *Tableau bon levain à vous de cuire la pâte. L'art brut de Jean Dubuffet*. New York and Paris, 1953.

Loreau, Max, ed. *Catalogue des travaux de Jean Dubuffet*. 36 vols. Lausanne, 1966–88.

Ragon, Michel. "Jean Dubuffet." *Cimaise* 5, no. 3 (1958), pp. 11–22. English translation by J. F. Koenig, pp. 7–9.

Max Ernst

Spies, Werner, with Sigrid Metken and Günter Metken. *Max Ernst: Oeuvre-Katalog*. 5 vols. English translation by James Emmons; French translation by Valérie Brière. Houston, Texas, and Cologne, Germany, de Menil Foundation, 1975–87.

Alberto Giacometti

Art News 64, no. 6 (1965), p. 61, ill.

Brenson, Michael. "Looking at Giacometti." *Art in America* 67, no. 1 (1979), pp. 118–20.

Bucarelli, Palma. *Giacometti*. French translation by Elena Parisini; English translation by Anelia Pinna. Rome, 1962.

Courtois, Michel. "La figuration magique de Giacometti." *Art International* 6, nos. 5–6 (1962), pp. 38–45.

Du 22, no. 252 (1962), pp. 2–46. Special section devoted to Alberto Giacometti, with contributions by M. G., H. Wescher, A. Skira, C. Bernoulli, C. Giedion-Welcker, and I. Yanaihara.

Dupin, Jacques. *Alberto Giacometti*. Paris, 1962.

———. "La réalité impossible." In *Alberto Giacometti* (exhib. cat.). With a text by Michel Leiris. Saint-Paul-de-Vence, Fondation Maeght, 1978, pp. 33–47.

Fletcher, Valerie J. "Alberto Giacometti: His Art and Milieu." In *Alberto Giacometti, 1901–1966* (exhib. cat.). Compiled by Valerie J. Fletcher. Washington, The Hirshhorn Museum and Sculpture Garden, 1988, pp. 18–56.

Forge, Andrew. "Arts and Entertainment: Giacometti." *New Statesman* 70 (July 23, 1965), pp. 131–32.

———. "On Giacometti." *Artforum* 13, no. 1 (1974), pp. 39–43.

Freund, Andreas. "Giacometti Exhibition Opens in Paris." *The New York Times* (October 24, 1969), p. 44.

Genêt, Jean. *L'Atelier d'Alberto Giacometti*. 2nd rev. ed. Décines, France, 1963.

Giedion-Welcker, Carola. *Contemporary Sculpture: An*

Evolution in Volume and Space. Translated by Mary Hottinger-Mackie and Sonia Marjasch. New York, 1955.

Habasque, Guy. "La XXXIᵉ Biennale de Venise." *L'Œil* no. 93 (1962), pp. 32–41, 72–73.

Hohl, Reinhold. *Alberto Giacometti*. Stuttgart, 1971.

———. "Form and Vision: The Work of Alberto Giacometti." In *Alberto Giacometti: A Retrospective Exhibition* (exhib. cat.). New York, The Solomon R. Guggenheim Museum, 1974, pp. 13–46.

———. "What's All the Fuss About? Giacometti and Twentieth-Century Sculpture." In *Alberto Giacometti, 1901–1966* (exhib. cat.). Compiled by Valerie J. Fletcher. Washington, The Hirshhorn Museum and Sculpture Garden, 1988, pp. 57–61.

Joray, Marcel. *Schweizer Plastik der Gegenwart* (Schweizer Kunst der Gegenwart, vol. 12). 3 vols. Translated by Maria Netter. Neuchâtel, 1955–67.

Lamarche-Vadel, Bernard. *Alberto Giacometti*. Paris, 1984.

Leiris, Michel. "Thoughts around Alberto Giacometti." *Horizon* 19, no. 114 (1949), pp. 411–17.

Loercher, Diana. "New Look at Giacometti, Sculptor of Phantoms." *The Christian Science Monitor* (April 17, 1974), F, p. 6.

Lord, James. *Giacometti: A Biography*. New York, 1985.

Matter, Mercedes. *Alberto Giacometti*. Introduction by Andrew Forge. Photographs by Herbert Matter. New York, 1987.

Meyer, Franz. *Alberto Giacometti: Eine Kunst existentieller Wirklichkeit*. Frauenfeld and Stuttgart, 1968.

Negri, Mario. "Frammenti per Alberto Giacometti." *Domus* no. 320 (1956), pp. 40–48.

Ponge, Francis. "Réflexions sur les statuettes, figures et peintures d'Alberto Giacometti." *Cahiers d'art* 26 (1951), pp. 74–90.

Rosenberg, Harold. "The Art World: Reality at Cockcrow." *The New Yorker* 50, no. 16 (June 10, 1974), pp. 70–84. Reprinted in Harold Rosenberg, *Art on the Edge: Creators and Situations*. New York, 1975, pp. 120–31.

Rowell, Margit. "Giacometti." In *Qu'est-ce que la sculpture moderne?* (exhib. cat.). Compiled by Margit Rowell. Paris, Musée National d'Art Moderne, Centre Georges Pompidou, 1986, pp. 180–87.

Sartre, Jean-Paul. "Giacometti in Search of Space." *Art News* 54, no. 5 (1955), pp. 26–29, 63–65.

Scheidegger, Ernst, ed. *Alberto Giacometti: Schriften, Fotos, Zeichnungen*. Zurich, 1958.

Schneider, Pierre. "Introducción: 1. Los Giacometti; 2. Alberto Giacometti; 3. Schneider–Diego Giacometti." In *Giacometti: Giovanni 1868–1933, Augusto 1877–1947, Alberto 1901–1966, Diego 1902–1985* (exhib. cat.). Mexico City, Centro Cultural Arte Contemporáneo, 1987, pp. 15–63.

Svendsen, Louise Averrill. *Alberto Giacometti, Sculptor and Draftsman* (exhib. cat.). New York, The American Federation of Arts, 1977.

Sylvester, David. "Giacometti: An Inability to Tinker." *The [London] Sunday Times Magazine* (July 4, 1965), pp. 19–25, ill. p. 27.

Watt, Alexander. "Alberto Giacometti: Pursuit of the Unapproachable." *Studio International Art* 167, no. 849 (1964), pp. 20–27.

Juan Gris

Cooper, Douglas. *Juan Gris, ou le goût du solennel*. Paris and Geneva, 1949.

———, ed. and trans. *Letters of Juan Gris, 1913–1927*. London, 1956.

———, and Margaret Potter. *Juan Gris: catalogue raisonné de l'oeuvre peint*. 2 vols. Paris, 1977.

Gayo Nuño, Juan Antonio. *Juan Gris*. Translated by Kenneth Lyons. Boston, 1975.

———. *Juan Gris*. Translated by Kenneth Lyons. New York, 1986.

Gee, Malcolm. *Dealers, Critics, and Collectors of Modern Painting: Aspects of the Parisian Art Market between 1910 and 1930*. New York and London, 1981.

Golding, John. *Cubism: A History and Analysis, 1907–1914*. New York, 1959.

Grazia Messina, Maria, and Jolanda Nigro Covre. *Il Cubismo dei cubisti: ortodossi/eretici a Parigi intorno al 1912*. Rome 1986.

Leymarie, Jean. "Juan Gris." In *Juan Gris* (exhib. cat.). Edited by Douglas Cooper and Hans Albert Peters. Baden-Baden, Kunsthalle, 1974, pp. 13–21.

Preston, Stuart. "Current and Forthcoming Exhibitions: New York." *The Burlington Magazine* 102, no. 693 (1960), pp. 546–49.

Rosenthal, Mark. *Juan Gris* (exhib. cat., University Art Museum, University of California, Berkeley). New York, 1983.

Soby, James Thrall. *Juan Gris* (exhib. cat.). New York, The Museum of Modern Art, 1958.

Spies, Werner. "Juan Gris oder: Der Gang durch das Prisma." *Frankfurter Allgemeine Zeitung* (April 22, 1974), p. 25.

Wassily Kandinsky

Der Ararat no. 8 (July 1920), pp. 73–74: "Russland," by L. Z.

Grohmann, Will. *Wassily Kandinsky: Life and Work*. Translated by Norbert Guterman. New York, 1958[?].

Washton Long, Rose-Carol. *Kandinsky: The Development of an Abstract Style*. Oxford, England, and New York, 1980.

Paul Klee

Adler, Jankel. "Memories of Paul Klee." *Horizon; a Review of Literature & Art* 6, no. 34 (October 1942), pp. 264–67.

Miller, Margaret, ed. *Paul Klee*. 2nd rev. and enlarged ed. New York, 1945. With statements by the artist and articles by A. H. Barr, Jr.; J. Feininger; L.

Feininger; and J. J. Sweeney. First published in 1941 as the catalogue of the Paul Klee memorial exhibition.

Spiller, Jürg. "Uber Norm und Anorm bei Paul Klee." In *Documenta Geigy II, Internationaler Kongress für Psychiatrie in Zürich*. Basel, 1957.

Fernand Léger

Apollo 100, no. 152 (October 1974), pp. 343–46: "The Sale-Room."

Bernstein, Roberta. "Jasper Johns and the Figure, Part One: Body Imprints." *Arts Magazine* 52, no. 2 (October 1977), pp. 142–44.

Daulte, François. "Beauté, mon beau souci: à propos d'une exposition à la Galerie Daniel Malingue." *L'Œil* no. 299 (June 1980), pp. 48–51.

Herbert, John, ed. *Christie's Review of the Season, 1974*. London and New York, 1974.

Henri Matisse

Apollonio, Umbro. *Fauves e Cubisti*. Bergamo, 1959.

Aragon, Louis. *Henri Matisse: A Novel*. 2 vols. Translated by Jean Stewart. New York, 1972.

Armory Show 50th Anniversary Exhibition, 1913–1963. Organized by the Munson-Williams-Proctor Institute and sponsored by the Henry Street Settlement, New York. Utica, 1963.

Arnason, H. H. *History of Modern Art: Painting, Sculpture, Architecture*. Rev. and enlarged ed. New York, 1977.

Art at Auction: The Year at Sotheby's and Parke Bernet, 1969–70. New York, 1971.

Art at Auction: The Year at Sotheby Parke Bernet, 1976–77. London and Totowa, New Jersey, 1977.

Art News 49, no. 5 (1950), cover ill. and ill. p. 5.

Barr, Alfred H., Jr. *Matisse: His Art and His Public*. New York, 1951.

Basler, Adolphe. *Henri Matisse* (Junge Kunst, vol. 46). Leipzig, 1924.

———. "Henri Matisse." *Der Cicerone* 16, no. 21 (November 6, 1924), pp. 1000–1009.

Brown, Milton W. *The Story of the Armory Show*. New York, 1963.

Carrà, Massimo, and Xavier Derying. *Tout l'oeuvre peint de Henri Matisse, 1904–1928*. Introduction by Pierre Schneider. Translated by Simone Darses. Paris, 1982.

Caspers, Frank. "Philadelphia Honors Henri Matisse with Impressive Retrospective." *The Art Digest* 22, no. 14 (1948), pp. 9, 34.

Charmet, R. "Le Salon d' Automne 1955: rétrospectives et sculpture." *Arts* [Paris], no. 541 (November 9–15, 1955), p. 10.

Chassé, Charles. *Les Fauves et leur temps*. Lausanne and Paris, 1963.

Cowart, Jack. "Matisse's Artistic Probe: The Collage." *Arts Magazine* 49, no. 9 (1975), pp. 53–55.

Crespelle, Jean-Paul. *The Fauves*. Translated by Anita Brookner. Greenwich, Connecticut, 1962.

Daix, Pierre. *Cubists and Cubism*. Translated by R. F. M. Dexter. New York, 1982 a.

———. *Le temps des révolutions: fauvisme, expressionnisme, cubisme, futurisme, 1900–1914 (La grande histoire de la peinture moderne*, vol. II). Edited by Jean-Luc Daval. Paris, 1982 b.

Daval, Jean-Luc. *Journal de l'art moderne, 1884–1914*. Geneva, 1973.

Diehl, Gaston. *Henri Matisse*. New York, 1954.

Duthuit, Georges. *Matisse: Fauve Period*. New York, 1956.

———, and Pierre Reverdy. *The Last Works of Henri Matisse, 1950–1954*. New York, 1958. Originally published as "Dernières oeuvres de Matisse, 1950–1954," in special issue of *Verve* nos. 35–36 (1958).

Ferrier, Jean-Louis. "1907: 'Immensité intime' et simplification du tableau." In *Hommage à Henri Matisse*, special issue of *XX^e Siècle* (1970), pp. 39–43, devoted to Henri Matisse.

Flam, Jack D. "The Norton Matisses: *The Rose, Lorette, Two Rays*" (Norton Gallery Studies, vol. II). Palm Beach, Art Museum of the Palm Beaches, 1973.

———. "Matisse and the Fauves." In *"Primitivism" in 20th Century Art: Affinity of the Tribal and the Modern*. Edited by William Rubin. Vol. I. New York, The Museum of Modern Art, 1984, pp. 211–39.

———. *Matisse: The Man and His Art, 1869–1918*. Ithaca, New York, and London, 1986.

Flanner, Janet. "De diverses formes de beauté." *L'Œil* no. 34 (1957), pp. 24–31.

Fourcade, Dominique. "Matisse et Manet?" In *Bonjour Monsieur Manet* (exhib. cat.). Edited by Catherine David, Isabelle Monod-Fontaine, and Frédérique Mirotchnikoff. Paris, Musée National d'Art Moderne, Centre Georges Pompidou, 1983, pp. 25–32.

———. "Crise du cadre." *Cahiers du Musée National d'Art Moderne* nos. 17–18 (1986), pp. 68–76.

França, José-Augusto. "Matisse, 1970." *Colóquio* no. 59 (June 1970), pp. 18–23.

Francastel, Pierre. *Du classicisme au cubisme* (*Histoire de la peinture française*, vol. II). Brussels and Paris, 1955.

Freund, Gisèle. *Itinéraires*. Paris, 1985.

Fry, Roger. *Henri Matisse*. London and New York, 1935.

Georges-Michel, Michel. "Tra Fauves e Cubisti." *La Biennale di Venezia* no. 2 (October 1950), pp. 9–10.

Giry, Marcel. *Fauvism: Origins and Development*. Translated by Helga Harrison. New York, 1982.

Gowing, Lawrence. "Introduction." In *Matisse, 1869–1954: A Retrospective Exhibition at the Hayward Gallery* (exhib. cat.). London, The Arts Council of Great Britain, 1968, pp. 7–45.

———. *Matisse*. New York and Toronto, 1979.

Grazia Messina, Maria, and Jolanda Nigro Covre. *Il Cubismo dei cubisti: ortodossi/eretici a Parigi intorno al 1912*. Rome, 1986.

338

Gros, C. J. "Henri Matisse." *Cahiers d'art* 2, nos. 7–8 (1927), pp. 273–74.

Guichard-Meili, Jean. *Matisse*. New York, 1967.

———. "Les odalisques." In *Hommage à Henri Matisse*, special issue of *XX^e Siècle* (1970), pp. 63–69, devoted to Henri Matisse.

———. *Matisse: Paper Cutouts*. Translated by David Macey. New York, 1984.

Hohl, Reinhold. "Matisse und Picasso." In *Henri Matisse* (exhib. cat.). Edited by Felix Baumann. Zurich, Kunsthaus, 1982, pp. 26–40.

Jacobus, John. *Henri Matisse*. New York, 1972.

Klein, John. Review of *Matisse*, by Pierre Schneider, *The Drawings of Henri Matisse*, by John Elderfield, and *The Sculpture of Henri Matisse*, by Isabelle Monod-Fontaine. *Art Journal* 45, no. 4 (1985), pp. 359–67.

Lassaigne, Jacques. *Matisse*. Translated by Stuart Gilbert. Geneva, 1959.

———. "La peinture sans limites." *Les Lettres françaises* no. 785 (August 6–12, 1959), p. 10.

Laude, Jean. "Les 'ateliers' de Matisse." *Colóquio* 16, no. 18 (1974), pp. 16–25.

Lebensztejn, Jean-Claude. "Constat amiable." *Cahiers du Musée National d'Art Moderne* nos. 17–18 (1986), pp. 84–91.

Leymarie, Jean. "Il Fauvismo: la piena maturità." *L'Arte moderna* 3, no. 26 (1967), pp. 281–320.

Luzi, Mario, and Massimo Carrà. *L'opera di Matisse dalla rivolta 'fauve' all'intimismo, 1904–1928*. Milan, 1971.

Mannering, Douglas. *The Art of Matisse*. New York, 1982.

Marchiori, Giuseppe. *Matisse*. Paris, 1967.

Marmer, Nancy. "Matisse and the Strategy of Decoration." *Artforum* 4, no. 7 (1966), pp. 28–33.

Matisse, Henri. *Portraits*. Monte Carlo, 1954.

Monod-Fontaine, Isabelle. *Matisse: oeuvres de Henri Matisse (1869–1954)*. Paris, Musée National d'Art Moderne, Centre Georges Pompidou, 1979.

Muller, Joseph-Émile. *Fauvism*. Translated by Shirley E. Jones. Enlarged ed. New York and Washington, 1967.

Mushakojo. *Henri Matisse, 1890–1939*. Tokyo, 1939.

Myers, Bernard S. *Modern Art in the Making*. New York, 1950.

———. "Matisse and the Fauves." *American Artist* 15, no. 10 (1951), pp. 70–72, 86.

Negri, Renata. *Matisse e i Fauves*. Milan, 1969.

Noël, Bernard. *Matisse*. Paris, 1983.

Radulescu, Neagu. *Matisse*. Bucharest, 1970.

Raynal, Maurice. *Peintres du XX^e siècle*. Geneva, 1947.

———. "Fauvism." In *Matisse, Munch, Rouault: Fauvism, Expressionism* (*History of Modern Painting*, vol. II). Introduction by Georg Schmidt. Translated by Stuart Gilbert and Douglas Cooper. Geneva, 1950, pp. 17–73.

Russell, John. "The Birth of a Wild Beast." *Horizon* 18, no. 3 (1976), pp. 4–17.

Schacht, Pierre. *Henri Matisse*. Dresden, 1922.

Scheiwiller, Giovanni. *Henri Matisse*. Milan, 1933.

Schneider, Pierre. *Matisse*. Translated by Michael Taylor and Bridget Strevens Romer. New York, 1984.

Seghers, Lode. "Mercado de las artes en el extranjero." *Goya* nos. 140–141 (1977), pp. 170–76.

Seldis, Henry J. "The Magic of Matisse." *Apollo* 83, no. 5 (1966), pp. 244–55.

Selz, Jean. *Henri Matisse*. Paris, 1964.

———. *Henri Matisse*. Rev. ed. New York, 1989.

Sembat, Marcel. *Henri Matisse*. Paris, 1920.

Sutton, Denys. "The Mozart of Painting." *Apollo* 92, no. 105 (1970), pp. 358–65.

Swane, Leo. *Henri Matisse*. Stockholm, 1944.

Taillandier, Yvon. "Matisse et la préhistoire du bonheur." In *Hommage à Henri Matisse*, special issue of *XX^e Siècle* (1970), pp. 85–95, devoted to Henri Matisse.

Watkins, Nicholas. *Matisse*. Oxford, 1977.

———. *Matisse*. Oxford, 1984.

Wilenski, R. H. *Modern French Painters*. New York and London, 1940.

Zervos, Christian. "Henri Matisse, Notes on the Formation and Development of His Work." In Christian Zervos, ed. *Henri Matisse*. Translated by Charles J. Liebmann, Jr. Paris and New York, 1931, pp. 9–32.

Joan Miró

Art News 44, no. 10 (1945), p. 16, ill.

Baro, Gene. "Miró: A Leap in the Air." *Arts Magazine* 39, no. 1 (1964), pp. 38–43.

Bonnefoy, Yves. *Miró*. New York, 1967.

Breton, André. "Constellations de Joan Miró." *L'Œil* no. 48 (December 1958), pp. 50–55. Also published as the introduction to the portfolio of Miró's prints, *Constellations*, issued by Pierre Matisse in a limited edition of 350 in 1959.

Bucci, Mario. *Joan Miró*. Florence, 1968.

Burr, James. "Round the London Galleries: The Catalan Magician." *Apollo* 80, no. 31 (1964), pp. 238–40.

Cahiers d'art 9, nos. 1–4 (1934), pp. 11–58. Special section devoted to Joan Miró, with contributions by C. Zervos, M. Raynal, R. Desnos, B. Péret, E. Hemingway, R. Gaffé, R. Hoppe, W. Grohmann, V. Huidobro, P. Guéguen, J. Johnson Sweeney, L. Massine, H. Read, J.-V. Foix, J. Voit, and A. Jakovski.

Cary, Elisabeth Luther. "Paintings by Some of Our Older Moderns." *The New York Times* (January 19, 1936), section 9, p. 9.

Cirici-Pellicer, Alexandre. *Miró y la imaginación*. Barcelona, 1949.

Cirlot, Juan-Eduardo. *Joan Miró*. Barcelona, 1949.

———. *La pintura surrealista*. Barcelona, 1955.

Davidson, Martha. "Subconscious Pictography by Joan Miró." *Art News* 35, no. 10 (December 1936), pp. 11, 26.

Dictionnaire abrégé du Surréalisme. Paris, Galerie des Beaux-Arts, 1938. Published on the occasion of

the "Exposition internationale du Surréalisme," January–February 1938.

Diehl, Gaston. *Miró*. Paris, 1974.

Dupin, Jacques. *Joan Miró: Life and Work*. Translated by Norbert Guterman. New York, 1962.

————, Rosa Maria Malet, and Antoní Tàpies. *Joan Miró: anys 20, mutacio de la realitat*. Barcelona, 1983.

Georgel, Pierre, and Isabelle Monod-Fontaine. *Dessins de Miró provenant de l'atelier de l'artiste et de la Fondation Joan Miró de Barcelone* (exhib. cat.). Paris, Musée National d'Art Moderne, Centre Georges Pompidou, 1978.

Gimferrer, Père. *Miró: catalan universel*. Translated by Joëlle Guyot and Robert Marrast. Paris, 1978.

Greenberg, Clement. *Joan Miró*. New York, 1948.

H[abasque], G[uy]. Review of *Miró* by Jacques Dupin. *L'Œil* no. 93 (1962), pp. 73–74, ill. p. 51.

H[ess], T[homas] B. "Reviews and Previews." *Art News* 50, no. 9 (1952), p. 40.

Hugnet, Georges. *Surrealiste Schilderkunst*. Amsterdam, 1938.

Kramer, Hilton. "Month in Review." *Arts Magazine* 33, no. 9 (1959), pp. 48–51.

Krauss, Rosalind, and Margit Rowell. *Joan Miró: Magnetic Fields* (exhib. cat.). New York, The Solomon R. Guggenheim Museum, 1973.

Lassaigne, Jacques. *Miró: Biographical and Critical Study*. Translated by Stuart Gilbert. Geneva, 1963.

Lubar, Robert S. "Joan Miró before *The Farm*, 1915–1922: Catalan Nationalism and the Avant-Garde." Ph.D. diss., New York University, 1988.

Marchiori, Giuseppe. "Miró through the Years." In *Homage to Joan Miró*, special issue of *XXᵉ Siècle* devoted to Joan Miró. Edited by G. di San Lazzaro. Translated by Bettina Wadia. New York, 1972, pp. 15–32.

Matthews, J. H. *The Imagery of Surrealism*. Syracuse, 1977.

————. "André Breton and Joan Miró: Constellations." *Symposium* 34, no. 4 (1980), pp. 353–76.

The Minneapolis Institute of Art Bulletin 40, no. 25 (October 20, 1951), pp. 125–27: "Van Gogh and Modern Painting."

Miró, Joan. *Joan Miró: Selected Writings and Interviews*. Edited by Margit Rowell. Translated from the French by Paul Auster; from the Spanish and Catalan by Patricia Mathews. Boston, 1986.

Penrose, Roland. *Miró*. London, 1970.

————. "Enchantment and Revolution: Joan Miró." *Artforum* 22, no. 3 (1983), pp. 55–59.

Perucho, Juan. *Joan Miró and Catalonia*. New York, 1968.

Picon, Gaëtan, ed. *Joan Miró, Carnets catalans: dessins et textes inédits*. 2 vols. Geneva, 1976.

Prévert, Jacques, and Georges Ribémont-Dessaignes. *Joan Miró*. Paris, 1956.

Rose, Barbara. "Miró in America." In *Miró in America* (exhib. cat.). Edited by Barbara Rose, with essays by Judith McCandless and Duncan Macmillan. Houston, The Museum of Fine Arts, 1982, pp. 5–45.

Rosenblum, Robert. *Cubism and Twentieth-Century Art*. New York, 1960.

Rowell, Margit. *Joan Miró: peinture–poésie*. Paris, 1976.

————. *The Captured Imagination: Drawings by Joan Miró from the Fundació Joan Miró, Barcelona* (exhib. cat.). New York, 1987.

Rubin, William S. "Miró in Retrospect." *Art International* 3, nos. 5–6 (1959), pp. 34–41.

————. *Dada and Surrealist Art*. New York, 1968.

————. *Miró in the Collection of The Museum of Modern Art*. New York, The Museum of Modern Art, 1973.

Teixidor, Joan. " 'Constellations'." In *Homage to Joan Miró*. Special issue of *XXᵉ Siècle* devoted to Joan Miró. Edited by G. di San Lazzaro. Translated by Bettina Wadia. New York, 1972, pp. 38–41.

Tzara, Tristan. "Pour passer le temps. . . ." *Cahiers d'art* 20–21 (1945–46), pp. 277–93.

Zervos, Christian. *Histoire de l'art contemporain*. Paris, 1938.

Amedeo Modigliani

Cachin, Françoise, and Ambrogio Ceroni. *Tout l'oeuvre peint de Modigliani*. Translated by Simone Darses. Paris, 1972.

Diehl, Gaston. *Modigliani*. Rev. ed. New York, 1989.

Formes (English ed.) 14 (April 1931). Advertisement for Galerie Paul Guillaume, Paris.

Franchi, Raffaello. *Modigliani*. 3rd ed. Florence, 1946.

Lanthemann, Jean. *Modigliani, 1884–1920, catalogue raisonné: sa vie, son oeuvre complet, son art*. With essays by Nello Ponente and Jeanne Modigliani. Barcelona, 1970.

Lassaigne, Jacques. "Modigliani." In Maurice Raynal. *From Picasso to Surrealism* (*History of Modern Painting*, vol. III). Translated by Douglas Cooper. Geneva, 1950, pp. 32–37.

Pfannstiel, Arthur. *Modigliani et son oeuvre: étude critique et catalogue raisonné*. Paris, 1956.

Piccioni, Leone, and Ambrogio Ceroni. *I dipinti di Modigliani*. Milan, 1970.

Roy, Claude. *Modigliani*. Translated by James Emmons and Stuart Gilbert. 2nd rev. ed. New York, 1985.

Piet Mondrian

Holtzman, Harry, and Martin S. James, eds. and trans. *The New Art—The New Life: The Collected Writings of Piet Mondrian*. Boston, 1986.

Ottolenghi, Maria Grazia. *L'opera completa di Mondrian*. Milan, 1974.

————. *Tout l'oeuvre peint de Mondrian*. Introduction by Michel Butor. Translated by Simone Darses. Paris, 1976.

Pablo Picasso

Art News 39, no. 16 (1941), p. 17: "New Forms up to the Time of the New War, 1930–39."

Art News 68, no. 8 (1969), p. 13, ill.

Barr, Alfred H., Jr. *Picasso: Fifty Years of His Art.* New York, 1946.

Bille, Ejler. *Picasso, Surrealisme, Abstrakt Kunst.* Copenhagen, 1945.

Bonfante, Egidio, and Juti Ravenna. *Arte Cubista. Con le "Méditations esthétiques sur la peinture" di Guillaume Apollinaire.* Venice, 1945.

Buchheim, Lothar Günther. *Picasso: A Pictorial Biography.* Translated by Michael Heron. New York, 1959.

Bulletin de "l'Effort Moderne" no. 13 (March 1925), ill.

Cahiers d'art 7, nos. 3–5 (1932). Special issue devoted to the Picasso exhibition at Galerie Georges Petit, Paris. With contributions by C. Zervos, A. Salmon, F. Fagus, A. Farge, G. Apollinaire, I. Stravinsky, J. E. Blanche, J. Metzinger, H. Mahaut, R. Gignoux, L. Vauxcelles, P. Guéguen, G. Hugnet, R. Gómez de la Serna, J. Cocteau, J. J. Sweeney, H. S. Ede, C. Einstein, P. Reverdy, M. Raynal, A. Ozenfant, O. Schürer, A. Breton, P. Éluard, W. Grohmann, M. Dale, V. Huidobro, A. Basler, J. Maritain, M. de Zayas, A. J. Eddy, G. Scheiwiller, and Picasso.

Cahiers d'art 10, nos. 7–10 (1935). Special issue "Picasso, 1930–1935." With contributions by C. Zervos, P. Éluard, A. Breton, B. Péret, Man Ray, Dali, G. Hugnet, J. Sabartés, L. Fernández, J. González, and Miró.

Cahiers d'art 13, nos. 3–10 (1938), pp. 73–196. Special section on Picasso. With contributions by Christian Zervos and Paul Éluard.

Camón Aznar, José. *Picasso y el cubismo.* Madrid, 1956.

Cassou, Jean. *Picasso.* Translated by Mary Chamot. New York, 1940.

———. *Picasso.* Paris, 1949[?].

de Champris, Pierre. *Picasso: ombre et soleil.* Paris, 1960.

Cheney, Sheldon. *The Story of Modern Art.* New York, 1941.

Chrysler Museum Bulletin 2, no. 5 (1973), pp. 1–2: "Picasso Retrospective."

Cohen, Janie L. "Picasso's Exploration of Rembrandt's Art, 1967–1972." *Arts Magazine* 58, no. 2 (1983), pp. 119–26.

Combalia Dexeus, Victòria, ed. *Estudios sobre Picasso.* Barcelona and Madrid, 1981.

Connaissance des arts 222 (August 1970), p. 79: "Conseils aux acheteurs: le cubisme à la grande cote."

Connoisseur 173, no. 697 (1970), pp. 191–93: "International Salesroom."

Cowling, Elizabeth. " 'Proudly We Claim Him as One of Us': Breton, Picasso, and the Surrealist Movement." *Art History* 8, no. 1 (1985), pp. 82–104.

Crastre, Victor. *La Naissance du Cubisme (Céret 1910).* Geneva, 1950.

Daix, Pierre. *La vie de peintre de Pablo Picasso.* Paris, 1977.

———. "Braque and Picasso at the Time of the *Papiers Collés.*" In *Braque: The Papiers Collés* (exhib. cat.). Edited by Isabelle Monod-Fontaine and E. A. Carmean, Jr. Washington, National Gallery of Art, 1982, pp. 23–43.

———. *Cubists and Cubism.* Translated by R. F. M. Dexter. New York, 1982.

———. "On a Hidden Portrait of Marie-Thérèse." *Art in America* 71, no. 8 (1983), pp. 124–29.

———, and Georges Boudaille. *Picasso: The Blue and Rose Periods. A Catalogue Raisonné, 1900–1906.* Translated by Phoebe Pool. Greenwich, Connecticut, 1966.

———, and Joan Rosselet. *Picasso: The Cubist Years, 1907–1916. A Catalogue Raisonné of the Paintings and Related Works.* Translated by Dorothy S. Blair. Boston, 1979.

Daulte, François. *Picasso.* Geneva, 1966.

Daval, Jean-Luc. *Journal de l'art moderne, 1884–1914.* Geneva, 1973.

Documents 2, no. 3 (1930), pp. 113–84. Special issue "Hommage à Picasso." With contributions by R. Desnos, C.-H. Puech, R. Vitrac, M. Leiris, L. Pierre-Quint, G. Monnet, G. Ribémont-Dessaignes, J. Prévert, C. Einstein, A. Schaeffner, M. Jouhandeau, J. Baron, G. Bataille, E. Jolas, M. Heine, M. Mauss, C. Mauclair, E. Kasyade, and G. H. Rivière.

Du 18 (August 1958). Special issue "Picasso Taurómaco." With essays by J. Cocteau, M. Gasser, P. Illo, H. de Montherlant, B. Geiser, P. F. Althaus, G. Freund, R. Char, and R. Rufener.

Elgar, Frank, and Robert Maillard. *Picasso.* Translated by Francis Scarfe. New York, 1956.

Estrada, Genaro. *Genio y figura de Picasso.* Plaza de Miravalle, Mexico, 1936.

Farr, Dennis. "Quintessential Cubism: A New Look." *Apollo* 117, no. 256 (1983), pp. 508–9.

Frankfurter, Alfred M. "Picasso in Retrospect: 1939–1900. The Comprehensive Exhibition in New York and Chicago." *Art News* 38, no. 7 (1939), pp. 11–21, 26–30.

Gaffé, René. *À la verticale: réflexions d'un collectionneur.* Brussels, 1963.

Gee, Malcolm. *Dealers, Critics, and Collectors of Modern Painting: Aspects of the Parisian Art Market between 1910 and 1930.* New York and London, 1981.

Glueck, Grace. "New York: Trendless but Varied, the Season Starts." *Art in America* 59, no. 5 (1971), pp. 118–23.

Gómez Sicre, José. "Barr y Picasso." *El Nacional* 4, no. 1 (January 12, 1947), p. 9.

Haesaerts, Paul. *Picasso et le goût du paroxysme.* Amsterdam, 1938.

Hohl, Reinhold. "Widerspruch als Stilprinzip." In *Picasso: Druckgraphik, illustrierte Bücher, Zeichnungen, Collagen und Gemälde aus dem Sprengel Museum Hannover* (exhib. cat.). Edited by Magdalena C. Moeller. Hanover, Sprengel Museum, 1986, pp. 19–27.

Hunter, Sam. *Picasso: Cubism to the Present.* New York, 1957.

Jaffé, Hans L. C. *Pablo Picasso*. Garden City, New York, and New Jersey, 1980.

Kahnweiler, Daniel-Henry. *The Rise of Cubism*. Translated by Henry Aronson. New York, 1949.

———. *Les années héroïques du cubisme*. Paris, 1950.

LeClerc, André. *Picasso*. New York, 1947.

Leighten, Patricia. "Picasso: Anarchism and Art, 1897–1914." Ph.D. diss., Rutgers University, 1983.

———. "Picasso's Collages and the Threat of War, 1912–13." *The Art Bulletin* 67 (1985), pp. 653–72.

———. *Re-Ordering the Universe: Picasso and Anarchism, 1897–1914*. Princeton, 1989.

Level, André. *Picasso*. Paris, 1928.

Leymarie, Jean. *Picasso Drawings*. Translated by James Emmons. Geneva, 1967.

———. *Picasso: The Artist of the Century*. Translated by James Emmons. New York, 1972.

Lipton, Eunice. *Picasso Criticism, 1901–1939: The Making of an Artist-Hero*. New York and London, 1976.

Mackenzie, Helen F. *Understanding Picasso: A Study of His Styles and Development*. Chicago, 1940.

Merli, Joan. *Picasso, el artista y la obra de nuestro tiempo*. 2nd ed. Buenos Aires, 1948.

Meyer, Franz, William Rubin, Zdenek Felix, and Reinhold Hohl. *Picasso aus dem Museum of Modern Art New York und Schweizer Sammlungen* (exhib. cat.). Basel, Kunstmuseum, 1976.

Miller, Dorothy Canning, ed. *Masterpieces of Modern Art: The Nelson A. Rockefeller Collection*. Introduction by Nelson A. Rockefeller, text by William S. Lieberman, and essay by Alfred H. Barr, Jr. New York, 1981.

Museum Bulletin [Virginia Museum of Fine Arts] no. 5 (1941), p. 1: "Pablo Picasso."

Palau i Fabre, Josep. *Picasso: The Early Years, 1881–1907*. Translated by Kenneth Lyons. New York, 1981.

Parmelin, Hélène. *Picasso Plain: An Intimate Portrait*. Translated by Humphrey Hare. New York, 1963.

Payró, Julio E. *Picasso y el ambiente artístico-social contemporáneo*. Buenos Aires, 1957.

Penrose, Roland. *The Eye of Picasso*. New York, 1967.

Perry, Jacques. *Yo Picasso*. Paris, 1982.

Raynal, Maurice. *Picasso*. Translated by Richard Landauer. Munich, 1921.

———. *Picasso*. Translated by James Emmons. Geneva, 1953.

La Révolution Surréaliste 3, nos. 9–10 (1927), p. 20, ill.

Rosenblum, Robert. *Cubism and Twentieth-Century Art*. New York, 1960.

———. "Picasso and the Coronation of Alexander III: A Note on the Dating of Some *Papiers Collés*." *The Burlington Magazine* 113, no. 823 (1971), pp. 604–7.

Russoli, Franco. *Pablo Picasso*. Translated by Edith Combe. Milan, 1953.

———, and Fiorella Minervino. *L'opera completa di Picasso cubista*. Milan, 1972.

Seghers, Lode. "Mercado de las artes en el extranjero." *Goya* no. 94 (1970), pp. 256–58.

Soby, James Thrall. "Picasso: A Critical Estimate." *Parnassus* 11, no. 8 (1939), pp. 8–12.

Steinberg, Leo. "Resisting Cézanne: Picasso's 'Three Women'." *Art in America* 66, no. 6 (1978), pp. 114–33.

———. "The Polemical Part" ("Resisting Cézanne," part 2). *Art in America* 67, no. 2 (1979), pp. 114–27.

———. "Kvinnorna i Alger och Picasso i stort." In *Pablo Picasso* (exhib. cat.). Translated by Tua Waern. Stockholm, Moderna Museet, 1988, pp. 121–222.

Sutton, Denys. *Picasso, peintures: époques bleue et rose*. Paris, 1955.

Vinchon, Jean. "Les mythes du taureau et du cheval dans les arts normaux et pathologiques." *Art d'aujourd'hui* 2, no. 8 (1951), pp. 14–16.

Weisner, Ulrich, Rolf P. Horstmann, Max Imdahl, Bernhard Kerber, and Gundolf Winter. *Zeichnungen und Collagen des Kubismus: Picasso, Braque, Gris* (exhib. cat.). Bielefeld, Kunsthalle, 1979.

Wood, Jeremy. "London, Tate Gallery Exhibition: The Essential Cubism. Braque, Picasso & Their Friends, 1907–1920." *Pantheon* 41, no. 3 (1983), pp. 275–76.

Zennström, Per-Olov. *Pablo Picasso*. Stockholm, 1948.

Zervos, Christian. "De l'importance de l'objet dans la peinture d'aujourd'hui (III)." *Cahiers d'art* 5, no. 6 (1930), pp. 281–94.

———. *Pablo Picasso: oeuvres*. 33 vols. Paris, 1932–78.

Pierre-Auguste Renoir

Cabanne, Pierre. *Renoir*. With contributions by R. Cogniat, F. Daulte, F. Duret-Robert, C. Renoir, M. Robida, C. Roger-Marx, D. Rouart, and Y. Taillandier. Paris, 1970.

Drucker, Michel. *Renoir*. Paris, 1944.

Haesaerts, Paul. *Renoir: Sculptor*. New York, 1947.

Meier-Graefe, Julius. *Renoir*. Leipzig, 1929.

Vollard, Ambroise. "Renoir sculpteur." *Beaux-Arts* no. 93 (October 12, 1934), p. 1.

Auguste Rodin

Elsen, Albert E. *Rodin*. New York, 1963. Published in conjunction with a Rodin exhibition at The Museum of Modern Art, New York, and the California Palace of the Legion of Honor, San Francisco.

Grunfeld, Frederic V. *Rodin: A Biography*. New York, 1987.

Jewell, Edward Alden. "French Art Work Is Displayed Here: St. Étienne Gallery Presents Paintings by Renoir, Signac, Utrillo, and van Gogh; Cézanne Canvases Hung; Two Bronze Heads by Rodin Also Shown—Exhibitions in Other Galleries Listed." *The New York Times* (March 1, 1940), p. 16.

Lami, Stanislas. "Auguste Rodin." In *Dictionnaire des sculpteurs de l'école française au dix-neuvième siècle*. Vol. IV. Paris, 1921, pp. 161–75.

Tancock, John L. *Rodin Museum: Handbook*. Philadelphia, 1969.

———. *The Sculpture of Auguste Rodin: The Collection of the Rodin Museum, Philadelphia*. Philadelphia, 1976.

Watkins, Fridolyn G. *Catalogue of the Rodin Museum*. Philadelphia, 1929[?].

Georges Rouault

Brillant, Maurice. "Rouault's Thoughts about Sacred Art." In *Homage to Georges Rouault*, special issue of *XX^e Siècle*. Edited by G. di San Lazzaro. Translated by Joan Sánchez. New York, 1971.

Dorival, Bernard, and Isabelle Rouault. *Rouault: l'oeuvre peint*. In English and French. 2 vols. Monte Carlo, 1988.

Maritain, Jacques. *Georges Rouault*. With notes on Rouault's prints by W. Lieberman. New York, 1954.

Sam Szafran

Lord, James. "Szafran: la valeur du réel." *L'Œil* no. 216 (December 1972), pp. 44–49.

Yves Tanguy

Ashbery, John. "Yves Tanguy, Geometer of Dreams." *Art in America* 62, no. 6 (November–December 1974), pp. 71–75.

Bazin, Germain, and Charles Sterling. "L'École de Paris à New York." Special issue of *L'Amour de l'art* 25, no. 2 (July 1945).

Breton, André. *Yves Tanguy*. In French and English. English translation by Bravig Imbs. Designed by Marcel Duchamp. New York, 1946.

Breuning, Margaret. "Surrealist Disillusion of Yves Tanguy." *Art Digest* 19, no. 16 (May 15, 1945), p. 9.

Cahiers d'art 20–21 (1945–46), pp. 384–88: "Yves Tanguy: nouvelles peintures."

Catoir, Barbara. "Ausstellungen: Deutschland. Baden-Baden, Staatliche Kunsthalle Ausstellung: Yves Tanguy." *Pantheon* 41, no. 1 (January–March 1983), pp. 45–46.

Coates, Robert M. "The Art Galleries: Tanguy and de Chirico." *The New Yorker* 31, no. 32 (September 24, 1955), pp. 156–60.

Connaissance des arts, nos. 365–366 (July–August 1982), p. 14: "Une aussi longue absence" [Tanguy retrospective at the Musée National d'Art Moderne, Centre Georges Pompidou, Paris].

Fried, Alexander. "2nd Annual Exhibition." *Bulletin of the California Palace of the Legion of Honor* 5, no. 8 (December 1947), pp. 59–66.

Jean, Marcel. "Yves Tanguy, peinture de la voie lactée." *Les Lettres nouvelles* 3, no. 25 (March 1955), pp. 367–79. Published in English in *Art News* 54 (September 1955), pp. 30–31, 51–56.

Levy, Julien. "Tanguy, Connecticut, Sage." *Art News* 53, no. 5 (September 1954), pp. 24–27.

Micha, René. "La première rétrospective de Tanguy en Europe." *Art International* 25, nos. 9–10 (November–December 1982), pp. 45–47.

L'Œil no. 232 (November 1974), pp. 56–58: "Nouvelles des arts: New York, rétrospective Tanguy."

Onslow-Ford, Gordon. *Yves Tanguy and Automatism*. Inverness, California, 1983.

Preston, Stuart. "Paris, Beaubourg: Yves Tanguy." *The Burlington Magazine* 124, no. 954 (September 1982), p. 575.

Rubin, William S. *Dada and Surrealist Art*. New York, 1968.

Sage, Kay. *Yves Tanguy: un recueil de ses oeuvres/A Summary of His Works*. With contributions by A. Breton, P. Éluard, L. R. Lippard, B. Karpel et al. In French and English. English translation by Kay Sage. New York, 1963.

Soby, James Thrall. "Inland in the Subconscious: Yves Tanguy." *Magazine of Art* 42, no. 1 (January 1949), pp. 2–7.

The Tiger's Eye, no. 3 (March 15, 1948), p. 104, ill.

View 2, no. 2 (May 1942). Special issue devoted to Yves Tanguy and Pavel Tchelitchew. With contributions about Tanguy by A. Breton, N. Calas, J. J. Sweeney, B. Péret, and C. H. Ford.

Waldberg, Patrick. "Yves Tanguy." *L'Œil* no. 95 (November 1962), pp. 48–56.

Maurice de Vlaminck

Artemis 1977–78 (Consolidated Audited Annual Report, 1977–78). Luxembourg, 1978.

Cailler, Pierre, ed. "André Derain, 1880–1954." *Documents: encyclopédie générale des beaux-arts au XIX^e et XX^e siècles* no. 109. Geneva, 1959.

Daval, Jean-Luc. *Journal de l'art moderne, 1884–1914*. Geneva, 1973.

Derain, André. *Lettres à Vlaminck*. Paris, 1955.

Dorival, Bernard. "Fauves: The Wild Beasts Tamed." *Art News Annual* 51, no. 7 (1953), pp. 98–129, 174, 176.

Duthuit, Georges. *Les Fauves*. Geneva, 1949.

Elderfield, John. *The "Wild Beasts": Fauvism and Its Affinities* (exhib. cat.). New York, The Museum of Modern Art, 1976.

Fels, Florent. *Vlaminck*. Paris, 1928.

———. *L'art vivant, de 1900 à nos jours*. Geneva, 1950.

Lee, Sherman E. "The Water and the Moon in Chinese and Modern Painting." *Art International* 14, no. 1 (January 20, 1970), pp. 47–59.

Leymarie, Jean. *Fauvism*. Translated by James Emmons. [Lausanne], 1959.

———. "Il Fauvismo: la fase preparatoria." *L'arte moderna* 3, no. 24. Milan, 1967.

———. *Fauves and Fauvism*. New York, 1987.

Loucheim, Aline B. "From 'Wild Beasts' to Old Masters." *The New York Times Magazine* (October 5, 1952), pp. 24–30.

Muller, Joseph-Émile. *Fauvism*. Translated by Shirley E. Jones. New York, 1967.

Rosenstein, Harris. "French Beasts and Tormented Teutons: Fauvism and Expressionism, 1900–1914, as Parallel Movements and International Expressionism, 1900–1955, as Surveyed in Two New York Galleries." *Art News* 67, no. 3 (May 1968), pp. 46–47, 63–65.

Russell, John. *The World of Matisse, 1869–1954*. New York, 1969.

Sauvage, Marcel. *Vlaminck: sa vie et son message*. Geneva, 1956.

———, ed. *Maurice Vlaminck: Mein Testament. Gespräche und Bekenntnisse*. Zurich, 1959.

Selz, Jean. *Vlaminck*. Translated by Graham Snell. New York, 1961[?].

Stabile, Blanca. "André Derain." *Ver y estimar: revista mensual de critica artistica* no. 2 (December 1954), p. 3.

[de] Vlaminck, Maurice. "Avec Derain: nous avons créé le Fauvisme." *Jardin des arts*, no. 8 (June 1955), pp. 473–79.

Édouard Vuillard

Cooper, Douglas, ed. *Great Private Collections*. Introduction by Kenneth Clark, New York, 1963.

Ritchie, Andrew Carnduff. *Édouard Vuillard* (exhib. cat.). New York, The Museum of Modern Art, in collaboration with The Cleveland Museum of Art, 1954.

Roger-Marx, Claude. *Vuillard: His Life and Work*. Translated by Edmund B. d'Auvergne. London, 1946.

Index

Numbers in italics refer to pages with illustrations.